Iconography of the
Tale of Genji

Iconography of

Miyeko Murase

The Tale of Genji

Genji Monogatari Ekotoba

New York · **WEATHERHILL** · *Tokyo*

Publication of this book was assisted by grants from the Kajima
Foundation, the Suntory Foundation, and the Japan Foundation.

First edition, 1983

Published by John Weatherhill, Inc., of New York and Tokyo, with editorial offices
at 7–6–13 Roppongi, Minato-ku, Tokyo 106, Japan. Protected by copyright under
terms of the International Copyright Union; all rights reserved. Printed in Japan.

Library of Congress Cataloging in Publication Date: Murase, Miyeko, 1924– / Iconogra-
phy of the Tale of Genji. / "Translation, with illustrations, of the Genji monogatari
ekotoba": p. / Includes index. / 1. Murasaki Shikibu, b. 978? Genji monogatari—
Illustrations. 2. Narrative painting, Japanese—To 1868. 3. Narrative painting,
Japanese—Technique. I. Genji monogatari ekotoba. English. 1983. II. Title. /
ND1053.M79 1983 759.952 83–3452 ISBN 0–8348–0188–4

To Mary Griggs Burke

Contents

Colar plates appear following page 100

Acknowledgments and Photo Credits

I was extremely fortunate to have received encouragement and cooperation from a large number of people in bringing this project to completion. First of all, my most sincere gratitude is due to the Japan Foundation, whose financial assistance enabled me to complete my research for this book in the summer of 1981. The same foundation contributed funds toward the publication of the results of this research; it would not have been possible to produce this book in its present form without their continued support and endorsement.

My personal and warmest thanks go to the Kajima Art Foundation, particularly to its former president, the late Kajima Ume, and the present head, Atsumi Itsuko. I am deeply grateful to them, as they not only offered generous financial assistance for the publication of this work, but also their enthusiasm and commitment to the project. They were, in addition, instrumental in interesting Weatherhill in this venture. I only regret that Mrs. Kajima is no longer with us to witness the final outcome.

Through the good offices of the Weatherhill staff, the Suntory Foundation also extended its assistance toward this project, and I am truly appreciative of their generosity.

My deepest gratitude also goes to the private collectors, and to the staff members of the museums here, in Japan, and in Europe that own the *Genji* paintings included herein. These individuals were always accommodating in spite of their busy schedules. They allowed me to examine paintings, often for long hours during hot summer days; their cooperation and willingness to help were indispensable.

It is not possible to mention all the names of other friends and colleagues who assisted me in many different ways. I must, however, express my special thanks to Mr. Katō Hideyuki of the Shiryō Hensanjo of Tokyo University, who helped me decipher some of the unclear and difficult passages in the manuscript translated here. Without his assistance I would have felt much less confident of my own readings of certain portions of this work. Professor Gustina Scaglia of Queens College, New York, offered suggestions and advice as to the format and organization of this book. Her knowledge and insights—the results of her own experience with similar projects—are of especial value. Stephanie Wada, a graduate student and my assistant in the Department of Art History and Archaeology, Columbia University, deserves special thanks, as she spent many hours going over the proofs with meticulous care.

My editors at Weatherhill were most kind. My schedule, as this book went to press, was especially hectic, crowded with numerous other commitments and responsibilities. I know that it was difficult for them to have to communicate

with me about every small detail via written correspondence. I am deeply grateful for their patience and understanding, without which this book could never have come to be.

Finally, thanks must be extended to those individuals and institutions who have kindly granted permission to reproduce their photographs. Their names are given in alphabetical order, followed by the figure numbers or by the chapter and scene numbers of the Osaka manual that their photographs are used to illustrate; those numbers in boldface type indicate color illustrations. Credits are due to:

Mary Griggs Burke (New York): Fig. 1; 1–3, 2–3, 3–2, 4–1, 4–6, **5–3**, 6–1, 7–1, 7–2, 7–5, 10–3, 12–1, 12–4, 13–2, 13–6, 14–3, 14–4, 17–3, 20–3, 21–5, 22–2, 22–3, 24–4, 25–2, 26–3, 27–1, 28–1, 29–4, 30–1, 32–5, 36–1, 37–2, 38–1, 39–2, 39–6, 40–1, 40–2, 44–3, 45–1, 46–5, 47–1, 47–2, 49–1, 49–10, 49–15, 50–5, 50–6, 51–2, 53–1, 53–4 (photos by Otto Nelson)

Albert P. Cardarelli (Boston): Fig. 3

Columbia University (New York): 4–5, 32–3, 34–2

Eisei Bunko Foundation (Tokyo): 41–4

Freer Gallery of Art, Smithsonian Institution (Washington): 1–1, 3–11, 5–2, 6–2, 9–6, 19–2, 21–6, 26–4, 29–3, 31–1, 34–8, 35–8, 36–4, 37–4, 41–2, 43–1, 48–2, 49–9, 51–9, 52–5

Hosomi Minoru (Osaka): **26–2**

Kyoto National Museum: 5–1, 8–1, 11–1, 12–5, 15–2, 18–3, 19–4, 22–6, 25–1, 26–1, **28–3,** 29–2, 32–4, 33–1, 34–14, 35–1, 39–4, 41–3, 44–5, 45–2, 47–4; 37–3, 50–7, 53–6 (from the Ikeda collection)

Mary and Jackson Burke Foundation (New York): Fig 4; 6–5

New York Public Library: 1–2, 1–5, 2–1, 4–3, 5–4, 5–8, 6–4, 6–6, 6–7, 7–7, 9–2, 9–7, 10–2, 10–4, **10–5,** 10–6, 10–7, 10–8, 12–3, 13–1, 13–4, 14–1, 20–2, 21–1, 21–2, 21–4, 22–1, 22–4, 24–3, 28–2, 29–5, 34–4, 34–7, 34–9, 34–11, 35–2, 35–3, 35–4, 39–5, 40–3, 47–6, 48–3, 49–3, 49–5, 49–7, 49–8, 49–11, 49–12, 49–13, 50–3, 51–5, 51–8, 52–2, 52–4, 53–3

Osaka Women's College, Fig. 5

Östasiatiska Museet (Stockholm): 14–2, **19–1,** 20–4, 21–3, 23–1, 24–1, 29–1, 37–5, 54–2

Seattle Art Museum: 33–3, 35–5

Tenri Central Library: 9–3, 9–5, **17–2,** 35–6, 35–7, 35–10, 36–6, 38–3, 39–3, 39–7

Tokugawa Reimeikai Foundation (Tokyo): Figs. 6, 7; 1–4, 2–2, 2–4, 2–5, 4–2, 5–7, 7–3, 8–3, 9–1, 11–2, 13–3, 15–1, 16–1, 17–1, 18–2, 19–3, 19–6, 20–1, 22–5, 24–5, 27–2, 28–4, 31–4, 32–2, 33–2, 34–5, 34–6, **35–9,** 36–2, 36–5, 37–1, 38–2, 39–1, 41–1, 42–1, 43–2, 44–2, 46–3, 46–4, 48–1, 49–2, 49–4, 50–2, **50–4,** 51–1, 52–6, 52–7, 52–8, 53–5, 54–1

Tokyo National Museum: Fig. 2; 3–1, 5–8, 7–6, 12–2, 13–4, 18–4, 20–2, 34–3, 41–4, 42–2, 51–6, 53–2

Yamato Bunkakan (Nara): 51–3, 51–10

Yanagi Takashi (Kyoto): 31–2, 47–5; **51–12** (courtesy of Heibonsha)

Introduction

1. About the *Tale of Genji*

The Tale of Genji (*Genji Monogatari*) is one of the earliest examples of romantic literature in the world. Written circa A.D. 1000, it is all the more impressive in that its author, Murasaki Shikibu, was a relatively young woman. Her extraordinary achievement is evident in the complexity of the novel's plot, the depth of its emotions, its keen observation of nature and human psychology, and its exquisite prose style.

The events described in the novel span almost three-quarters of a century, involving more than four hundred and thirty characters. In the Japanese, the book is divided into fifty-four chapters, and in Edward Seidensticker's recent English translation, it runs to more than one thousand and ninety pages.[1]

The book begins with the birth of Genji, known in later literature as Hikaru Genji (The Shining Genji), the son of an emperor by his favorite concubine. A man of rare physical beauty and cultivated taste, Genji is for Murasaki Shikibu the pinnacle of masculine character. His experiences are followed from his youth through his meteoric rise in rank and power, focusing above all on his countless romantic associations with women of different classes, personalities, and appearances, even with those of modest physical charms. More than ten women have fairly constant relationships with him throughout his life. In addition, he has two legitimate wives, first Aoi and then the Third Princess. More important, however, is his relationship with Murasaki, his favorite, who, because of her low birth, never becomes his legitimate wife.

After the passing of this great man at the age of fifty-two, the novel continues with the life of Genji's handsome but lackluster son Yūgiri (Evening Mist) and, finally, with the lives and rivalries of Genji's grandson Niou (Perfume) and the tragic Kaoru (Fragrance). The last ten chapters of the novel, which are mainly devoted to Kaoru and Niou, are commonly known as the *Uji Jūjō* (Ten Books of Uji) since their episodes are often set in the rustic countryside of Uji. The theme of these chapters is the superficial friendship and rivalry between the two princes; here the plot is subordinate to the psychological development of Kaoru.

Kaoru, who passes as Genji's son, is actually the child of a tragic liaison between Kashiwagi, son of Genji's best friend, and the Third Princess, Genji's young second wife; he is a melancholy introvert—a sort of "modern" man—prone to wavering attempts at courtship. His complex characterization is regarded as the creation of the first antihero in literature.[2]

Niou, Genji's grandson, is the antithesis of Kaoru, and his successes, which forever elude Kaoru, are drawn in sharp contrast to Kaoru's struggles. Easy-

going, unreliable, and somewhat shallow, Niou is always successful with women, but without total emotional commitment.

Genji and Murasaki, the personifications of male and female virtues, are believed to have been modeled to some extent after historical personages. Whoever her models were—and there is some scholarly debate over this—Murasaki Shikibu obviously derived them from the life and society that she herself witnessed, transforming them according to her own concepts of the ideal man and woman. Throughout the novel, Genji is depicted as a man of utmost refinement: sensitive and quick to recognize and appreciate beauty in nature, human emotions, the arts, colors, shapes, fragrances. He is the symbol par excellence of the ideals held highest by the cultivated court society of Heian Japan. Murasaki, her beauty unequaled, represents the ideal of warm compassion, grace, and refinement: the only flaw in this otherwise perfect person is that she is barren.

Because the book vividly reflects contemporary social mores, it is a valuable historical document as well as a great work of fiction; the ideas it expresses on art, the aesthetics of courtly elegance, and cultivated taste are seldom touched upon in other contemporary sources. This is particularly important because they reveal attitudes about aesthetics at a time when the Japanese were becoming increasingly conscious and proud of their indigenous characteristics.

That the author of this intricate romance, a keen observer of human foibles and social mores, as well as a critic of artistic theories, was a relatively young woman is another remarkable aspect of this book. Murasaki Shikibu came from a literary family that included poets and several women authors, among them the wife of Fujiwara Kaneie (929–90) who wrote the *Kagerō Nikki* (The Gossamer Years),[3] and her niece, a daughter (b. 1008) of Sugawara Takasue, who wrote the *Sarashina Nikki* (The Sarashina Diary).[4] Lady Murasaki's father, Fujiwara Tametoki, was a minor nobleman and a poet. It is thought that her personal name was Takako, but this cannot be ascertained since women were more often referred to by the ranks and titles held by their male kinsmen. Thus, "Shikibu" may refer to the title held by her father, *Shikibu no Daijō* (Senior Secretary in the Bureau of Ceremonials). The origin of "Murasaki" is also unclear. It means lavender, and it may refer to wisteria (*fuji*), in reference to her family name. It may refer as well to Murasaki, the most important female character in her novel. The date of her birth is equally uncertain, but it is thought to be around 970 or 978. She was apparently a bright child, but she was born when evidence of superior female intelligence was no cause for special joy in Japan. According to an entry in her memoir, the *Murasaki Shikibu Nikki*,[5] she was able to memorize and recite passages from the Chinese classics, which she learned by eavesdropping on the lessons given to her older brother but forbidden to her because of her sex. At that time the study of Chinese literature was considered inappropriate for the delicate female sex, and Murasaki's father lamented her intellectual prowess, wishing that she had been born a male.

She recorded in her journal others' perceptions of her as "pretentious, awkward, difficult to approach, prickly, too fond of her tales, haughty, prone to versifying, disdainful, cantankerous, and scornful,"[6] which disturbed her considerably. Another comment that described her as "strangely meek and a completely different person," when met seems to have pleased her. Around 997, she married a minor Fujiwara clansman named Noritaka, apparently more than twenty years her senior and already the father of five sons. She gave birth to a daughter in 999 who would later become a poetess of some repute under the name of Daini no Sammi. Murasaki's marriage lasted only a few years, however, as Noritaka died in 1001. Around 1005 she entered service at the court of Shōshi, the consort of Emperor Ichijō and the eldest daughter of Fujiwara Michinaga, the archpatriarch of the clan.

It is not known exactly when Murasaki Shikibu began this novel, or what prompted her to embark on such an ambitious project. Her interest in literature from early childhood and her wish to cope with the tedium of being a young widow and mother, of which she speaks in her memoir, may be as good a reason as any for her motivation. At any rate, indications are that she started her novel before entering court life and that by the time she began service it was well under way. In 1008, she was hailed by Fujiwara Kintō (966–1041), the leading poet of her time, as *Waka Murasaki* (the name of the novel's fifth chapter; it also means "young Murasaki"); it can also be read as *waga Murasaki* (meaning "my Murasaki").[8] According to her memoir, her novel was read aloud to the Emperor Ichijō in the first month of the sixth year of the Kankō era (1009).[9] Fujiwara Michinaga also noted that there was a manuscript of her novel in the empress's possession, which means that the work was by then more or less complete.[10]

Murasaki's memoir complements her novel enormously, as it reveals not only the details—the daily activities and atmosphere—at court during the period of her service, but also her perceptive and probing mind.

Murasaki lived during one of the most brilliant periods in the history of Japanese literature, distinguished by the presence of three of the greatest female writers of all time: the witty and sharp-tongued Sei Shōnagon (ca. 968–1025), known for the biting remarks on people, objects, ideas, and events that fill her *Makura no Sōshi* (The Pillow Book of Sei Shōnagon);[11] the passionate Izumi Shikibu (b. 976?), author of the *Izumi Shikibu Nikki* (The Izumi Shikibu Diary);[12] and Murasaki Shikibu herself. In contrast to these other two women, Murasaki seems to have been quiet and introspective.

We know little more about the relatively short life of this exceptional woman. She must have died sometime around 1015, when her name ceases to appear in court records.

Almost a century after the court had severed official ties with China in 894, the Japanese were gradually assimilating what they had previously borrowed from China. Moving away from the indiscriminate imitation of Chinese arts, the Japanese of Murasaki's time created styles in art that were better suited

to their own temperament and that they would develop further in later periods. One development, which made an immeasurable impact on Japanese culture, was the invention of the *kana* script. The script developed as phonetic symbols from the cursive writing of selected Chinese characters and represents separate syllables of Japanese words. It is an easy and practical syllabary that enabled the Japanese to record their spoken language. Although it was inadequate for official business, it was most effective as a way of recording human feelings. The freedom of expression it provided affected subsequent artistic developments, especially literature, calligraphy, and painting. For the first time, poets and novelists were able to produce a vernacular literature. Without *kana*, it would have been impossible to produce *waka* (verse written in *kana* and restricted to thirty-one syllables), some of the beautiful calligraphic works, and above all, great novels like the *Tale of Genji*.

As men were slow to discard literary forms and conventions borrowed from China, their works often lacked freedom of expression and originality of vision. Women, however, were quick to take advantage of *kana*, probably because they were discouraged from using the Chinese language in their literary endeavors. In fact, women—Murasaki among them—virtually monopolized prose writing in *kana*. Never before or after this time did women play such an important role in Japanese literature.

While Murasaki's book cannot be separated completely from the literary works of her predecessors, such tenth-century romantic works as the *Taketori Monogatari* (The Tale of the Bamboo Cutter), the *Ise Monogatari* (The Tales of Ise), the *Sumiyoshi Monogatari* (The Tales of Sumiyoshi), and *Yamato Monogatari* (The Tales of Yamato) do not begin to anticipate such a full-scale romance as the *Genji*. These collections of short tales and *waka* were only fragile precedents that hinted at the way that Murasaki followed in the creation of her masterpiece. As early as the beginning of the Kamakura period, around 1200, the anonymous author of the *Mumyō Zōshi* (Nameless Book), was already aware of this fact and called Murasaki's effort a miraculous performance for a woman who had almost nothing to draw upon from the past.[13]

Although it is difficult to pinpoint the earlier literature that might have helped Murasaki Shikibu in her own work, the effects of her novel on later literature are easy to determine. Unfortunately, neither Murasaki's own handwritten manuscript nor the manuscript that Michinaga saw in the empress's possession exist today. But many later copies, some dating from the early Kamakura period, attest to the novel's enormous popularity even outside her court circle. One young woman, the author-to-be of the *Sarashina Nikki*, noted her pleasure at receiving a copy of this novel as a gift (in 1021), when she was a girl.[14] It is clear that not long after the *Genji Monogatari* was completed, hand-copied sets were widely circulated among the literary public. Later romantic literary works that clearly reflect their debt to Murasaki include the *Hamamatsu Monogatari*, the *Nezame Monogatari*, and the *Sagoromo Monogatari*,

among others, and there is as well an enormous number of scholarly works that were inspired by this masterpiece. It has also served as a subject for paintings and crafts. No other Japanese written text, not even the sacred books of Buddhism, match this novel in popularity and longevity; indeed, the *Genji Monogatari* is the pinnacle of Japanese literary achievement.

2. Illustrating the *Genji*

The creative spirit that blossomed with the *Tale of Genji* also touched the visual arts, resulting in the cultivation of secular painting, called *yamato-e,* the pictures (*e*) of Yamato. Yamato initially referred to the Nara region, but it came to denote anything particularly Japanese. The term *yamato-e* was used in the Heian period in contradistinction to *kara-e* (literally, painting of T'ang China); it suggested a genre of painting distinct from the Chinese-derived *kara-e,* just as literary works in *kana* were clearly distinguished from those written in Chinese characters.

Secular painting evolved from a combination of factors. There was, of course, a legacy of Chinese narrative paintings, particularly of Buddhist subjects, of which only a handful dating prior to the Heian period are preserved. Secular narrative paintings produced in China and imported to Japan are known only through documentary records, such as the catalogue of objects donated to Tōdai-ji in 756 by Emperor Shōmu's widow.[1] The paintings listed are now known only by their titles, but some of these are so reminiscent of extant Chinese works that one is tempted to think the works are preserved. For example, there is record of a pair of six-paneled screens of ink drawings representing scenes of night revelry, a subject that recalls Ku Hung-chung's Sung-dynasty handscroll in Peking, entitled the *Night Revels of Han Hsi-tsai.*[2] The exact contribution that Chinese narrative painting might have made toward the formation of *yamato-e* in Japan remains unclear, however, because in style, narrative method, and artistic premise the Chinese narrative paintings that do exist are so different from Japanese works of the Heian period.

One tradition in China that might have influenced Japanese narrative painting was that of narrator-monks who recited texts accompanying paintings. A rare example of a handscroll from Tun-huang, now in the Bibliothèque Nationale, Paris (Pelliot 4524), describes a contest between Śāriputra and Raudrākṣa. Two types of text, one in prose and the other in vernacular verse, are written on the reverse side of the scroll, so that when the scroll is partly unrolled, the scene and its appropriate text appear in close proximity. Apparently, the narrator-monks explained the painted scenes by reciting these texts to their audience. While examples of the narrator-monks in China are

confined to their narration of Buddhist paintings, scholars agree that the verse which accompanied such paintings also contributed to the formation of vernacular literature in China.

This tradition of narrators was adopted by the Japanese. Apparently, a large illustrated biography of Prince Shotoku (574–622), painted at Shitennō-ji in Osaka, was used by the *etoki* (narrator),[4] and eventually recitation of stories was no longer limited to religious functions. For example, in one episode from chapter 50 of the *Genji Monogatari*, *Azumaya* (The Eastern Cottage), the princess Nakanokimi "took out illustrations to old romances," and while her sister Ukifune examined the pictures, their maidservant Ukon read aloud from the text. This episode is illustrated in the *Genji Monogatari Emaki* (Tokugawa Reimeikai Foundation collection, see 50–4), where Nakanokimi, who has just had her hair washed, is having it combed, while Ukifune, facing her, holds a picture book in her hand, and Ukon holds the text.

No doubt ancient China's narrative paintings and the tradition of narrators enriched *yamato-e* in Japan. However, a clear unilateral development from the Chinese works to *yamato-e*— especially in the brilliant, truly Japanese expression of narrative handscroll paintings known as *emaki*, or *emaki-mono*—is difficult to trace.

The emergence of narrative painting in Japan may be tied more closely to the Japanese practice of complementing *waka* poetry with paintings than to Chinese influence. In the ninth century, *waka* and painting were inseparable, both in a thematic and a physical sense. For example, *waka* were often written within a specially reserved area on painted screens. No ninth-century example of these screens remains today, but their existence is recorded in anthologies of poems, and examples do exist from later periods. Equally numerous are poems written on paintings that were later copied into poetry anthologies. Sometimes the anthologies include references to the occasions that underlie the production of such screens, as well as brief prose descriptions of the painted scenes that inspired the poets. *Waka* express emotions succinctly, since by definition they are very brief. It is the prose introductions that give more concrete descriptions of the painted scenes that inspired the poetry. For example, brief descriptions of scenes on a four-paneled screen belonging to a certain Sai'in, a royal princess who was the priestess of the Kamo Shrine, offer tantalizing glimpses of lost paintings. The descriptions are found in the *Tsurayuki Shū*, an anthology of poems by Ki no Tsurayuki (d. 945), one of the greatest poets of Heian Japan.[6] They may be translated as follows: 1. Women of a household come into the garden to view plum blossoms and traces of snow remaining on the mountains. 2. A person stands under a tree looking at blossoms in the distance. 3. Women gather under wisteria by a pond to see the flowers reflected in the water. 4. A person looks at a waterfall from its basin. 5. A traveler rests at the foot of a pine tree that grows by the seashore. 6. A person watches snow falling in the garden.

Many scholars consider these prose fragments, which were inspired by narrative paintings, to be the precursors of romantic literature in Japan. The arts

of painting and literature depended on each other so closely that some scholars suggest that paintings served as a kind of memory bank in the days when narrative tales were not yet written but were transmitted orally.[7] Painting and literature seem to have worked hand in hand to develop the plot of a tale, one leading the other to the next stage.[8] In fact, the genre of romantic tales seems to have been in a state of flux, evolving as paintings inspired poems that were then incorporated into the plot, altering it and providing a new theme for yet another painting.

The evolution of the *Sumiyoshi Monogatari* illustrates this rather unusual process of the growth of a literary work.[9] This tale, an early romantic literary work combining prose and poetry, predates the *Tale of Genji,* which in fact mentions the *Sumiyoshi's* enormous popularity. It is not known exactly when it was written, but evidence suggests that illustrations for it already existed in the mid-tenth century. Nakatomi Yoshinobu (921–91), a noted courtier-poet-scholar, was asked, most likely by an emperor or his consort, to compose poems for paintings illustrating episodes from this tale. Unfortunately, the paintings Yoshinobu saw are lost, but the seven poems he composed are included in his anthology (now in the Imperial Library in Tokyo).[10] A short preface to Yoshinobu's poems gives a rare insight into the relationship between literature and painting. The preface states that the request was made since there were some scenes in the painting that "should be accompanied by poems but those were missing." Each of the seven poems is preceded by its own preface, which briefly describes the painted scene. Some of these prefaces are translated below to give a better idea of this apparently typical Heian practice of adding paintings and poems to a work in prose.

The *Sumiyoshi Monogatari,* one of the numerous Cinderella-type stories enormously popular before Murasaki's time, centers around the fate of a beautiful stepdaughter, simply known as the princess. A handsome prince, Chūjō (lieutenant-general), fell in love with her, but he was tricked into marrying one of the princess's stepsisters. Despondent, the princess fled, and Chūjō spent a long time searching for her. Yoshinobu's sequence of seven poems clearly suggests a progression of the story, beginning with Chūjō's arrival at the princess's retreat at Sumiyoshi; thus, it is probable that the tale was already illustrated and embellished with poems up to the point when Chūjō rediscovered the princess in the lovely setting of Sumiyoshi. Only the prose introductions to three of his poems will be translated:

> Preface 2. After arriving at Sumiyoshi, [Chūjō][11] stands at the edge of the veranda talking to Ukon [the princess's maidservant].

> Preface 3. On his way to visit the princess at Sumiyoshi, [Chūjō] passes through the woods of Kaminabi on a late August night.

Chūjō continued his secret visits to the princess, but could not be united with her; this is clear from the preface to Yoshinobu's seventh poem, which reads:

Preface 7. The autumn wind of August deepened [Chūjō's] longing for Sumiyoshi, as he stayed away in his palace [in the capital]. In Sumiyoshi, too, the wind blew hard, and [the painting] shows the Princess languishing.

The *Sumiyoshi Monogatari* of the Heian period is believed lost, and extant texts, which end with the couple's happy marriage immediately after the princess had been discovered, are believed to reflect an extensive rewriting of the original, done in the early Kamakura period. However, the conclusion to the Heian original was probably similar because happy endings were customary then as well. It seems, then, that when Yoshinobu composed his poems, the tale had not yet reached completion.

Although the exact date of Yoshinobu's poems is not known, his anthology was probably compiled between 969 and 986. Historians believe that Yoshinobu's seven poems, following the custom of the time, were written in specially designated areas of the paintings. If this hypothesis is correct, the *Sumiyoshi* story evolved step-by-step, as paintings were executed and the poems added. The poems would then be incorporated into the text, thus creating a new recension. This evolution may be illustrated by the following formula: the original tale + paintings + poems = an extended tale (including the poems).[12]

The *Sumiyoshi Monogatari* was by no means the first romantic tale in Japan to be illustrated, but again, literary sources offer the only evidence. The earliest illustrated tale mentioned in literature is the tragic story of the virgin of Ikutagawa (*Ikuta Otome Zuka*), which was presented to Onshi, the consort of Emperor Uda, sometime before her death in 907. The *Tosa Nikki* (The Tosa Diary), a travelogue on the Tosa district by Ki no Tsurayuki, was also illustrated shortly after its completion in 935. Some scholars conclude that illustrations for literary works were so common that early romantic tales such as the *Genji* and *Sumiyoshi* were, from their inception, meant to be illustrated, and that their texts were intended to be recited by one person to another who looked at the pictures while listening, as the scene from the *Eastern Cottage* chapter in the *Genji Monogatari Emaki,* discussed above, suggests.[13]

Thus, we have some idea of the ambience in which the *Tale of Genji* was written. Unfortunately, no eleventh-century *Genji* paintings, not even documentary references to them, exist. The earliest records of lost *Genji* paintings or extant paintings are from the beginning of the twelfth century, approximately a century after the novel was written. The earliest reference to *Genji* pictures is found in a court diary, the *Chōshū Ki,* by the courtier Minamoto Morotoki (1077–1136).[14] According to this diary, on the twenty-seventh day of the eleventh month, the second year of the Gen'ei era (1119), Morotoki was commissioned to procure paper for *Genji* pictures to be made for Shōshi, consort of the cloistered emperor Go-Shirakawa. Nothing more about this request can be ascertained, however, because the portions of the diary pertaining to the end of that year and the following six years are lost.

The earliest extant *Genji* paintings date from the beginning of the twelfth

century.[15] And what paintings they are!—some of the most beautiful ever created by Japanese artists. Unfortunately, however, they are now in an extremely fragmented condition. Only twenty-eight sections of text and twenty segments of paintings remain today. The sections are divided among various collections in Japan, the Gotoh Museum and the Tokugawa Reimeikai Foundation holding the largest share, including nineteen of the paintings divided between them. The twentieth section is in the collection of the Tokyo National Museum, but this last fragment is too heavily over-painted to allow appreciation of its original beauty.[16]

For the purpose of preservation, sections of the text and the paintings are kept as separate sheets, but originally they were mounted in handscrolls, in which a section of text regularly alternated with an illustration. Stylistically, these fragments may be dated to the early twelfth century, not very much later than that set commissioned, according to the *Chōshū Ki*, in 1119, and in fact some scholars believe that these fragments may be from it.

The text and paintings, executed with the utmost finesse and sophistication, are the epitome of the refined courtly style of the period, quite in keeping with the novel's central characteristics. The text, almost a full version of the novel, is written in the elegant *kana* script, on paper delicately decorated with thin sheets of gold and silver cut into small pieces of varying shapes. Five different calligraphic hands have been identified among the twenty-eight text fragments.

Brilliantly colored in red, green, blue, and many other hues, the small compositions—like the illuminated manuscripts of medieval Europe—weave a rich brocade of patterns, distilling for eternity the ideals of an introspective Heian society. We see, within these small picture frames, the recreation of the courtiers' lives, their joys and sorrows, and the figures, though seldom shown in motion, achieve a timeless grace in their exquisite imagery. The beauty of these early *Genji* paintings remains unsurpassed.

The twenty paintings depict episodes from thirteen chapters of the novel, and episodes from these and seven more chapters are included in the twenty-eight textual fragments. Thus twenty chapters are represented in the fragments, and it seems that there was more than one illustration per chapter. A list of the extant fragments of text and paintings is found in the catalogue at the end of this volume. As the chart in the catalogue indicates, five of the extant chapters contain more than one painted scene; these are: chapters 36, *Kashiwagi* (The Oak Tree); 38, *Suzumushi* (The Bell Cricket); 44, *Takekawa* (Bamboo River); 49, *Yadorigi* (The Ivy); and 50, *Azumaya* (The Eastern Cottage). Akiyama has suggested that as many as one hundred episodes might have been included in the original set of this *Genji*, comprising more than ten scrolls.[17] In his careful research, Akiyama determined that these paintings were executed by four groups of painters working under one man who possessed an exceptional artistic vision. Such an enormous undertaking must have required extraordinary patronage, most likely from court circles.

The paintings are executed in the *tsukuri-e* ("built-up pictures") technique, in

which preliminary sketches are made directly on the paper, and even the notations and reminders for colors and the nature of objects are written in ink, all of which is concealed once the pigments are applied. In some sections, colors have flaked off, revealing the ink sketches and notations. Mineral colors are applied in thick layers, sometimes superimposed on other colors, creating a rich intensity unattainable by techniques in which colors are applied only in single layers. In this way forms can be changed while colors are being applied. The last and most important stage in such *tsukuri-e* is the application of the finishing lines in ink over the colors. It is in this final stage that such delicate details as ink lines for the eyes and eyebrows are added.

The human figures, strictly conventionalized throughout the scrolls, are depicted without emotions or individual differences in physiognomy and gender. They seldom stand or move about; furthermore, the seated figures are completely enveloped in billowing, colorful robes. Both the male and the female figures have small round faces; their features are briefly delineated in the technique known as *hikime-kagihana* (dashes for eyes, hooks for noses), showing thick brows and small, full rosebud lips. Under examination with microscopes, Akiyama discovered that while the line used for an eye looked like a single hair-thin brushline, it was in fact a cluster of several threadlike lines. This technique creates the subtlest hint of the figures' different moods.

The very anonymity of the characters represented by these highly stylized figures allowed viewers to identify themselves psychologically with the individuals portrayed in the paintings.[18] It seems that the Heian courtiers read romantic tales and viewed their illustrations with an extraordinary degree of emotional involvement. A passage in the mid-tenth-century novel, the *Yamato Monogatari*, refers to a group of men and women looking at pictures of a tale, imagining themselves in the places of the people depicted, and composing poems about them.[19] The absence of individuality in the *Genji* figures, then, was an indispensable quality that enhanced a close emotional bond between the pictures and their viewers.

Another convention, *fukinuki-yatai* (blown-off roof), is used to show the interiors of rooms from above, without ceiling or roof, so that viewers have an unobstructed view. And if the postures and faces of the characters are relatively staid, the architectural elements vividly reflect mood and emotion, almost as in modern abstract painting. Horizontal lines achieve an effect of serenity; diagonal lines, of disturbance and agitation. They often clash violently against one another or form unsettling frameworks from which figures seem to slide off dangerously (see 36–2). Human emotions, never allowed to explode, are expressed indirectly by such architectural forms. This pictorial device at once epitomizes the evocative mood of the novel and underscores the refined nature of the aesthetic standards that governed the Fujiwara court.

There are no extant *Genji* illustrations from the more than one hundred years following. To study the pictorial tradition of *Genji* illustrations during this century, it is necessary to turn once again to literary records. Court diaries like

the *Chōshū Ki* usually give no more than terse references to various events. However, one unusual document, entitled *Genji Higishō* (Notes on a Confidential Conference on the *Genji*),[20] details a dispute that developed over a particular group of *Genji* paintings. The document, now in the Imperial Library, terminates with a memorandum entitled *Genji-e Chinjō* (Petition on *Genji* Paintings). It is a petition for shogunal adjudication of the correct iconography for certain *Genji* paintings. Apparently a shogun, most likely Munetaka, an imperial prince who ruled from 1252 to 1266, commissioned *Genji* paintings on *shikishi* (small square sheets of paper usually used for writing or painting), which were then to be pasted on screens. Critical observers of this new set of *Genji* pictures found fault with some details and voiced their objections, whereupon those who produced the pictures responded in their own defense and petitioned for the shogun's judgment. Both arguments were presented to the shogun and recorded in the *Chinjō*—the only known record in the history of Japanese painting describing a dispute over iconographic details in a painting.

What irked the critics was the portrayal of an episode in chapter 8, *Hana no En* (The Festival of the Cherry Blossoms). In an earlier episode of the same chapter, Genji had met the Sixth Princess and had been enchanted by her. The painting in question, illustrating the second episode evidently depicted Genji at a banquet seated boldly behind the screens with the princess. Critics of this painting complained that it was unfaithful to the text of the novel, and that the correct representation of the episode should show Genji outside the barrier. The second point of contention was over the scene of an episode in chapter 51, *Ukifune* (A Boat upon the Waters). Ukifune was missing from her house at Uji, and Prince Niou came to inquire. The critics argued that the painting should show the prince seated on an *aori*, whereas in this painting he was sitting on a *mukabaki*. *Aori* is a fairly large piece of leather or some other material, draped over a horse's sides to protect the rider from dirt. *Mukabaki*, on the other hand, are shinguards, which would not seem to have been large enough to substitute as a cushion for the prince.

The answer to these accusations was an assertion that the paintings were beyond criticism because they were faithfully modeled on the earlier, very much respected series of *Genji* scrolls in the shogunal collection. The *Chinjō* gives a brief description of this model, an early twelfth-century set of twenty handscrolls. The paintings in this set were executed by several ladies-in-waiting, and the text was written by several noblemen-calligraphers. Two of the calligraphers are mentioned by name: Fujiwara Tadamichi (1097–1164), a poet-statesman-calligrapher, and Minamoto Arihito (1103–47), a musician and poet of royal birth.[21]

The arguments recorded in the *Chinjō* touch upon the problem of the fidelity of the painting to its text. These two points also suggest that at least two recensions of *Genji* illustrations may have existed in the mid-thirteenth century. The two scenes over which the dispute occurred are not represented in the twelfth-century *Genji* scroll, but they can be studied in many later examples. Tosa

Mitsunori (1583–1638), many of whose works are reproduced in this book, painted the scene of Genji and the Sixth Princess from chapter 8 more than once (for example, in the albums now in the Burke and Tokugawa collections). While he was usually careful not to duplicate the same composition in his various *Genji* projects, for this episode he chose to repeat the scene as mirror images. He depicted Genji looking frustrated by his awkward position only partly inside the princess's screens (see 8–3). In the scene from chapter 51, Mitsunori portrayed Prince Niou seated on a large, cushionlike form (see 51–12). It presumably represents the *aori* and not the shinguard (*mukabaki*), but this is only conjecture since the true nature and form of these temporary cushions is unknown.

Genji paintings continue to be mentioned in documents throughout the thirteenth century,[22] but only a few fragments exist from this period (they have been separated from a book and divided between the Tokugawa Reimeikai and the Yamato Bunkakan Museum).[23] There are only five illustrations among the fragments, representing episodes from chapter 51, *Ukifune* (A Boat upon the Waters). Executed in delicate black ink, in the technique known as *hakubyō* (white drawing), these fragile drawings are dreamlike. Pitch black areas on the courtiers' hats and the women's flowing black hair are sharply contrasted against faint, thread-thin outlines. They have a haunting beauty that contrasts quite strikingly with the brilliantly chromatic *Genji* paintings of the twelfth century.

Only one fragment has survived from the fourteenth century. (Originally in a handscroll, it is now divided between the Tenri Library in Nara and the Metropolitan Museum of Art in New York.) Sections from chapters 5, *Waka Murasaki* (Lavender), and 6, *Suetsumuhana* (The Safflower), are represented in the Tenri collection, while a short scroll representing an episode from chapter 14, *Miotsukushi* (Channel Buoys), is in New York.[24] Brilliantly colored, these paintings have a naive charm found in many *Genji* paintings from later centuries.

The number of surviving *Genji* paintings gradually increases from the late Muromachi period in the sixteenth century. The majority of the extant *Genji* illustrations from this period are delicate *hakubyō* drawings, most consisting of several small handscrolls (about fifteen centimeters in height) representing numerous episodes from all fifty-four chapters. The *hakubyō* drawings, which became popular in the second half of the thirteenth century, may have survived the artistic metamorphosis that characterizes the Muromachi period, when Zen-inspired ink painting in the Chinese mode all but superseded *yamato-e*. It is quite possible that the monochromatic *hakubyō* style would have retained its appeal in a period when ink painting was in vogue.

Most of these *hakubyō* scrolls are preserved in fragmentary condition. Although the mid-thirteenth-century *hakubyō* drawings in the Tokugawa Reimeikai and in the Yamato Bunkakan Museum are works by a superb artist, those

from the Muromachi period are usually rather naive, sometimes even crude works which may be attributed to amateurs. One such example, a set in the Spencer Collection of the New York Public Library, includes colophons, one of which, by an unknown hand and probably contemporary with the scroll or only slightly postdating it, attributes the scroll to a daughter of the distinguished courtier, Konoe Taneie (1503–66). The second inscription, at the end of the scroll, was written by the artist of the scroll, who states that it was made in the twenty-third year of the Tenmon era (1554), and that it follows its model faithfully. Nothing even remotely approximating this model for the Spencer scrolls has been found so far, though we can assume that it was like many of the extant *hakubyō* scrolls, since scenes in all of them, including the one in the Spencer Collection, share a number of common iconographic features. It is interesting, however, that the depiction of some episodes in these *hakubyō* scrolls differs markedly from compositions found in the twelfth-century *Genji* paintings. Thus, it may be surmised that by the sixteenth century the iconography of *Genji* paintings had been enriched and diversified, resulting in different recensions of illustrations.

Hakubyō might have been favored by sixteenth-century amateur artists, but it was soon elevated to a courtly art at the hands of such Tosa artists as Tosa Mitsunori, who was responsible for many *hakubyō* albums of the early seventeenth century, two of which are now in American collections—the Freer Gallery of Art in Washington, D.C. (Cat. No. 9) and the Burke collection in New York (Cat. No. 8). The majority of *Genji* paintings from the Momoyama and Edo periods, however, are brilliant polychromatic works. Artists of almost all inclinations produced them, including Tosa artists and even members of the Kanō school, who represented the official taste of the ruling class. A screen of *Genji* paintings, now in the Imperial collection, is attributed to Kanō Eitoku (1543–90), the archpatriarch of that school. Other artists of the Kanō school as well as members of the Kaihō and Rimpa schools also executed *Genji* illustrations. These paintings usually follow the standard iconographic forms, but their styles reflect the traits of their own schools; only the Tosa works can be said to maintain a stylistic tie, albeit a tenuous one, to the masterpieces from the Heian period.

These artists worked from the late sixteenth to the early seventeenth centuries, a period of splendid wall decorations. Large screens were also used to depict episodes from the *Genji*, and a new compositional scheme seems to have been devised around this time. A pair of six-paneled screens (Burke collection, Cat. No. 1), although from a later period (the early eighteenth century), is a typical example of this new form, with one episode from each of the fifty-four chapters on the pair (Fig. 1). On these screens episodes are arranged vertically in a sequence, progressing from the top right corner of a right-hand screen, then moving downward on the first panel; thereafter, that movement is repeated as they advance toward the far left panel on the left-hand screen. Yet another

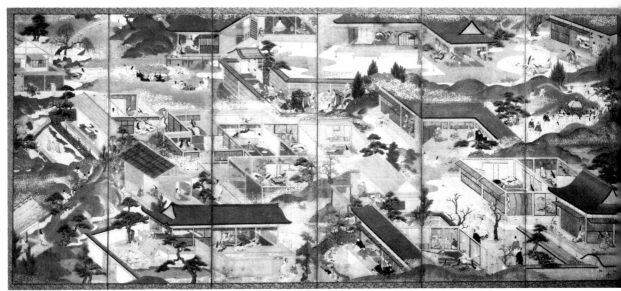

Fig. 1

common screen form depicts only a few episodes or even a single episode on a screen (for example, the pair in the Seattle Art Museum, Cat. No. 14). Episodes involving a large number of people or sumptuous settings, both outdoors and indoors, are preferred in such enlarged compositions.

Small, inexpensive folding fans—daily necessities in Japanese life—became popular vehicles for *Genji* illustrations. According to a seventeenth-century travelogue, the *Chikusai*, Sōtatsu's painting shop, which was known as Tawaraya, was popular for its production of fans decorated with brilliantly painted scenes from the *Genji*.[25] The basic iconography was also disseminated widely as it appeared on playing cards and sea shells used in popular games.

Abundant examples, in book form, handscrolls, and screens, are available from the Edo period, some of which are reproduced here. Some Edo-period works contain fifty-four illustrations, one scene to a chapter. Another type, which was particularly popular in the eighteenth century, is the so-called dowry set, intended for young women who were about to be married; such sets were often placed in beautiful lacquer boxes. These usually consist of fifty-four books, one volume for each chapter. The entire text of the novel is reproduced in these sets, while in all other projects it was customary to copy only some passages from the novel. As a rule, more than one episode in a chapter is selected for illustration in these large sets.

Genji stories also became favorite subjects for artisans working with lacquer, metal, and textiles. Even such small objects as *kozuka* (small knives) or *tsuba* (sword guards) are sometimes decorated with a single image, such as a sprig or two of flowers or plants or a bird (Fig. 2), that has come to be associated with specific episodes in the novel, suggesting that the text, or at least some of

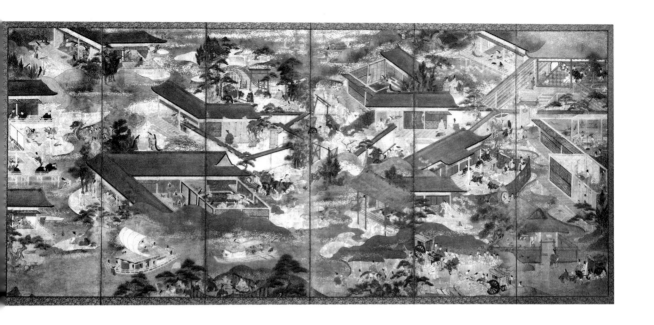

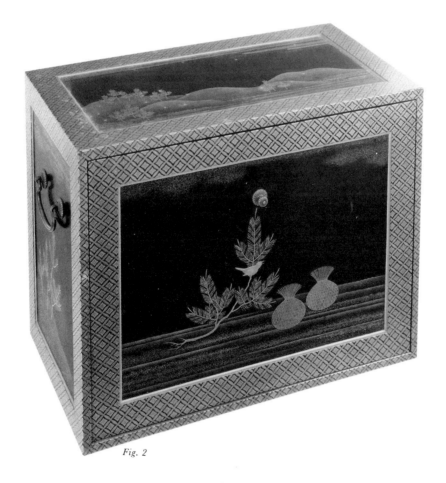

Fig. 2

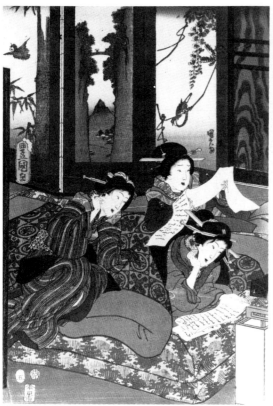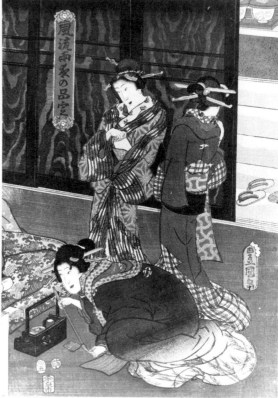

Fig. 3

its many episodes, was readily recognized and the cryptic message under-
stood.[26]

In this regard, ukiyo-e woodcuts of the nineteenth century occupy a singular
position in the evolution of the *Genji* iconography. That episodes from this classic
tale should be depicted at all in ukiyo-e is somewhat unexpected since this art
represents the antithesis of the courtly taste that the novel championed. Ukiyo-e
artists, undaunted by the long tradition of *Genji* illustrations, introduced free
and bold transformations of the centuries-old iconography and even of the
novel's plot. For instance, a print by Utagawa Kunisada (1786–1865) shows
the rather unceremonious behavior of six women discussing some letters (Fig.
3). This is obviously a parody of the famous scene from chapter 2, *Hahakigi*
(The Broom Tree), in which Genji and his young friends discuss the merits
and virtues of various women (see 2–2).

Ukiyo-e artists also opened a new avenue in the pictorial treatment of this
ancient subject. Women from famous episodes are singled out and represented
on hanging scrolls in solitary splendor. Most likely this was inspired by the
convention in ukiyo-e paintings and woodcuts of depicting beautiful courtesans
singly. Even when entirely separated from their narrative context, such paint-

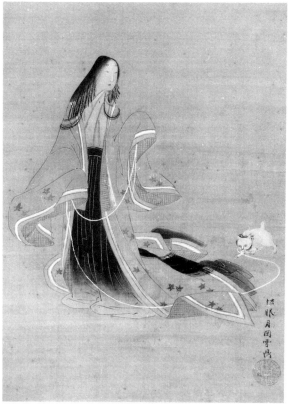

Fig. 4

ings as those by Tsukioka Settei (d. 1786), for example, were easily recognized as a representation of the Third Princess, Genji's tragic young wife, with her favorite cat (Fig. 4).

3. The Osaka Manuscript

Inevitably the long-lasting popularity and proliferation of *Genji* imagery led to many variants, even to the corruption of it soriginal form. The mid-thirteenth-century dispute over details of the *Genji* iconography, as it is described in the *Chinjō*, should not mislead scholars into assuming that all pictures were produced with an equal degree of attention. A set of pictures intended for a shogun was obviously a very special case. Yet sometime before the sixteenth century, someone was inspired (or irked by the general condition of illustrated *Genji Monogatari*) to codify its pictures. There seems to have been a need for a canon of textual excerpts and paintings to help artists in creating an illustrated *Genji*, and an

Fig. 5

artist's manual, the manuscript of which is now in the collection of the Osaka Women's College (Osaka Joshi Daigaku) Library in Japan, might have been edited under such circumstances (Fig. 5).[1] It is the work translated here.

This manuscript bears the title, *Genji Monogatari Ekotoba*. The word *ekotoba*, strictly speaking, refers to pictures (*e*) that accompany a text (*kotoba*), but it is sometimes used as a synonym for *emaki*. In reality, the *ekotoba* section of this manuscript consists not of complete texts but rather of brief excerpts taken from the fifty-four chapters of the *Genji Monogatari*, and these excerpts are accompanied not by paintings but by verbal descriptions of the painted scenes. In other words, this manuscript was intended as a working model for painters and calligraphers who prepared books or scrolls of illustrated *Genji Monogatari*.[2]

It is a hand-copied manuscript whose calligraphy suggests that it was written in the sixteenth century, either in the late Muromachi or the early Momoyama period.[3] It is the earliest extant manuscript that codifies the iconography of *Genji* pictures; however, it is by no means the first of its kind. That it is a copy of an earlier manuscript is apparent from certain types of errors found in the text. Some portions of the Osaka manuscript are lost, but these are preserved in another, later version of the manual in the Imperial Library. The Imperial Library version from the mid-Edo period is considered a copy of yet another, unknown model.[4] Nevertheless, these two manuals are so closely related to each other that they may reflect a common source book.

The manuscript in the Osaka collection measures 23.3 centimeters in height by 17.7 centimeters in width and contains 292 folios. Originally there were four more folios corresponding to folios 56 through 59, which are now lost. The cover of the book is made of gray paper with printed designs of chrysanthemum

flowers and bears the title *Genji Monogatari Ekotoba,* written in the same hand as the text. A part of the backing paper of the cover has detached, revealing the following legends on the verso: *Genji hikiuta ka?* (Are these poems quoted from the *Tale of Genji?*), and *Kazuhito Shinnō shinkan* (By the royal hand of Prince Kazuhito). These legends were written by someone other than the calligrapher of the title and the text. So far no basis for the attribution of the written work to Prince Kazuhito, who was later enthroned as Emperor Go-Yōzei (r. 1587–1611), has been found. The scribe's ignorance about the nature of the manual is revealed in the legend wherein he considered the book to be but a collection of poems quoted from the *Tale of Genji.*

The text itself, which is preceded by a blank sheet, is divided into fifty-four chapters, as is the original novel, and the entire book is written by one calligrapher. Each chapter is identified by its title, written in a bold, larger script, clearly distinguishable from the rest of the text. Each of the fifty-four chapters is further divided into a series of scenes, its number varying from one, for chapter 16, *Sekiya* (The Gatehouse), to as many as fifteen, for chapter 49, *Yadorigi* (The Ivy). Each scene consists of two parts. One is an excerpt from the novel, written in large, clear script. These quotations seem to have been intended for a scribe who needed a model for the text of a new *Genji* book or scroll. Such a model was necessary since in most cases the entire novel could not be reproduced because of its great length—the notable exception being the large and expensive dowry sets, in which the complete novel was reproduced.

What is most interesting about the Osaka manual are the passages that precede the excerpts from the novel. These passages, while closely related in content to the excerpts, describe painted compositions meant to accompany quotations from the text. This part of the manuscript is written in a more modern language, and it is particularly useful for students of *Genji* paintings, since the passages give scenariolike directives that specify an iconographic program for each painted composition. They provide full descriptions of settings, seasonal attributes, time of day, and requirements for the clothing and action of the cast of characters.

That these passages were intended as guides and directives for painters is further supported by the frequent use of the term *beshi* (should) in the instructions about objects, figures, settings, or actions. For example, a passage accompanying scene 2 of chapter 26, *Tokonatsu* (Wild Carnations), reads: "Wild carnations in the garden should be at their best." A stronger comment accompanying scene 4 of chapter 20, *Asagao* (The Morning Glory), reads: "Genji and Murasaki, dressed in informal clothes, should definitely be included in this scene." Sometimes the manual gives painters the opportunity to choose between two or more compositions. A commentary to scene 5 of chapter 21, *Otome* (The Maiden), reads: "The scene after this one is also good for illustration, ..." and scene 3 of chapter 22, *Tamakazura* (The Jeweled Chaplet), includes the observation that "this scene has many elements that can be illustrated in a painting, but the rest of the story is not suited for illustration."

A remark on the size of composition is found at scene 1 of chapter 24, *Kochō* (Butterflies): "This painting may be made as large as one wishes." Occasionally, comments are intended to ease the work of painters. One of these reads: "If a large painting is desired, this scene can be combined with the previous one in one composition, since the two scenes occur on the same day (in scene 2, chapter 46, *Shii ga Moto*. [Beneath the Oak])."

It is apparent from the author's frequent use of the expression *tokoro*, or "this scene shows," that the archetype of this manual was written by someone who studied many various *Genji* paintings. For example, scene 1 of chapter 25, *Hotaru* (Fireflies), contains a passage that reads: "Genji is shown peering at Tamakazura from the side." Another directive for scene 1 of chapter 10, *Sakaki* (The Sacred Tree), reads: "This painting illustrates a scene in which Genji visits Nonomiya, where Rokujō is in temporary residence . . . (this portion of the manual was lost from the Osaka version but is preserved in the Imperial Library version)."[5] A comment included in the instruction for scene 3 of chapter 2, *Hahakigi* (The Broom Tree), reads: "Although this is a tale within a story, it is often illustrated."

In most instances, the directives—including extraordinarily minute details of clothing or furnishings—are intelligent paraphrases and summaries of the novel. Some commentaries are so terse that it suggests the painted scenes were well known and therefore no further explanations were needed. For example, the scene of the carriage competition between Rokujō and Aoi in chapter 9, *Aoi* (Heartvine), is one of the novel's most frequently illustrated and best-known episodes, and the directive simply states: "The time may be the Fourth Month. It is the story of the competing carriages." Sometimes the instructions direct the users of the manual to the textual excerpts for detailed descriptions of events, settings, or clothing.

After a blank page at the end of the manual, the names of all fifty-four chapters are listed, along with the number of scenes selected for illustration in each chapter. The total of these episodes is given erroneously as 380; the correct total (before the four folios were lost) should be 282.

Ideally, to understand the Osaka manual, it would be helpful to compare its iconographic program with that of the twelfth-century *Genji Monogatari Emaki,* but because the masterpiece is in extremely fragmentary condition, this is difficult to do. However, the most striking feature that does emerge from a comparative study of the fragmentary remains of the earliest work is a distinct trend through the later periods to select those scenes for illustration that most effectively helped further the major plots of the novel; that is, scenes were chosen with the idea in mind that the main features of the novel could be transmitted even in the absence of a text.

The most consistent leitmotifs of the novel are the amorous relationships, which make up a majority of the painted scenes, followed by portrayals of festivals and ceremonies. The romantic relationships are, however, only hinted at. With the notable exception of the dowry sets, amorous couples are seldom

shown in each other's arms. There are depictions of men spying on ladies through breaks in hedges or screens or in pursuit of fleeing women, which only imply forthcoming romantic affairs. A couple's exchange of poems is the most frequent scene for illustration, since it often provides a pivotal point in the novel's plot, and 123 of the manual's 282 scenes are of this type. The problem here is that the repetition of such scenes does not result in an exciting or varied pictorial composition. No matter what the content of a letter or poem may be, scenes depicting its dispatch or receipt look very much alike, seriously hampering any attempt to determine the significance of the scenes.

Such difficulties are aggravated by the fact that the faces and gestures of the people in the *Genji* paintings, while delicate, are in most cases completely neutral in expression. One of the two rare exceptions occurs in scene 1 of chapter 31, *Makibashira* (The Cypress Pillar), which shows the wife of Higekuro pouring ash from an incense burner over her husband as he readies himself to see another lady. In scene 2 of chapter 39, *Yūgiri* (Evening Mist), the jealous Kumoinokari snatches a letter to her husband written by the mother of his new love.

Some scenes that appear in the Heian-period *emaki* survived more or less intact in works of subsequent periods, suggesting that an iconographic tradition for such scenes had been established even earlier than the twelfth century. Seven of the scenes from the twenty remaining Heian fragments belong to this category: chapters 5, *Waka Murasaki* (Lavender), scene 3; 15, *Yomogiu* (The Wormwood Patch), scene 2; 16, *Sekiya* (The Gatehouse), scene 1; 44, *Takekawa*, (Bamboo River), scenes 2 and 3; 45, *Ujibashihime*, (The Lady at the Bridge), scene 2; and 49, *Yadorigi* (The Ivy), scene 1.

Some compositions found in these early extant *Genji* paintings never reappear in later works, including the Osaka manual. Interestingly, these scenes do not have a direct bearing on the development of a main plot; rather, they depict secondary episodes, such as intimate domestic scenes, which create poignant backgrounds for the story. For example, chapter 48, *Sawarabi* (Early Ferns), in the Heian fragments includes a scene in which the Princess Nakanokimi's household prepares her clothes in expectation of her move to the capital where she is to be married to Prince Niou. Scene 4 from chapter 50, *Azumaya* (The Eastern Cottage), shows Nakanokimi and her sister Ukifune enjoying pictures together. This episode is included in the Osaka manual, but the Heian fragment is the only known example of a painting illustrating this scene.

The most unexpected scene in the *Genji* paintings of the Heian period (Fig. 6) illustrates a domestic episode from chapter 38, *Yokobue* (The Flute). After Kashiwagi's death, his friend Yūgiri tries to console Kashiwagi's widow, to whom he is gradually becoming attracted. One evening Yūgiri is given Kashiwagi's favorite flute. That same night, the ghost of Kashiwagi appears in Yūgiri's dream, frightening one of his small children. Yūgiri is awakened by the screams of his baby, and his young wife, Kumoinokari, confronting jealousy for the first time in her marriage to her childhood sweetheart, takes the baby in her arms and offers it a "well-shaped breast."[6] In a charming representation, the young mother is shown

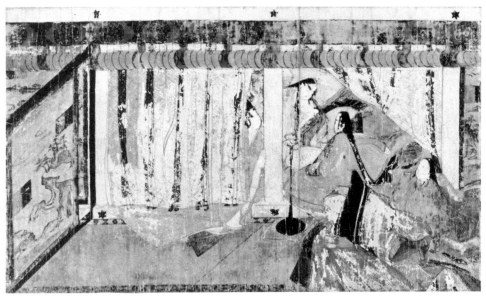

Fig. 6

nursing the baby while her husband looks on. This episode is excluded from
the Osaka manual. In some works, such as the Muromachi-period scrolls of
hakubyō drawings, the story itself is retained, but with a significant change in its
pictorial representation: the domestic sense of the story is supplanted by a more
literal interpretation showing Kashiwagi's ghost appearing in Yūgiri's dream.
While an exquisite mood and refined taste pervade the Heian-period paintings,
these few glimpses of intimate domesticity are vivid reminders that the novel
was appreciated for its fidelity to life as well.

A comprehensive study of the *Genji* paintings from all periods has only recently
begun. But pioneering works by such scholars as Akiyama and Shirahata have
made it clear that the central iconographic program, including such elements
as the selection of episodes and the composition of each scene, has remained
largely unchanged through the centuries.[7] In this respect, the Osaka manual can
be regarded as the official sanction of a popular iconography. As for the textual
excerpts that accompany the illustrations, there seems to have been greater
leeway for copies in terms of length and selection of passages. Very few extant
Genji books or scrolls have textual excerpts that exactly match the quotations
cited in the Osaka manual. Textual quotations, especially when brief, show
a greater divergence from the samples given in the manual, possibly because
the calligraphers commissioned for such projects were well-read courtiers who
undoubtedly had more than a casual knowledge of the novel and may have had
predilections for particular poems or passages. Their latitude, however, is
limited to such minor matters as shortening the prose quotations when poems
are included, thereby giving a greater emphasis to the latter.

The question still remains: By whom and for whom was the Osaka manual

written? No document provides an answer. But a comparison of its directives with work from the Tosa School points to a Tosa artist as its possible author. In this regard the small album leaves of *Genji* scenes associated with Tosa Mitsunori (1583–1638) are especially instructive; their adherence to details stipulated in the Osaka manual is seldom matched in other *Genji* paintings.

Mitsunori's works are now in the collections of Mrs. Jackson Burke, New York (sixty leaves); the Freer Gallery, Washington, D.C. (thirty leaves); and the Tokugawa Reimeikai, Japan (sixty leaves). In addition, there are many other small paintings and drawings attributed to this artist; especially important among them are those in the Tokyo National Museum (fifty-four leaves) and the Östasiatiska Museet, Stockholm (twelve leaves). When the backing-sheets were removed from the paintings, Mitsunori's seals were found on the backs of the paintings in the albums in the Burke, Freer, and the Tokugawa collections. Those in the Stockholm collection have not been examined in a similar manner, but on stylistic grounds we can expect to find the same seals there, too. The attribution of the drawings in the Tokyo National Museum collection is more problematical. While the paintings are too severely damaged to allow a thorough study, their general stylistic features suggest that they are the works of a Mitsunori follower who closely adhered to his master's delicate drawing style. Altogether, there are more than two hundred album leaves, representing not simply a large number of *Genji* scenes, but ones of an unusually rich iconographic variety.

Among the *Genji* paintings associated with Mitsunori's name, the group in the Tokyo National Museum includes the largest number of standard compositions most closely related to earlier Tosa works. (Only twelve leaves remain in the Stockholm album, making it difficult to draw a definite conclusion on its iconographic program.) These earlier Tosa works include the album in the Kyoto National Museum (Cat. No. 12), painted by Tosa Mitsuyoshi (1539–1613), who is reputed to be either the father or teacher of Mitsunori. In three other Mitsunori album collections, many popular scenes are conspicuously absent; for instance: scene 1 of chapter 5, *Waka Murasaki* (Lavender), in which Genji spies on young Murasaki as she grieves over the escape of her favorite sparrow; a chance encounter between Genji and Akashi at the beach of Sumiyoshi in scene 2, chapter 14, *Miotsukushi* (Channel Buoys); young maidservants making snowballs while Genji and Murasaki watch in scene 4, chapter 20, *Asagao* (The Morning Glory); Yūgiri's visit to Akikonomu's palace where many young girls are collecting insects in an autumn garden in scene 3, chapter 28, *Nowaki* (The Typhoon); and the ball game in scene 14, chapter 34, *Wakana I* (New Herbs). The poignant scenes of Yūgiri's visit to Kashiwagi's widow at Ono in scene 4, chapter 39, *Yūgiri* (Evening Mist) and of Niou's abduction of Ukifune on a snowy evening in scene 6, chapter 51, *Ukifune* (A Boat upon the Waters) are also excluded. These are extremely popular scenes that over the years have become a staple of *Genji* compositions. Even when Mitsunori chose to include a well-known episode, he seems to have been determined to avoid the much-repeated compositions. For example, the painting for scene 2 of

chapter 45, *Ujibashihime* (The Lady at the Bridge), generally represents the older sister raising the plectrum of her *biwa* to the moon, while Kaoru spies on her through the hedge. Mitsunori, however, shies away from the typical, and in the Tokugawa album he instead shows Kaoru seated on the veranda of the girl's house.

Mitsunori also tried to avoid repeating the same scenes for different projects. Out of the more than two hundred album leaves associated with his name, only a small number are repetitions; Most often the drawings in the Tokyo National Museum collection repeat scenes found in other albums. Otherwise, it is clear that Mitsunori made a conscious effort to create as many iconographic variations as possible.

In this context, it is interesting that the albums in the Tokugawa and Burke collections often complement each other. Mitsunori painted scene 1 of chapter 20, *Asagao* (The Morning Glory), for both albums. In that story, Genji broke off a vine of morning glory and sent it to Princess Asagao with a letter. For the Tokugawa album, Mitsunori painted Genji as he waited for a young page to break off a vine in the garden; for the Burke album the artist depicted the princess and her maids as she received Genji's letter attached to the morning glory. Similarly, for scene 1 of chapter 40, *Minori* (The Rites), Mitsunori again painted two successive moments of a story. As Murasaki was nearing the end of her life, she sent from her sickbed a poem to the Akashi lady through the young Third Prince; then, Buddhist rites were dedicated in her honor, and a dancer performed a sacred dance. The dance performance is illustrated in the Burke album, while the dispatch of the poem was chosen for the Tokugawa album.

Two successive moments from chapter 37, *Yokobue* (The Flute) are listed as separate episodes in the Osaka manual: In scene 1, Genji's young wife (the Third Princess) received a letter from her father, sent with bamboo shoots and taro shoots, which Genji also saw. A moment later, in scene 2, the baby Kaoru crawled on the floor biting a bamboo shoot. In the album leaf in the Tokugawa collection, Mitsunori shows Genji coming into his wife's room where her father's gifts have arrived, while, for the leaf in the Burke album, Mitsunori illustrated the charming second scene. It is clear that this remarkable artist had a comprehensive scheme of *Genji* illustrations in mind, of which each commission was conceived as a small part.

For centuries, through the late Muromachi, Momoyama, and Edo periods, the Tosa artists barely managed to survive as a school. Their chief function during those lean years was the conservation of *yamato-e*, interest in which was declining. While there are no works by Mitsunori's predecessors, such as Mitsuyoshi, that reflect familiarity with the wide iconographic choices of the Osaka manual, their position might have enabled such artists as Mitsunori to own a copy, inspiring them to test its practicality and adaptability. But these are only speculations. There is no clue at present to help determine when or by whom the original of this manual was compiled.

It must be also noted that there is no evidence that this manual was widely

circulated among painters of different schools. *Genji* paintings by artists of other schools, such as the Kanō and Kaihō, usually stay within the framework of a very popular, standard iconographic formula. Sōtatsu's works are exceptions to this rule. The famous pair of screens in the Seikadō collection, as well as some others associated with this master, reflect the freedom with which he created large compositions to illustrate a few episodes. Yet small fan paintings of *Genji* that are attributed to Sōtatsu's studio usually rely on the standard iconographic program.

4. On the Translation of the Manuscript and Method of Reference

Two key considerations shaped my decision to translate the *Genji Monogatari Ekotoba* into English. First, the *Tale of Genji,* Japan's greatest literary classic, is the best-known work of Japanese literature in the West. Second, in the history of Japanese painting, only the genre of *Genji* illustrations has enjoyed such great popularity over such a long period of time.

As decisive as the historical factors has been a practical consideration. I have often been asked to determine the textual sources of *Genji* paintings whose content is nebulous, for example, couples who are unidentifiable and involved in guileless activities. Except for a few of the most famous scenes or for those firmly related to the text, the majority of these paintings contain few clues that could aid in identifying the chapters they illustrate. Indeed, whether they illustrate *Genji* or some other literary work is not always certain or ascertainable. To recognize from paintings specific episodes of the *Genji* would require a prodigious memory of an enormous number of events involving some well over four hundred characters. One would also have to be able to distinguish between numerous scenes that look almost identical to one another. Even if one were able to keep track of the names in the enormous cast of characters and of the events in which they are involved, it would be next to impossible to identify individuals since the painted figures look very much alike and very little action is depicted. To compound the difficulty, many of the later *Genji* paintings do not even include such helpful clues as seasonal attributes. And when some clues are to be found, their symbolism is all but inaccessible today, except to a small circle of specialists.

I felt, therefore, that there was a need for a catalogue of, or a guidebook to, the *Genji* paintings in which the story and the exact textual source of each scene could be identified. The *Genji Monogatari Ekotoba,* although it is without illustrations, seemed to me to provide the ideal material, especially where examples of paintings accompanied its directives. In other words, this volume was to be not merely an English translation of the Osaka manual, but also a reconstruction

of the pictorial source materials that the author of the original manual might have consulted at the time he edited his book.

Since Katagiri's reprint of the Osaka manuscript had not been available until earlier this year, my first task was to decipher and transcribe the handwriting of the sixteenth-century author, which is often idiosyncratic and unclear. Several words in the manual are impossible to decipher and are left untranslated, because there is no way to be absolutely certain of the scribe's intentions. It is quite possible that such ambiguities already existed in earlier versions, since the same passages in the copy in the Imperial Library are equally obscure.

The directives in the Osaka manual at times appear to be summaries of long passages in the novel. My translation of the directives, therefore, owes a great deal to the recent English translation by Edward Seidensticker, who, with almost uncanny deftness, follows the literary structure of the Japanese original. (That is, where the wording of the manual's directives is taken directly from the *Genji*, I have used Seidensticker's translation of those words and phrases.) The symbol found immediately after the heading for each scene in a directive (the letter "s" followed by numerals) refers to the pages in Seidensticker's translation corresponding to that directive. Samples of the text given in the manual are direct quotations from the novel; therefore, the readers are again referred to Seidensticker's work. In order to avoid further confusion, I have kept Seidensticker's romanization of personal names in most cases, notwithstanding occasional inconsistencies. Readers of my translation will observe one notable change from Seidensticker's translation: the change of tenses. While Seidensticker chose the past tense for his work, I use the present. The choice of tense in translating Japanese into English often presents a problem, as the language does not always make specific reference to the time of an action or event. The manual does not give a more specific idea of time than the novel does, but there is a clear sense that the author is describing a picture placed in front of him.

To aid the users of this translation, every chapter and every scene is numbered, although this is not the case in the Japanese original. The four pages covering the last section of chapter 9 (*Aoi*) and the beginning of chapter 10 (*Sakaki*) that are missing from the Osaka version have been supplemented from the text in the collection of the Imperial Library. Occasionally, there are errors in the directives, for example, the inaccurate identification of a character, musical instrument, or description of costume. These are minor errors, however, which would not create any major difference in the development of the plot or the effect of a painting. Readers are alerted only to the more serious errors, such as those involving a change in the identity or gender of the characters or the season of the year.

Since this English version of the Osaka manual is expected to serve as a kind of dictionary of Genji paintings, indexes are provided listing details of scenes that might help determine their themes, including plants, flowers, and other indicators of seasons, as well as animals, birds, furnishings, and musical instruments. Readers of this translation must be warned, however, that all *Genji*

paintings may not contain such helpful clues or that the symbols may not always be correctly represented.

Because not a single set of existing *Genji* paintings includes all 282 episodes, the most difficult part of the project was finding appropriate illustrations from among extant *Genji* paintings to match the directives given in the manual. This is not to say that a project of such magnitude was never conceived. On the contrary, evidence suggests that many extant works are fragments of larger sets making up comprehensive pictorial cycles. The *Genji* paintings of the Heian period are of this category as are the seventeenth-century handscrolls in the Spencer Collection of the New York Public Library (Cat. No. 16). Neither of them is preserved intact, however. Illustrations for episodes in the present version, therefore, had to be assembled from various sources that date from different periods. Of the 282 episodes included in the Osaka manual, thirty-nine cannot be illustrated by extant examples. I hope many of these paintings still missing will be found in the near future.

In searching for the best illustrative materials, handscrolls and albums, which often include textual excerpts as well as dense pictorial representations, proved to be the most useful. However, ceremonies and festivals involving a large number of people and sumptuous settings were, for obvious reasons, often excluded from or treated summarily in albums and handscrolls. For such compositions large screens were chosen for illustrations, for example, the pair in the Seattle Art Museum, in which two episodes, both festival scenes, are spread across the surface of two folding screens (Cat. No. 14).

In chapter 3 of this introduction I speculated that a copy of the manual might have been in the possession of Tosa Mitsunori, who possibly attempted to recreate, in a reverse process, so to speak, the *Genji* paintings that served as source materials for the editor of the original manual. It therefore seemed appropriate to choose whenever possible illustrative materials from Mitsunori's works. Since the book in the Tokugawa Reimeikai is the only complete color album among his remaining works, it has been chosen as the core material. However, it must be stressed that the primary concern in selecting examples for illustration was the painting's fidelity to the description given in the manual's directives, and Mitsunori's works are unusually faithful in this respect.

Time and again Mitsunori included small, almost imperceptible details in his compositions so as to conform to the manual's directive; for instance, the ruined state of the safflower lady's house is indicated by just a tiny break on one girder in the railings of the veranda in scene 1, chapter 15, *Yomogiu* (The Wormwood Patch). He shows women who have taken vows carefully distinguished from others by their short hair, or Tō no Chūjō making a grand appearance at court with his robe's long train trailing behind him, exactly as described in the novel and in the directive for scene 3, chapter 29, *Miyuki* (The Royal Outing). Such minute details are seldom included in paintings by other artists.

Mitsunori was equally careful to observe the seasonal cues specified in the directives in his representation of appropriate flowers and plants. These in fact

often serve as the most helpful clues in identifying scenes or in differentiating compositions that are otherwise almost identical. In the manual, most episodes (excepting about forty-five) are linked to specific seasons or months of the year. The autumn season dominates (about fifty-five scenes), as Murasaki Shikibu often dwells upon the beauty of crimson leaves and the tranquility of the season. (The readers of this translation will note that the seasons are calculated according to the lunar calendar and do not exactly coincide with our dates or seasons; for example, the second month is in spring.) The manual gives minute details of costume design, but these are usually ignored in most paintings. It would have been impossible to follow elaborately detailed descriptions in these miniature paintings. Also, many of the details and styles described in the novel and in the directives might have been unfamiliar to painters who worked in later periods.

The paintings reproduced here date over a wide span of time, from the early twelfth through the mid-eighteenth centuries, reflecting an equally wide spectrum of styles. They represent both typical and atypical examples produced through the ages. A study of them reveals a few general characteristics of *Genji* paintings that are worth noting because they also apply to works excluded from the essay.

All of the *Genji* paintings have a delicacy and refinement that are also intrinsic to the novel; yet a closer examination of them reveals a subtle change in general aesthetic principles that occurred after the twelfth century. As has been discussed in chapter 3, six scenes found in fragments from the Heian period reappear in most of the later versions, retaining almost identical compositions. Some other scenes are found only in the Heian scrolls and never reappear, not even in the manual. These scenes do not reflect upon the emotional facets of the plot; rather, their function is more literal, that is, they describe situations leading up to, or following, climactic moments. In general, however, the *Genji* pictures from later periods place a greater emphasis on the development of plots in a tangible manner, while the Heian paintings in many cases convey the inner psychological struggles of each personality.

The famous scene from chapter 36, *Kashiwagi* (The Oak Tree), in the collection of the Tokugawa Reimeikai, is the epitome of Heian aesthetic principles (Fig. 7). Genji is presented with a baby, born of the illicit affair between his young wife, the Third Princess, and Kashiwagi, son of his best friend. In this painting, Genji, holding the infant in his arms, is placed in precarious balance within the architectural setting defined by diagonal lines that slant at impossible angles. It is a brilliant expression, subtle yet evocative of the uncertain fate of his young wife and of the dilemma that tears at Genji's heart. The seventeenth-century depiction of the same episode by Tosa Mitsunori succinctly illuminates the changes in aesthetics that occurred over the centuries. In the album in the Freer Gallery collection, Mitsunori shows Genji holding the baby in his lap, his head bent slightly to one side; the Third Princess, seated across from her husband, also bends her head slightly, and her hair is already trimmed short

Fig. 7

(see 36–4). The setting is practically identical to that found in many other scenes by this artist. Although Mitsunori portrayed the same poignant moment of the story, his rendition in the Freer album does not have the compelling sense of emotion that permeates the other, earlier composition.

Mitsunori introduces tangible, more literal symbols to offset the loss of suggestive power. For instance, a scene in the same Freer album suggests the emptiness in Genji's heart that Murasaki's death has created by including her favorite objects, such as a koto, scrolls of painting, and books, against the background of her favorite season, the early spring with its first blossoming of plums in scene 2 of chapter 41, *Maboroshi* (The Wizard). In the same album, the gentle autumn grasses that sway under the heavy dew are subtle hints of the rift arising between Niou and Nakanokimi in scene 9 of chapter 49, *Yadorigi* (The Ivy). Despite such changes, it is in Mitsunori's delicate and subtle works that we find a distant echo of the exquisite artistic vision that guided the creation of the superb *Genji* paintings of the Heian period.

Among the extant sets of *Genji* paintings, the largest cycle is found in the dowry sets of fifty-four books, such as Spencer 129 (Cat. No. 17) and a similar set in woodcut, made in 1650 by Yamamoto Harumasa (1610–82). The latter is reproduced in its entirety in Seidensticker's translation. The Spencer book includes no less than 225 scenes. While they may appear to be the most logical illustrations to use for the present translation, such sets seem to belong to a different recension. Many compositions in these books are unique; for example, scenes showing only landscape settings in chapter 21, *Otome* (The Maiden) (Seidensticker, 378, 381, 383, and 385) are peculiar to this recension. Pictures in these books often do not correspond to precise instructions given in the manual, and frequently specific attributes are absent. If these pictures were taken out of context, many would be unidentifiable. At the same time, some scenes, such as those showing death or amorous adventures, tend to be overtly explicit. Here they

clearly differ from the traditional *Genji* paintings. Even though the entire text is reproduced in these books, the intent to clarify the plot through the pictures alone is extremely strong, even to the detriment of traditional aesthetic concerns. Finally, these books contain many new compositions, such as the scene showing the birth of Genji, scenes which had not been traditionally illustrated. Thus, the compositions in these books are not always the most helpful for our purpose and are reproduced here only when there is no other available example.

PART TWO

The Translations
and Paintings

1. The Paulownia Court

<div align="center">SCENE 1</div>

EKOTOBA

In the autumn the emperor sends a woman of the middle rank called Myōbu to Kiritsubo's home. Myōbu's father is a guards officer. The book describes the beautiful moonlit night. The early month's crescent moon may be shown. Under the autumn moon the weeds should grow high in the garden. The lady's mother receives Myōbu at the veranda and reads the royal note. Myōbu's carriage should be by the veranda. The mother is most likely dressed in a robe of gray and looks quite beautiful with her hair cut short. She should be seated beside the curtain, while Myōbu remains at the veranda. The baby prince should be asleep behind the blind. The letter is the royal note.
[In the bottom margin:]
In the summer, the lady Kiritsubo is feeling unwell. The emperor orders that she be given the honor of a hand-drawn carriage. He weeps as he still cannot bring himself to the final parting. The baby prince may also be shown in this scene.*
[In the top margin:]
Kiritsubo returns the poem:

> "I leave you, to go the road we all must go.
> The road I would choose, if only I could,
> is the other."†

A hand-drawn carriage looks like a palanquin with wheels, and it is drawn by hand.

<div align="center">⌁⌁</div>

GENJI

This was the emperor's letter: "It seems impossibly cruel that although I had hoped for comfort with the passage of time my grief should only be worse. I am particularly grieved that I do not have the boy with me, to watch him grow and mature. Will you not bring him to me? We shall think of him as a memento."

There could be no doubting the sincerity of the royal petition. A poem was appended to the letter, but when she had come to it the old lady was no longer able to see through her tears:

> "At the sound of the wind, bringing dews to Miyagi Plain,
> I think of the tender *hagi* upon the moor." (s 8–9)

* This is a summary of the event described in 5–9.
† This poem is found on s 6.

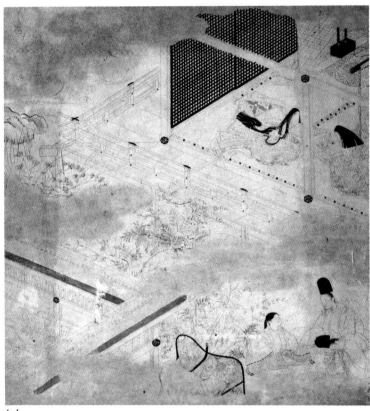

1–1

Scene 2

EKOTOBA

After the above episode, the moon is sinking and the wind is blowing. There should be bell crickets among the grasses. Myōbu prepares to leave, and the mother presents her with Kiritsubo's robes and an assortment of bodkins and combs.

[In the bottom margin:]
The emperor is looking at the illustrations of "The Song of Everlasting Sorrow," with four or five women in attendance, when Myōbu comes back with a sad report on the lady's mother. As he looks at the keepsakes of the lady's robes and the set of bodkins and combs, the emperor weeps. The moon is setting.

[In the top margin:]
The time is about the same as the above episode and it may not be necessary to illustrate this scene. This episode may also be combined with the above scene in one composition.

> "And will no wizard search her out for me
> That even he may tell me where she is?"*

GENJI

The moon was sinking over the hills, the air was crystal clear, the wind was cool, and the songs of the insects among the autumn grasses would by themselves have brought tears. It was a scene from which Myōbu could not easily pull herself.

"The autumn night is too short to contain my tears
 Though songs of bell cricket weary, fall into silence."

This was her farewell poem. Still she hesitated, on the point of getting into her carriage.

The old lady sent a reply:

"Sad are the insect songs among the reeds.
 More sadly yet falls the dew from above the clouds.

"I seem to be in a complaining mood." (s 10)

* This poem is found on s 12.

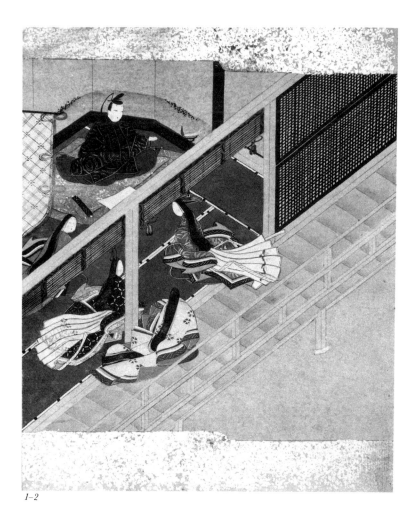

1–2

SCENE 3

EKOTOBA

Genji is probably seven or eight years old. He is sent to the Korean physiognomist for consultation. Udaiben, the grand moderator, his guardian at court, accompanies him. They meet near Tō-ji and exchange many poems. There is also an exchange of gifts between the emperor and the Korean.

゛゛゛

GENJI

The boy was disguised as the son of the grand moderator, his guardian at court. The wise Korean cocked his head in astonishment.

"It is the face of one who should ascend to the highest place and be father to the nation," he said quietly, as if to himself. "But to take it for such would no doubt be to predict trouble. Yet it is not the face of the minister, the deputy, who sets about ordering public affairs." (s 14)

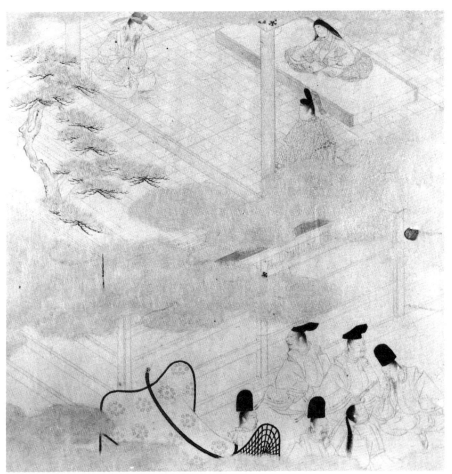

1–3

SCENE 4

EKOTOBA

After the above episode, Genji is twelve years old, and goes through his initiation ceremonies, receiving the cap of an adult. Genji appears in his boyish coiffure in midafternoon at the Grand Hall. The ritual cutting of the boy's hair is performed by the secretary of the treasury. The Kiritsubo emperor himself is present. The Minister of the Left, who is to bestow the official cap, should also be present.

⌐⌐⌐

GENJI

The throne faced east on the east porch, and before it were Genji's seat and that of the minister who was to bestow the official cap. At the appointed hour in midafternoon Genji appeared. The freshness of his face and his boyish coiffure were again such as to make the emperor regret that the change must take place. (s 16)

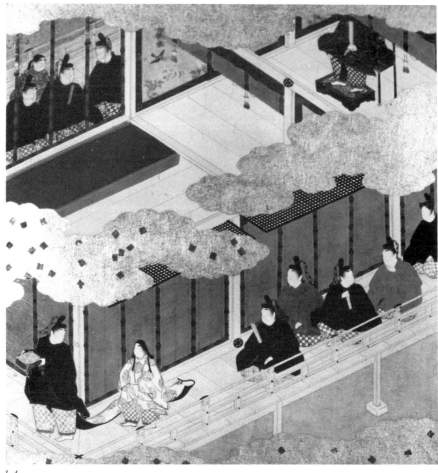

1–4

SCENE 5

EKOTOBA

After the above event, Genji changes into an adult outfit. A chamberlain comes with an imperial message that the minister is expected in the royal chambers. A lady-in-waiting brings the gifts to him. There is a banquet. In the Grand Hall should be the gifts of a horse and a falcon from the secretariat. There are many princes and high courtiers near the stairs in the courtyard.

‿‿‿

GENJI

There came a message through a chamberlain that the minister was expected in the royal chambers. A lady-in-waiting brought the customary gifts for his services, a woman's cloak, white and of grand proportions, and a set of robes as well. As he poured wine for his minister, the emperor recited a poem which was in fact a deeply felt admonition:

"The boyish locks are now bound up, a man's.
And do we tie a lasting bond for his future?"

This was the minister's reply:

"Fast the knot which the honest heart has tied.
May lavender, the hue of the troth, be as fast."

The minister descended from a long garden bridge to give formal thanks.

(s 18)

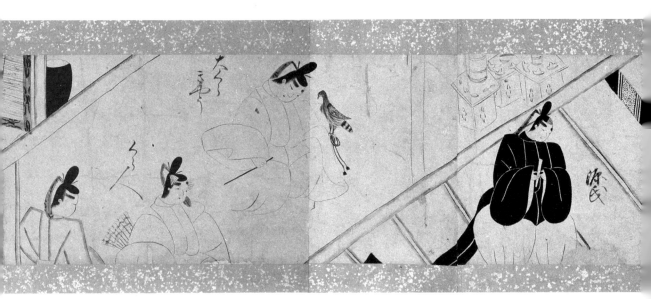

I–5

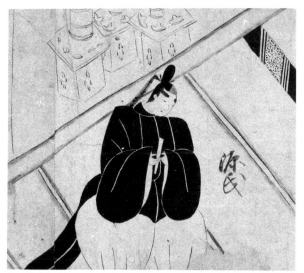

Detail of 1–5

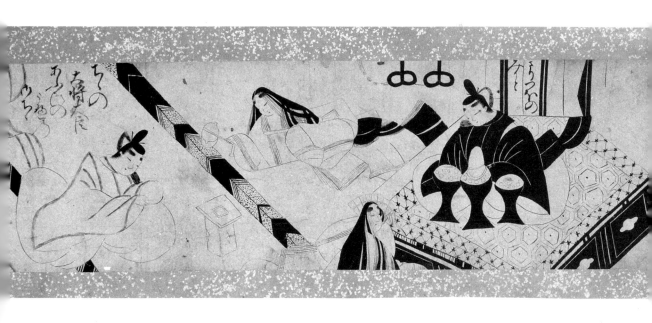

2. The Broom Tree

<center>SCENE 1</center>

EKOTOBA

It is summer. Genji is sixteen years old. He is spending his time with his books in his own palace quarters. Tō no Chūjō should be there. Numerous pieces of colored paper should be lying on a shelf. Tō no Chūjō opens them to read. Genji tries to hide them. A lamp is nearby.

GENJI

"You do have a variety of them," said Tō no Chūjō, reading the correspondence through piece by piece. This will be from her, and this will be from *her*, he would say. Sometimes he guessed correctly and sometimes he was far afield, to Genji's great amusement. Genji was brief with his replies and let out no secrets. (s 21)

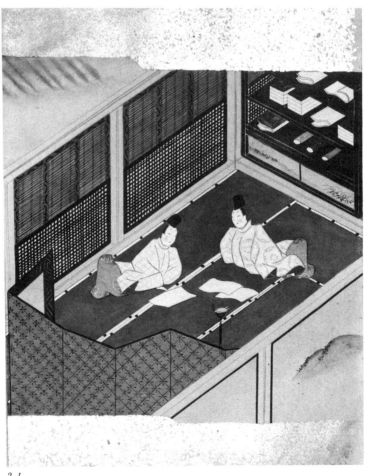

2–1

Scene 2

EKOTOBA

Following the above episode, a guards officer and a functionary in the ministry of rites should be with Genji.

〜〜〜

GENJI

At this point two young courtiers, a guards officer and a functionary in the ministry of rites, appeared on the scene, to attend the emperor in his retreat. Both were devotees of the way of love and both were good talkers. Tō no Chūjō, as if he had been waiting for them, invited their views on the question that had just been asked. The discussion progressed, and included a number of rather unconvincing points.

(s 23)

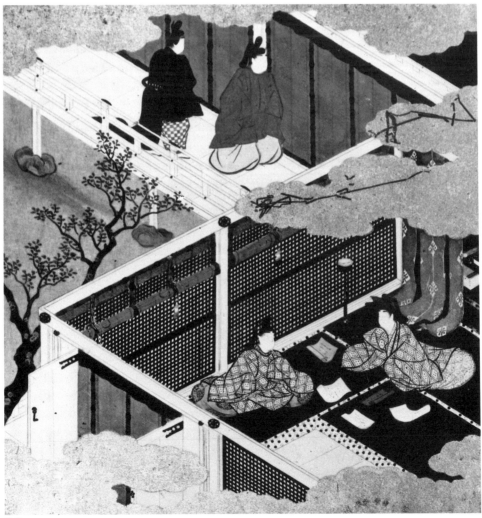

2–2

SCENE 3

Although this is a tale within a story, it is often illustrated in paintings. The maple leaves are scattered in the autumn wind. There are chrysanthemums in the garden. The moon is shining on a pond. There are gaps in the earthen wall, and a carriage is nearby. Inside the wall, a courtier is seated on the veranda, playing a flute. Behind the blinds a woman plays on a Chinese koto in the *banjiki* scale. She also plays a Japanese koto.

GENJI

 " 'Uncommonly fine this house, for moon, for koto.
 Does it bring to itself indifferent callers as well?

 " 'Excuse me for asking. You must not be parsimonious with your music. You have a by no means indifferent listener.'

"He was very playful indeed. The woman's voice, when she offered a verse of her own, was suggestive and equally playful.

 " 'No match the leaves for the angry winter winds.
 Am I to detain the flute that joins those winds?'

"Naturally unaware of resentment so near at hand, she changed to a Chinese koto in an elegant *banjiki*. Though I had to admit that she had talent, I was very annoyed." (s 31)

2–3

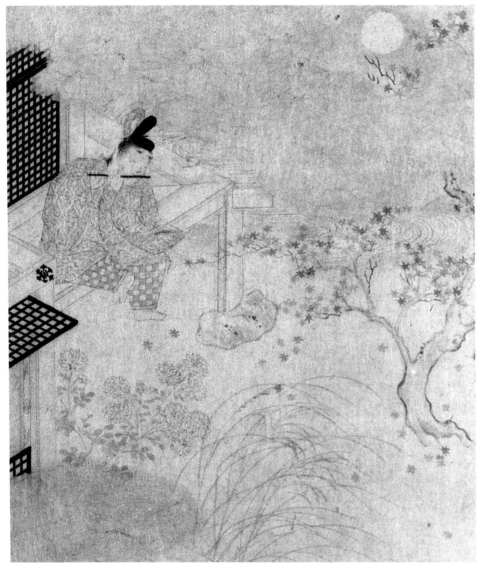

Detail of 2–3

Scene 4

EKOTOBA

It is summer. Genji goes to the house of the governor of Iyo to avoid the taboo of traveling in a forbidden direction. There are springs in the garden. A wattle fence and the foregarden are of a deliberately rustic appearance. Fireflies fly around. The host is the governor of Kii, the son of the governor of Iyo. Another son is said to be about twelve or thirteen. There should be women behind screens. In the women's quarters, there should be many different objects.*

GENJI

The waters were as they had been described, a most pleasing arrangement. A fence of wattles, of a deliberately rustic appearance, enclosed the garden, and much care had gone into the plantings. The wind was cool. Insects were humming, one scarcely knew where, fireflies drew innumerable lines of light, and all in all the time and the place could not have been more to his liking. His men were already tippling, out where they could admire a brook flowing under a gallery. The governor seemed to have "hurried off for viands." Gazing calmly about him, Genji concluded that the house would be of the young guardsman's favored in-between category. (s 39–40)

* The writing is unclear here.

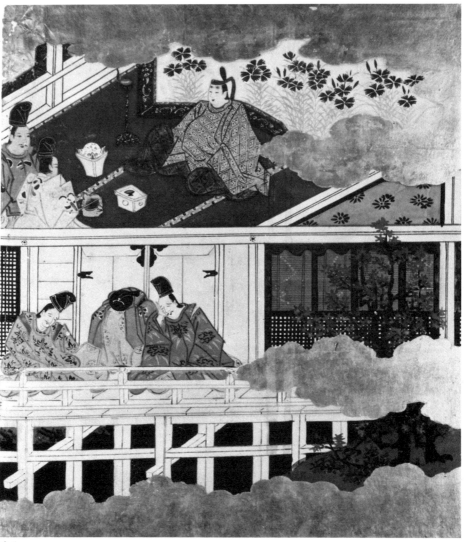

2–4

SCENE 5

EKOTOBA
It is about the middle of the month and after the above episode. The moon is still bright in the dawn sky and the cocks should be crowing in the garden. Genji, who has made his way through to the side of Utsusemi (the lady of the locust shell), is returning at dawn. She sees him to the door. There should be the serving woman, Chūjō. The house comes to life, as Genji's men awaken. Genji summons the governor of Kii to his palace.

~×~×~

GENJI
The cocks were now crowing insistently. He was feeling somewhat harried as he composed his farewell verse:

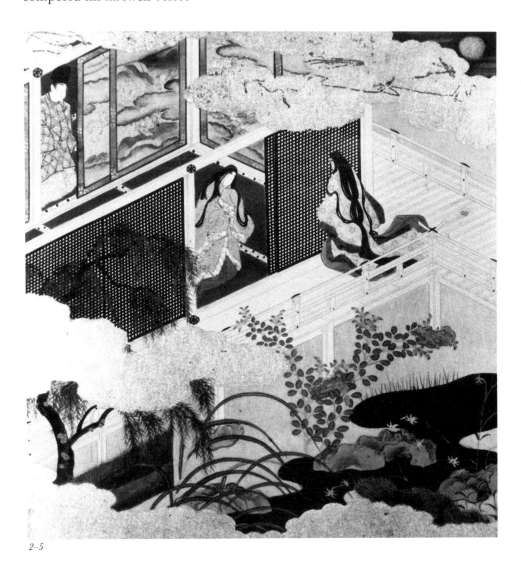

2–5

"Why must they startle with their dawn alarums
When hours are yet required to thaw the ice?"

The lady was ashamed of herself that she had caught the eye of a man so far above her. His kind words had little effect. She was thinking of her husband, whom for the most part she considered a clown and a dolt. She trembled to think that a dream might have told him of the night's happenings.

This was the verse with which she replied:

"Day has broken without an end to my tears.
To my cries of sorrow are added the calls of the cocks."

It was lighter by the moment. He saw her to her door, for the house was coming to life. A barrier had fallen between them. (s 44)

Scene 6

EKOTOBA

Genji again goes to the house of the governor of Iyo to avoid the taboo. The lady withdraws with Chūjō for the night, and Genji keeps her brother beside him.

〜〜〜

GENJI

He heaved a deep sigh. This evidence of despondency had the boy on the point of tears.

Genji sent the lady a poem:

"I wander lost in the Sonohara moorlands,
For I did not know the deceiving ways of the broom tree.

"How am I to describe my sorrow?"
She too lay sleepless. This was her answer:

"Here and not here, I lie in my shabby hut.
Would that I might like the broom tree vanish away." (s 48)

the Locust

SCENE 1

s his way through to the governor's house with the boy
through to the west. Screens should be folded back and
thrown over their frames. Utsusemi and Nokiba no
. A lamp should be nearby. The boy should be shown
mi conceals half her face, but her facial features are
very delicate. She has on a purple singlet with a woven
facing east, has thrown a purplish cloak over a singlet
garments are somewhat carelessly open all the way to
sers, exposing her bosom. She is plump and of a fair

3–1

"But why do you have them closed on such a warm evening?"

"The lady from the west wing has been here since noon. They have been at Go."

Hoping to see them at the Go board, Genji slipped from his hiding place and made his way through the door and the blinds. The shutter through which the boy had gone was still raised. Genji could see through to the west. One panel of a screen just inside had been folded back, and the curtains, which should have shielded off the space beyond, had been thrown over their frames, perhaps because of the heat. The view was unobstructed. (s 50)

Scene 2

EKOTOBA

After the above episode, the game of Go is over. The boy feigns sleep for a time, and helps Genji to slip inside. He comes out onto the veranda, holding Utsusemi's summer robe as a keepsake. He then pulls back behind the door of

3–2

a gallery. An elderly serving woman calls out to question. Since it is near the end of the month, the moon is shining in the dawn. The boy should also be shown.

<center>ヽ・ヽ・ヽ</center>

GENJI
Genji was horrified, but could not very well shove her inside. He pulled back into the darkness of a gallery.

Still she followed. "You've been with our lady, have you? I've been having a bad time with my stomach these last few days and I've kept to my room. But she called me last night and said she wanted more people around. I'm still having a terrible time. Terrible," she muttered again, getting no answer. "Well, goodbye, then."

She moved on, and Genji made his escape. He saw more than ever how dangerous these adventures can be. (s 54–55)

4. Evening Faces

<div align="center">

SCENE 1

</div>

EKOTOBA

Genji stops to inquire after his old nurse, Daini no Menoto, at her house in Gojō. Next to the nurse's house lives Yūgao. The fence of plaited cypress is new. The four or five narrow shutters above have been raised, and women are looking out. Genji catches outlines of foreheads beyond blinds, and behind them the figures of other women who stood up to look at him. A *yūgao* vine is climbing a board wall. He leans out of his carriage for a closer look. A little girl in cool-looking unlined yellow trousers comes out through a sliding door, and hands to Genji's man a scented white fan, on which a *yūgao* flower is placed.

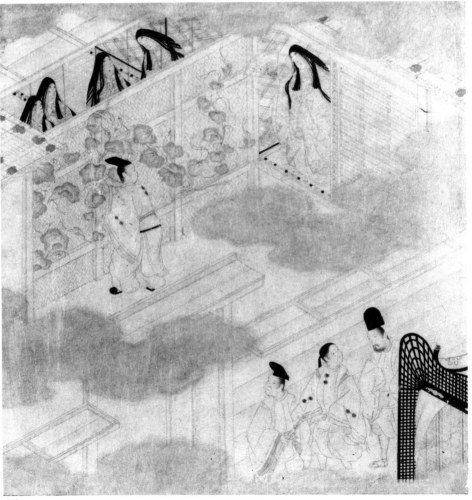

4–1

GENJI

A pretty little girl in long, unlined yellow trousers of raw silk came out through a sliding door that seemed too good for the surroundings. Beckoning to the man, she handed him a heavily scented white fan.

"Put it on this. It isn't much of a fan, but then it isn't much of a flower either."
Koremitsu, coming out of the gate, passed it on to Genji. (s 58)

SCENE 2

EKOTOBA

Genji emerges from the Rokujō Lady's quarters. The curtain is pulled aside and the lady lifts her head from her pillow to look at him. Chūjō, one of her women, follows Genji down a gallery. She is wearing an aster robe and a gossamer train. Glancing back, Genji takes her hand at the corner railing. In the garden are many flowers, among them morning glories. A little page boy, his trousers wet with dew, breaks off a sprig for Genji.

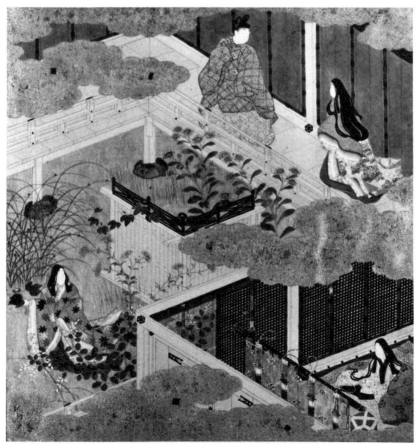

4–2

GENJI

> "Though loath to be taxed with seeking fresher blooms,
> I feel impelled to pluck this morning glory.

"Why should it be?"

She answered with practiced alacrity, making it seem that she was speaking not for herself but for her lady:

> "In haste to plunge into the morning mists,
> You seem to have no heart for the blossoms here."

A pretty little page boy, especially decked out for the occasion, it would seem, walked out among the flowers. His trousers wet with dew, he broke off a morning glory for Genji. He made a picture that called out to be painted. (s 63)

SCENE 3

EKOTOBA

On the morning of the sixteenth day of the Eighth Month, Genji is with Yūgao at a nearby villa. Together they look out into the garden overgrown with grasses. There should also be mountain doves crying in the bushes.

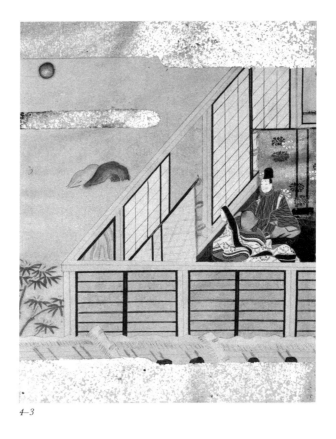

4–3

GENJI

> "Because of one chance meeting by the wayside
> The flower now opens in the evening dew.

"And how does it look to you?"

> "The face seemed quite to shine in the evening dew,
> But I was dazzled by the evening light."

Her eyes turned away. She spoke in a whisper.
To him it may have seemed an interesting poem. (s 69–70)

SCENE 4

EKOTOBA

Koremitsu lifts Yūgao's body into the carriage, and helps Ukon to ride with it.
He himself proceeds on foot, the skirts of his robe hitched up. Genji makes his
way back home on Koremitsu's horse.

<center>〜・〜・〜</center>

GENJI

"Take my horse and go back to Nijō, now while the streets are still quiet."

He helped Ukon into the carriage and himself proceeded on foot, the skirts
of his robe hitched up. It was a strange, bedraggled sort of funeral procession,
he thought, but in the face of such anguish he was prepared to risk his life. Barely
conscious, Genji made his way back to Nijō. (s 74)

SCENE 5

EKOTOBA

It is the dawn of the eighteenth day of the Eighth Month. As Yūgao's body is
taken to Kiyomizu, Genji looks back again and again. As he comes to the Kamo
river, Genji dismounts from his horse. Dipping his hands in the river, Koremitsu
pours water over Genji's hands to prepare him for supplication.

<center>〜・〜・〜</center>

GENJI

He managed only with great difficulty to stay in his saddle. Koremitsu was at
the reins. As they came to the river Genji fell from his horse and was unable to
remount.

"So I am to die by the wayside? I doubt that I can go on."

Koremitsu was in a panic. He should not have permitted this expedition, how-
ever strong Genji's wishes. Dipping his hands in the river, he turned and made
supplication to Kiyomizu. (s 77)

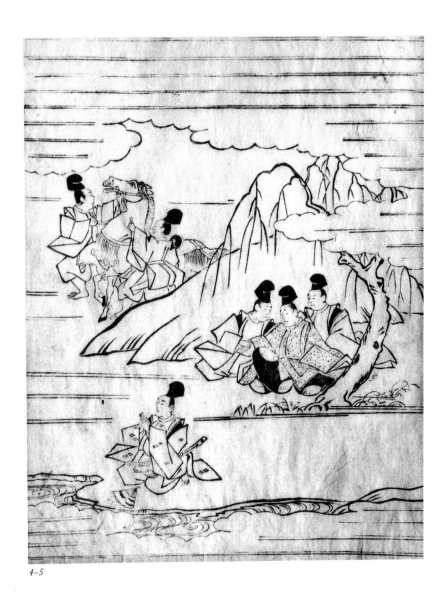

4–5

SCENE 6

Genji sends a note to Nokiba no Ogi by his young messenger. It is attached to a long reed. The guards lieutenant, her husband, may be nearby.

〜〜〜

GENJI
"Did you know that thoughts of you had brought me to the point of expiring?

"I bound them loosely, the reeds beneath the eaves,
And reprove them now for having come undone."

56 THE TRANSLATIONS AND PAINTINGS

He attached it to a long reed.

The boy was to deliver it in secret, he said. But he thought that the lieutenant would be forgiving if he were to see it, for he would guess who the sender was. One may detect here a note of self-satisfaction. (s 81)

4–6

5. Lavender

<div align="center">SCENE 1</div>

EKOTOBA

Genji is seventeen years old. The place is in the northern hills, and the time is either late in the Third Month, or the first of the Fourth Month. Genji, accompanied by Koremitsu, peers over from behind the wattled fence. The blinds are slightly raised. A nurse, perhaps in her forties, is making an offering of flowers. She is leaning against a central pillar and has a holy text spread out on an armrest. There should be two women and some children. Murasaki has on a soft white singlet and a russet robe, and her hair spreads over her shoulders like a fan. She is lamenting for the baby sparrows that have got loose.

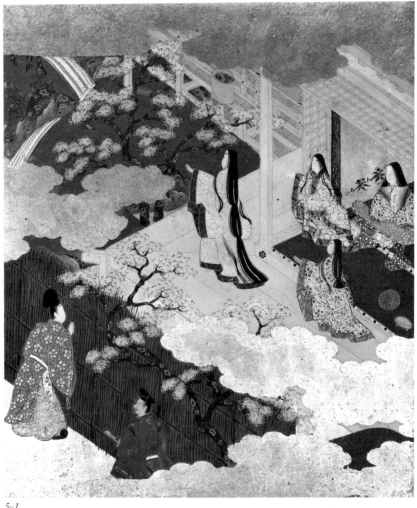

5–1

GENJI

"Inuki let my baby sparrows loose." The child was very angry. "I had them in a basket."

"That stupid child," said a rather handsome woman with rich hair who seemed to be called Shōnagon and was apparently the girl's nurse. "She always manages to do the wrong thing, and we are forever scolding her. Where will they have flown off to? They were getting to be such sweet little things too! How awful if the crows find them." She went out. (s 87–88)

Scene 2

EKOTOBA

Genji goes to the bishop's house. There are a variety of flowers and grasses, and a brook. As it is a moonless night, flares should be set out. The bishop spends all night conducting services in the chapel of Lord Amitabha. In the meantime, Genji talks to the nurse. Next to them should be screens, behind which should be Murasaki. Genji's fan should be shown.

GENJI

"You will think me headstrong and frivolous for having addressed you without warning, but the Blessed One knows that my intent is not frivolous at all." He found the nun's quiet dignity somewhat daunting.

"We must have made a compact in another life, that we should be in such unexpected conversation." (s 92)

5–2

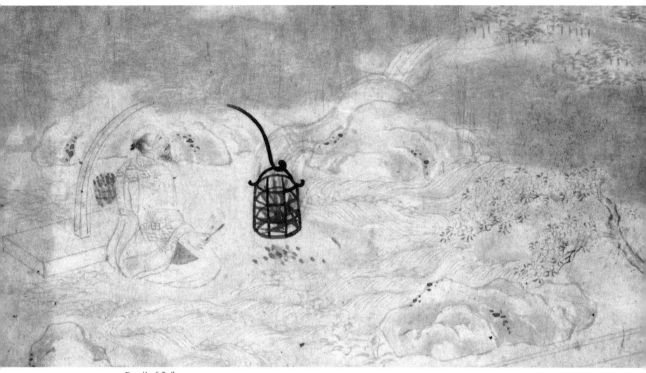

Detail of 5-2

SCENE 3

It is at the bishop's place. They place some spreads on the rocks beside cascading waters. Tō no Chūjō from Ōidono takes out a flute. Ben no Kimi sings, marking time with a fan. Some retainers play on the flageolet and others, the *shō* pipes. The bishop brings out a seven-stringed Chinese koto and presses Genji to play it. Genji plays a tune. Children should be at their sides.

Farewell presents from the bishop are placed in front of them, or most likely beside them: a rosary of hard metal, still in the original Chinese box, wrapped in a netting and attached to a branch of cinquefoil pine; several medicine bottles of indigo decorated with sprays of cherry and wisteria. Two or three courtiers who have come to meet Genji in their carriages should be included. There should also be priests and acolytes, who shed tears as they listen to the music.

✎✎✎

GENJI

The bishop brought out a seven-stringed Chinese koto and pressed Genji to play it. "Just one tune, to give our mountain birds a pleasant surprise."

Genji protested that he was altogether too unwell, but he played a passable tune all the same. And so they set forth. (s 95)

Scene 4

At dawn in early winter there is a heavy mist and the ground should be white with frost. He is on his way back from Murasaki's place in a carriage. Genji has someone knock on the gate.

〜〜〜

GENJI
Passing the house of a woman he had been seeing in secret, he had someone knock on the gate. There was no answer, and so he had someone else from his retinue,

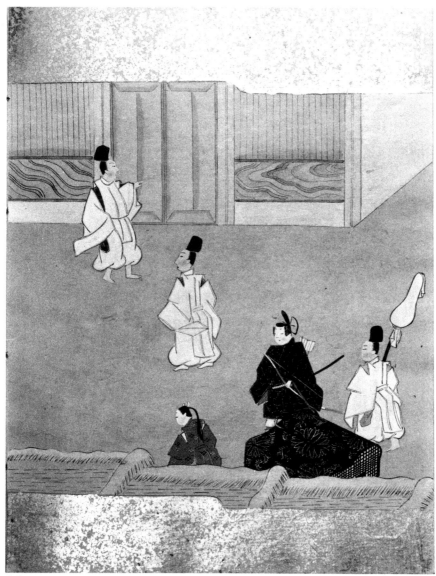

5–4

a man of very good voice, chant this poem twice in tones that could not fail to attract attention:

> "Lost though I seem to be in the mists of dawn,
> I see your gate, and cannot pass it by."

She sent out an ordinary maid who seemed, however, to be a woman of some sensibility:

> "So difficult to pass? Then do come in.
> No obstacle at all, this gate of grass." (s 105–6)

SCENE 5

EKOTOBA

At the beginning of the winter, Aoi plays on a Japanese koto. Genji summons Koremitsu and asks some questions.

~·~·~

GENJI

His wife was as always slow to receive him. In his boredom and annoyance he took out a Japanese koto and pleasantly hummed "The Field in Hitachi." (s 107)

SCENE 6

EKOTOBA

It is in the winter, following the above episode. It is still dark and the morning mist should be rising. It is the scene of Genji's abduction of Murasaki. Koremitsu's horse should be positioned outside the gate, and Koremitsu should be in the garden. Genji's carriage is pulled inside the gate. Genji carries Murasaki into the carriage. Shōnagon comes out with several of Murasaki's robes. There should be two retainers.

~·~·~

GENJI

He smoothed her hair. Her father had come for her, she thought, only half awake.

"Let's go. I have come from your father's." She was terrified when she saw that it was not after all her father. "You are not being nice. I have told you that you must think of me as your father." And he carried her out.

A chorus of protests now came from Shōnagon and the others....

His carriage had been brought up. The women were fluttering about helplessly and the child was sobbing. Seeing at last that there was nothing else to be done, Shōnagon took up several of the robes they had been at work on the night before, changed to presentable clothes of her own, and got into the carriage.

(s 108)

SCENE 7

EKOTOBA

In winter Murasaki is brought to Nijō. Genji has four girls sent to her quarters. There should be small screens, curtains, and pictures. Genji accompanies Murasaki, who is dressed in dark mourning robes. They come to the east wing. She peers at the flowers in the foreground, delicately touched by frost. Streams of courtiers of the medium ranks should be shown.

＞＜・＞

GENJI

She went out to look at the trees and pond after he had departed for the east wing. The flowers in the foregound, delicately touched by frost, were like a picture. Streams of courtiers, of the medium ranks and new to her experience, passed back and forth. Yes, it was an interesting place. (s 109)

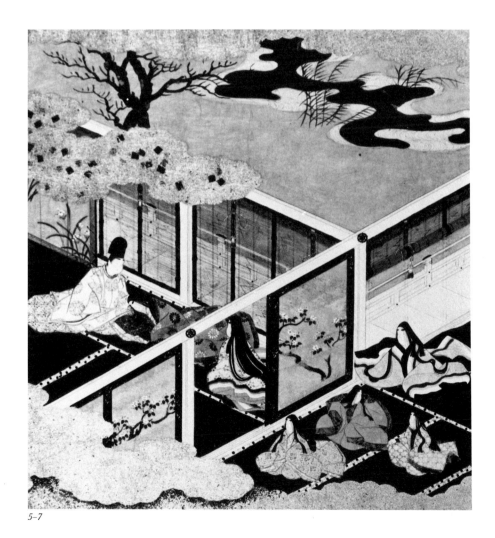

5–7

EKOTOBA

After the above episode, Murasaki tries to hide what she has written. Genji takes it from her and reads it. There should be an inkstone, and the lavender paper that Genji has written on should be on the floor.

꙳ꞏ꙳ꞏ꙳

GENJI

"I sigh, though I have not seen Musashi," he wrote on a bit of lavender paper. She took it up, and thought the hand marvelous. In a tiny hand he wrote beside it:

> "Thick are the dewy grasses of Musashi,
> Near this grass to the grass I cannot have.

"Now you must write something."

"But I can't." She looked up at him, so completely without affectation that he had to smile.

5–8

"You can't write as well as you would like to, perhaps, but it would be wrong of you not to write at all. You must think of me as your teacher."

It was strange that even her awkward, childish way of holding the brush should so delight him. Afraid she had made a mistake, she sought to conceal what she had written. He took it from her.

> "I do not know what it is that makes you sigh.
> And whatever grass can it be I am so near to?"

The hand was very immature indeed, and yet it had strength, and character.

<div align="right">(s 110)</div>

6. The Safflower

SCENE 1

EKOTOBA

It is a misty moonlit night and the moon is just past full. The safflower lady is playing on a koto. Tayū, Myōbu and others should be there. In the garden there are red plum blossoms. Genji takes cover behind a moldering, leaning section of bamboo fence and listens to the music. Tō no Chūjō, in an informal robe, comes forward toward Genji.

GENJI

Genji tried to slip away, for he still did not recognize his friend, and did not want to be recognized himself.

Tō no Chūjō came forward. "I was not happy to have you shake me off, and so I came to see you on your way.

"Though together we left the heights of Mount Ouchi,
 This moon of the sixteenth night has secret ways."

6–1

Genji was annoyed and at the same time amused. "This is a surprise.

> "It sheds its rays impartially here and there,
> And who should care what mountain it sets behind?"

"So here we are. And what do we do now?"

(s 115)

<center>SCENE 2</center>

EKOTOBA

It is after the above episode, and in the spring. Genji and Tō no Chūjō come to visit Ōidono. They proceed, playing their flutes, and the minister joins in with a Korean flute. Within the blinds, Nakatsukasa joins them on the lute and Aoi, on the koto.

GENJI

Having no outrunners, they were able to pull in at a secluded gallery without attracting attention. There they sent for court dress. Taking up their flutes again, they proceeded to the main hall as if they had just come from court. The minister, eager as always for a concert, joined in with a Korean flute. He was a fine musician, and soon the more accomplished of the ladies within the blinds had joined them on lutes.

(s 116)

6–2

SCENE 3

EKOTOBA

After the twentieth of the Eighth Month, Genji comes to the house of the saf-
flower princess. She receives him through the curtains. There should be a serving
woman by the curtains. Raising a corner of the curtain, Genji slips inside.

GENJI

> "Silence, I know, is finer by far than words.
> Its sister, dumbness, at times is rather painful."

He talked on, now joking and now earnestly entreating, but there was no
further response. It was all very strange—her mind did not seem to work as
others did. Finally losing patience, he slid the door open. (s 120)

SCENE 4

EKOTOBA

After the above episode, the young princes pass their time in dance practice at
Ōidono's palace. The drum is on the veranda; there should also be flutes, flageo-
lets, and *shō* pipes. Genji and Tō no Chūjō join them.

GENJI

Everyone was caught up in preparations for the outing. Young men gathered to
discuss them and their time was passed in practice at dance and music. Indeed
the house quite rang with music, and flute and flageolet sounded proud and high
as seldom before. Sometimes one of them would even bring a drum up from the
garden and pound at it on the veranda. (s 121–22)

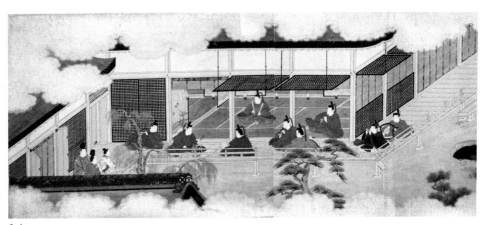

6–4

Scene 5

EKOTOBA

The princess ... [her forehead?]* bulges; her nose is long, pendulous, and colored. Her figure is tall and attenuated. Her skin is whiter than snow, and her hair fans out down to the hem of her robe, with about a foot to spare. She raises a sleeve to her mouth. Over a sadly faded singlet she wears a robe, discolored with age to a murky drab, and an old sable jacket. Genji is preparing to leave. As the gate is damaged and leaning, the old gatekeeper is unable to open it. A girl servant, wearing dirty robes, comes up hugging in her arms a bucket containing embers. As Genji approaches the gate, he has one of his men brush the snow from an orange tree in the garden. The snow cascades from a pine tree. A carriage and his attendants are also included.

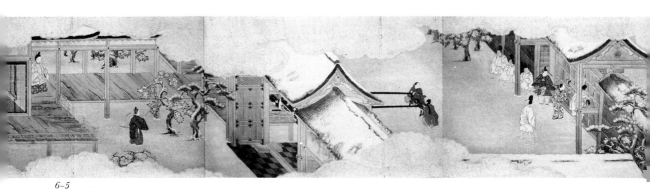

6–5

GENJI

Seeing the struggle the old man was having with the gate, she tried to help. They were a very forlorn and ineffectual pair. One of Genji's men finally pushed the gate open.

> "My sleeves are no less wet in the morning snow
> Than the sleeves of this man who wears a crown of snow."

And he added softly: "The young are naked, the aged are cold."
He thought of a very cold lady with a very warmly colored nose, and he smiled.

(s 125)

* Four characters here are illegible.

Scene 6

EKOTOBA

Around the tenth of the First Month, Genji pays a visit to the safflower lady. The sun streams in unobstructed. The princess raises her sleeve to cover her

mouth. She may be dressed in a cloak of figured lavender and saffron. A woman brings a battered mirror stand, a Chinese comb box, and a man's toilet stand. Genji rests a partly raised shutter on a stool that he has pulled near, and turns to his toilet.

✕･✕･✕

GENJI

Remembering the sight that had so taken him aback that other morning, he raised it only partway and rested it on a stool. Then he turned to his toilet. A woman brought a battered mirror, a Chinese comb box, and a man's toilet stand. He thought it very fine that the house should contain masculine accessories.

(s 130)

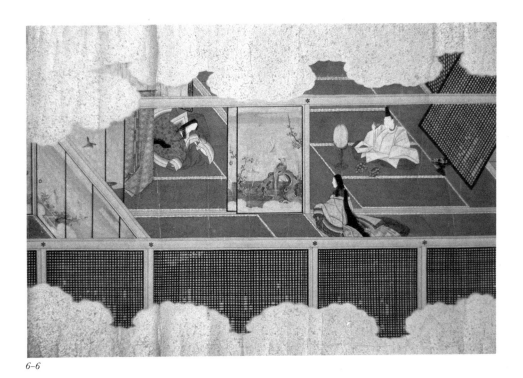

6–6

SCENE 7

EKOTOBA

After the above episode, Genji visits Murasaki's quarter at Nijō. He helps arrange her dollhouses. He draws the picture of a lady and gives her a red nose. When he shows it to Murasaki, she laughs. He looks at his own face in a mirror and daubs his nose red, then pretends to wipe at his nose. Murasaki comes near and rubs at his nose. She is dressed in a soft cloak of white lined with red. The rose plum in the foreground shows traces of color.

He pretended to wipe vigorously at his nose. "Dear me. I fear it will not be white again. I have played a very stupid trick upon myself. And what," he said with great solemnity, "will my august father say when he sees it?"

Looking anxiously up at him, Murasaki too commenced rubbing at his nose.

"Don't, if you please, paint me a Heichū black. I think I can endure the red." They were a charming pair. (s 131)

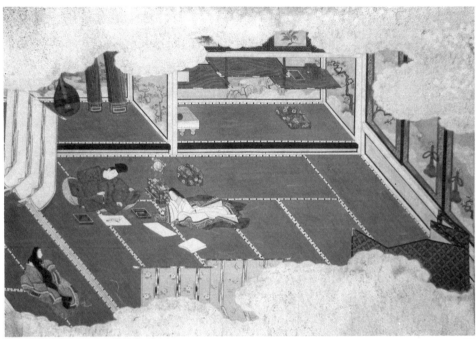

6-7

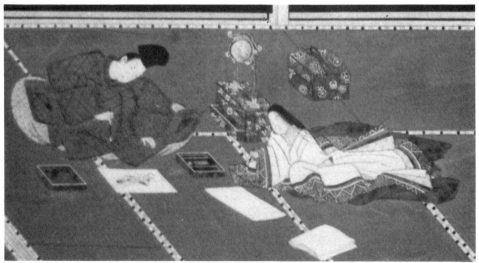

Detail of 6-7

7. An Autumn Excursion

SCENE 1

EKOTOBA

Genji is seventeen or eighteen years old. . . . 10, 6, 3, 5, 10.*

It is after the tenth of the Tenth Month. The scene is the royal excursion to the Suzaku Palace. The emperor is attended by his entire court, the princes and others. The crown prince is also present, and the emperor's ladies are all there.†
The virtuosos from the high and middle court ranks are chosen for the flutists' circle. Music comes from boats rowed out over the lake, and there are Chinese and Korean dances. Genji and Tō no Chūjō dance "Waves of the Blue Ocean." There should be many spectators standing among the trees and rocks.

GENJI

The forty men in the flutists' circle played most marvelously. The sound of their flutes, mingled with the sighing of the pines, was like a wind coming down from deep mountains. "Waves of the Blue Ocean," among falling leaves of countless hues, had about it an almost frightening beauty. The maple branch in Genji's cap was somewhat bare and forlorn, most of the leaves having fallen, and seemed at odds with his handsome face. The General of the Left replaced it with several chrysanthemums which he brought from below the royal seat.

(s 133–34)

* One character here is difficult to understand. No reference to the numbers that follow can be found in the novel.
† In the novel, it is said that the ladies were able to attend only the rehearsal.

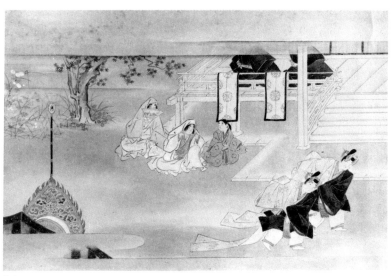

7–1

Scene 2

EKOTOBA
It is the twenty-eighth or twenty-ninth of the Twelfth Month. Genji pays a visit to Fujitsubo, who is still with her family. He is seated outside the blinds, but Prince Hyōbu withdraws behind them. Ōmyōbu scurries around to and fro to help Genji. Chūnagon should also be there.

＞＞＞

GENJI
When, at dusk, the prince withdrew behind the blinds, Genji felt pangs of jealousy. In the old years he had followed his father behind those same blinds, and there addressed the lady. Now she was far away—though of course no one had wronged him, and he had no right to complain. (s 136)

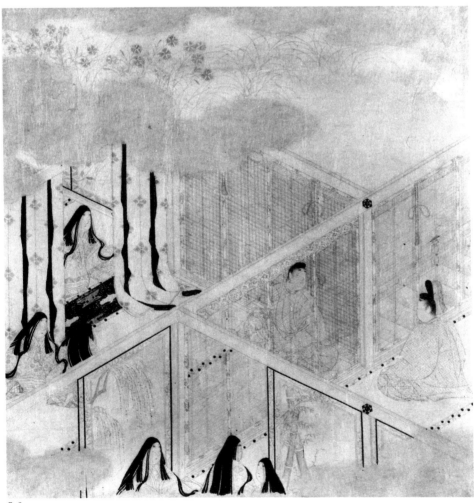

7–2

SCENE 3

EKOTOBA

Genji is eighteen years old. He comes to Nijō. In the room is a yard-high shelf. Murasaki is playing with dolls and small dollhouses. Inuki, beside her, breaks a small dollhouse. Shōnagon tries to brush Murasaki's hair. Genji is on his way to the morning festivities at court. There should be a carriage. The women come out to see him off. Murasaki is dressed in cloaks of unfigured pinks, lavenders, and yellows.

GENJI

"This year you must try to be just a little more grown up," said Shōnagon. "Ten years old, no, even more, and still you play with dolls. It will not do. You have a nice husband, and you must try to calm down and be a little more wifely. Why, you fly into a tantrum even when we try to brush your hair." (s 137)

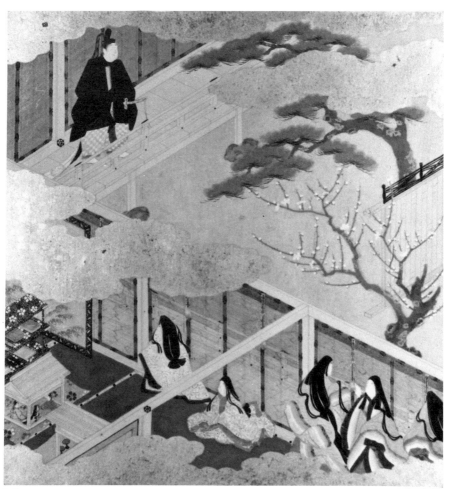

7–3

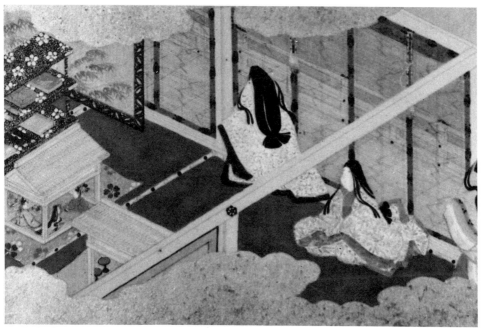

Detail of 7–3

SCENE 4

EKOTOBA

At Nijō, Genji gives Murasaki a lesson on koto playing. He takes out a flute, while Murasaki presses a string [on a koto] with her left hand. Genji is dressed casually.

GENJI

"You must be careful. The second string breaks easily and we would not want to have to change it." And he lowered it to the *hyōjō* mode.

After plucking a few notes to see that it was in tune, he pushed it toward her. No longer able to be angry, she played for him, briefly and very competently. He thought her delightful as she leaned forward to press a string with her left hand. He took out a flute and she had a music lesson. (s 142)

SCENE 5

EKOTOBA

It is summer. Naishi is more bedecked than usual. Tugging at her apron, Genji teases her. They exchange fans. Naishi's red fan has a painting of a tall grove. The emperor Kiritsubo watches the two exchange pleasant banter through a break in the screens.

"Sere and withered though these grasses be,
 They are ready for your pony, should you come."

She was really too aggressive.

"Were mine to part the low bamboo at your grove,
 It would fear to be driven away by other ponies.

"And that would not do at all."

He started to leave, but she caught at his sleeve. "No one has ever been so rude to me, no one. At my age I might expect a little courtesy."

These angry tears, he might have said, did not become an old lady.

"I will write. You have been on my mind a great deal." He tried to shake her off but she followed after.

" 'As the pillar of the bridge—' " she said reproachfully.

Having finished dressing, the emperor looked in from the next room.

(s 144–45)

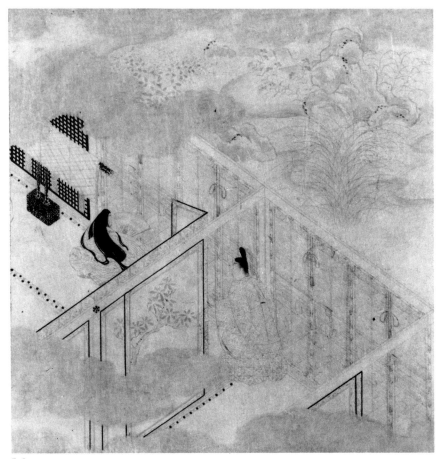

7–5

SCENE 6

EKOTOBA

After the above episode, Genji strolls past the Ummeiden Pavilion. Naishi flirtingly plays on her lute.

GENJI

"No one waits in the rain at my eastern cottage.
Wet are the sleeves of the one who waits within."

It did not seem right, he thought, that he should be the victim of such reproaches. Had she not yet, after all these years, learned patience?

"On closer terms with the eaves of your eastern cottage
I would not be, for someone is there before me."

He would have preferred to move on, but, remembering his manners, decided to accept her invitation. For a time they exchanged pleasant banter. All very novel, thought Genji. (s 145–46)

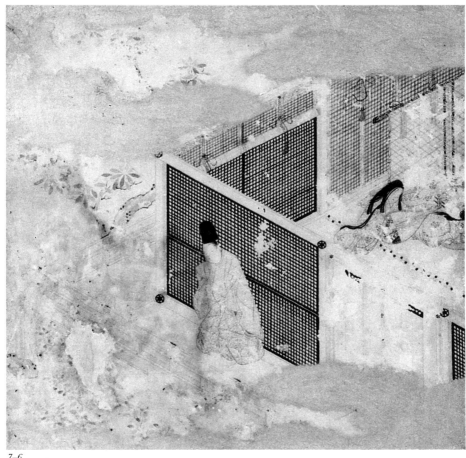

7–6

Scene 7

EKOTOBA

It is in the summer and after the above episode. Genji's coat and trousers are draped over the screen. His sword is unhooked from his belt and should be placed beside him. Tō no Chūjō tries to frighten Genji with a menacing voice. Naishi comes out from behind the screen. Genji takes Tō no Chūjō's arm, brandishing a sword while trying to retrieve his own clothing draped over the screen. Then, Genji unfastens his friend's belt and tries to pull off his clothes, as he bursts seams in all of Tō no Chūjō's clothes.

✕✕✕

GENJI

"Well, then, let's be undressed together." Genji undid his friend's belt and sought to pull off his clothes, and as they disputed the matter Genji burst a seam in an underrobe.

"Your fickle name so wants to be known to the world
 That it bursts its way through this warmly disputed garment.

"It is not your wish, I am sure, that all the world should notice."
Genji replied:

"You taunt me, sir, with being a spectacle
 When you know full well that your own summer robes are showy."

Somewhat rumpled, they went off together, the best of friends. (s 146–47)

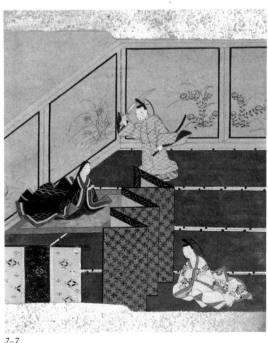

7–7

8. The Festival of the Cherry Blossoms

Scene 1

EKOTOBA

In the Kōnin era (810–823), and at the time of the opening of the Shinsen[en].*

Genji is nineteen years old. It is past the twentieth of the Second Month. Genji meets the sixth daughter of the Minister of the Right [Oborozukiyo] in the gallery at Kokiden's pavilion. The princess holds up her fan, which has a painting showing a "three-ply cherry" with a misty moon reflected on the water.

GENJI

" 'What can compare with a misty moon of spring?' " It was a sweet young voice, so delicate that its owner could be no ordinary serving woman.

She came (could he believe it?) to the door. Delighted, he caught at her sleeve.

"Who are you?" She was frightened.

There is nothing to be afraid of.

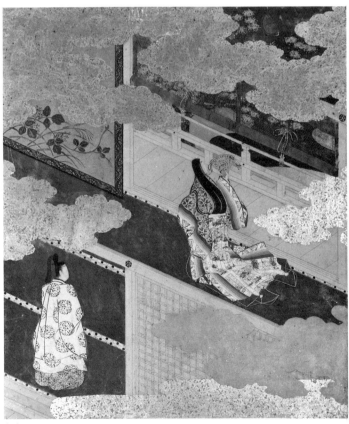

8–1

"Late in the night we enjoy a misty moon.
There is nothing misty about the bond between us."

Quickly and lightly he lifted her down to the gallery and slid the door closed. Her surprise pleased him enormously. (s 152)

* The meaning here is unclear.

SCENE 2

EKOTOBA

Aoi casually plucks out a tune on a koto. Genji and the minister are present. Ben no Chūjō should also be there.

꙳꙳꙳

GENJI

In his boredom he thought of this and that. Pulling a koto to him, he casually plucked out a tune. "No nights of soft sleep," he sang, to his own accompaniment.

The minister came for a talk about the recent pleasurable events. (s 154–55)

SCENE 3

EKOTOBA

There is a banquet at the mansion of the Minister of the Right in Nijō. A large number of the princes and high courtiers gather at the main hall. Wisteria flowers have for the most part fallen, but some are at their belated best.* Genji wears a robe of a thin white Chinese damask with a red lining and under it a very long train of magenta. He raises the blind at the corner door. Behind the blinds should be the First, Third, and Sixth Princesses. Genji takes the Sixth Princess's hand through a crack in the blind.

꙳꙳꙳

GENJI

"I wander lost on Arrow Mount and ask:
 May I not see the moon I saw so briefly?

"Or must I continue to wander?"
It seemed that she could not remain silent:

"Only the flighty, the less than serious ones,
 Are left in the skies when the longbow moon is gone."

It was the same voice. He was delighted. And yet— (s 157)

* The novel refers to cherry blossoms here.

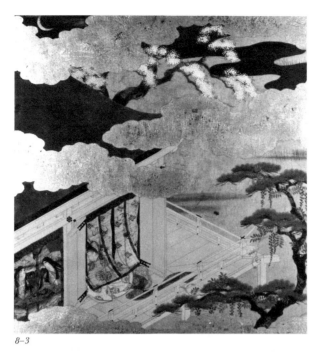

8–3

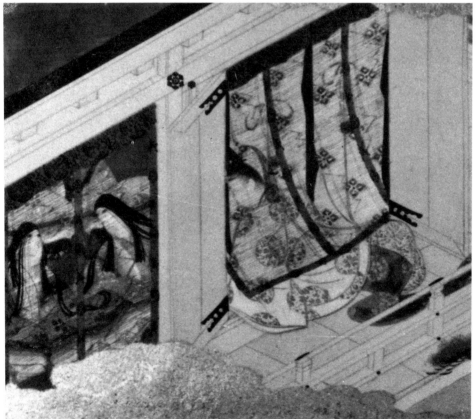

Detail of 8–3

9. Heartvine

EKOTOBA

Genji is twenty-one or twenty-two years old. The time may be the Fourth
Month. It is the story of the competing carriages.

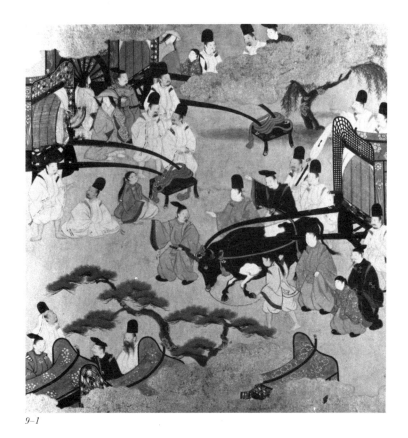

9–1

9–2

GENJI

The Rokujō lady, behind the lesser ones, could see almost nothing. Quite aside from her natural distress at the insult, she was filled with the bitterest chagrin that, having refrained from display, she had been recognized. The stools for her carriage shafts had been broken and the shafts propped on the hubs of perfectly strange carriages, a most undignified sight. It was no good asking herself why she had come.

(s 160)

SCENE 2

EKOTOBA

It is in the Fourth Month. Genji comes over to Murasaki's rooms as she is ready to go to view the Kamo festival. Genji trims Murasaki's hair himself. A Go board and heartvine wrapped in paper should be shown. All the little ladies look lovely in their festive dresses; their hair flows over the trousers.

〜〜〜

GENJI

Even ladies with very long hair usually cut it here at the forehead, and you've not a single lock of short hair. A person might even call it untidy."

The joy was more than a body deserved, said Shōnagon, her nurse.

"May it grow to a thousand fathoms," said Genji.

> "Mine it shall be, rich as the grasses beneath
> The fathomless sea, the thousand-fathomed sea."

Murasaki took out brush and paper and set down her answer:

> "It may indeed be a thousand fathoms deep.
> How can I know, when it restlessly comes and goes?"

She wrote well, but a pleasant girlishness remained.
Again the streets were lined in solid ranks.

(s 163–64)

SCENE 3

It is autumn. Aoi is seized with labor pains. Genji takes her hand, while her mother comes with medicine. As she is raised a little, she gives birth to a baby.

～˙～˙～

GENJI

Thinking that these calmer tones meant a respite from pain, her mother came with medicine; and even as she drank it down she gave birth to a baby boy. Everyone was delighted, save the spirits that had been transferred to mediums. Chagrined at their failure, they were raising a great stir, and all in all it was a noisy and untidy scene. There was still the afterbirth to worry about.　　(s 169)

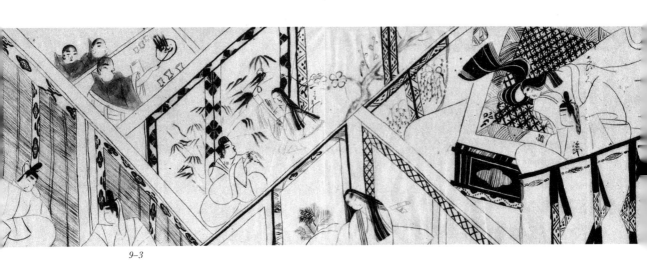

9–3

SCENE 4

EKOTOBA

The Rokujō lady's robes are permeated with the scent of the poppy seeds burned at exorcisms, and she changes them repeatedly. Yet, the odor persists, and she is overcome with self-loathing.

～˙～˙～

GENJI

She was not herself. The strangest thing was that her robes were permeated with the scent of the poppy seeds burned at exorcisms. She changed clothes repeatedly and even washed her hair, but the odor persisted. She was overcome with self-loathing. And what would others be thinking? It was a matter she could discuss with no one. She could only suffer in distraught silence.　　(s 169)

EKOTOBA

After Aoi's death, a letter of condolence comes from the Rokujō lady. It is written on dark blue-gray paper, and attached to a branch of chrysanthemum. Genji reads it.

〜〜〜

GENJI

The garden [was] enshrouded in mist. A letter was brought in, on dark blue-gray paper attached to a half-opened bud of chrysanthemum. In the best of taste, he thought. The hand was that of the Rokujō lady.

"Do you know why I have been so negligent?

"I too am in tears, at the thought of her sad, short life.
Moist the sleeves of you whom she left behind.

"These autumn skies make it impossible for me to be silent." (s 173)

9–5

SCENE 6

EKOTOBA

The wind is high and there are chilly autumn rains. Princess Ōmiya is at the railing of the veranda,* looking out over the frostbitten garden. Tō no Chūjō

comes calling after he has changed to lighter mourning clothes. Genji is dressed in a summer cloak of a finely glossed red singlet under a robe of a deep gray. More details are given in the book.

❧❧❧

GENJI
Gentians and wild carnations peeped from the frosty tangles. After Tō no Chūjō had left, Genji sent a small bouquet by the little boy's nurse, Saishō, to Princess Omiya, with this message:

> "Carnations at the wintry hedge remind me
> Of an autumn which we leave too far behind.

"Do you not think them a lovely color?" (S 175–76)

* This should be Genji, and not the princess.

9–6

SCENE 7

EKOTOBA

At about the same time as above, in the Twelfth Month, Boar-day sweets are served. There are festivities. Ben no Kimi, Shōnagon's daughter, slips the cakes inside Murasaki's curtains. Genji and Shōnagon should be present. Koremitsu may be busily running about to take care of various things.

~~~

GENJI

"You must see that it gets to her and to no one else. A solemn celebration. No carelessness permitted."

She thought it odd. "Carelessness? Of that quality I have had no experience."

"The very word demands care. Use it sparingly." (s 182)

9–7

# 10.   The Sacred Tree

## SCENE 1

EKOTOBA

It is on the seventh of the Ninth Month. The painting shows Genji's visit to the Rokujō lady who has withdrawn to the temporary shrine of the priestess, her daughter. The autumn flowers are gone and pine crickets are in the wintry tangles. The evening moon is shining. There should be the shrine gate, of unfinished logs; a low wattle fence; and the fire lodge.

Genji is seated on the veranda and the lady is behind the blinds. Having broken off a branch of the sacred tree, Genji pushes the blind to one side. The lady looks aside a little in an alluring way. Next to them should be . . .* Clusters of priests, Genji's carriage, and more than ten outrunners should be shown.

＞﹀﹀

GENJI

He pushed a branch of the sacred tree in under the blinds.

> "With heart unchanging as this evergreen,
>     This sacred tree, I enter the sacred gate."

She replied:

> "You err with your sacred tree and sacred gate.
>     No beckoning cedars stand before my house."

*10–1*

And he:

> "Thinking to find you here with the holy maidens,
>   I followed the scent of the leaf of the sacred tree."

Though the scene did not encourage familiarity, he made bold to lean inside the blinds.                                                                (s 187)

---

\* The calligrapher left space enough for about two letters here. His model was probably illegible.

## Scene 2

**EKOTOBA**

Then, before going down to Ise, the priestess is given the final audience with the emperor. The carriages of her ladies are lined up before the eight ministries. The procession then passes before Genji's mansion at Nijō. To the lady's carriage, Genji sends out a poem attached to a sacred branch.

⌇⌇⌇

**GENJI**

The procession left the palace in the evening. It was before Genji's mansion as it turned south from Nijō to Dōin. Unable to let it pass without a word, Genji sent out a poem attached to a sacred branch:

> "You throw me off; but will they not wet your sleeves,
>   The eighty waves of the river Suzuka?"

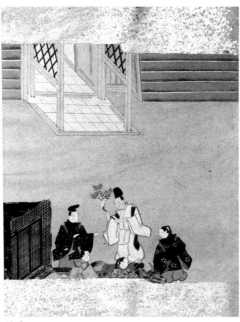

*10–2*

It was dark and there was great confusion, and her answer, brief and to the point, came the next morning from beyond Osaka Gate.

> "And who will watch us all the way to Ise,
> To see if those eighty waves have done their work?"

Her hand had lost none of its elegance, though it was a rather cold and austere elegance.

(s 190)

## Scene 3

EKOTOBA

It is about the twentieth of the Twelfth Month, and at Fujitsubo's family palace in Sanjō. After the death of the old emperor Kiritsubo, Prince Hyōbu comes to take Fujitsubo back to her family palace. Genji, in mourning, comes to see them. He should be inside the room. Fujitsubo should be inside the blinds. There should also be Ōmyōbu and many carriages. The branches of the pine in the foregarden are weighed down by snow and the pond is frozen over.

GENJI

The branches of the pine in the garden were brown and weighed down by snow.

The prince's poem was not an especially good one, but it suited the occasion and brought tears to Genji's eyes:

*10–3*

"Withered the pine whose branches gave us shelter?
Now at the end of the year its needles fall."

The pond was frozen over. Genji's poem was impromptu and not, perhaps, among his best:

"Clear as a mirror, these frozen winter waters.
The figure they once reflected is no more."

This was Omyōbu's poem:

"At the end of the year the springs are silenced by ice.
And gone are they whom we saw among the rocks."

There were other poems, but I see no point in setting them down.     (s 192)

## SCENE 4

EKOTOBA

It may be towards the end of summer. Fujitsubo, at Prince Hyōbu's palace, is not feeling well. Ōmyōbu and Ben should be at her side. There should be screens and curtains. In front of the lady should be fruits, laid out on the lid of a decorative box. Prince Hyōbu and her chamberlain are sent for. Genji is pushed into a closet. Ōmyōbu and Ben push his clothes in after him.

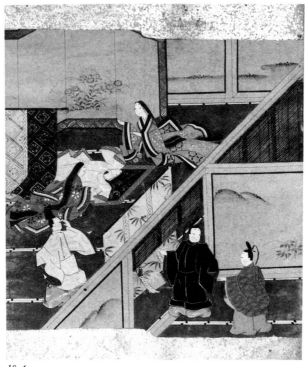

10–4

GENJI

Several other women, alerted to the crisis, were now up and about. Omyōbu and Ben bundled a half-conscious Genji into a closet. They were beside themselves as they pushed his clothes in after him. Fujitsubo was now taken with fainting spells. Prince Hyōbu and her chamberlain were sent for. A dazed Genji listened to the excitement from his closet.

Towards evening Fujitsubo began to feel rather more herself again.    (s 196)

## Scene 5

EKOTOBA

The time is autumn. Genji is staying at the Unrin-in temple. Details are given in the book.

~·~·~

GENJI

He would still, in the dawn moonlight, remember the lady who was being so cruel to him. There would be a clattering as the priests put new flowers before the images, and the chrysanthemums and the falling leaves of varied tints, though the scene was in no way dramatic, seemed to offer asylum in this life and hope for the life to come.    (s 199)

## Scene 6

EKOTOBA

Genji makes his departure from the Unrin-in temple. He is still in mourning, his carriage is draped in black. The priests come to see him off. Villagers and old people kneel by the road to see him off. He has his men break off and carry autumn leaves.

~·~·~

GENJI

The woodcutters came down from the hills and knelt by the road to see him off. Still in mourning, his carriage draped in black, he was not easy to pick out, but from the glimpses they had they thought him a fine figure of a man indeed.
(s 201)

## Scene 7

EKOTOBA

There is a rhyme-guessing contest at the Nijō palace. Tō no Chūjō holds the third rank at this time. He comes calling, bringing with him several collections

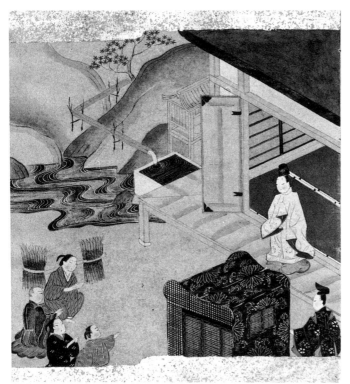

10–6

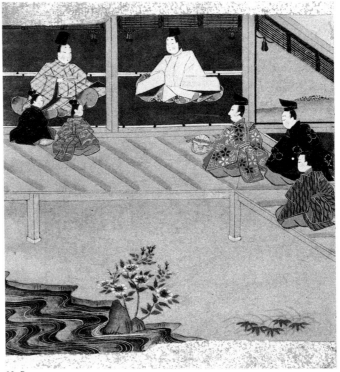

10–7

of Chinese poetry. Genji opens cases nearby and brings out various collections. Connoisseurs of Chinese poetry should be divided into teams of the right and of the left. Tō no Chūjō is in the left group. There should be prizes, bamboo baskets, and cypress boxes.

Two days later, Tō no Chūjō gives a banquet for the victors at the Nijō palace. Food should be arranged in cypress boxes. Below the veranda in front, some roses are coming into bloom. Some should be in buds. Many courtiers of high and low ranks are divided into the left and right groups, and old retainers are at the end of the line. At this time, too, collections of Chinese poetry are brought out and they compose more poems. One of Tō no Chūjō's sons, a boy of eight or nine who has just this year been admitted to the royal presence, sings "Takasago" for them. Genji takes off a singlet and presents it to him. Tō no Chūjō hands the robe to the boy. The poem in the text differs from this, then the next . . . *

꒰꒱

GENJI

On an evening of quiet summer rain when the boredom was very great, Tō no Chūjō came calling and brought with him several of the better collections of Chinese poetry. Going into his library, Genji opened cases he had not looked into before and chose several unusual and venerable collections. Quietly he sent out invitations to connoisseurs of Chinese poetry at court and in the university. Dividing them into teams of the right and of the left, he set them to a rhyme-guessing contest. The prizes were lavish.                                    (s 209)

* The manual is unclear here.

## SCENE 8

EKOTOBA

It may be summer. Oborozukiyo is spending some time with the minister at Nijō, as she is suffering from attacks of malaria. Genji comes to see her in secret. At night there comes a furious thunderstorm. Toward dawn Genji is unable to escape and hides beside the blinds. The minister comes to look in on the princess. Flushed, Oborozukiyo slips through the bed curtains. Genji's pale magenta sash is entwined in her skirts. As he goes out, the minister picks up a wadded bit of paper, on which are traces of writing.

꒰꒱

GENJI

[The minister] lifted the bed curtains. A gentleman was lying there in dishabille. He hid his face and sought to pull his clothes together. Though dizzy with anger, the minister pulled back from a direct confrontation. He took the bit of paper off to the main hall.                                    (s 213)

10–8

THE SACRED TREE  95

# 11.  The Orange Blossoms

## SCENE 1

**EKOTOBA**

Genji passes a small house by Nakagawa. There should be a great Judas tree, and a cuckoo calling. Inside a woman is playing the Azuma melody on a Japanese koto. Genji has the carriage turned and peeks in. Koremitsu is sent inside the gate as his messenger.

◆◆◆◆

**GENJI**

Just then a cuckoo called from a nearby tree, as if to urge him on. He had the carriage turned so that he might alight. Koremitsu, as always, was his messenger.

> "Back at the fence where once it sang so briefly,
>   The cuckoo is impelled to sing again."

The women seemed to be near the west veranda of the main building.

(s 216)

*11–1*

## SCENE 2

EKOTOBA
It is at Reikeiden's apartments. On his way to visit the lady of the orange blossoms, Genji stops by at Reikeiden's apartments and talks with the lady. The tall trees in the garden are a dark wall in the light of the quarter moon. In the foreground should be orange blossoms. A nightingale calls. The lady of the orange blossoms is in the west front.

GENJI
There came the call of a cuckoo—might it have been the same one? A pleasant thought, that it had come following him. "How did it know?" he whispered to himself.

> "It catches the scent of memory, and favors
>  The village where the orange blossoms fall."          (s 217)

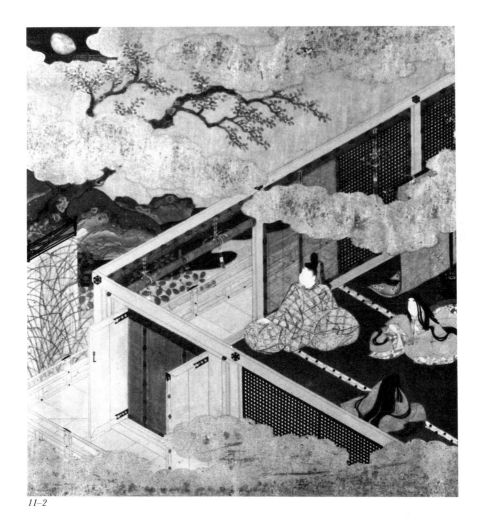

*11–2*

# 12.  Suma

## Scene 1

EKOTOBA
It may be in the evening, around the twentieth of the Third Month. Before his departure to Suma in exile, Genji visits his father-in-law. His carriage, a humble one covered with cypress basketwork, might be mistaken for a woman's. The minister looks old and is weeping. Genji should be shown. His little boy scrambles and rolls about the room. The boy's nurse should also be there. Tō no Chūjō also comes to visit. Wine cups should be shown before them.

~·~·~

GENJI
"I have gone on grieving for my daughter. And then I think what agony all this would have been to her, and am grateful that she lived such a short life and was spared the nightmare. So I try to tell myself, in any event."    (s 221)

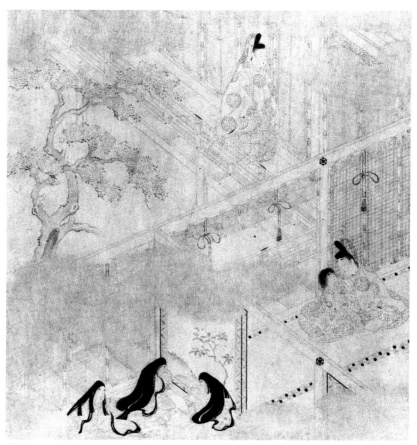

12–1

## SCENE 2

It is the same time as above. As Genji is leaving for Suma, Tō no Chūjō and Prince Hotaru come calling. To receive them, Genji changes to informal dress of unfigured silk, and combs his hair in front of a mirror. Murasaki, tears in her eyes, is huddled against a pillar.

᠃᠄᠃

GENJI

As he combed his hair he could not help noticing that loss of weight had made him even handsomer.

"I am skin and bones," he said to Murasaki, who sat gazing at him, tears in her eyes. "Can I really be as emaciated as this mirror makes me? I am a little sorry for myself.

"I now must go into exile. In this mirror
An image of me will yet remain beside you."

Huddling against a pillar to hide her tears, she replied as if to herself:

"If when we part an image yet remains,
Then will I find some comfort in my sorrow."

Yes, she was unique—a new awareness of that fact stabbed at his heart.

(s 224)

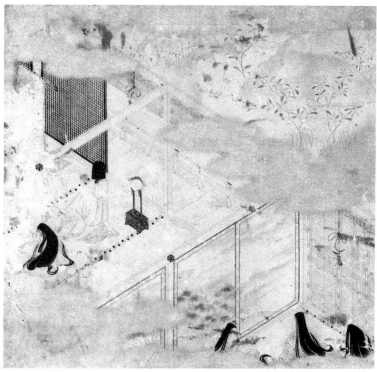

12–2

# SCENE 3

**EKOTOBA**

The late moon of about the twentieth of the Third Month is rising. Genji visits the grave of his father, emperor Kiritsubo. He is on horseback and has four or five attendants. Dismounting, he bows toward the Kamo Shrine.

❧

**GENJI**

Dismounting, Genji bowed toward the shrine and said as if by way of farewell:

> "I leave this world of gloom. I leave my name
> To the offices of the god who rectifies."

The guards officer, an impressionable young man, gazed at him in wonder and admiration. (s 228)

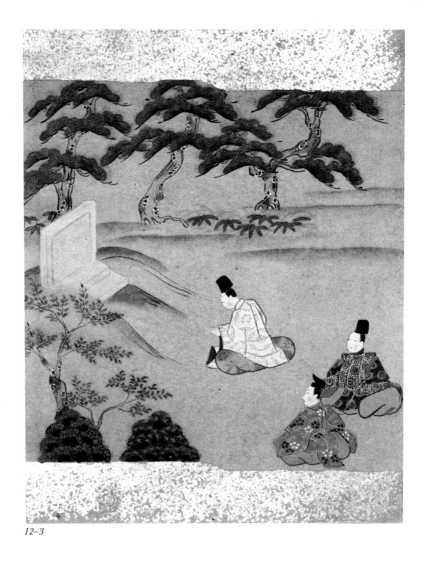

*12–3*

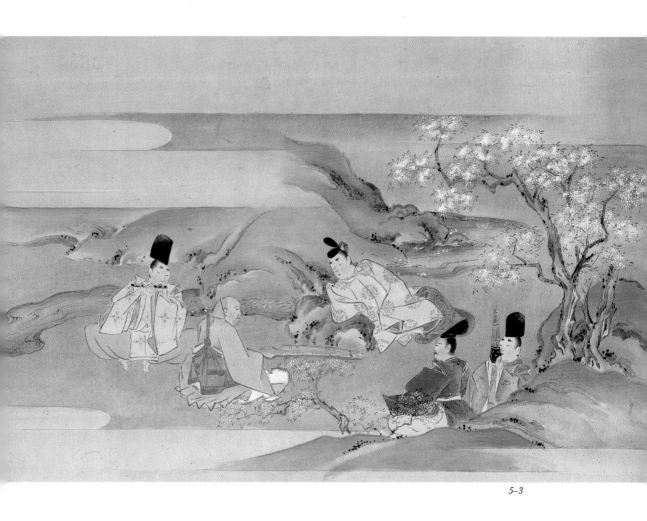

5–3

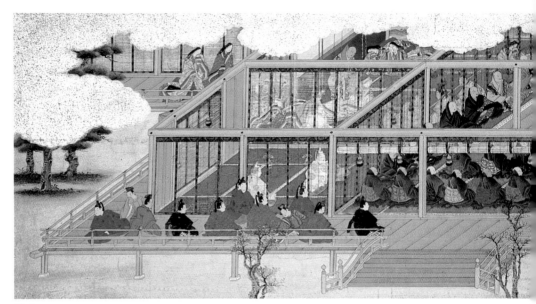

10–5

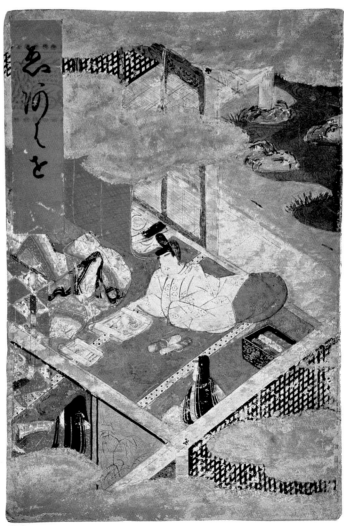

17–2

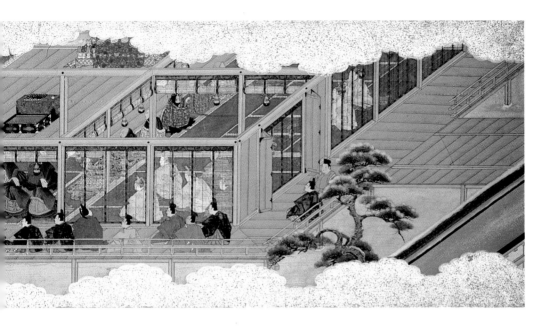

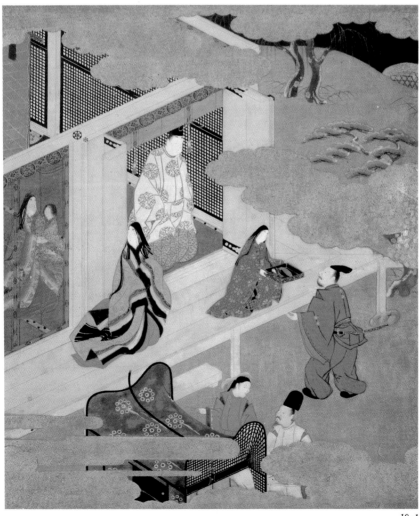

19–1

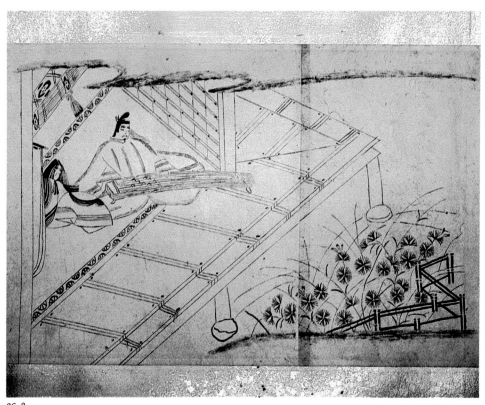

26–2

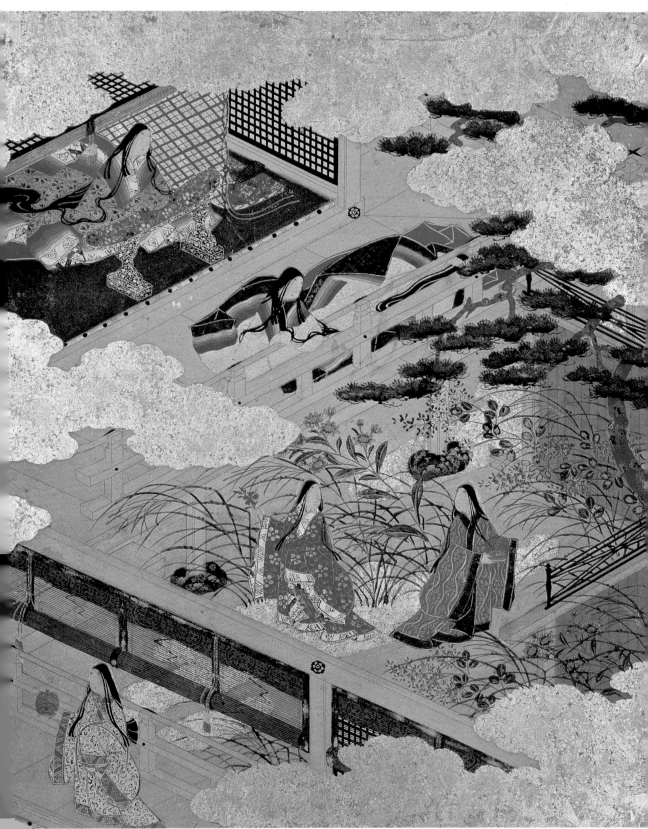

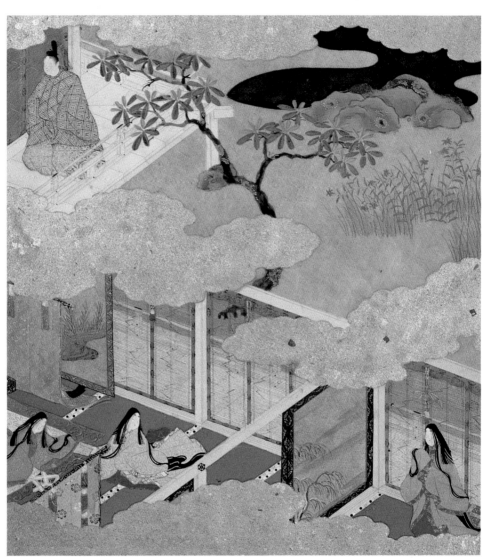

35–9

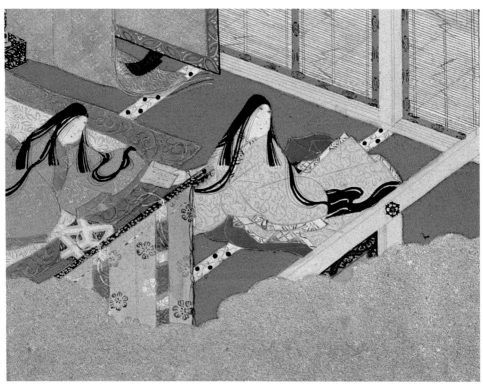

*Detail of 35–9*

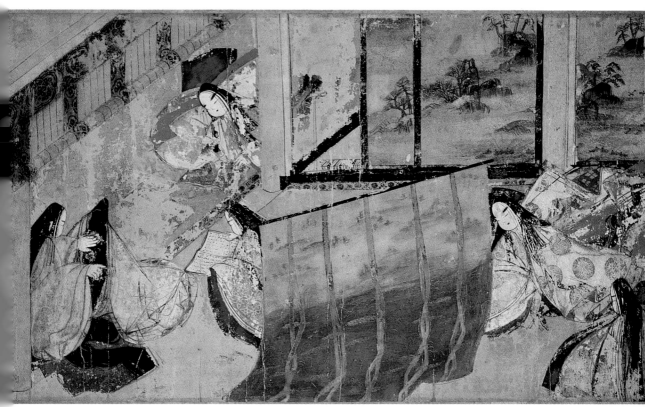

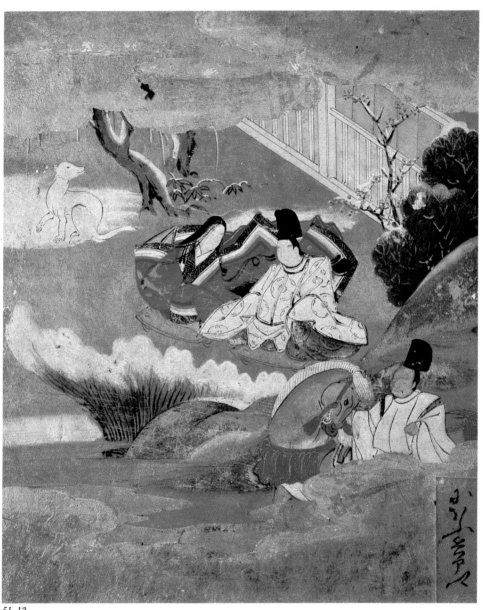

51–12

## SCENE 4

EKOTOBA

It is autumn at Suma. His house should be a grass-roofed cottage with reed-roofed galleries and plaited bamboo fences. Awake alone at night, Genji plucks a few notes on his koto.

▾·▾·▾

GENJI

He plucked a few notes on his koto, but the sound only made him sadder.

> "The waves on the strand, like moans of helpless longing.
> The winds—like messengers from those who grieve?"

He had awakened the others. They sat up, and one by one they were in tears.

(s 236)

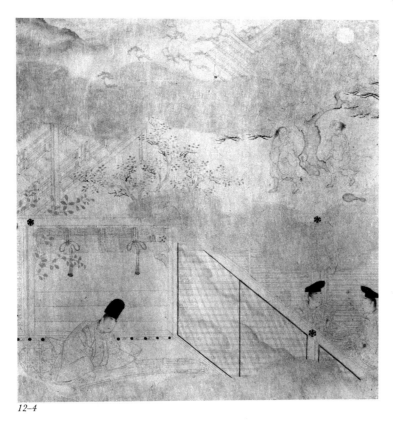

12–4

## SCENE 5

EKOTOBA

After the twentieth of the Second Month, Tō no Chūjō, who is now a councillor, comes to see Genji in Suma. There should be a sapling cherry, sending out a scattering of blossoms. Over a singlet dyed lightly in a yellowish color Genji is

wearing a hunting robe and trousers of greenish gray. Nearby should be Genji's personal utensils and accessories, such as the boards and stones for Go and backgammon games and religious objects. His room is open to anyone who wishes to look in.

Wine is brought in. Fishermen bring shellfish and other things. Tō no Chūjō gives them clothes. Fodder is brought out to feed the horses. There should be a black pony. A line of geese should be shown flying and calling. A koto should be shown. Fishermen coming up to the house should not be included, if [the painting is] small.*

ヽヽヽ

GENJI

A line of geese flew over in the dawn sky.

> "In what spring tide will I see again my old village?
> I envy the geese, returning whence they came."

Sorrier than ever that he must go, Tō no Chūjō replied:

> "Sad are the geese to leave their winter's lodging.
> Dark my way of return to the flowery city."

He had brought gifts from the city, both elegant and practical.     (s 244–45)

* This phrase is missing from this manual, but it is preserved in the version in the Imperial Library.

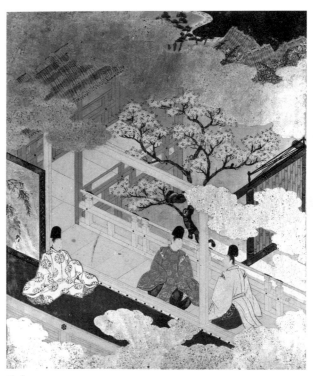

12–5

# 13. Akashi

<div align="center">SCENE 1</div>

EKOTOBA

It is the first or the second of the Third Month. The wind is fierce, the tide is high, and the screens are ripped. The gallery adjoining Genji's rooms is struck by lightning. Flames spring up and the gallery is destroyed. Genji is moved to a building out in back, and offers prayers to countless gods. The building is crowded with people of every station and rank. The sky is as black as ink.

GENJI

Genji offered prayers to the king of the sea and countless other gods as well. The thunder was increasingly more terrible, and finally the gallery adjoining his rooms was struck by lightning. Flames sprang up and the gallery was de-

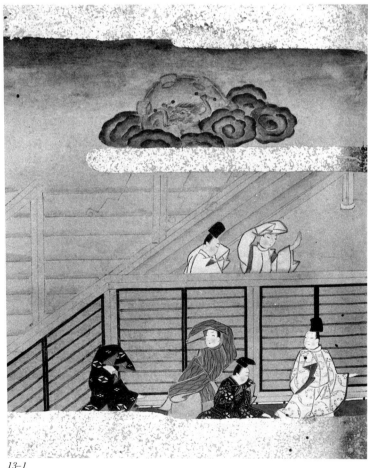

*13–1*

stroyed. The confusion was immense; the whole world seemed to have gone mad. Genji was moved to a building out in back, a kitchen or something of the sort it seemed to be. It was crowded with people of every station and rank. The clamor was almost enough to drown out the lightning and thunder. Night descended over a sky already as black as ink. (s 249)

## SCENE 2

EKOTOBA

It must be two or three days after the above episode. The monk of Akashi comes on a boat to take Genji away from Suma. Genji sends Yoshikiyo down to the beach to meet the messenger on the boat. Genji should be at a house up the hill.

〜〜〜

GENJI

Genji's dream had given intimations. He sent Yoshikiyo down to the boat immediately. Yoshikiyo marveled that it could even have been launched upon such a sea. (s 251)

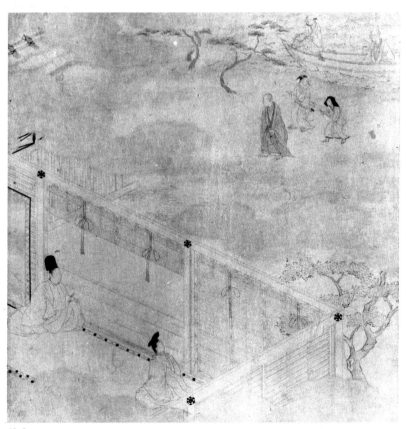

13–2

EKOTOBA

It is the Fourth Month. At Akashi, looking over to the island of Awaji, Genji is playing on the thirteen-stringed koto. The monk is playing a lute. There should also be a seven-stringed koto.

GENJI

Sending to the house on the hill for a lute and a thirteen-stringed koto, the old man now seemed to change roles and become one of these priestly mendicants who make their living by the lute. He played a most interesting and affecting strain. Genji played a few notes on the thirteen-stringed koto which the old man pressed on him and was thought an uncommonly impressive performer on both sorts of koto.

(s 255)

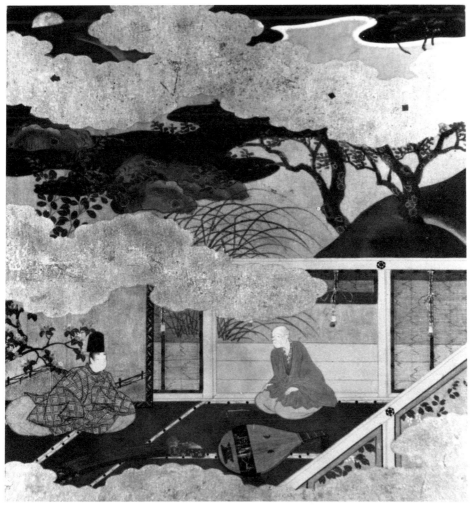

*13–3*

# Scene 4

## EKOTOBA

It is most likely in the Fourth or the Fifth Month. The moon is near full. Riding on a roan-colored horse, Genji is going to visit the daughter of the monk in the hills. Genji is tempted to turn his horse's head back to the city, when he looks at the full moon shining over the bay.

∿∿∿

## GENJI

The lady's house was some distance back in the hills. The coast lay in full view below, the bay silver in the moonlight. He would have liked to show it to Murasaki. The temptation was strong to turn his horse's head and gallop on to the city.

> "Race on through the moonlit sky, O roan-colored horse,
> And let me be briefly with her for whom I long."          (s 261–62)

*13–4*

# Scene 5

## EKOTOBA

It is in the evening of the same day as above. Genji slips into the house of the monk's daughter. There should be a cypress door and tall pine trees. The lady should be playing a koto by the curtains.

GENJI

A curtain string brushed against a koto, to tell him that she had been passing a quiet evening at her music.

"And will you not play for me on the koto of which I have heard so much?

"Would there were someone with whom I might share my thoughts
    And so dispel some part of these sad dreams."

"You speak to one for whom the night has no end.
    How can she tell the dreaming from the waking?"

The almost inaudible whisper reminded him strongly of the Rokujō lady.

(s 263)

## SCENE 6

EKOTOBA

It is autumn. Before his departure for the capital, Genji pays a farewell visit to the monk's daughter. He is playing the seven-stringed koto. The monk pushes a thirteen-stringed koto toward his daughter behind the blinds.

༽ ༾ ༽

GENJI

Unable to restrain himself, the old man pushed a thirteen-stringed koto toward his daughter. She was apparently in a mood for music. (s 266)

*13–6*

# 14.  Channel Buoys

EKOTOBA

In the Fifth Month, Genji visits the lady of the orange blossoms. Her house is in a ruinous condition. She is looking out from near the veranda at the west front. It is a night of misty moonlight and a water rail cries nearby. Both Genji and the lady should be shown.

~·~·~

GENJI

From nearby there came the metallic cry of a water rail.

"Did not this bird come knocking at my door,
What pretext would I find to admit the moon?"

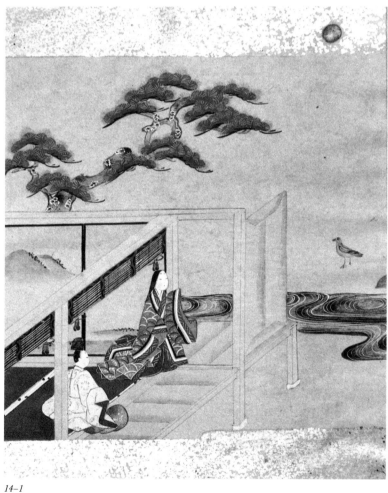

14–1

Her soft voice, trailing off into silence, was very pleasing. He sighed, almost wishing it were not the case that each of his ladies had something to recommend her. It made for a most complicated life.

> "You respond to the call of every water rail?
> You must find yourself admitting peculiar moons."    (s 279)

## SCENE 2

EKOTOBA

In the autumn Genji makes a pilgrimage to Sumiyoshi accompanied by Yūgiri. Genji is in a carriage. Yūgiri rides on horseback, and has put even his stableboys into livery. Genji's attendants are princes and courtiers, their robes of deep and brilliant hues, like maple leaves and cherry blossoms against the deep green of the pine groves. The young courtiers have caparisoned their horses. There should be many courtiers of the Sixth Rank; among them the yellow-green robes of the imperial secretariat stand out. There should also be guards. There are many bearers of offerings and uniformed dancers in attendance. It is like a royal procession. The Akashi lady has also come by boat. Her boat should be pulled in.

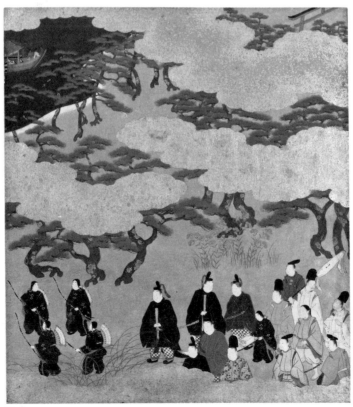

14–2

GENJI

Like the Kawara minister, he had been granted a special honor guard of page boys, ten of them, all very pretty, of uniform height, and resplendently decked out, the cords that bound up their hair in the pageboy style a most elegant blending from white to deep purple.                                    (s 281)

SCENE 3

EKOTOBA

Genji makes an excursion to the Naniwa area. Akashi's boat has also entered the bay of Naniwa. Koremitsu grinds ink and takes out a short writing brush, which he brings to Genji's carriage.

GENJI

"Firm the bond that brings us to Naniwa,
  Whose channel buoys invite me to throw myself in."

Koremitsu sent it to the lady by a messenger who was familiar with the events at Akashi. She wept tears of joy at even so small a favor. A line of horsemen was just then passing by.

This was her reply, to which she tied sacred cords for the lustration at Tamino:

"A lowly one whose place is not to demand,
  To what purpose, at Naniwa, should I cast myself in?"      (s 284)

14–3

## SCENE 4

It is probably toward the end of autumn. Genji comes to pay a visit to the Rokujō lady at her deathbed. He is seated near her at the other side of the curtains. Through an opening in the curtains, Genji sees the lady, who has raised herself to an armrest. Beside the lady is her daughter, who sists with her chin in hand.

GENJI

And the one beyond, to the east of the bed curtains, would be the priestess. Her curtain frames had been pushed casually to one side. She sat chin in hand, in an attitude of utter despondency. Though he could not see her well, she seemed very beautiful. (s 286)

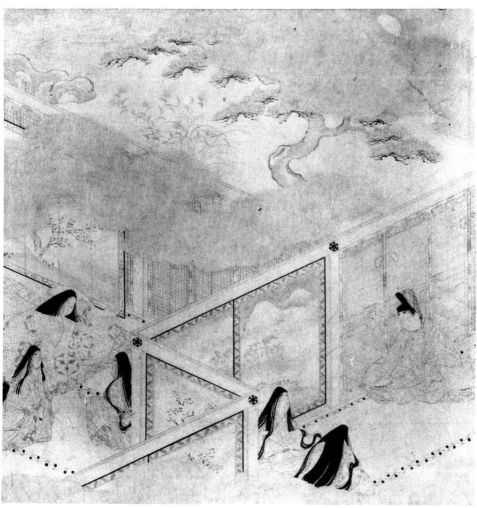

14–4

# 15.  The Wormwood Patch

## SCENE 1

**EKOTOBA**

It is early in winter at the house of the safflower princess. Her house is in ruins. The gates are broken down and the earthen wall crumbled. The branches of a willow drop to the ground. Wisteria blossoms should trail from a giant pine. The garden should be overgrown with wormwood and bindweed, and should look like wild woods. The princess's aunt comes laden with gifts, and accompanied by two attendants. Her carriage should be near the veranda and its curtains drawn up. There should be an old woman and Jijū's child.* The princess puts a piece of her own hair and a jar of incense on the lid of a box to give to Jijū.

～～～

**GENJI**

The everyday robes she might have offered as farewell presents were yellow and stained. And what else was there, what token of her gratitude for long years of service? She remembered that she had collected her own hair as it had fallen, rather wonderful, ten feet or so long. She now put it into a beautifully fabricated box, and with it a jar of old incense.

> "I had counted upon them not to slacken or give,
>   These jeweled strands—and far off now they are borne."  (s 297)

* More correctly, it should read: "an old woman and Jijū."

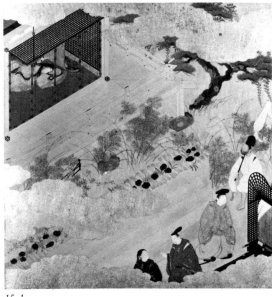

*15–1*

## SCENE 2

EKOTOBA

In the Fourth Month, Genji stops by the house of the safflower princess. The condition of her house and its garden is described in detail in the above episode. Wisteria should be in bloom and the moon out. A few women and an old woman should be shown as the princess's attendants. An old lady called Shōshō, Jijū's aunt, is also in attendance. Genji comes in, accompanied by Koremitsu, who beats at the grass with a horsewhip and keeps an umbrella over Genji's head.

GENJI

"Myself will I break a path through towering weeds
And ask: does a constant spirit dwell within?"

Genji spoke as if to himself, and despite Koremitsu's warnings got from his carriage.

Koremitsu beat at the grass with a horsewhip. The drops from the trees were like a chilly autumn shower.

"I have an umbrella," said Koremitsu. "These groves shed the most fearful torrents."

Genji's feet and ankles were soaking. (s 299)

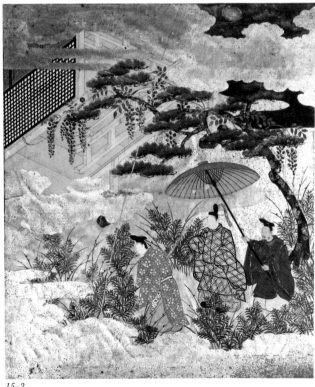

15–2

THE WORMWOOD PATCH  *113*

# 16. The Gatehouse

SCENE 1

EKOTOBA

It is at the end of the Ninth Month. There should be autumn leaves and grasses touched lightly by the frost. The lady of the locust shell is on her way back from Hitachi province, and her party comes to the Osaka barrier. All dressed in travel clothes, her party pulls aside its carriages for Genji to pass. Genji is on his pilgrimage to Ishiyama. Their travel livery, described in the book as damasks and dappled prints, must refer to the clothes worn by the attendants of the lady of the locust shell. There should be many men in Genji's party. Genji sends for Kogimi and gives him a message for the lady.

GENJI

The lady too was assailed by memories, of events which she had kept to herself all these years.

> "It flowed as I went, it flows as I return,
>     The steady crystal spring at the barrier rise."

There was no point in trying to explain what she meant. (s 304)

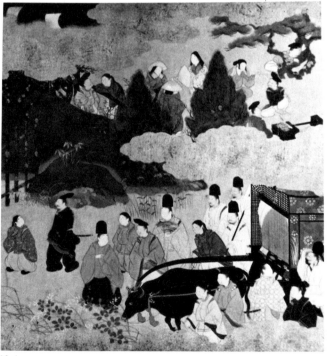

16–1

# 17.  A Picture Contest

**EKOTOBA**

When the former high priestess of Ise is about to be presented at court, the
Suzaku emperor sends gifts: comb boxes, vanity chests, incense coffers, incense,
and sachets. When they are brought in, Genji also comes in and looks at them.
Genji opens and reads a poem in the Suzaku emperor's own hand, which has
been placed in a comb box. There should be either curtains or blinds between
Genji and the lady.

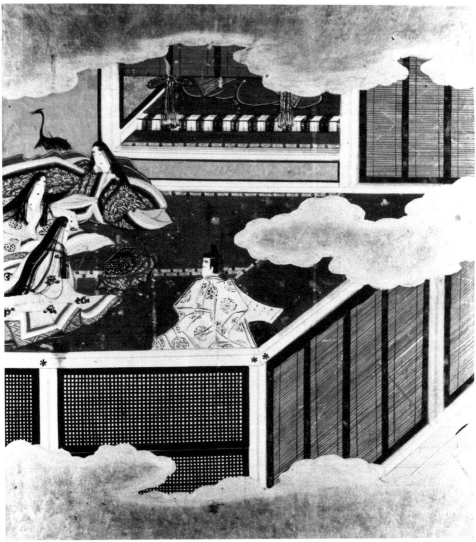

*17–1*

GENJI

Akikonomu's lady of honor showed them to Genji. He took up a comb box of the most remarkable workmanship, endlessly fascinating in its detail. Among the rosettes on the box of decorative combs was a poem in the Suzaku emperor's own hand:

"I gave you combs and sent you far away.
The god now sends me far away from you?"          (s 307)

## SCENE 2

EKOTOBA

It is around the tenth of the Third Month. Genji and Murasaki ransack all the chests and bookcases for paintings and sort them out. He shows Murasaki for the first time the sketchbooks and journals of his exile in Suma.

GENJI

"Better to see these strands where the fishermen dwell
Than far away to weep, all, all alone.

"I think the uncertainty might have been less cruel."
It was true.

"Now more than in those painful days I weep
As tracings of them bring them back to me."          (s 311)

## SCENE 3

EKOTOBA

It is after the twentieth of the Third Month. The picture contest is held in the presence of the Reizei emperor. On the left is the Akikonomu faction, led by three ladies: Heinaishinosuke, Jijū no Naishi, and Shōshō no Myōbu. Both Akikonomu and Kokiden should be behind the curtains. In front are Genji, Gon no Chūnagon, and Prince Hotaru.

The paintings of the left group are in boxes of red sandalwood set on sappan-wood stands with flaring legs. Purple Chinese brocades are spread under the stands, which are covered with delicate lavender Chinese embroidery. Six little girls are wearing red robes and white jackets lined with red, from under which red and lavender peep out.

As for the right side, the boxes are made of heavy aloes, and the stands of lighter aloes. Green Korean brocades cover the stands; the streamers and flaring legs are all in the latest style. The little girls are wearing green robes and, over them, white jackets with green linings, and their singlets are grayish green lined with yellow.

There should be many ladies of high rank arranged in front and back of the scene. The Suzaku emperor should be shown at Akikonomu's side. When painting this episode on a fan, one should depict the retired emperor sending paintings to Akikonomu and Oborozukiyo sending her pictures to both groups.

~·~·~

GENJI

Genji and Tō no Chūjō were present, upon royal invitation. Prince Hotaru, a man of taste and cultivation and especially a connoisseur of painting, had taken an inconspicuous place among the courtiers. Perhaps Genji had suggested inviting him. It was the emperor's wish that he act as umpire. He found it almost impossible to hand down decisions. . . . but they* sometimes seemed to run out of space, so that the observer was left to imagine the grandeur of nature for himself. Some of the more superficial pictures of our own day, their telling points in the dexterity and ingenuity of the strokes and in a certain impressionism, did not seem markedly their inferior, and sometimes indeed seemed ahead of them in brightness and good spirits. Several interesting points were made in favor of both.                                             (s 314)

*This refers to the old masters who painted the pictures entered in the contest.

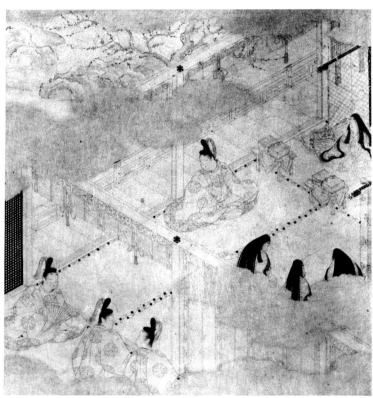

17–3

## SCENE 4

EKOTOBA

Dawn is approaching, birds are singing, and the moon is out. The banquet is given in the royal presence. The royal musicians are called in and others join. Tō no Chūjō chooses a Japanese koto, and Prince Hotaru takes up a Chinese koto, as does Genji. Shōshō no Myōbu takes up a lute. Courtiers with a good sense of rhythm are set to marking time.

~·~·~

GENJI

A quarter moon having risen, the western sky was silver. Musical instruments were ordered from the royal collection. Tō no Chūjō chose a Japanese koto. Genji was generally thought the finest musician in court, but Tō no Chūjō was well above the ordinary. Genji chose a Chinese koto, as did Prince Hotaru, and Shōshō no Myōbu took up a lute. Courtiers with a good sense of rhythm were set to marking time, and all in all it was a very good concert indeed. Faces and flowers emerged dimly in the morning twilight, and birds were singing in a clear sky. (s 316)

# 18.   The Wind in the Pines

## SCENE 1

**EKOTOBA**

It is autumn. The Akashi lady is moving to the capital. The old monk comes to see her off at Akashi beach, and gazes off into the distance.

᛭᛭᛭

**GENJI**

The party set sail at perhaps seven or eight in the morning.

The lady's boat disappeared among the mists that had so saddened the poet. The old man feared that his enlightened serenity had left him forever. As if in a trance, he gazed off into the mists.

The old woman's thoughts upon leaving home were in sad confusion.

> "I want to be a fisherwife upon
> A far, clean shore, and now my boat turns back."

Her daughter replied:

> "How many autumns now upon this strand?
> So many, why should this flotsam now return?"

A steady seasonal wind was blowing and they reached Oi on schedule.

(s 322)

## SCENE 2

**EKOTOBA**

It is about the same time as above. Genji is about to return to the city after he visited the Akashi lady at the Katsura villa. He stands in the doorway fondling

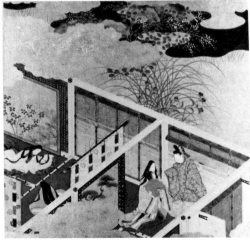

*18–2*

the little girl, who stretches her arms and strains toward him. Genji looks back toward the lady who remains behind the curtains.

<center>ᔛᘁᔛ</center>

GENJI

The lady hung back. This morning's farewell seemed more difficult than all the years away from him. There was just a little too much of the grand lady in this behavior, thought Genji. Her women, urging her on, had to agree. Finally she came forward. Her profile, half hidden by the curtain, was wonderfully soft and gentle. (s 326)

<center>SCENE 3</center>

EKOTOBA

It is autumn. The autumn leaves are not quite at their best, but the autumn flowers are very beautiful. Moonlight floods the scene. Courtiers and princes come to meet Genji in Katsura, and they should be at his chapel. There is a banquet. Falconers offer a sampling of their take, tied to autumn reeds. Genji sends for the cormorant fishermen for the party. There is a concert with flutes, the Japanese koto, and lutes.

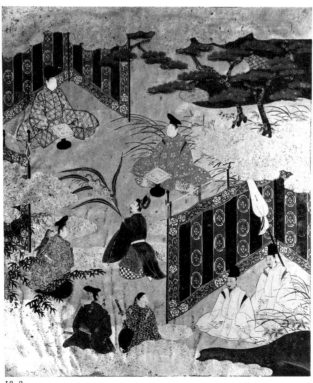

*18–3*

GENJI

An impromptu banquet [had been put together].

The calls of the cormorant fishermen made him think of the fishermen at Akashi, their speech as incomprehensible as the chirping of birds. Back from their night upon the moors, the young falconers offered a sampling of their take, tied to autumn reeds. The flagons went the rounds so frequently that a river crossing seemed out of the question, and so of course a day of roistering must be passed at Katsura. Chinese poems were tossed back and forth. As moonlight flooded the scene the music was more boisterous.          (s 327–28)

## SCENE 4

GENJI

It may be about the same time as above. Genji has spread the letter from Katsura before Murasaki, but she does not look at it. Leaning against an armrest, he gazes into the lamplight.

✦✦✦

GENJI

[He was] leaning against an armrest. "I am too old to leave this sort of thing scattered around the house." He gazed into the lamplight, and his thoughts were in Oi.

Though he had spread the letter before her, Murasaki did not look at it.

He smiled. "You are very funny when you are pretending not to want to see." He came nearer, quite exuding charm.          (s 330)

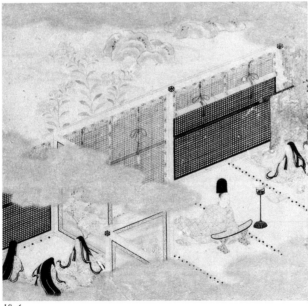

18–4

# 19.   A Rack of Cloud

## SCENE 1

EKOTOBA

It is in the winter. There is snow. The little princess is being moved from Ka-
tsura to the Nijō palace. The Akashi lady, her mother, is putting her into the
waiting carriage. The little girl tugs at her mother's sleeves and urges her to
climb in the carriage too. The Akashi lady is dressed in several soft white robes.
The nurse gets into the carriage, taking with her the sword and a sacred guard-
ian doll. Some little page girls should be in the baby's attendance. An old nun
and others come out to see them off.

GENJI

The little girl jumped innocently into the waiting carriage, the lady having
brought her as far as the veranda to which it had been drawn up. She tugged
at her mother's sleeves and in charming baby talk urged her to climb in too.

> "It is taken away, the seedling pine, so young.
> When shall I see it grandly shading the earth?"

Her voice broke before she had come to the end.
She had every right to weep, thought Genji.

> "A seedling, yes, but with the roots to give
> The thousand years of the pines of Takekuma.

"You must be patient."                                     (s 333–34)

## SCENE 2

EKOTOBA

In winter, and there is bright evening sunlight. At Nijō, Genji is about to set off
to Katsura. The little princess clings to his trousers and seems prepared to go
with him. Murasaki and the nurse are also there.

GENJI

The little girl clung to his trousers and seemed prepared to go with him.
   "I've a twenty-acre field," he sang, looking fondly down at her, "and I'll
be back tomorrow."
   Chūjō was waiting in the gallery with a poem from her mistress.

> "We shall see if you are back tomorrow,
> If no one there essays to take your boat."

Chūjō's elocution was beautiful. He smiled appreciatively.

"I go but for a while, and shall return
Though she may wish I had not come at all."          (s 337)

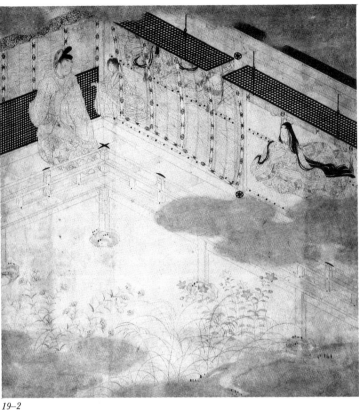

19–2

## Scene 3

EKOTOBA

It is after the above episode, and Genji has gone to Katsura. Taking the little girl in her arms, Murasaki offers one of her own breasts to the baby. There should be various toys lying about. The nurse and little page girls should also be shown. The princess is probably about [three years old].*

GENJI

[She knew] how desperate her own loneliness would be in such circumstances. Taking the little girl in her arms, she playfully offered one of her own small breasts. It was a charming scene.          (s 337)

* The Princess's age is not mentioned in this manual, but it is stated in the Imperial Library version.

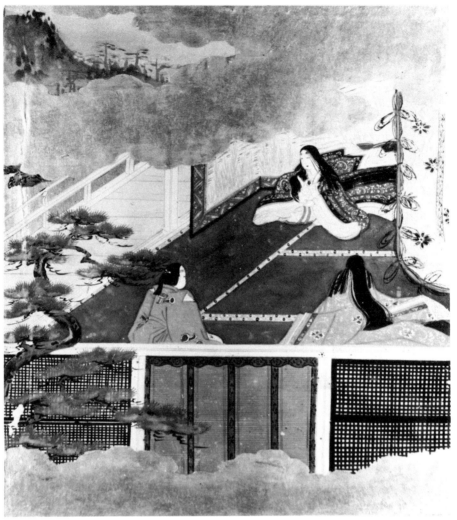

*19–3*

## SCENE 4

After the above episode, Genji arrives at Katsura. He plays a koto, while the Akashi lady takes up a lute.

࿔࿔࿔

GENJI
[He] reach[ed] for a koto. Always at such times their last night at Akashi came back to him. Diffidently she took up the lute which he pushed towards her, and they played a brief duet. He marveled again that her accomplishments should be so varied. He told her all about the little girl. (s 337)

*124* THE TRANSLATIONS AND PAINTINGS

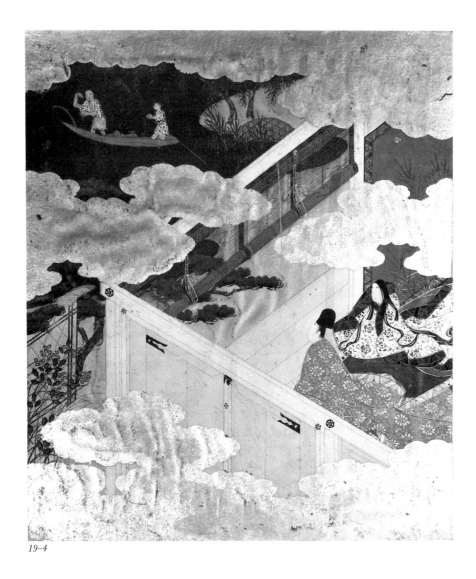

19-4

## SCENE 5

EKOTOBA

An old bishop over seventy years old talks with the Reizei emperor. It is a little before dawn, between shifts of courtiers on night duty.

❧❧❧

GENJI

"It all goes back to your parents. I had been in awful fear of keeping the secret." The old man was weeping. "I have forced myself to speak of what I would much prefer to have forgotten."

It was full daylight when the bishop left. (s 342)

## SCENE 6

Genji comes to visit Akikonomu, who has returned home to Nijō for a time. He goes behind the blinds and addresses her through only a curtain. He is dressed in dark mourning robes. A gentle autumn rain disturbs the grasses in the garden near the veranda.

~\~\~

GENJI

"And so here are the autumn flowers again with their ribbons all undone. It has been a rather dreadful year, and it is somehow a comfort that they should come back, not one of them forgetting its proper time."

Leaning against a pillar, he was very handsome in the evening light.

(s 344)

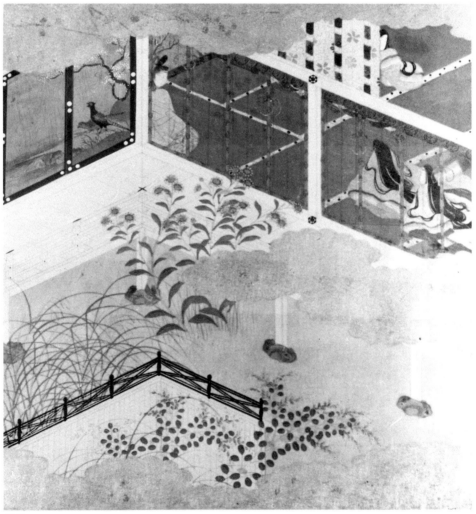

19–6

# SCENE 7

EKOTOBA
The scene is at Nijō. After Genji comes back at night from Akikonomu's apartments, he lies for a time on the veranda as far as possible from the lamps, and exchanges talk with several of Murasaki's maids. Murasaki may not be shown in this scene. She is described in the novel as feeling rather tired.* The autumn wind blows gently.

~·~·~

GENJI

He went Murasaki's wing of the house. He did not go inside immediately, but, choosing a place on the veranda as far as possible from the lamps, lay for a time in thought. He exchanged desultory talk with several of her women. He was thinking of love. Had those wild impulses still not left him?                    (s 346)

---

* In the novel, it is Akikonomu, and not Murasaki, who is feeling tired.

# 20.  The Morning Glory

## SCENE 1

EKOTOBA

In autumn, after coming back from the Fifth Princess's apartments, Genji stands looking out at the morning mist. Trailing over the withered wisteria is a morning glory that still has one or two little blooms. He breaks it off and sends it to Princess Asagao.

❧

GENJI

"You turned me away in shame and humiliation, and the thought of how the rout must have pleased you is not comfortable.

"I do not forget the morning glory I saw.
Will the years, I wonder, have taken it past its bloom?

"I go on, in spite of everything, hoping that you pity me for the sad thoughts of so many years."

(s 351)

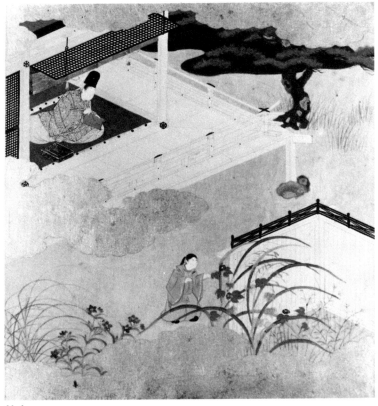

20–1

## SCENE 2

EKOTOBA
It is winter, and there is snow. Genji secretly lets himself in through the back gate to the apartments of the Fifth Princess. The gate is rusty and hard to open. When he is ready to leave, an old porter opens it. His carriage and attendants are outside the gate.

ᵡᵡᵡ

GENJI
A chilly-looking porter rushed out. He was having trouble and there was no one to help him.

"All rusty," he muttered. Genji felt rather sorry for him.

And so thirty years had gone by, like yesterday and today. It was a fleeting, insubstantial world, and yet the temporary lodgings which it offered were not easy to give up. The grasses and flowers of the passing seasons continued to pull at him.

> "And when did wormwood overwhelm this gate,
>     This hedge, now under snow, so go to ruin?"

Finally the gate was opened and he made his way in.                    (s 353–54)

20–2

## SCENE 3

After the above episode, the Fifth Princess receives Genji and talks to him. As Genji starts off, he is joined by Naishi, who has become a nun and keeps the princess's company. She emerges before Genji and moves up closer to him.

GENJI

> "I do not forget that bond, though years have passed,
>   For did you not choose to call me Mother's mother?"

It was a bit extreme.

> "Suppose we wait for another world to tell us
>   Of instances of a child's forgetting a parent."                    (s 355)

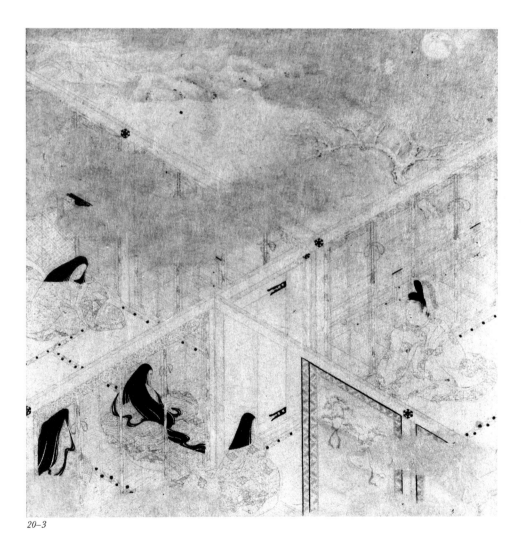

20–3

## SCENE 4

EKOTOBA

It is at Nijō on a moonlit night. There should be a waterfowl on the frozen lake. The moon should be shining on the brook. Little maidservants are sent down to the garden to make snowmen. Their jackets and trousers and ribbons trail off in many colors. The smaller girls let their fans fall. Some of their older fellows jeer at them from the east veranda. Genji and Murasaki, dressed in informal clothes, should definitely be included in this scene. There should be a fire in the brazier.

❦❦❦

GENJI

The smaller ones quite lost themselves in the sport. They let their fans fall most immodestly from their faces. It was all very charming. Rather outdoing themselves, several of them found that they had a snowball which they could not budge. Some of their fellows jeered at them from the east veranda. (s 357)

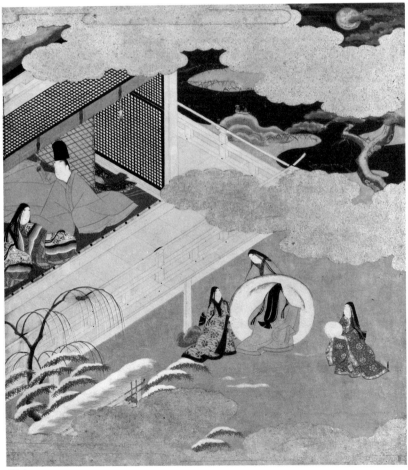

20–4

# 21. The Maiden

EKOTOBA

It may be summer, when the night is short. Yūgiri must be about fourteen or fifteen years old, holding the Sixth Rank. Genji has him read passages from *The Grand History* in front of Tō no Chūjō. In their presence should also be Sadaiben, Shikibū no Tayū, and Sachūben. Tō no Chūjō and some others have tears in their eyes.

> ⌇⌇⌇

GENJI

Genji conducted mock examinations with the usual people in attendance, Tō no Chūjō, Sadaiben, Shikibu no Tayū, Sachūben, and the rest. The boy's chief tutor was invited as well. Yūgiri was asked to read passages from *The Grand History* on which he was likely to be challenged. He did so without hesitation, offering all the variant theories as to the meaning, and leaving no smudgy question marks behind. Everyone was delighted, and indeed tears of delight might have been observed. It had been an outstanding performance, though not at all unexpected.

(s 364)

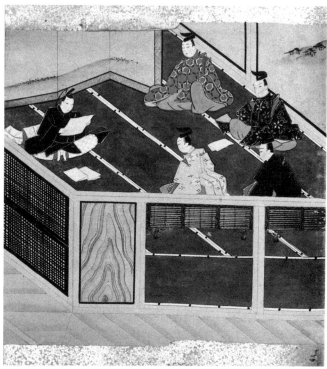

*21–1*

## SCENE 2

EKOTOBA

It may be in autumn. Tō no Chūjō is visiting Princess Ōmiya's apartments. Before the Princess, Kumoinokari plays on a Chinese koto and a lute,* while Tō no Chūjō plays on a Japanese koto. Wanting to hear the music, many women crowd behind curtains. Yūgiri comes in and is seated on the other side of the curtains.

～～～

GENJI

All eager to see, the old women were crowding and jostling one another behind screens.

" 'The leaves await the breeze to scatter them,' " he sang. " 'It is a gentle breeze.' My koto does not, I am sure, have the effect of that Chinese koto, but is a strangely beautiful evening. Would you let us have another?"

The girl played "Autumn Winds," with her father, in fine voice, singing the lyrics. The old lady looked affectionately from the one to the other.

Yūgiri came in, as if to add to the joy.

"How very nice," said Tō no Chūjō, motioning him to a place at the girl's curtains. (s 367)

* Kumoinokari's lute playing is not mentioned in the novel.

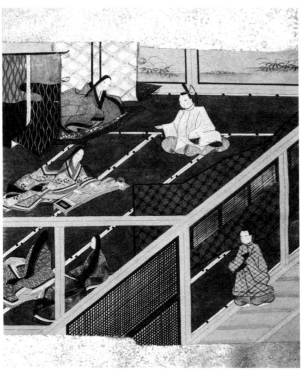

21–2

EKOTOBA

It is at the beginning of winter and early in the morning. The ground is still white with frost and ice. Tō no Chūjō comes to Princess Ōmiya's apartments. Kumoinokari and Yūgiri have been hiding behind the screens. Her nurse comes to take her away* and tries to hide Yūgiri.

⌇⌇⌇

GENJI

A page boy in blue! Anger drove away a part of the sorrow.
"You heard that?

"These sleeves are crimson, dyed with tears of blood.
How can she say that they are lowly blue?

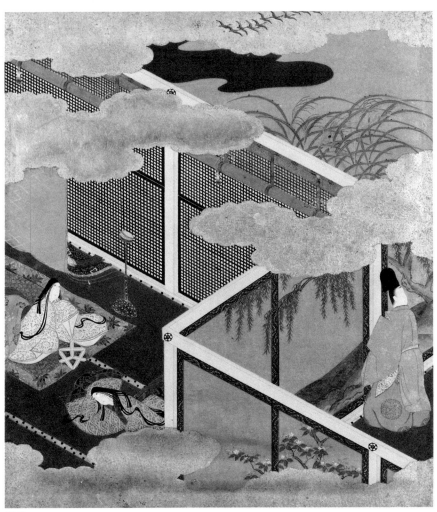

21–3

"It was very unkind."

> "My life is dyed with sorrows of several hues.
> Pray tell me which is the hue of the part we share."

She had scarcely finished when her father came to take her away.     (s 374)

* In the novel, Tō no Chūjō comes to take her away.

## SCENE 4

EKOTOBA

It is toward the end of winter, in the early hours of the morning, when everyone is asleep. There are carpets. The Gosechi dancers are grouped at court in an enclosure of screens put up near the veranda. There should also be Kumoinokari and others. Yūgiri reaches from outside the screens and tugs at Kumoinokari's sleeve.* There should be many attendants.

⌁⌁⌁

GENJI

She may have been just a little prettier. He could not say, for the light was not good; but she did so remind him of his love that, though it would have been an exaggeration to say that he transferred his affections on the spot, he found himself strongly drawn to her. He reached forward and tugged at a sleeve. She was startled, by the tugging and by the poem which followed:

> "The lady who serves Toyooka in the heavens
> Is not to forget that someone thinks of her here.

"I have long been looking through the sacred fence."     (s 375–76)

* Actually, Yūgiri tugs at a Gosechi dancer's sleeve, and not at Kumoinokari's. The legend that appears in the painting reproduced here is correct.

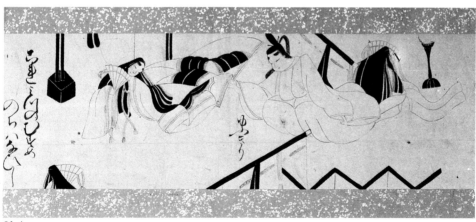

21-4

## SCENE 5

It is spring, on the twentieth of the Second Month. The first cherries should be in bloom. The emperor Reizei pays a visit to the Suzaku palace of the retired emperor. Both the Reizei emperor and the Suzaku retired emperor pay a royal visit to the Rokujō palace to view the cherries.* Everyone wears uniform dress, green over white lined with red. The emperor Reizei wears red, as does Genji. There should be musicians being rowed out on the lake. They play on their instruments and dancers perform the "Spring Warbler." When the dance is over, Genji offers a cup to the Suzaku emperor. Prince Hotaru should also be present. The scene after this one is also good for illustration; its details are found in the novel.

GENJI

When the dance was over he offered a cup to the Suzaku emperor, and with it a verse:

> "The warblers are today as long ago,
>   But we in the shade of the blossoms are utterly changed."

21–5

The Suzaku emperor replied:

"Though kept by mists from the ninefold-garlanded court,
I yet have warblers to tell me spring has come."

Prince Hotaru [—now holding the rank of Hyōbu—]† filled the emperor's cup and offered this poem:

"The tone of the flute is as it always has been,
Nor do I detect a change in the song of the warbler."

It was very thoughtful and tactful of him to suggest that not all was decline. With awesome dignity, the emperor replied:

"The warbler laments as it flies from tree to tree—
For blossoms whose hue is paler than once it was?"

And that I have no more poems to set down—is it because, the occasion being a formal one, the flagons did not make the complete rounds? Or is it that our scrivener overlooked some of them?

The concert being at such a distance that the emperor could not hear very well, instruments were brought into the royal presence: a lute for Prince Hotaru, a Japanese koto for Tō no Chūjō, for the retired emperor a thirteen-stringed Chinese koto, and for Genji, as always, a seven-stringed Chinese koto. They must all play for him, said the emperor. They were accomplished musicians and they outdid themselves, and the concert could not have been finer. Numerous courtiers were happy to sing the lyrics, "How Grand the Day" and "Cherry-Blossom Girl" and the rest. A misty moon came up, flares were set out on the island, and the festivities came to an end.          (s 380–82)

---

* Genji's new palace at Rokujō is described in the next episode in the novel. It is not the site of the cherry-blossom viewing at this time.
† This phrase is omitted in Seidensticker's translation.

## Scene 6

EKOTOBA

This episode is about four apartments in Genji's Rokujō Palace. The time is around the Tenth Month. The southwest quarter is assigned to Akikonomu. Her garden plantings are chosen for rich autumn colors, and there is a profusion of autumn flowers and leaves. Clear spring water flows off into the distance.

The hills are high in the southeast quarter, Genji's own, where spring-blossoming trees and bushes are planted in large numbers. The lake is ingeniously designed. Among the plantings in the garden are cinquefoil pines, red plums, cherries, wisteria, and *yamabuki*. There are touches of bushes scattered through the groves.

The northeast quarter is given to the lady of the orange blossoms. Her garden has the summer in mind. In the forward parts of the garden are thickets of Chinese bamboo, and the tall trees are deep and mysterious as mountain groves. There is a hedge of mayflower. Oranges, wild carnations, roses, and fruit trees are there, and a few spring and autumn flowers and bushes are mixed in as well.

The northwest quarter is assigned to the lady from Akashi, designed for the winter view with a chrysanthemum hedge. There are Chinese bamboo and tall pines. In among the deep groves are mountain trees which one would be hard put to identify.

They move to these quarters in the autumn. Akikonomu arranges red leaves and chrysanthemums on the lid of an ornamental box and sends them over to Murasaki. More details are given in the novel.

*21–6*

On an evening when a gentle wind was blowing she arranged leaves and flowers on the lid of an ornamental box and sent them over to Murasaki. Her messenger was a rather tall girl in a singlet of deep purple, a robe of lilac lined with blue, and a gossamer cloak of saffron. She made her practiced way along galleries and verandas and over the soaring bridges that joined them, with the dignity that became her estate, and yet so pretty that the eyes of the whole house were upon her. Everything about her announced that she had been trained to the highest service.

This was Akikonomu's poem, presented with the gift:

"Your garden quietly awaits the spring.
Permit the winds to bring a touch of autumn."

The praise which Murasaki's women showered on the messenger did not at all displease her. (s 386)

# 22.  The Jeweled Chaplet

EKOTOBA

It may be early summer. An official of the Fifth Rank on the viceroy's staff, called Tayū no Gen, may be dressed in monk's robes. He comes to visit the grandmother. Tamakazura may be shown in this composition, but away from all the others.

⌒⌒⌒

GENJI

"Oh, come on. I don't care if she's blind and has a club foot. I swear it by all the gods."

He asked that a day be named when he might come for her. The nurse offered the argument often heard in the region that the end of the season was a bad time to marry.

22–1

He seemed to think that a farewell poem was called for. He deliberated for rather a long time.

> "I vow to the Mirror God of Matsura:
> If I break it he can do what he wants with me.

"Pretty good." He smiled.

Poetry was not perhaps what he had had most experience with.　　(s 391)

## Scene 2

EKOTOBA

Tamakazura is traveling to the capital by boat. They raise their heads a little near Iwaya. There should be Ateki, the "grandmother," and Bungo no Suke, Ateki's brother.

＞＼．＼＼

GENJI

They passed Echo Bay in Harima.

"See the little boat back there, almost flying at us. A pirate, maybe?"

The brother thought he would prefer the cruelest pirate to the Higo man. There was nothing to be done, of course, but sail on.

> "The echoes of Echo Bay are slight and empty
> Beside the tumult I hear within myself."　　(s 393)

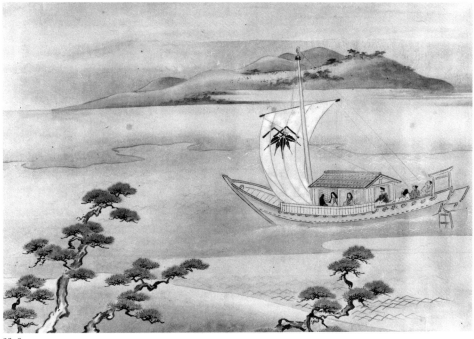

22–2

# SCENE 3

Toward the end of the Eighth Month or in the Ninth Month, Tamakazura makes a pilgrimage to Hatsuse. Accompanied by Bungo no Suke, her party includes two bowmen, three or four grooms and pages, and some women. In addition to Tamakazura are three: Ateki, her brother, and the grandmother. Ukon also comes with two women who seem to be of considerable standing and a number of attendants, men and women. Four or five horses are included. The autumn wind is blowing up from the valley, and the river before them is the Hatsuse. The two parties meet, and Ukon talks with Tamakazura, the grandmother, brother, and Ateki. It is a beautiful scenic spot, and there is a house standing on a high cliff. People pass back and forth before it. This scene has many elements that can be illustrated in a painting, but the rest of the story is not suited for illustration.

GENJI

The river before them was the Hatsuse.

> "Had I not come to the place of cedars twain,
>     How should I have met you here beside the old river?"

said Ukon. "I am very happy."

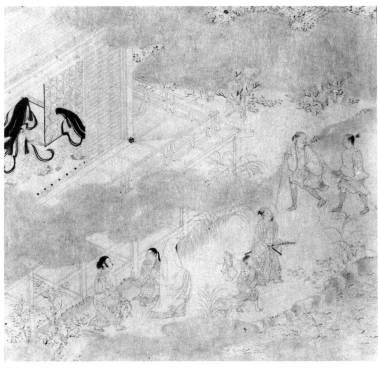

22–3

Tamakazura replied:

"I know little, I fear, about the swift old river,
　But I know the flow of tears of happiness."

She was indeed weeping, and very beautiful.　　　　　　　　　　　　(s 400)

## Scene 4

EKOTOBA

It is the Ninth Month, at Rokujō. Genji summons Ukon to massage his legs.
Murasaki covers her ears with her sleeves. Genji looks toward her, and Ukon
keeps looking down.

〜〜〜

GENJI

"Ah, yes, memories do come back. Where has she been all this time?"

　Ukon did not know how to begin. "She has been very far away. Some of
the people who were with her then are still with her. We talked about the old
days. It was so sad."

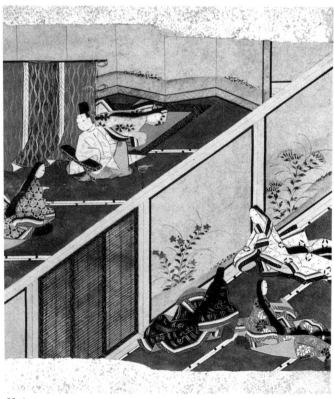

22–4

"Do remember, please, that we have an uninformed audience."

"You needn't worry," said Murasaki, covering her ears. "Your audience is too sleepy to care in the least."                                                    (s 401)

## SCENE 5

EKOTOBA

It may be in the Tenth Month. Tamakazura is moved to the house of the lady of the orange blossoms, and takes a seat in an outer room.* That evening Genji pays a visit. He pushes the curtain aside, making Tamakazura shy. Ukon brings a lamp nearer. The lady of the orange blossoms should also be present.

GENJI

"A very soft and suggestive sort of light. I was told that you wished to see your father's face. Is that not the case?" He pushed the curtain aside.

She looked away, but he had seen enough to be very pleased.

"Can't we have a little more light? This is really *too* suggestive."

Ukon trimmed a lamp and brought it near.

"Now we are being bold."                                                     (s 404)

* In the novel, Genji takes a seat there.

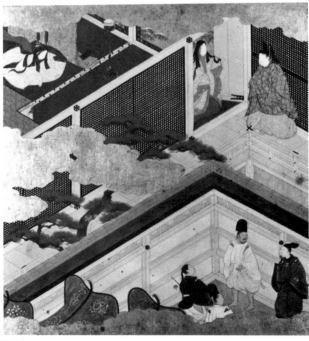

22–5

<center>SCENE 6</center>

It is winter and at the time of the distribution of robes. With the help of the ladies-in-waiting, Genji and Murasaki put many dresses into chests and wardrobes. Murasaki's box holds a lavender robe and a singlet of a fashionable russet lined with yellow. The box to be sent to his little daughter of Akashi contains a white robe lined with red and a singlet beaten to a fine glow. Into the box for the lady of the orange blossoms goes a robe of azure with a woven pattern of seashells, fulled to a high sheen. Into the box for Tamakazura, he puts a cloak of bright red and a robe of russet lined with yellow. He chooses for the box to be sent to the safflower lady a white robe lined with green and decorated with Chinese vignettes. For the Akashi lady there is a cloak of Chinese white with birds and butterflies flitting among plum branches. For the lady of the locust shell, now a nun, he selects a habit of a deep blue-gray and adds a yellow singlet of his own with a lavender jacket.

<center>〜〜</center>

GENJI

Murasaki too was with him. "A very hard choice indeed. You must always have the wearer in mind. The worst thing is when the clothes do not suit the lady."

Genji smiled. "So it is a matter of cool calculation? And what might my lady's choices be for herself?"

"My lady is not confident," she replied, shyly after all, "that the mirror can give her an answer." <span style="float:right">(s 406)</span>

*22–6*

# 23.  The First Warbler

EKOTOBA

It is New Year's Day, and Genji goes to the Akashi princess's rooms. Murasaki
is there. The princess's page girls and young serving women are out on the
forward hill busying themselves with seedling pines. The Akashi lady sends
over New Year delicacies in "bearded baskets" and with them a warbler on a
fabricated pine branch.

GENJI

The Akashi lady—it was clear that she had gone to enormous trouble—had
sent over New Year delicacies in "bearded baskets" and with them a warbler
on a very cleverly fabricated pine branch:

> "The old one's gaze rests long on the seedling pine,
> Waiting to hear the song of the first warbler,

in a village where it does not sing."

Yes, thought Genji, it was a lonely time for her. One should not weep on
New Year's Day, but he was very close to tears.                    (s 410)

23–1

*Detail of 23–1*

## SCENE 2

### EKOTOBA

It is at the same time as above. The carolers include all of the city's children with good singing voices and they come to Genji's palace. Their dress is described in the book. The book also describes Genji giving them a gift of cotton. The whole thing is like a kind of a dance.

❧❧❧

### GENJI

The moon was almost too bright in the dawn sky and there were snow flurries. A wind came down through the tall pines. The soft yellow-greens and whites of the carolers did nothing to break the cold, white calm, and the cloth posies in their caps, far from seeming to intrude with too much color, moved over the scene with a light grace such as to make the onlookers feel that years were being added to their lives. (s 416)

# 24. Butterflies

SCENE 1

EKOTOBA

Towards the end of the Third Month, Akikonomu's women come over to Murasaki's spring garden. The dragon and phoenix boats are afloat on the large lake. The little pages and helmsmen, their hair bound up in the page-boy manner, wear Chinese dress, and palace musicians are in the boats. With twigs in their bills, waterfowl fly in and out over the rocks in streams in the garden. The late cherry blossoms are at their best, a willow trails its branches, yellow *yamabuki* are smiling in pleasant disarray along the lake shore, and the wisteria is beginning to send forth its lavender around the corridor. Mandarin ducks course about on the water, creating decorative patterns in the waves. There are princes and high courtiers. The empress herself is not able to pay a visit. This painting may be made as large as one wishes.

*24–1*

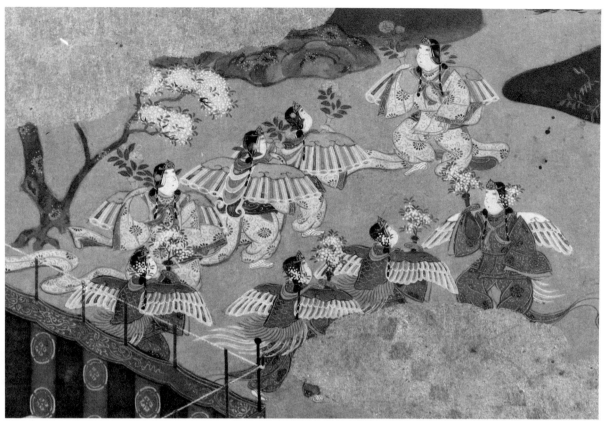

*Detail of 24–1*

GENJI

The branches caught in mists from either side were like a tapestry, and far away in Murasaki's private gardens a willow trailed its branches in a deepening green and the cherry blossoms were rich and sensuous. (s 419)

## Scene 2

EKOTOBA

It is turning dark, and there should be flares in the garden. Palace musicians are invited to sit on the moss carpet below the verandas with their flutes and kotos. The princes and high courtiers have their kotos and flutes. All the good musicians should be included. It is also permissible to paint this scene with the above in one composition, but the time should be both during the day and at night.

GENJI

The sky and the music, the spring modes and echoes, all seemed better here— no one could fail to see the difference. The night was passed in music. (s 420)

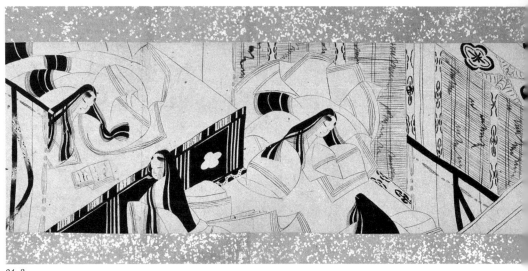

*24–3*

## SCENE 3

EKOTOBA

This is later, and toward the dawn. Girls are dressed as birds and butterflies.
The birds bring cherry blossoms in silver vases. A few petals are scattered. The
butterflies bring *yamabuki* in gold vases, and present them from the foot of the
stairs. There should be dragon and phoenix boats. Seats are put out for the
orchestra in one of the galleries adjoining Akikonomu's main hall.

⌁⌁⌁

GENJI

The little girls came to the stairs with their flowers. Incense bearers received
them and set them out before the holy images.

Yūgiri delivered this poem from Murasaki:

> "Low in your grasses the cricket awaits the autumn
> And views with scorn these silly butterflies."                    (s 423)

## SCENE 4

EKOTOBA

It is in the summer. Genji comes to visit Tamakazura. Together they look at a
luxuriant new growth of Chinese bamboo in the foregarden. Ukon should be
there. Genji raises the blind.

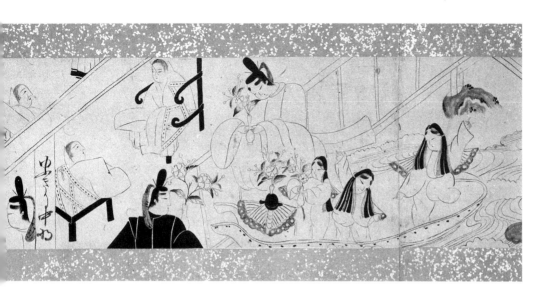

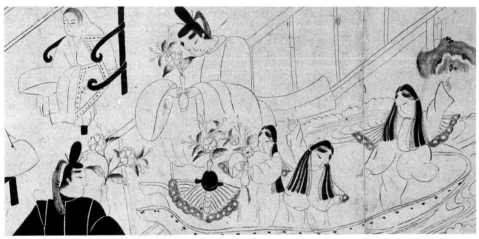

*Detail of 24–3*

GENJI
He paused to admire a luxuriant new growth of Chinese bamboo swaying in the breeze.

> "The bamboo so firmly rooted within our hedges
>   Will send out distant shoots to please its convenience?"

He raised the blind. She slipped away, but not before she had given him an answer:

"Why should the young bamboo at this late date
    Go forth in search of roots it has left behind,

and make trouble for itself?"
    He had to feel sorry for her.                                    (s 426)

*24–4*

## Scene 5

EKOTOBA
Toward the end of the Fifth Month, on a rainy day, Genji goes to Tamakazura's apartments. She is at her writing desk, and turns away shyly. Genji toys with an orange on the lid of a box, and takes her hand. In the foregarden are Chinese bamboo, and there are many blossoms on the oak tree. Although this is the description of Genji's own apartments, it may be used for this scene.

GENJI

There was an orange in the fruit basket before her.

> "Scented by orange blossoms long ago,
>     The sleeve she wore is surely the sleeve you wear.

"So many years have gone by, and through them all I have been unable to forget. Sometimes I feel as if I might be dreaming—and as if the dream were too much for me. You must not dismiss me for my rudeness."

And he took her hand.

Nothing like this had happened to her before. But she must not lose her composure.

> "The sleeve bears the scent of that blossom long ago.
>     Then might not the fruit as quickly vanish away?"        (s 427)

24–5

# 25. Fireflies

EKOTOBA

It is summer. Tamakazura receives Prince Hotaru with a curtain between them.
While he is talking to her, Genji, who had earlier put a large number of fireflies
in a bag, releases them toward Tamakazura. She brings a fan to her face. Saishō
should be beside them. Genji is shown peering at Tamakazura from the side.

GENJI

Genji had earlier in the evening put a large number of fireflies in a cloth bag.
Now, letting no one guess what he was about, he released them. Tamakazura
brought a fan to her face. Her profile was very beautiful.                    (s 432)

25–1

EKOTOBA

There is a horse race at the equestrian grounds at Rokujō. Blinds are hung all along the galleries, and there are curtains with rich colors at the hems fading to white above. Everyone comes to watch, including many ladies and the people of lower ranks who look through the doors. Since the equestrian grounds are visible from all four quarters of Genji's palace, everyone should hang blinds and watch. Those in green robes and trains of purple gossamer are Tamakazura's girls from the orange blossom lady's quarters in the west wing. There are four of them. Her women are in festive dress, trains blending from lavender at the waist down to deeper purple and Chinese jackets the color of carnation shoots. Murasaki's girls wear singlets of deep pink and trains of red lined with green.*

GENJI

Genji went out to the stands toward midafternoon. All the princes were there, as he had predicted. The equestrian archery was freer and more varied than at the palace. The officers of the guard joined in, and everyone sat entranced through the afternoon.

(s 435)

* In the novel the little girls from the lady of the orange blossoms wear these dresses.

25–2

FIREFLIES    *155*

# SCENE 3

On a rainy day of early summer, Genji goes to see Tamakazura and talks with her. He is stroking her hair as he speaks.

ↆↆↆ

GENJI

> "Beside myself, I search through all the books,
> And come upon no daughter so unfilial.

"You are breaking one of the commandments."

He stroked her hair as he spoke, but she refused to look up. Presently, however, she managed a reply:

> "So too it is with me. I too have searched,
> And found no cases quite so unparental."　　　　　　(s 438)

# 26.  Wild Carnations

SCENE 1

EKOTOBA

It is a hot day in the Sixth Month. Trout, goby, and other fish should be on the board. Numerous princes from the Ōidono come. Yūgiri should be there, too. They eat cold rice.

GENJI

It was a very hot day. Genji was cooling himself in the angling pavilion of the southeast quarter. Yūgiri and numerous friends of the middle court ranks were with him. They had offered to roast trout which had been brought from the Katsura and goby from nearer streams. (s 441)

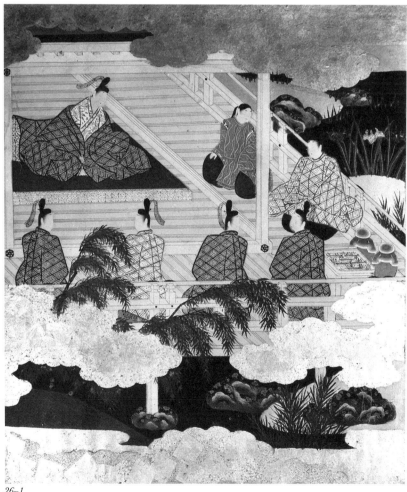

26–1

## SCENE 2

EKOTOBA

In autumn, Genji comes to Tamakazura's apartments and shows her how to play a Japanese koto. She is sitting close to him, with her head bowed slightly. There should be many of her women before them. The wild carnations in the garden should be at their best.

~·~·~

GENJI

"No, let me hear just a little more, and perhaps I will be clever enough to imitate it." And so the Japanese koto brought her close to him when other devices had failed. "Is it the wind that accounts for that extraordinary tone?" He thought her quite ravishing as she sat in the dim torchlight as if seeking an answer to her question.                                                    (s 445)

## SCENE 3

EKOTOBA

Tō no Chūjō comes to Kumoinokari's rooms, accompanied by Ben no Shōshō. She is napping. One hand holds a fan and her head is cradled on an arm. As the minister taps with his fan, she is awakened and looks up at him. There must be lamps.

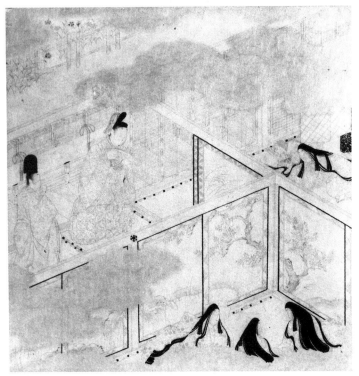

26–3

GENJI

Her women too were asleep, behind blinds and screens. They were not easily awakened. She looked innocently up at him as he tapped with his fan, her eyes round and startled, and the flush that came over her face delighted him.

(s 447)

## SCENE 4

EKOTOBA

Tō no Chūjō goes to Kokiden's apartments. The blinds are raised high, and the minister looks through an opening between the sliding doors. The Ōmi princess is at a contest of backgammon with Gosechi. Ōmi shakes and shakes the dicebox.

GENJI

He thought he would look in on her, since her room was not far away. He found her, blinds raised high, at a contest of backgammon.

Her hands at her forehead in earnest supplication, she was rattling off her prayer at a most wondrous speed. "Give her a deuce, give her a deuce." Over and over again. "Give her a deuce, give her a deuce."

This really was rather dreadful. Motioning his attendants to silence, he slipped behind a hinged door from which the view was unobstructed through sliding doors beyond.

(s 448–49)

26–4

## 27. Flares

SCENE 1

EKOTOBA

In summer, Genji gives Tamakazura koto lessons. Since the new moon is quick to set, it is dark outside. Ukon starts the flares in the garden, under a spindle tree that arches over the brook.

~·~·~

GENJI

"They burn, these flares and my heart, and send off smoke.
The smoke from my heart refuses to be dispersed.

"For how long?"
Very strange, she was thinking.

"If from your heart and the flares the smoke is the same,
Then one might expect it to find a place in the heavens." (s 455–56)

27–1

## SCENE 2

EKOTOBA

After the above episode, Yūgiri plays his flute, Ben no Shōshō keeps time, and Kashiwagi and Genji play on the koto.

⌒⌒⌒

GENJI

"I felt the autumn wind in your flute and had to ask you to join me."

His touch on the koto was soft and delicate, and Yūgiri's flute, in the *banjiki* mode, was wonderfully resonant. Kashiwagi could not be persuaded to sing for them.

"You must not keep us waiting."

His brother, less shy, sang a strain and repeated it, keeping time with his fan, and one might have taken the low, rich tones for a bell cricket.          (s 456)

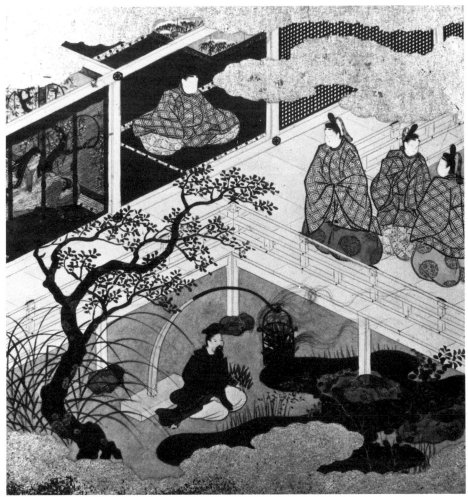

27–2

# 28.  The Typhoon

## SCENE 1

EKOTOBA
Murasaki's women fight with the unruly blinds that are blown by the wind. Murasaki comes out onto the veranda to see what the winds have done to each of

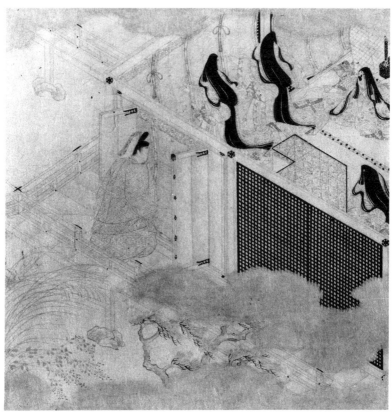

*28–1*

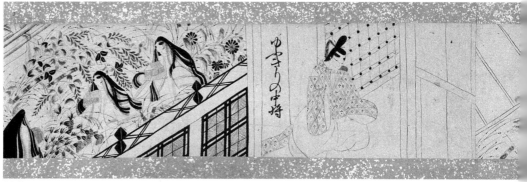

*28–2*

the flowers. The screens are folded and the door is open at a corner. Yūgiri sees her over a low screen. Genji is away with his daughter.

GENJI

The screens having been folded and put away, the view was unobstructed. The lady at the veranda—it would be Murasaki. Her noble beauty made him think of a fine birch cherry blooming through the hazes of spring. It was a gentle flow which seemed to come to him and sweep over him.                    (s 458)

SCENE 2

EKOTOBA

The day after the typhoon, Yūgiri goes to Genji's quarters. The sun is out, but Murasaki is still lying behind the curtains while Genji has arisen and is talking to her. They must be dressed in informal clothes. Yūgiri overhears them and withdraws a few steps. The shutters are not yet raised. After the previous day's

Detail of 28-2

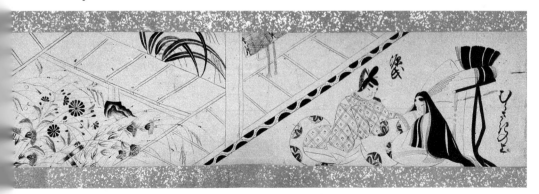

typhoon, the trees have been uprooted on the hillocks and branches are broken. Damage has been done to the shingles and tiles and shutters and fences.

>·>·>

GENJI

The wan morning light was caught by raindrops all across the sad expanse. Black clouds seethed and boiled overhead. He coughed to announce his presence.

"Yūgiri is with us already." It was Genji's voice. "And here it is not yet daylight."

There was a reply which Yūgiri did not catch, and Genji laughed and said: "Not even in our earliest days together did you know the parting at dawn so familiar to other ladies. You may find it painful at first."

This sort of bedroom talk had a very disturbing effect on a young man. (s 460)

## Scene 3

EKOTOBA

Yūgiri makes his way over the bridge along a gallery to Akikonomu's quarters as Genji's messenger. He can see from the distance that two shutters have been raised at the main hall and many women are there. Some are inside and some others are leaning against the balustrades. They have on robes of lavender and pink and various deeper shades of purple, and yellow-green jackets lined with green, all appropriately autumnal hues. Some little girls are sent down to the garden to lay out insect cages in the damp garden. They pick a wild carnation that has been damaged by the winds and bring it back.

>·>·>

GENJI

He made his way along a gallery and through a door to Akikonomu's south-west quarter. He could see from the south veranda of the east wing that two shutters and several blinds had been raised at the main hall. Women were visible in the dim light beyond. Two or three had come forward and were leaning against the balustrades. Who might they be? Though in casual dress, they managed to look very elegant in multicolored robes that blended pleasantly in the twilight. Akikonomu had sent some little girls to lay out insect cages in the damp garden. (s 462)

## Scene 4

EKOTOBA

Genji visits Tamakazura. There should be a mirror stand and the screens should be folded. The sunlight streams in. Raising a curtain behind the blinds, Yūgiri

looks into the room. Tamakazura is shy and tries to hide behind a pillar, but Genji pulls her toward him. Her face is plump and rich strands of hair sway.

✗✗✗

GENJI

Waiting through this apparently intimate tête-à-tête, Yūgiri caught sight of a somewhat disarranged curtain behind the corner blinds. Raising it over the frame, he found that he had a clear view deep into the room. He was rather startled at what he saw. They were father and daughter, to be sure, but it was not as if she were an infant for Genji to take in his arms, as he seemed about to do.

(s 463–64)

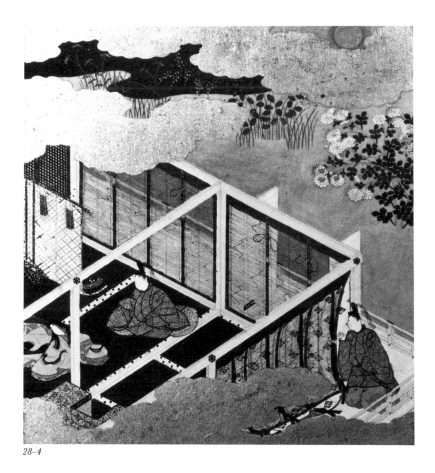

*28-4*

SCENE 5

EKOTOBA

Genji goes next to see the lady of the orange blossoms. Her women are at their sewing, and her younger women are pressing bolts of cotton on lacquered pails.

Scattered about the room should be red silks beaten to a soft luster and gossamer of a delicate saffron. In front is a foregarden.

~·~·~

GENJI

He went next to see the lady of the orange blossoms. Perhaps because the weather had suddenly turned chilly and she had not been expecting guests, her older women were at their sewing and her younger women were pressing bolts of cotton on long, narrow boxes of some description. Scattered about the room were red silks beaten to a soft luster and gossamers of a delicate saffron.     (s 464)

# 29.  The Royal Outing

EKOTOBA

In the Twelfth Month there is a royal outing to Ōharano. The princes and high officials are beautifully fitted out. All the princes, ministers, and councillors turn out with their guards and grooms, who are in the finest of livery. The courtiers of the Fifth and Sixth ranks are dressed in yellow-green robes and lavender singlets. The princes and high courtiers in charge of the falcons are there. The falconers from the guards are dressed in robes with unusual prints. Higekuro, who is the general at this time, comes out in uniform with a quiver. His face is dark and his beard heavy. There should be spectators' carriages. The spectators fight for places, and some carriages have their wheels broken.

GENJI

Even the skies seemed intent on favoring the occasion, for there were flurries of snow. The princes and high courtiers in charge of the falcons were in fine hunting dress. The falconers from the guards were even more interesting, all in printed robes of most fanciful design.                                    (s 467–68)

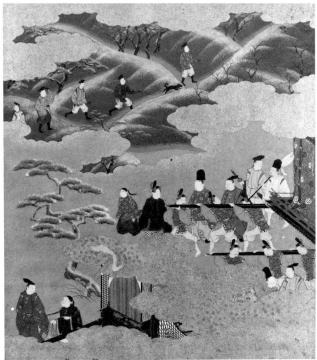

29–1

*Detail of 29–1*

## SCENE 2

EKOTOBA

By a guards officer the emperor sends Genji a brace of pheasants tied to a leafy branch.

✕✕✕

GENJI

By a guards officer the emperor sent a brace of pheasants tied to a leafy branch. I shall not seek to record the contents of the royal letter, but this was the poem:

> "Deep in the snows of this Mount Oshio
> Are ancient pheasant tracks. Would you might see them."

But I wonder if in fact precedent can be found for inviting a chancellor to be in attendance upon a royal hunt.

Genji received the messenger very ceremoniously and sent back this answer:

> "The snows beneath the pines of Oshio
> Have never known so mighty a company."

These are the bits I gathered, and I may not have recorded them accurately.

(s 469–70)

## SCENE 3

EKOTOBA

It is the first day of the Second Month. Princess Ōmiya is ill and remains behind the curtain. Genji comes, dressed in a robe of white Chinese brocade lined with

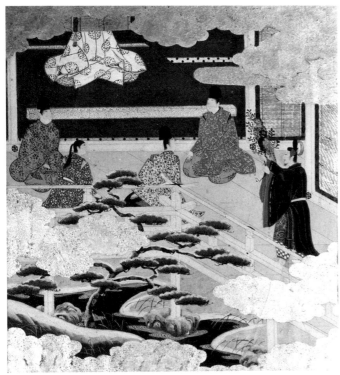

29–2

29–3

*Detail of 29–3*

red over several red singlets. Tō no Chūjō comes in to see the princess, dressed in purple trousers surmounted by a very long train of white lined with red. He should have with him his sons, a grand councillor and a chamberlain to the crown prince.* There should also be in his retinue upwards of ten middle-ranking courtiers, including privy secretaries, guards officers, a moderator, and lesser courtiers. There are wine cups there.

ᐧᐧᐧ

GENJI

It was also of course reminiscent, for Genji and Tō no Chūjō had not met in a very long time. When they did not see each other they were always finding themselves at odds over things that did not matter, but when they were together all the solid reasons for friendship reasserted themselves. They talked of happenings old and recent, and presently it was evening. Tō no Chūjō continued to press wine on his mother's guests.                                                (s 474)

* They are actually his younger brothers.

## SCENE 4

EKOTOBA

In the middle of the Second Month, Tamakazura goes to court. Princess Ōmiya sends her a collection of comb boxes. Akikonomu sends robes, a white train,

a Chinese jacket, combs for the formal coiffure, and Chinese perfumes. From every one comes various gifts, including fans. The safflower princess sends a robe of a greenish drab, lined trousers of a dusty rose, and a faded purple jacket of a minute weave, all in a beautifully wrought wardrobe and elaborate wrapping. Her letter is placed in a sleeve of a jacket.

GENJI

Attached to the jacket was a poem which showed the usual obsession with clothing.

> "How very unhappy I am, for my Chinese sleeves
> Cannot be friends with the sleeves of your Chinese robe."

The hand was, as always, rather dreadful, cramped and rocklike and stiff and angular. (s 478)

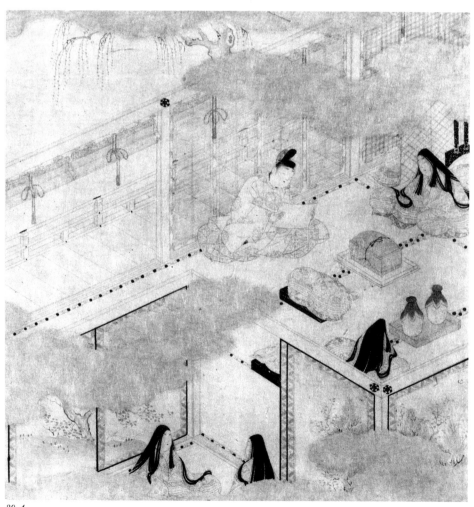

29–4

## SCENE 5

EKOTOBA

It is about the same time as above. Tō no Chūjō meets Tamakazura at Genji's quarters. Genji should be there. Lamps and wine cups should be shown.

❳·❳·❳

GENJI

> "Bitter, bitter, that the fisherfolk
> So long have hidden the treasures of the sea."

It was accompanied by an illustrative shedding of tears.

The company of two such splendid gentlemen had reduced Tamakazura to silence. The answering poem came from Genji:

> "The fisherfolk refusing to take them in,
> The grasses drifted ashore as best they might."          (s 479)

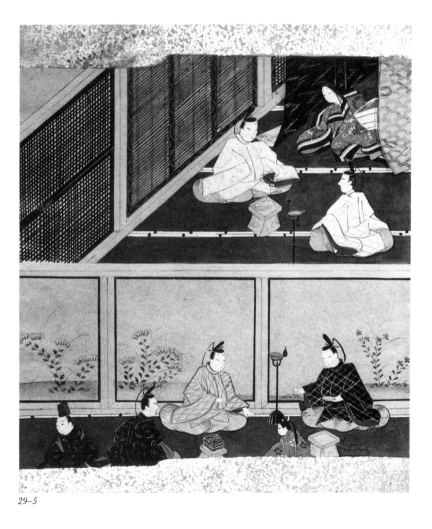

29–5

# 30.  Purple Trousers*

EKOTOBA

It is the autumn. For the mourning of Princess Ōmiya, Tamakazura is in light-gray. Yūgiri, dressed in a similar gray, comes as Genji's messenger. He pushes a bouquet of orchids† under Tamakazura's curtain, and tugs at her hand. There should be curtains, behind which must be her women.

⌇⌇⌇

GENJI

Perhaps thinking that there would not be another occasion to let her know of his interest, he had come provided with a fine bouquet of "purple trousers."

30–1

"We may find in these flowers a symbol of the bond between us." He pushed them under her curtains and caught at her sleeve as she reached for them.

"Dew-drenched purple trousers: I grieve as you do.
And long for the smallest hint that you understand."

Was this his own hint that he hoped for a union at "journey's end?" Not wanting to show her displeasure openly, she pretended that she did not understand and withdrew a little deeper into the room.

"It grew, if you ask, in the dews of a distant moor.
That purple is false which tells of anything nearer."   (s 483–84)

* The title of this chapter is given in this manual as *Ran* (orchids).
† As in the title of the chapter, *fujibakama* is changed here to *ran* (orchids).

SCENE 2

EKOTOBA
One moonlit night, Kashiwagi comes to Tamakazura's quarters as the messenger of his father, the minister, and takes shelter under a large laurel tree near the north porch.* Tamakazura sends back her answers through Saishō. He should be seated at the veranda.

ゝゝゝ

GENJI
"It is as you have suggested." The answer was to the point. "Too long an interview would without doubt attract attention, and so I must for the moment forgo the pleasure of a long conversation about my years of obscurity."

Somewhat intimidated, he offered only a verse in reply:

"I did not know it was Sibling Mountain we climbed,
And came to a halt on hostile Odae Bridge."

It was a futile complaint about unhappiness of his own making.
This was her answer:

"Not knowing that you did not know, I found
Your tracks up Sibling Mountain strange indeed."   (s 488)

* In the novel he is received at the south door.

# 31. The Cypress Pillar

EKOTOBA

On a snowy day in winter, General Higekuro is getting ready to visit Tama-
kazura and puts a small censer in his sleeve to perfume his robes. The women
are resting. Suddenly his wife stands up, steps behind her husband, and pours
the contents of a large censer over him. She should be in her casual, somewhat
rumpled and faded robes and her hair should be in disarray. This happens at
the veranda. His carriage should be there.

GENJI

The lady herself, apparently quite composed, was leaning against an armrest.
Suddenly she stood up, swept the cover from a large censer, stepped behind her
husband, and poured the contents over his head. There had been no time to
restrain her. The women were stunned.                    (s 497–98)

*31–1*

*Detail of 31–1*

## Scene 2

EKOTOBA

It is in winter, but there is no snow. In order to take Higekuro's wife home, her brothers, a guards captain, a chamberlain, and an official in the civil affairs

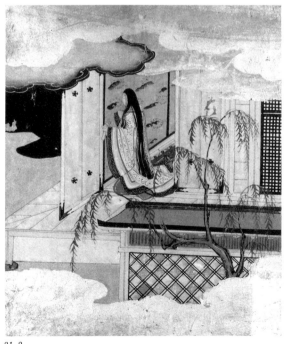

*31–2*

ministry, come in three carriages. Her daughter, aged twelve or thirteen, writes a poem and thrusts it into a crack in the pillar. There are two boys, aged ten and seven. There should be serving women named Moku and Chūjō. The wife should be included in this composition, but not the general.

✑ ✑ ✑

GENJI

Her favorite seat had been beside the cypress pillar in the east room. Now it must go to someone else. She set down a poem on a sheet of cypress-colored note-paper and thrust a bodkin through it and into a crack in the pillar. She was in tears before she had finished writing.

> "And now I leave this house behind forever.
> Do not forget me, friendly cypress pillar."

"I do not share these regrets," said her mother.

> "Even if it wishes to be friends,
> We may not stay behind at this cypress pillar."          (s 500)

## SCENE 3

EKOTOBA

After the wife has left the house, Higekuro stops by. Moku, who is in his service and has remained behind, tells him what has happened. He sees his daughter's poem. The older son is ten and in court service. The other boy must be a small child of eight or so. Higekuro weeps and strokes the boy's hair. Moku also weeps.

✑ ✑ ✑

GENJI

The other son was a pretty child of eight or so. Higekuro wept and stroked his hair and said that he must come home and help them remember his sister, whom he resembled closely.          (s 503)

## SCENE 4

EKOTOBA

In the Third Month, Genji comes to the quarters where Tamakazura used to live. Genji reminisces about the past, surveying the garden where wisteria and *yamabuki* are in brilliant flower in a hedge of Chinese bamboo. There should be many duck's eggs and oranges.

✑ ✑ ✑

GENJI

A clump of *yamabuki* grew untrimmed in a hedge of Chinese bamboo, very

beautiful indeed. "Robes of gardenia, the silent hue," he said to himself, for there was no one to hear him.

> "The *yamabuki* wears the hue of silence,
> So sudden was the parting at Idé road.

"I still can see her there."
He seemed to know for the first time—how strange!—that she had left him.

<div align="right">(s 508–9)</div>

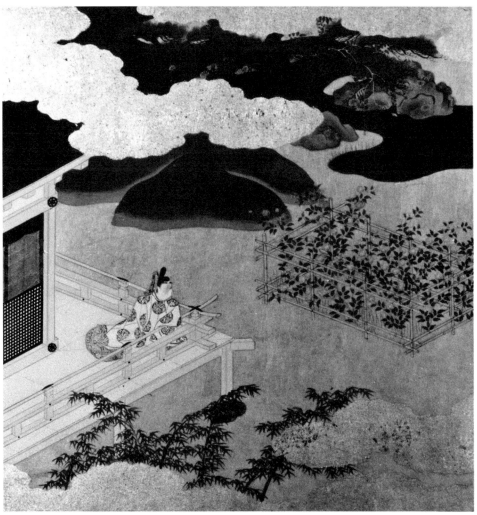

*31–4*

# 32.   A Branch of Plum

**EKOTOBA**

It is in the First Month. Genji and Murasaki take out boxes of Chinese perfumes and fabrics from the Nijō storehouses. The damasks and red and gold brocades should be scattered in front of them. Taking out all the jars, boxes, and censers, he divides them among his ladies.

✦✦✦

**GENJI**

He selected the choicest of them and gave the Kyushu silks and damasks to the serving women.

He laid out all the perfumes and divided them among his ladies. Each of them was to prepare two blends.                                              (s 511)

SCENE 2

**EKOTOBA**

On the tenth of the Second Month, a gentle rain is falling and the rose plum is in full bloom. Prince Hotaru comes calling on Genji, when a note from Princess

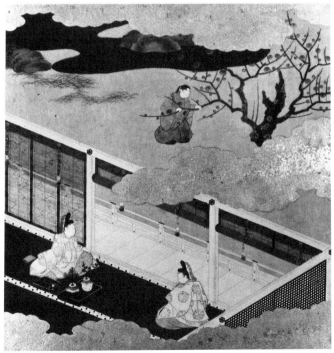

*32–2*

Asagao arrives. She also sends a perfume box, in which are two jars: an indigo one decorated with a pine branch and a white one attached to a plum branch from which most of the blossoms have fallen.* Then Yūgiri has wine brought out for the messenger and gives him a lady's robe of Chinese red lined with purple. Genji's reply, which Asagao's messenger takes with him, is tied to a spray of rose plum from the foregarden.

﹀﹅﹅

GENJI

Inspecting the gifts and finding them admirable, the prince came upon a poem in faint ink which he softly read over to himself.

> "Its blossoms fallen, the plum is of no further use.
> Let its fragrance sink into the sleeves of another."

Yūgiri had wine brought for the messenger and gave him a set of lady's robes, among them a Chinese red lined with purple.                    (s 513)

---

* In the novel, Asagao's note, and not the perfume jar, is attached to the plum branch.

## SCENE 3

EKOTOBA

In the same evening, the moon rises and there is wine. Genji and Prince Hotaru play lutes. Genji also plays a thirteen-stringed koto, Kashiwagi plays a Japanese koto, Yūgiri takes up a flute, and Kōbai beats time and sings.

﹀﹅﹅

GENJI

For Prince Hotaru there was a lute, for Genji a thirteen-stringed koto, for Kashiwagi, who had a quick, lively touch, a Japanese koto. Yūgiri took up a flute, and the high, clear strains, appropriate to the season, could scarcely have been improved upon. Beating time with a fan, Kōbai was in magnificent voice as he sang "A Branch of Plum." Genji and Prince Hotaru joined him at the climax. It was Kōbai who, still a court page, had sung "Takasago" at the rhyme-guessing contest so many years before. Everyone agreed that though informal it was an excellent concert.

Prince Hotaru intoned a poem as wine was brought in:

> "The voice of the warbler lays a deeper spell
> Over one already enchanted by the blossoms.

"For a thousand years, if they do not fall?"
Genji replied:

> "Honor us by sharing our blossoms this spring
> Until you have taken on their hue and fragrance."    (s 514–15)

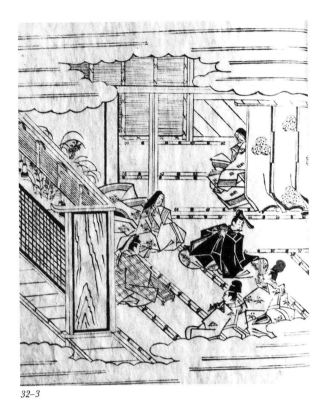

32–3

## Scene 4

EKOTOBA
It is in spring and at dawn on the tenth of the Second Month. Hotaru makes ready to leave Genji's palace. As he is getting into his carriage, Genji gives him a set of informal court robes and two jars of perfume. Kashiwagi, Kōbai, Yūgiri, and others should be out to see him off.

❧❧❧

GENJI
Genji had a set of informal court robes and two sealed jars of perfume taken out to his carriage.

> "If she catches a scent of blossoms upon these robes,
>     My lady will charge me with having misbehaved."

"How very sad for you," said Genji, coming out as the carriage was being readied.

> "I should have thought your lady might be pleased
>     To have you come home all flowers and brocades.

"She can scarcely be witness to such a sight every day."
The prince could not immediately think of an answer.

(s 515–16)

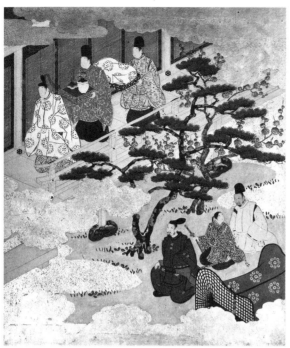

32–4

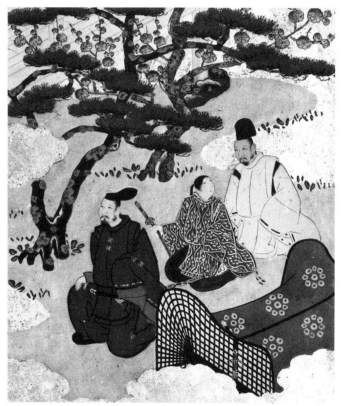

*Detail of 32–4*

EKOTOBA

It may be in the Third Month; the cherry blossoms have fallen. Yūgiri, Murasaki's oldest brother, and Kashiwagi try their hands at writing on booklets in the main hall. Genji joins them. This may be at the court; then it must be in the inner rooms. If so, Murasaki should also be shown. Genji holds a brush meditatively between his teeth. Other details are given in the book.

GENJI

He had with him only two or three women whom he could count on for interesting comments. They ground ink for him and selected poems from the more admired anthologies. Having raised the blinds to let the breezes pass, he sat out near the veranda with a booklet spread before him, and as he took a brush meditatively between his teeth the women thought that they could gaze at him for ages on end and not tire. His brush poised over papers of clear, plain reds and whites, he would collect himself for the effort of writing, and no one of reasonable sensitivity could have failed to admire the picture of serene concentration which he presented. (s 518)

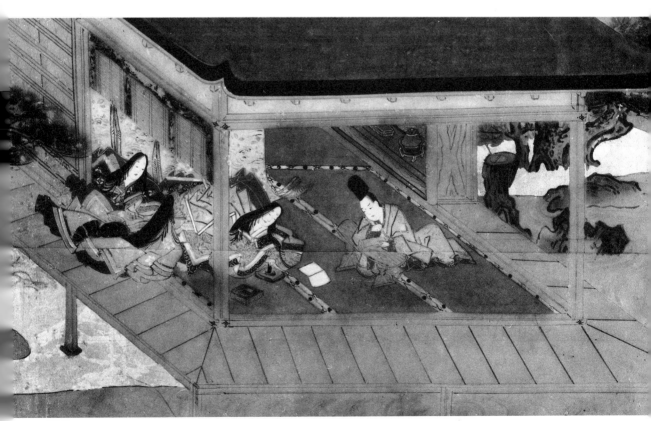

32–5

# 33.  Wisteria Leaves

### SCENE 1

**EKOTOBA**

On the seventh day of the Fourth Month, the moon has risen. Yūgiri comes to
Tō no Chūjō's mansion. There should be seven or eight of Tō no Chūjō's sons,
including Kashiwagi and Kōbai. Kashiwagi breaks off a rich spray of wisteria
and presents it to Yūgiri with a cup of wine. Yūgiri takes a sip from the cup.
There should be beautiful wisteria, hanging from a tall pine in the garden.
There should also be a pond in the garden and clouds in the sky.

✕✕✕

**GENJI**

The moment had come, thought Tō no Chūjō. "Underleaves of wisteria," he
said, smiling. Kashiwagi broke off an unusually long and rich spray of wisteria
and presented it to Yūgiri with a cup of wine. Seeing that his guest was a little
puzzled, Tō no Chūjō elaborated upon the reference with a poem of his own:

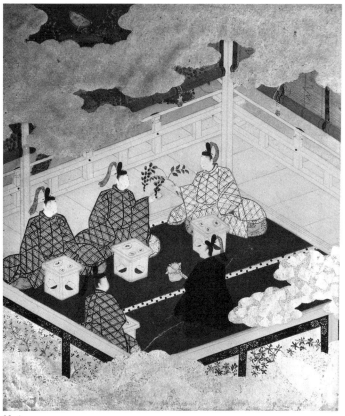

*33–1*

"Let us blame the wisteria, of too pale a hue,
      Though the pine has let itself be overgrown."

Taking a careful though elegant sip from the cup that was pressed upon him,
Yūgiri replied:

"Tears have obscured the blossoms these many springs,
      And now at length they open full before me."

He poured for Kashiwagi, who replied:

"Wisteria is like the sleeve of a maiden,
      Lovelier when someone cares for it."                (s 526–27)

## SCENE 2

EKOTOBA

In summer Yūgiri and Kumoinokari move to the Sanjō palace. They are looking
at the foregarden, with a book, when Tō no Chūjō stops by. He sees the poems
exchanged between the two and is almost in tears. Yūgiri blushes; his old nurse
also comes out and reminds him of her old grievances. Kumoinokari's face
flushes in embarrassment.

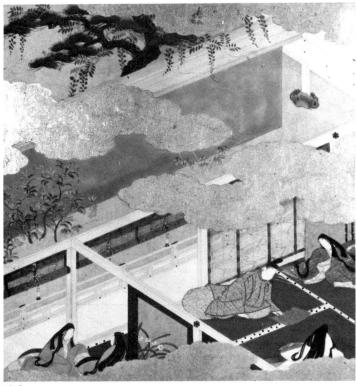

33–2

Tō no Chūjō looked at the poems that lay scattered about. "I would like to ask these same questions of your brook," he said, brushing away a tear, "but I rather doubt that you would welcome my senile meanderings.

> "The ancient pine is gone. That need not surprise us—
> For see how gnarled and mossy is its seedling."

Saishō, Yūgiri's old nurse, was not quite ready to forget old grievances. It was with a somewhat satisfied look that she said:

> "I now am shaded by two splendid trees
> Whose roots were intertwined when they were seedlings."    (s 534)

## SCENE 3

EKOTOBA

The emperor Reizei and the retired emperor Suzaku pay a state visit to Genji's Rokujō palace. The inner guards of the left and the right are mustered for mounted review at the equestrian grounds. From there, the royal party moves to the main hall. There are brocades spread along the galleries and arched bridges. The emperor is seated in the center, flanked by Genji and Suzaku. On the east lake are boats for cormorant fishing. The lieutenants of the inner guards advance to the stairs in front of the east seat, and present the fish from the pond. The royal party has a meal of small carp. The court musicians are also in attendance. One of Tō no Chūjō's sons, a boy of ten or so, dances "Our Gracious Monarch." The emperor takes off a robe and lays it over the boy's shoulders. Tō no Chūjō himself descends into the garden for ritual thanks. Genji breaks off a chrysanthemum and holds it in his hand. Autumn leaves should be brilliant on the mountains, some scattered on the ground. Under the autumn trees stroll young boys from the best families. They have their hair tied in boy's fashion, and are wearing gray-blues and roses with crimsons and lavenders showing at their sleeves.

GENJI

The lieutenants of the inner guards advanced from the east and knelt to the left and right of the stairs before the royal seats, one presenting the take from the pond and the other a brace of fowl taken by the royal falcons in the northern hills. Tō no Chūjō received the royal command to prepare and serve these delicacies. An equally interesting repast had been laid out for the princes and high courtiers. The court musicians took their places in late afternoon, by which time the wine was having its effect. The concert was quiet and unpretentious and there were court pages to dance for the royal guests. It was as always the excursion to the Suzaku Palace so many years before that people remembered.

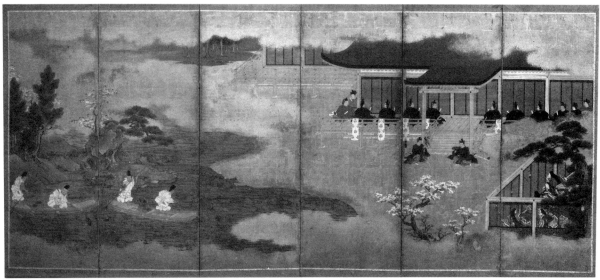

33–3

*Detail of 33–3*

One of Tō no Chūjō's sons, a boy of ten or so, danced "Our Gracious Monarch" most elegantly. The emperor took off a robe and laid it over his shoulders, and Tō no Chūjō himself descended into the garden for ritual thanks.

Remembering how they had danced "Waves of the Blue Ocean" on that other occasion, Genji sent someone down to break off a chrysanthemum, which he presented to his friend with a poem:

"Though time has deepened the hue of the bloom at the hedge,
I do not forget how sleeve brushed sleeve that autumn." (s 535–36)

# 34.  New Herbs I

## Scene 1

EKOTOBA

Probably it is toward the end of the Twelfth Month, as the book states that the year is drawing to an end. The Third Princess's initiation takes place at Suzaku's palace. Tō no Chūjō bestows the ceremonial train. The two ministers, and all the princes and high courtiers come. The whole of the emperor's private household and that of the crown prince are also present. Many Chinese treasures are taken out of the warehouse and supply rooms and sent as gifts. A large array of gifts come from Rokujō too. From Akikonomu come robes and combs in boxes. This is all described in the book.

GENJI

From Akikonomu came robes and combs and the like, all of them selected with the greatest care. She got out combs and bodkins from long ago and made sure that the necessary repairs did not obscure their identity. On the evening of the ceremony she dispatched them by her assistant chamberlain, who also served in the Suzaku Palace, with instructions that they be delivered directly to the Third Princess. With them was a poem:

> "I fear these little combs are scarred and worn.
> I have used them to summon back an ancient day."

The Suzaku emperor chanced to be with the princess when the gift was delivered. The memories were poignant. (s 546)

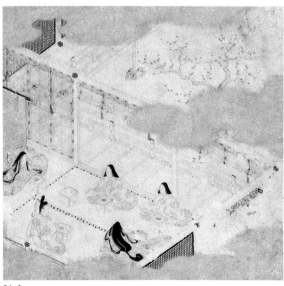

34–1

## SCENE 2

EKOTOBA

After the above episode, the Suzaku emperor takes the tonsure with the help of three clerics and the grand abbot of Hiei. Oborozukiyo rushes to his side, lamenting this event.

〜〜〜

GENJI

Oborozukiyo refused to leave his side.

"My worries about my daughters may come to an end," he said, "but how can I stop worrying about you?"

He forced himself to sit up. The grand abbot of Hiei shaved his head and there were three eminent clerics to administer the vows. The final renunciation, symbolized by the change to somber religious habit, was very sad indeed.

(s 546–47)

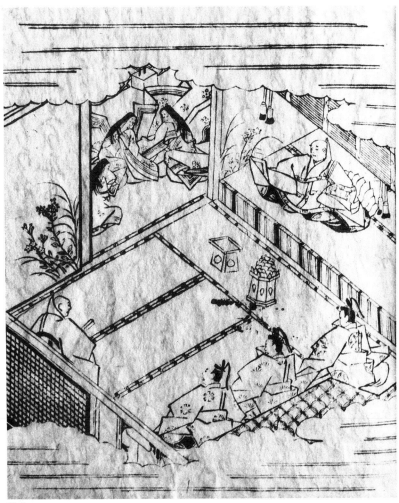

34-2

# SCENE 3

**EKOTOBA**

There is wine and dinner at the Suzaku place after he takes the tonsure. Genji and many high courtiers are present. There should be a heavy snow. More details are given in the book.

〳〵〳

**GENJI**

In the evening there was a banquet, for Genji's party and the Suzaku household. The priest's fare was unpretentious but beautifully prepared and served. The

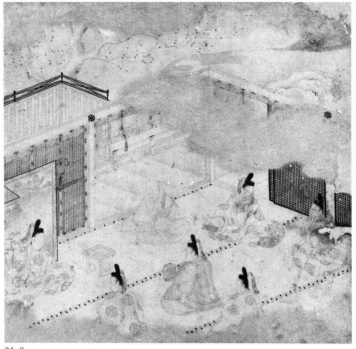

*34–3*

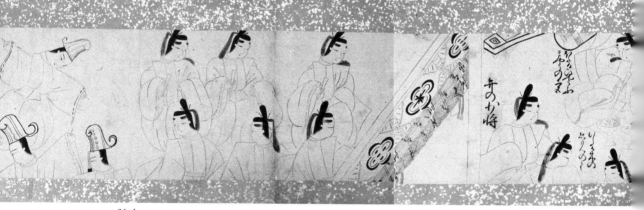

*34–4*

*190* THE TRANSLATIONS AND PAINTINGS

tableware and the trays of light aloeswood also suggested the priestly vocation and brought tears to the eyes of the guests. The melancholy and moving details were innumerable, but I fear that they would clutter my story.       (s 549)

## SCENE 4

EKOTOBA

Tamakazura celebrates Genji's fortieth birthday on the twenty-third of the First Month. There should be forty cushions, beds, armrests, and many other festive paraphernalia. Four boxes containing summer and winter robes are laid out upon two cupboards inlaid with mother-of-pearl. There should also be incense jars, medicine boxes, inkstones, vanity sets, wash basins, and other things. The stands for the ritual chaplets are made of aloeswood and sandalwood, decorated with gold metal trimmings. In addition to Genji, there should be women. Tamakazura brings her two small sons with her. They still wear their hair in the pageboy fashion and are dressed in casual robes. There should be wine cups and boxes of new herbs.

GENJI

Tamakazura was very much the matron, in an entirely pleasant way. Her congratulatory poem was most matronly:

"I come to pray that the rock may long endure
And I bring with me the seedling pines from the field."

Genji went through the ceremony of sampling the new herbs, which were arranged in four aloeswood boxes. He raised his cup.

"Long shall be the life of the seedling pines—
To add to the years of the herbs brought in from the fields?"

(s 551–52)

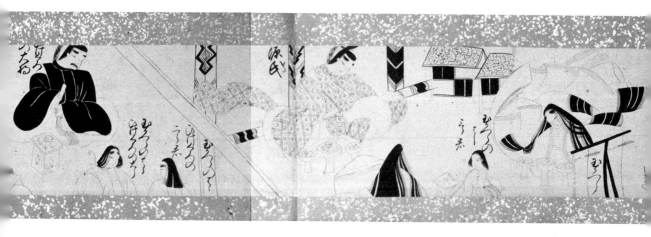

## Scene 5

EKOTOBA
Following the above episode, Tō no Chūjō plays the Japanese koto, and Prince Hotaru takes up a seven-stringed Chinese koto. High courtiers keep time at the stairway. Genji should be shown. Warblers are startled in their roosts.

❧❧❧

GENJI
His koto tuned very low, Tō no Chūjō managed an astonishingly rich array of overtones. Kashiwagi chose a higher, more approachable tuning. Not informed in advance that he had such talents, the audience, princes and all, was mute with admiration. (s 553)

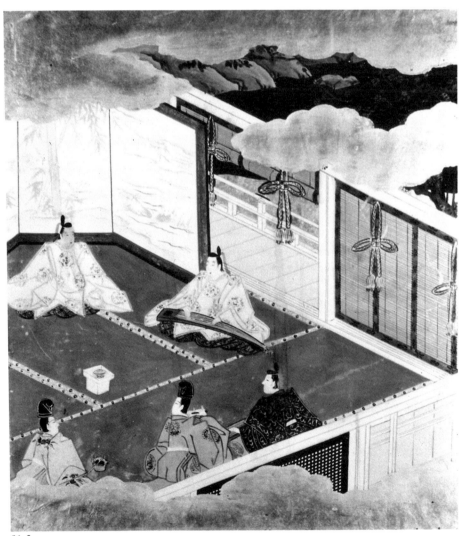

34–5

## SCENE 6

EKOTOBA

It is toward the middle of the Second Month. Genji sits near Murasaki, chin in hand. Drawing the inkstone toward her, Murasaki writes a poem.

꙳꙳꙳

GENJI

> "I had grown so used to thinking it would not change.
> And now, before my very eyes, it changes."

He took up the paper on which she had jotted down old poems that fitted her mood as well as this poem of her own. It was not the most perfect of poems, perhaps, but it was honest and to the point.

> "Life must end. It is a transient world.
> The one thing lasting is the bond between us."                (s 555)

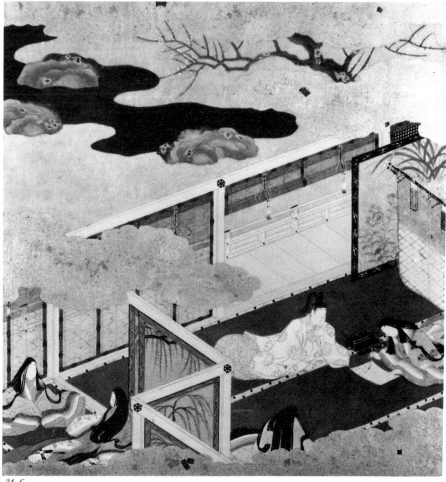

34–6

NEW HERBS I   *193*

## SCENE 7

It is toward the middle of the Second Month. At the first traces of dawn, Genji leaves the Third Princess's quarters, returns to Murasaki's wing, and taps on a shutter. He looks at the inner garden while waiting for the servant women to awake and to open the shutter.

〜〜〜

GENJI

The patches of snow were almost indistinguishable from the white garden sands. "There is yet snow by the castle wall," he whispered to himself as he came to Murasaki's wing of the house and tapped on a shutter. No longer in the habit of accommodating themselves to nocturnal wanderings, the women let him wait for a time. (s 556)

34–7

## SCENE 8

EKOTOBA
Following the above episode, Genji gets off a note to the Third Princess. It is attached to a sprig of plum blossom and delivered by a woman messenger at the gallery. Genji sits near the veranda with Murasaki. Dressed in white, Murasaki toys with a sprig of plum in her hand. Raising a blind, he looks at a warbler that is calling from the rose plum at the eaves. An inkstone and paper should be shown.

〜〜〜

GENJI
[Genji] attached it to a sprig of plum blossom.

> "Not heavy enough to block the way between us,
> The flurries of snow this morning yet distress me."

He told the messenger that the note was to be delivered at the west gallery.

Dressed in white, a sprig of plum in his hand, he sat near the veranda looking at patches of snow like stragglers waiting for their comrades to return. A warbler

34–8

called brightly from the rose plum at the eaves. "Still inside my sleeve," he said, sheltering the blossom in his hand and raising a blind for a better look at the snow. He was so youthfully handsome that no one would have taken him for one of the great men of the land and the father of a grown son.

(s 557–58)

SCENE 9

EKOTOBA

It is in the Fourth Month. At dawn, Genji is on his way back from Oborozukiyo's quarters, and Chūnagon sees him off. The morning sun is pouring over the hills, and Genji looks at the wisteria in brilliant bloom. Oborozukiyo should be behind a curtain. His carriage, a plain one covered with woven palm fronds, is brought up to the door at a gallery. There are four or five retainers, including the governor of Izumi. The book refers to the call of mandarin ducks in the pond.

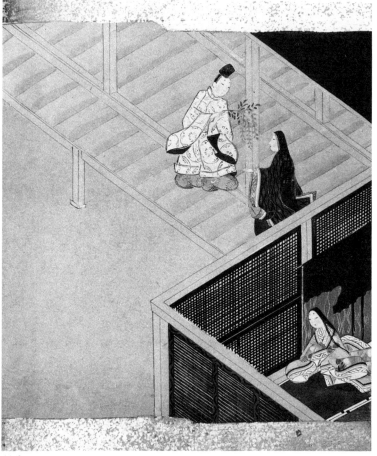

34–9

GENJI

He had one of them break off a spray of wisteria.

> "I have not forgotten the depths into which I plunged,
> And now these waves of wisteria seek to engulf me."

Chūnagon was very sorry for him, leaning against a balustrade in an attitude of utter dejection. Though even more fearful than he of being seen, Oborozukiyo felt constrained to answer.

> "No waves at all of which to be so fearful.
> My heart, unchastened, sends out waves to join them."     (s 562)

## SCENE 10

EKOTOBA

On the twenty-third of the Tenth Month, Murasaki makes thanksgiving offerings in honor of Genji's fortieth birthday at a temple in Saga. Courtiers and princes riding in carriages or on horseback set up a wintry rustling through the maple leaves. There should be many priests and temple furnishings.

≻·≺·≻

GENJI

The temple was a large one and the congregation was enormous and included most of the highest officials, in part, perhaps, because the fields and moors were at their autumn best. Already the carriages and horses sent up a wintry rustling through the dry grasses.     (s 565–66)

## SCENE 11

EKOTOBA

There is a banquet at Nijō after the above ceremony is over. The furnishings for the banquet include the chair of honor, decorated with mother-of-pearl. In the west room are twelve wardrobe stands, on which are the summer and winter robes and quilts and spreads, placed under covers of figured purple. Before the chair of honor are two tables spread with a Chinese silk of a gradually deepening hue towards the fringe.

The Akashi lady sends the ceremonial chaplet which is on an aloeswood stand with flared legs and decorations of gold birds in silver branches. The four screens behind have been commissioned by Prince Hotaru. Treasures on two tiered stands and other furnishings are set along the north wall. Gifts for the guests are laid out along the east and west verandas, viands in eighty boxes, and robes in forty Chinese chests. There should be a display of other gifts for the guests in front of the chair of honor, and many other gifts in the foreground.

High-ranking officials, ministers of the left and right, Prince Hotaru, and the others have seats near the south veranda. Awnings have been set out for the musicians in the garden, to the left and right of the dance platform. The musicians take their places, and the dancers perform "The Rakuson" dance toward sunset. Then Yūgiri and Kashiwagi dance the closing steps.

GENJI

The musicians took their places in early afternoon. There were dances which one is not often privileged to see, "Myriad Years" and "The Royal Deer," and, as sunset neared, the Korean dragon dance, to flute and drum. Yūgiri and Kashiwagi went out to dance the closing steps. The image of the two of them under the autumn leaves seemed to linger on long afterwards.         (s 566)

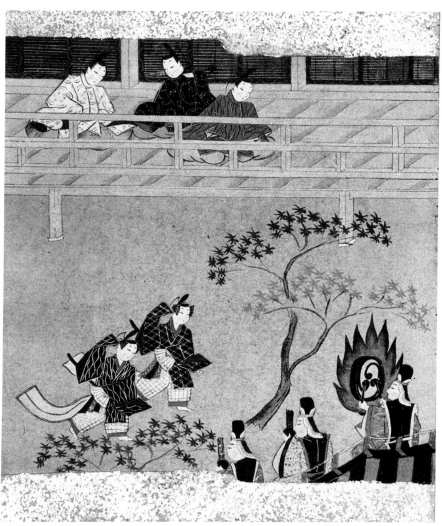

34–11

## SCENE 12

EKOTOBA

As Tō no Chūjō prepares to leave Genji's place, Genji sends out gifts to his carriage: a Japanese koto, a Korean flute, and a sandalwood book chest filled with Chinese manuscripts, accompanied by a gift of forty horses. In front of Genji is the remainder of the banquet and music party. Everyone should be there, including Prince Hotaru. In the room are screens of figured Chinese silk of a delicate lavender with ink drawings executed by the emperor himself. These are all described in the book in detail.

GENJI

Genji gave Tō no Chūjō a fine Japanese koto, a Korean flute that was among his particular favorites, and a sandalwood book chest filled with Japanese and Chinese manuscripts. They were taken out to Tō no Chūjō's carriage as he prepared to leave. There was a Korean dance by officials of the Right Stables to signify grateful acceptance of the horses. Yūgiri had gifts for the guardsmen.

(s 569)

## SCENE 13

EKOTOBA

The crown princess is about to deliver a baby and lies down behind the curtains. Beside her the old Akashi nun is talking. The Akashi lady is also weeping.

GENJI

"Old waves come upon a friendly shore.
A nun's sleeves dripping brine—who can object?

"It used to be the thing, or so I am told, to be tolerant of old people and their strange ways."

The crown princess took up paper and a brush from beside her inkstone.

"The weeping nun must take me over the waves
To the reed-roofed cottage there upon the strand."

Turning away to hide her own tears, the Akashi lady set down a poem beside it:

"An old man leaves the world, and in his heart
Is darkness yet, there on the Akashi strand." (s 571)

## SCENE 14

EKOTOBA
Genji and Prince Hotaru come out to a corner of the veranda to watch the others play football. There are Kashiwagi and his three younger brothers: Tō no Ben, Hyōe no Suke, and Taifu, as well as other young guardsmen. They all wear caps of state. Yūgiri breaks off a twig from a cherry tree and goes to sit on the stairs. The Third Princess should remain inside the curtains. Other women should also be watching the game. When a small Chinese cat comes running out with a large cat in pursuit, a curtain is pulled back to reveal the Third Princess behind it. Kashiwagi and Yūgiri both have a glimpse of her. Her robes are described in the book in detail.

〉〈〉

GENJI
A lady in informal dress stood just inside the curtains beyond the second pillar to the west. Her robe seemed to be of red lined with lavender, and at the sleeves and throat the colors were as bright and varied as a book of paper samples. Her cloak was of white figured satin lined with red. Her hair fell as cleanly as sheaves of thread and fanned out towards the neatly trimmed edges some ten inches beyond her feet. In the rich billowing of her skirts the lady scarcely seemed present at all. The white profile framed by masses of black hair was pretty and elegant. (s 583)

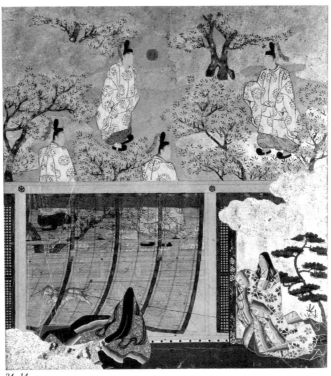

*34–14*

# 35.  New Herbs II

<center>SCENE 1</center>

EKOTOBA

It may be in the Third Month. Kashiwagi sits at the veranda and pets the
Third Princess's cat. The book describes how the cat speaks to him.

<center>〜〜〜</center>

GENJI

Sometimes when he was sitting at the veranda lost in thought it would come
up and speak to him.

"What an insistent little beast you are." He smiled and stroked its back.
"You are here to remind me of someone I long for, and what is it you long for
yourself? We must have been together in an earlier life, you and I."

He looked into its eyes and it returned the gaze and mewed more emphatically.
Taking it in his arms, he resumed his sad thoughts.　　　　(s 589–90)

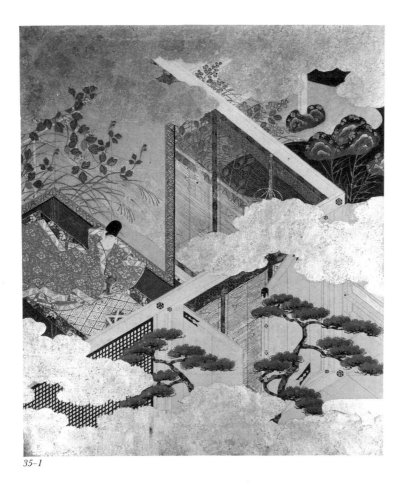

*35–1*

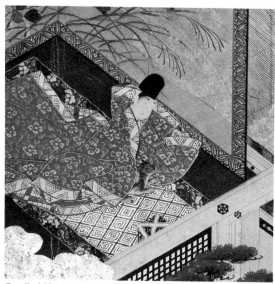
*Detail of 35-1*

## SCENE 2

EKOTOBA

On the twentieth of the Tenth Month, Genji makes a pilgrimage to the Sumi-yoshi Shrine, accompanied by the crown princess and all others. The high-ranking courtiers join them on horseback. There should be many carriages. The Akashi princess and Murasaki ride in the same carriage. The Akashi lady and her mother are in another carriage, followed by another carriage in which rides the nurse of the crown princess.

Musicians play eastern music. The high-ranking courtiers pull their robes down over their shoulders as they descend the stairs into the courtyard before the shrine, revealing lavender and pink robes with crimson sleeves under the dark jackets. They return, bringing back the reeds that have bleached and dried in the pine groves.

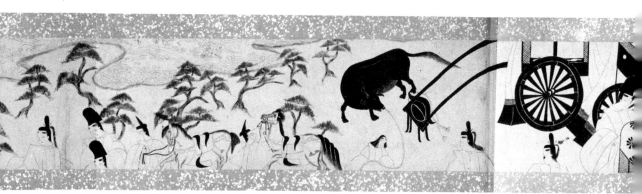
*35-2, 3, 4*

GENJI

It was late in the Tenth Month. The vines on the shrine fence were red and there were red leaves beneath the pine trees as well, so that the services of the wind were not needed to tell of the advent of autumn. The familiar eastern music seemed friendlier than the more subtle Chinese and Korean music. Against the sea winds and waves, flutes joined the breeze through the high pines of the famous grove with a grandeur that could only belong to Sumiyoshi. The quiet clapping that went with the koto was more moving than the solemn beat of the drums.                                                                    (s 594)

## SCENE 3

EKOTOBA

This follows the above episode. If a poem is needed, the same one as in the previous episode may be used here. The painting is also the same as above.

⌒⌒⌒

GENJI

Going inside, he took out a bit of paper and quietly got off a note to the old nun in the second carriage.

"You and I remember—and who else?
Only we can address these godly pines."                                   (s 594)

## SCENE 4

EKOTOBA

Following the above episode, sacred music is offered. There should be fires in the shrine courtyard, and musical instruments such as the Japanese koto, flutes, and *hichiriki* should be there. The dancers wave the sacred branches in the same way as in the sacred dance.

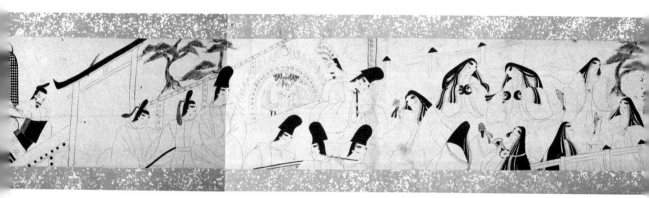

GENJI

> "So white these pines with frost in the dead of night.
> Bedecked with sacred strands by the god himself?"

She thought of Takamura musing upon the possibility that the great white expanse of Mount Hira had been hung out with sacred mulberry strands. Was the frost a sign that the god had acknowledged their presence and accepted their offerings?

This was the princess's poem:

> "Deep in the night the frost has added strands
> To the sacred branches with which we make obeisance."

And Nakatsukasa's:

> "So white the frost, one takes it for sacred strands
> And sees in it a sign of the holy blessing."

There were countless others, but what purpose would be served by setting them all down? Each courtier thinks on such occasions that he has outdone all his rivals—but is it so? One poem celebrating the thousand years of the pine is very much like another.

There were traces of dawn and the frost was heavier. The Kagura musicians had had such a good time that response was coming before challenge. They were perhaps even funnier than they thought they were. The fires in the shrine courtyard were burning low. "A thousand years" came the Kagura refrain, and "Ten thousand years," and the sacred branches waved to summon limitless prosperity for Genji's house. (s 595)

## SCENE 5

EKOTOBA

It is the twentieth of the First Month, and the moon is rising late. The plums in the foregarden are in full bloom; they are so heavy with blossoms that branches bend under their weight. A concert by some of the woman is taking place. The players are formed into groups and separated from one another by curtains. There should be the Third Princess, the Akashi lady, Murasaki, and many others. Each lady is accompanied by four little girls.

Murasaki has all her girls dressed in red robes, cloaks of white lined with red, jackets of figured lavender, and damask trousers. Their chemises are also red, fulled to a high sheen. She plays a Japanese koto. She is wearing over a robe of pink a robe of a deep hue, a sort of magenta, perhaps.

The crown princess has a thirteen-stringed Chinese koto. As she is heavy with child, she leans forward on an armrest. She is wearing a robe of rose plum, and

her hair falls thick and full. Her little girls are dressed in green robes, cloaks of pink lined with crimson, trousers of figured Chinese satin, and jackets of a yellow Chinese brocade.

The Akashi lady has on a figured "willow" robe, white lined with green, and a cloak of, perhaps, a yellowish green, and a train of a most delicate and yielding gossamer. She is kneeling on a cushion of green Korean brocade and is playing a lute. Every lady has a cushion. She has her two attendant girls dressed in rose plum and two others in white robes lined with red, and all four have on celadon-green cloaks and purple jackets and chemises aglow with the marks of the fulling blocks.

The Third Princess has put her girls into robes of a rich yellowish green, white cloaks lined with green, and jackets of magenta. She is smaller than the others, and plays on a smaller seven-stringed koto. She has on a white robe lined with red, over which her hair is flowing on both shoulders, suggesting the trailing stands of a willow.

The flares at the eaves burn bright. Out near the veranda are the third son of Higekuro, Tamakazura's son, who is playing on the *sho* pipes, and Yūgiri's eldest son, who has a flute. Yūgiri should also be there. Genji beats time.

⌁⌁⌁

GENJI
Yūgiri's voice was almost as good. I would be very hard put indeed to describe the pleasures of the night, which was somehow quieter as it filled with music.

It was the time of the month when the moon rises late. The flares at the eaves were just right, neither too dim nor too strong.                                (s 602)

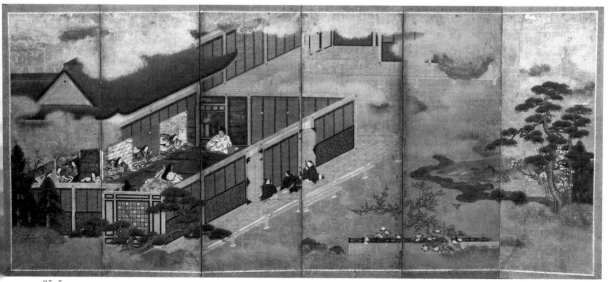

*35–5*

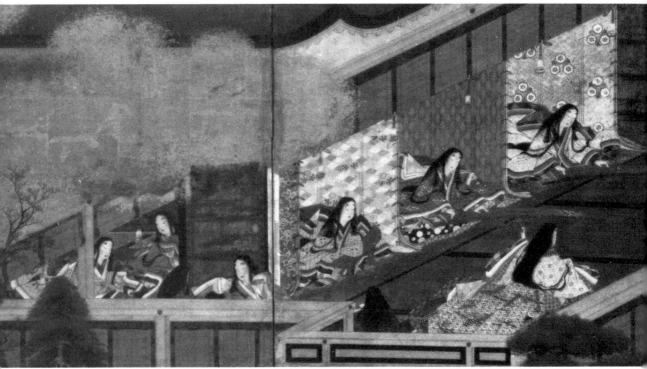

*Detail of 35–5*

## Scene 6

EKOTOBA

It is dawn, a few days after the tenth of the Fourth Month. Kashiwagi pushes his way through to the Third Princess's room. The door should be open. They are together, but the princess is shy. Jijū should be sleeping nearby. There are screens, and Kashiwagi himself pushes open a shutter to have a look at the princess's face. Kashiwagi finally prepares to leave.

GENJI

"I arise and go forth in the dark before the dawn.
I know not where, nor whence came the dew on my sleeve."

He showed her a moist sleeve.

He finally seemed to be leaving. So great was her relief that she managed an answer:

"Would I might fade away in the sky of dawn,
And all of it might vanish as a dream."

She spoke in a tiny, wavering voice and she was like a beautiful child. He hurried out as if he had only half heard. (s 615)

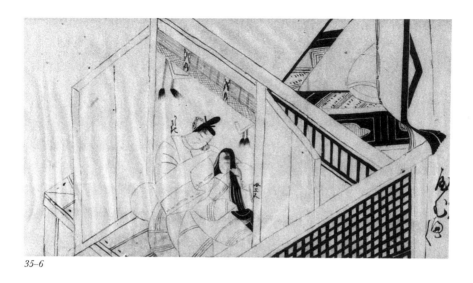

*35–6*

## SCENE 7

**EKOTOBA**

It is spring. Murasaki seems to have expired, and the women are wailing and others are in turmoil. Genji sits by her and looks at her face. Ascetics offer prayers.

**GENJI**

Genji longed to look into her eyes once more. It had been too sudden, he had not even been allowed to say goodbye. There seemed a possibility—one can only imagine the dread which it inspired—that he too was on the verge of death.

(s 617)

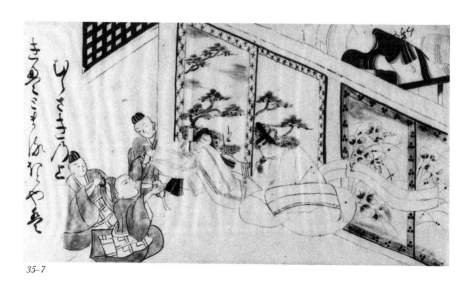

*35–7*

## SCENE 8

EKOTOBA
In the Sixth Month, Murasaki is ill. Feeling a respite, she is leaning against the armrest looking at the garden with Genji. There is dew on the lotus pads in the lake.

〜〜〜

GENJI
She was near tears herself.

"It is a life in which we cannot be sure
Of lasting as long as the dew upon the lotus."

And he replied:

"To be as close as the drops of dew on the lotus
Must be our promise in this world and the next."                (s 621)

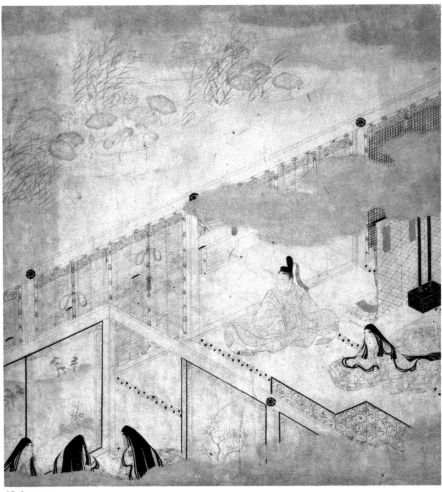

35–8

## SCENE 9

EKOTOBA

Genji is preparing to leave the Third Princess's room. He has left his fan, and is searching through her sitting room. He finds Kashiwagi's letter at the edge of a quilt. As her woman is opening the mirror for his toilet, Genji takes the letter and reads it. Kojijū notes this from a distance with horror. Other women of the household, but not the princess, should be in this composition. The letter, two sheets of paper in pale-green color, is covered with very small writing.

～～～

GENJI

There were two sheets of paper covered with very small writing. The hand was without question Kashiwagi's.

The woman who opened the mirror for him paid little attention. It would of course be a letter he had every right to see. But Kojijū noted with horror that it was the same color as Kashiwagi's of the day before. (s 624)

## SCENE 10

EKOTOBA

Oborozukiyo becomes a nun. Genji gets off a letter to her, and her answer comes attached to a branch of anise. A messenger should be shown.

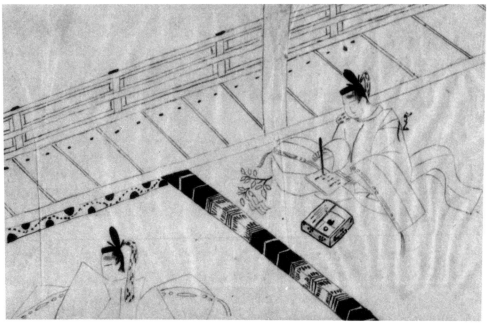

*35–10*

GENJI

> "How comes it that the fisherman of Akashi
> Has let the boat make off to sea without him?

"As for my prayers, they must be for everyone."

It was on deep green-gray paper attached to a branch of anise, not remarkably original or imaginative and yet obviously done with very great care. And the hand was as good as ever. (s 627–28)

## Scene 11

EKOTOBA

It is in the Twelfth Month, and there are a few flakes of snow, but the plums smile with their first blossoms. There is a rehearsal for the royal visit of the Suzaku emperor. The dancers are the children of high-ranking courtiers. They wear green singlets and pink robes lined with red. Thirty musicians are dressed in white, and are seated at the angling pavilion to the southeast of the main buildings. Four boys dance "Myriad Years," one does a dance about a Chinese general, and another, "The Rakuson." Any one of these dancers can be illustrated in this painting. Genji watches through the blind, accompanied only by Prince Hotaru and Higekuro. The lesser courtiers are on the veranda.

⟩⟩⟩

GENJI

As evening came on, Genji had the blinds raised, and as the festivities reached a climax his little grandchildren showed most remarkable grace and skill in several plain, unmasked dances. Their innate talents had been honed to the last delicate edge by their master. Genji was glad that he did not have to say which was the most charming. (s 634)

# 36.  The Oak Tree

SCENE 1

EKOTOBA

Kashiwagi is ill. Dressed in a white robe, he remains behind the curtains. Kojijū is beside him and shows him the Third Princess's note. The minister and the ascetic should be conferring.

GENJI

He sent for a lamp and read the princess's note. Though fragile and uncertain, the hand was interesting. "Your letter made me very sad, but I cannot see you. I can only think of you. You speak of the smoke that lingers on, and yet

> "I wish to go with you, that we may see
>    Whose smoldering thoughts last longer, yours or mine."

That was all, but he was grateful for it.                              (s 638–39)

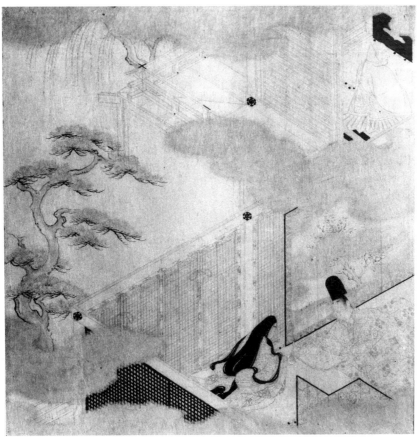

36–1

*Detail of 36–1*

## SCENE 2

EKOTOBA

The Third Princess is ill and the retired emperor Suzaku comes to her side. Her women dress her and help her to sit up. Genji, the host, should also be shown.

∿∿∿

GENJI

"I feel like one of the priests you have on night duty," said the emperor, pulling her curtains slightly aside. "I am embarrassed that my prayers seem to be hav-

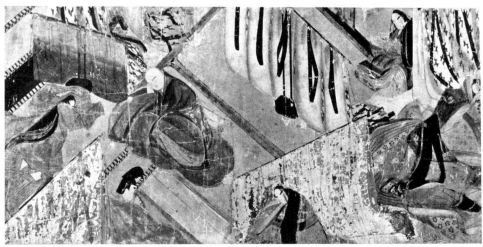

*36–2*

ing so little effect. I thought you might want to see me, and so here I am, plain and undecorated."

She was weeping. "I do not think I shall live. May I ask you, while you are here, to administer vows?" (s 642)

## SCENE 3

**EKOTOBA**

The retired emperor has the priests who have accompanied him cut the princess's hair. The former emperor and Genji both weep.

**GENJI**

He remonstrated with her all through the night and presently it was dawn.

"I do not want to be seen by daylight," said the Suzaku emperor. He summoned the most eminent of her priests and had them cut her hair. (s 643)

## SCENE 4

**EKOTOBA**

It is in the Third Month. Genji is at the princess's apartments. Taking advantage of a moment when there are no women with her, he talks to her. Kaoru should be beside Genji.

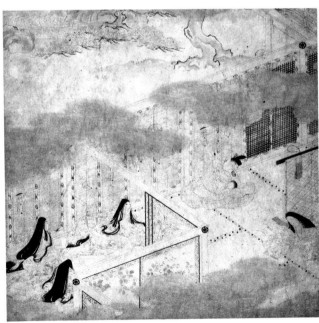

36–4

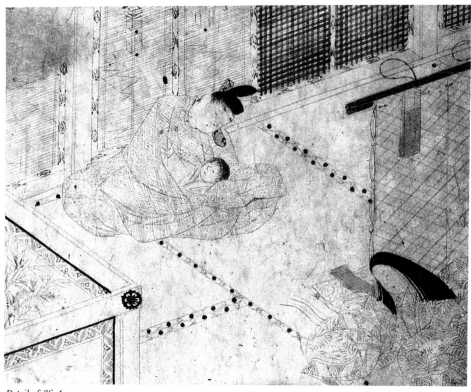

*Detail of 36–4*

GENJI

"Yes, very sad," he continued softly.

> "Should someone come asking when the seed was dropped,
>     What shall it answer, the pine among the rocks?"

She lay with her head buried in a pillow. He saw that he was hurting her, and fell silent.                                                         (s 650)

## SCENE 5

EKOTOBA

Yūgiri pays a visit to the Second Princess, who is at her mother's Ichijō house. The princess is behind the curtain. Her mother receives Yūgiri and weeps. There should be cherry blossoms.

⟩·⟩·⟩

GENJI

There were cherry blossoms in the forward parts of the garden. "This year alone" —but the allusion did not seem a very apt one. "If we wish to see them," he said softly, and added a poem of his own, not, however, as if he had a specific audience in mind.

"Although a branch of this cherry tree has withered,
It bursts into new bloom as its season comes."

The old lady was prompt with her answer, which was sent out to him as he was about to leave:

"The willow shoots this spring, not knowing where
The petals may have fallen, are wet with dew."          (s 652–53)

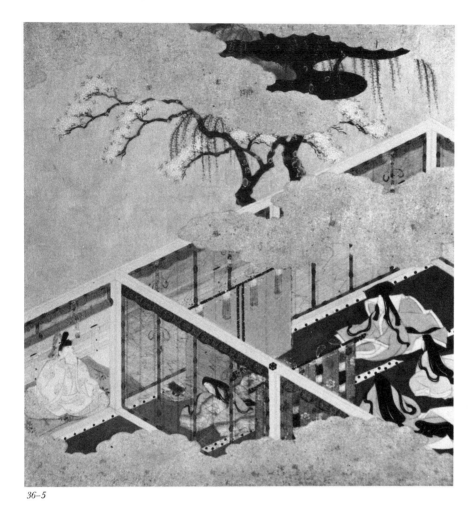

36–5

SCENE 6

EKOTOBA

It is towards the end of spring. The minister has not even had time to shave. Yūgiri shows him the poem by the mother of the Second Princess, which he copied on a piece of notepaper. The minister jots down his own poem on the same piece of notepaper. Kōbai should also be there.

He jotted down a poem on the same piece of notepaper, beside that of the princess's mother.

> "Drenched by the fall from these trees, I mourn for a child
> Who should in the natural order have mourned for me."

Yūgiri answered:

> "I doubt that he who left us wished it so,
> That you should wear the misty robes of evening."

And Kashiwagi's brother Kōbai:

> "Bitter, bitter—whom can he have meant
> To wear the misty robes ere the advent of spring?"            (s 654)

36–6

# 37. The Flute

SCENE 1

EKOTOBA

The retired emperor sends the Third Princess a letter, together with bamboo shoots and taro roots. Genji also sees the letter and gifts.

GENJI

"My people make their way with great difficulty through the misty spring hills, and here, the merest token, is what I asked them to gather for you.

"Away from the world, you follow after me,
And may we soon arrive at the same destination.

"It is not easy to leave the world behind."
Genji came upon her in tears.                                    (s 658)

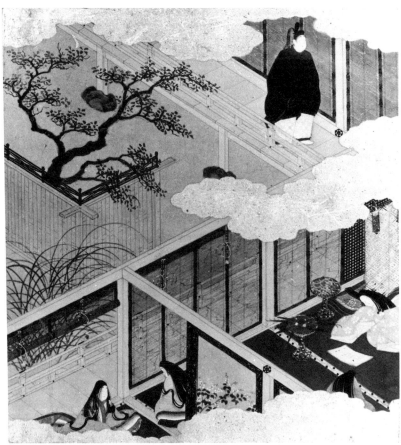

37–1

## SCENE 2

EKOTOBA

Following the above episode, Kaoru crawls around in a robe of white gossamer and a red chemise of a finely figured Chinese weave that trails long behind him. He totters up to some bamboo shoots and bites at one. Genji and the serving women should be there.

GENJI

Just cutting his teeth, the boy had found a good teething object. He dribbled furiously as he bit at a bamboo shoot.

"I see that his desires take him in a different direction," Genji said, laughing.

> "We cannot forget unpleasant associations.
> We do not discard the young bamboo even so."

He parted child and bamboo, but the boy only laughed and went on about his business.                                                    (s 660)

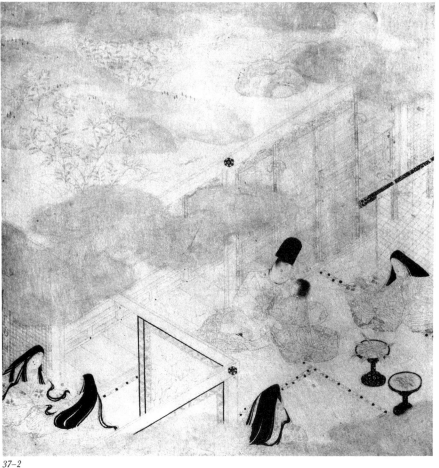

37–2

*Detail of 37–2*

SCENE 3

EKOTOBA
It is autumn, and the wild geese are flying wing to wing in the sky. Yūgiri visits the Second Princess at the Ichijō mansion. She remains far behind the curtain and plays on a Chinese koto. Her mother is playing a lute. Yūgiri should be shown in this scene.

⌇⌇⌇

GENJI
The moon had come out in a cloudless sky. And what sad, envious thoughts would the calls of the wild geese, each wing to wing with its mate, be summoning up? The breeze was chilly. In the autumn sadness she played a few notes, very faintly and tentatively, on a Chinese koto. He was deeply moved, but wished that he had heard more or nothing at all. Taking up a lute, he softly played the Chinese lotus song with all its intimate overtones.                                    (s 661)

THE FLUTE    *219*

37–3

## SCENE 4

EKOTOBA

Following the above episode, the princess's mother gives Yūgiri a flute that once belonged to Kashiwagi. Yūgiri blows a few notes on it. There may be a koto and a lute behind the curtains since the setting of this story is the same as in the previous episode.

～～～

GENJI

He blew a few notes in the *banjiki* mode, but did not finish the melody he had begun.

"My inept pluckings on the koto may perhaps be excused as a kind of memorial, but this flute leaves me feeling quite helpless, wholly inadequate."

The old lady sent out a poem:

"The voices of insects are unchanged this autumn,
Rank though the grasses be round my dewy lodging."

He sent back:

"The melody is as it always was.
The voices that mourn are inexhaustible."

Though it was very late, he left with great reluctance. (s 662)

## SCENE 5

EKOTOBA

Yūgiri visits the Rokujō palace. The small Third Prince and Second Prince are there. As Kaoru peeps from behind the curtain, Yūgiri motions towards him with

37–4

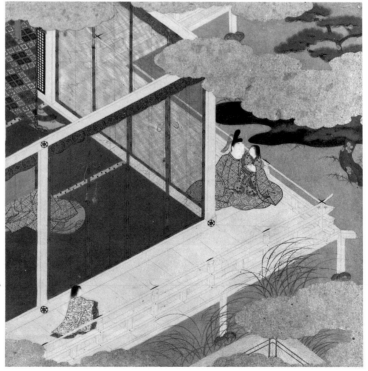

37–5

a fallen cherry branch. Kaoru has on a single robe of a deep purple. All the boys are three or four years old.

～．～．～

GENJI

Yūgiri had seen very little of the boy. Picking up a fallen cherry branch he motioned towards the blinds. The boy came running out. He had on but a single robe, of a deep purple. The fair skin glowed, and there was in the round little figure something, an extraordinary refinement, that rather outdid the princes.

(s 665)

# 38.   The Bell Cricket

SCENE 1

**EKOTOBA**

It may be in the summer. The Third Princess is dedicating holy images for her chapel. There should be chapel fittings, white and red lotus flowers should be set out in vases, and scrolls of holy writ should be placed on the tables. The princess is leaning against an armrest. Holding Kaoru, she gives orders to her women to put him out of sight. Genji looks in upon her apartments. There should be many high courtiers, priests, and serving women. The ceremony is truly fabulous.

～～～

**GENJI**

Tiny and pretty and overwhelmed by the crowd, the princess was leaning against an armrest.

"The boy is likely to be troublesome," he added. "Suppose you have someone put him out of sight."

Blinds hung along the north side of the room in place of the sliding doors.

(s 669)

*38–1*

THE BELL CRICKET   *223*

## SCENE 2

EKOTOBA

On the evening of the fifteenth of the Eighth Month, there is a full moon. Prince Hotaru and many high courtiers and princes gather at the princess's quarters. Genji should be included. There is a concert. There should be many autumn grasses and flowers in the garden, and bell crickets should be shown.

>·>·>

GENJI

There were judgments upon the relative merits of the insect songs.

"One is always moved by the full moon," said Genji, as instrument after instrument joined the concert, "but somehow the moon this evening takes me to other worlds." (s 672)

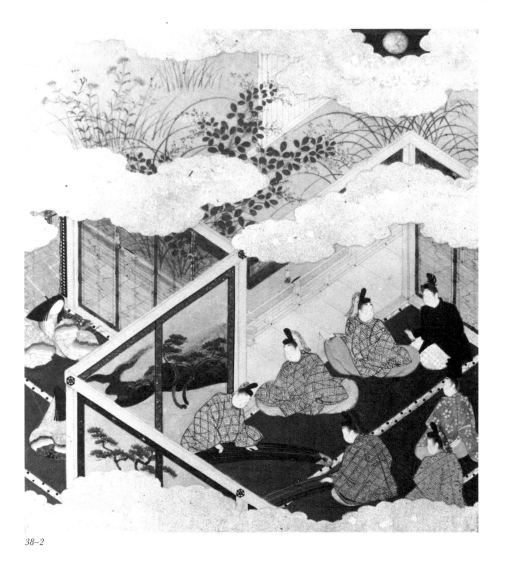

38–2

EKOTOBA

In the same evening of the full moon, but much later, a messenger comes from the Reizei emperor. Genji and other princes and courtiers all hurriedly get ready to ride in carriages, one by one, and go up to the royal palace.

GENJI

The procession, led by numerous outrunners and including Yūgiri and his friends Saemon no Kami and Tōsaishō, formed in order of rank, and so Genji gave up his quiet evening at home. Long trains gave a touch of formality to casual court dress. It was late and the moon was high, and the young men played this and that air on their flutes as the spirit moved them.                    (s 674)

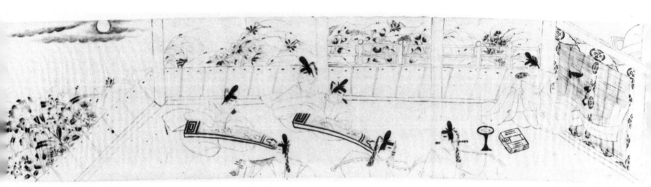

38–3

# 39. Evening Mist

## SCENE 1

**EKOTOBA**

In autumn, Yūgiri visits the Second Princess at the Ono villa. In the evening he sends his retainers back home. He slides himself into the princess's apartments, as she tries to withdraw. Shōshō is only able to stop him by getting hold of the hem of his trousers.

~·~·~

**GENJI**

It was still daylight, but the mists were heavy and the inner rooms were dark. The woman was horrified at having thus become his guide. The princess, sensing danger, sought to make her escape through the north door, to which, with sure instinct, he made his way. She had gone on into the next room, but her skirts trailed behind, making it impossible for her to bar the door. Drenched in perspiration, she sat trembling in the half-open door. (s 680)

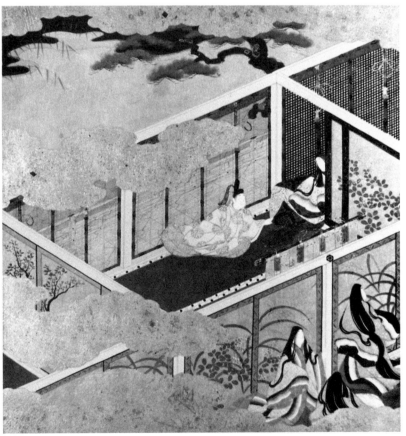

*39–1*

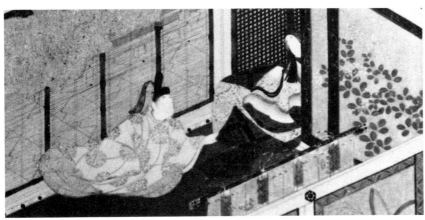

*Detail of 39–1*

## SCENE 2

EKOTOBA

In autumn, at Yūgiri's Sanjō mansion, Yūgiri opens and reads the letter from the princess's mother near a lamp. Kumoinokari comes lurching in and snatches the letter from over his shoulder.

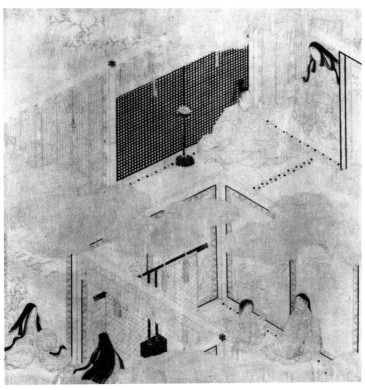

*39–2*

GENJI

It was dark when the old lady's letter arrived. In that strange hand, like the tracks of a bird, it was next to illegible. He brought it close to a lamp.

Kumoinokari came lurching through her curtains and snatched it from over his shoulder. (s 687–88)

<center>SCENE 3</center>

EKOTOBA

It is in the Ninth Month. Yūgiri lies gazing at the garden, when Kumoinokari sends one of their little boys with a note.

GENJI

One evening as he lay gazing up at the sky she sent one of her little boys with a note on a rather ordinary bit of paper.

> "Which emotion demands my sympathy,
> Grief for the one or longing for the other?

"The uncertainty is most trying."

He smiled. She had a lively imagination, though he did not think the reference to the princess's mother in very good taste. Coolly he dashed off a reply.

> "I do not know the answer to your question.
> The dew does not rest long upon the leaves.

"My feelings are for the world in general." (s 695)

39–3

## SCENE 4

EKOTOBA

Following the above episode and at Ono, Yūgiri stands at the corner railing and looks around with his fan raised to his eyes. The deer bay amidst the fields; gentians peer from the brown grasses. There should be insects among the grasses, and the roar of the waterfall should be suggested.

<center>⌇⌇</center>

GENJI

In casual court robes, pleasantly soft, and a crimson singlet upon which the fulling blocks had beaten a delicate pattern, he stood for a time at the corner railing. The light of the setting sun, almost as if directed upon him alone, was so bright that he raised a fan to his eyes, and the careless grace would have made the women envious had he been one of their number. But alas, they could not have imitated it. (s 695)

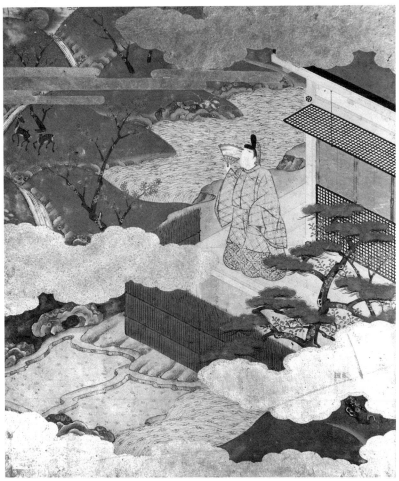

39–4

*Detail of 39–4*

## SCENE 5

**EKOTOBA**

Yūgiri visits the Second Princess after she has been moved to the Ichijō palace. The princess locks herself in a closet and closes its door. He peers through a crack and pleads. She has a quilt spread and spends the night there amongst the chests and cupboards. Shōshō should also be there.

*39–5*

GENJI

Daylight came and the impasse remained.

"Open the door just a crack," he said over and over again. There was no answer.

> "My sorrows linger as the winter night.
> The stony barrier gate is as slow to open."    (s 704)

## SCENE 6

EKOTOBA

It is winter. Yūgiri is getting ready to leave his Sanjō palace to visit the princess at the Ichijō mansion. Kumoinokari bursts into tears as she reaches for one of the singlets he has discarded.

GENJI

He changed his rumpled house clothes for exquisitely perfumed new finery. Seeing him off, a dazzlingly handsome figure in the torchlight, she burst into tears and reached for one of the singlets he had discarded.

39–6

*Detail of 39–6*

"I do not complain that I am used and rejected.
　　Let me but go and join them at Matsushima.

"I do not think I can possibly be expected to continue as I am."
Though she spoke very softly, he heard and turned back.
"You do seem to be in a mood.

　　"Robes of Matsushima, soggy and worn,
　　　For even them you may be held to account."　　　　　　(s 706)

## Scene 7

EKOTOBA
Tō no Chūjō sends one of his sons as a messenger to the Second Princess at the
Ichijō palace. The princess's women receive him at the veranda in front of her
curtains. The princess is behind the curtains.

"A bond from another life yet holds us together?
Fond thoughts I have, disquieting reports.

"Nor, I should imagine, will you have forgotten us."

The young man came marching in. The princess's women received him at the south veranda but could think of nothing to say. The princess was even more uncomfortable. He was one of Tō no Chūjō's handsomer sons, and they were all very handsome, and he carried himself well. As he looked calmly about him, he seemed to be remembering the past.                                        (s 710)

*39–7*

# 40.  The Rites

SCENE 1

**EKOTOBA**

At the time of the dedication of sutras at Nijō, on about the tenth of the Third Month, the Akashi lady and the lady of the orange blossoms watch the ceremonies through the open doors at the south and east openings. There should be Buddhist altars and other ceremonial fittings. Murasaki sends a poem to the Akashi lady through the Third Prince. There are musicians, and a dancer performs "General Ling." There should be many princes and high courtiers.

❧❧❧

**GENJI**

She sent a poem to the Akashi lady through little Niou, the Third Prince:

"I have no regrets as I bid farewell to this life.
 Yet the dying away of the fire is always sad."

If the lady's answer seemed somewhat cool and noncommittal, it may have been because she wished above all to avoid theatrics:

40–1

 THE TRANSLATIONS AND PAINTINGS

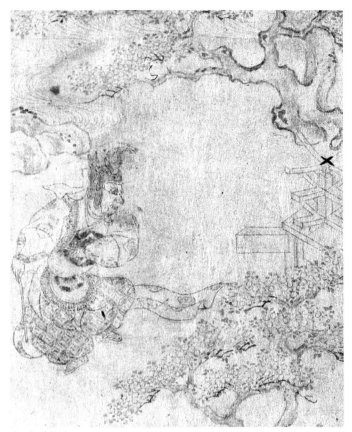
*Detail of 40–1*

"Our prayers, the first of them borne in on brushwood,
  Shall last the thousand years of the Blessed One's toils."

The chanting went on all through the night, and the drums beat intricate
rhythms. As the first touches of dawn came over the sky the scene was as if
made especially for her who so loved the spring. All across the garden cherries
were a delicate veil through spring mists, and bird songs rose numberless, as
if to outdo the flutes. One would have thought that the possibilities of beauty
were here exhausted, and then the dancer on the stage became the handsome
General Ling, and as the dance gathered momentum and the delighted onlookers
stripped off multicolored robes and showered them upon him, the season and
the occasion brought a yet higher access of beauty.                    (s 713–15)

## SCENE 2

EKOTOBA

It is on an autumn evening. Murasaki pulls herself from bed. Leaning against
an armrest, she looks at the garden. Genji and the empress are there.

"So briefly rests the dew upon the *hagi*.
Even now it scatters in the wind."

It would have been a sad evening in any event, and the plight of the dew even now being shaken from the tossing branches, thought Genji, must seem to the sick lady very much like her own.

"In the haste we make to leave this world of dew,
May there be no time between the first and last."

He did not try to hide his tears.
And this was the empress's poem:

"A world of dew before the autumn winds.
Not only theirs, these fragile leaves of grass."                    (s 717)

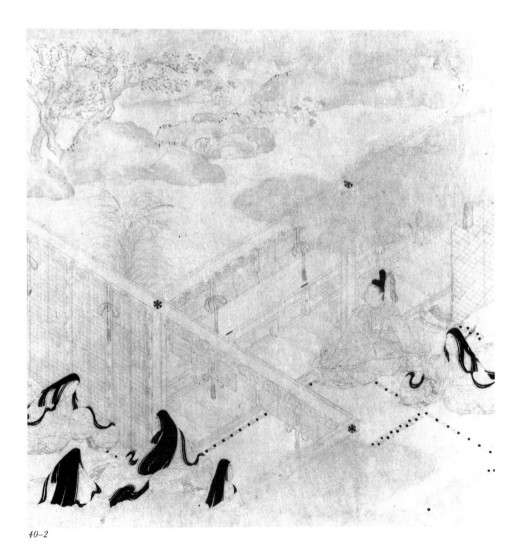

40–2

## Scene 3

EKOTOBA
It is in the autumn. Murasaki is fading away and is made to rest behind the cur-
tains. Genji is in tears, and her women go around weeping and lamenting.
Yūgiri, who is also weeping, tries to calm them down. Lifting the curtains, he
looks at Murasaki's face. There should be a lamp nearby. There may be a dim
morning twilight.

>·\·>

GENJI
In the dim morning twilight Genji had brought a lamp near Murasaki's dead
face. He knew that Yūgiri was beside him, but somehow felt that to screen
this beauty from his son's gaze would only add to the anguish.          (s 718)

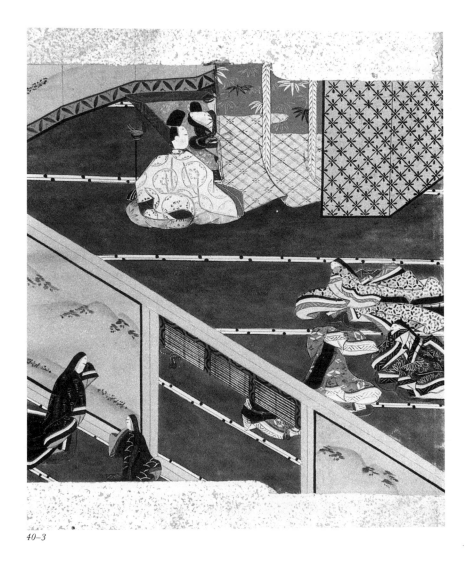

40–3

# 41.  The Wizard

<div style="text-align:center">SCENE 1</div>

EKOTOBA

It is the spring of the year after Murasaki has passed away. Genji admires the rose plum from the veranda, while Prince Hotaru strolls under the flowering branches.

>·>·>

GENJI

>"And why has spring so graciously come to visit
>A lodging where there is none to admire the blossoms?"

The prince was in tears as he replied:

>"You take me for the usual viewer of blossoms?
>If that is so, I seek their fragrance in vain."

He went out to admire the rose plum, and Genji was reminded of other springs. And who indeed was there to admire these first blossoms?  (s 723)

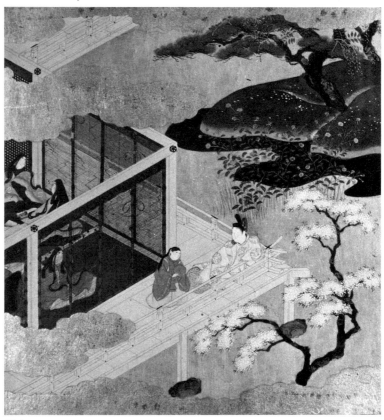

41–1

## SCENE 2

In the Second Month, Genji is looking at plum trees in full bloom and warblers singing their songs.

⌒⌒⌒

GENJI

The Second Month had come, and plum trees in bloom and in bud receded into a delicate mist. Catching the bright song of a warbler in the rose plum that had been Murasaki's especial favorite, Genji went out to the veranda.

> "The warbler has come again. It does not know
> That the mistress of its tree is here no more." (s 725)

41-2

*Detail of 41-2*

## SCENE 3

EKOTOBA

In the middle of the Seventh Month, Chūjō brings holy water for Genji's vesper devotions. He takes up her fan, on which she has written a poem. Bringing the inkstone close to him, he writes his own poem beside hers.

ᗑᗑᗑ

GENJI

Chūjō as usual brought holy water for Genji's vesper devotions. He took up her fan, on which she had written a poem:

> "This day, we are told, announces an end to mourning.
> How can it be, when there is no end to tears?"

He wrote beside it:

> "The days are numbered for him who yet must mourn.
> And are they numbered, the tears that yet remain?"         (s 732)

41–3

240  THE TRANSLATIONS AND PAINTINGS

## SCENE 4

EKOTOBA

In winter, Yūgiri brings two of his sons to Genji, after their call at the royal palace. With them are several of their uncles, who wear blue Gosechi prints. Naturally, Yūgiri should be included in this group.

<div style="text-align:center">~·~·~</div>

GENJI

Yūgiri brought two of his little boys, already in court service, to see their grand-father. They were very nearly the same age, and very pretty indeed. With them were several of their uncles, spruce and elegant in blue Gosechi prints, a very grand escort indeed for two little boys. At the sight of them all, so caught up in the festive gaiety, Genji thought of memorable occurrences on ancient festival days.

> "Our lads go off to have their Day of Light.
> For me it is as if there were no sun."  (s 733)

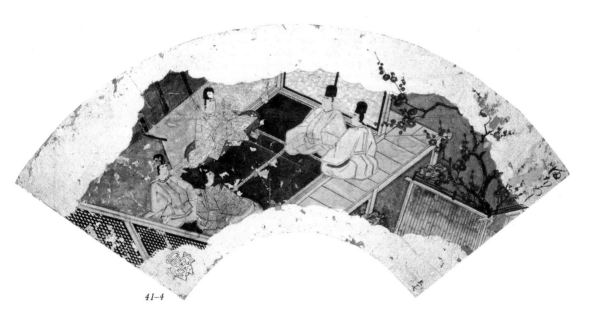

41–4

# 42.  His Perfumed Highness

SCENE 1

**EKOTOBA**

They leave on carriages after the banquet and archery meet are over. There should be many carriages, and some snow flurries. More details are given in the book.

＞・＼・＞

**GENJI**

The Left Guards won easily, as usual, and the meet was over early in the day. Starting back for Rokujō, Yūgiri invited Niou, Hitachi, and the Fifth Prince, also a son of the empress, to ride with him. Kaoru, who had been on the losing side, was making a quiet departure when Yūgiri asked him to join them. It was a large procession, including numbers of high courtiers and several of Yū-giri's sons—a guards officer, a councillor of the middle order, a moderator of the first order—that set off for Rokujō. The way was a long one, made more beautiful by flurries of snow.  (s 741–42)

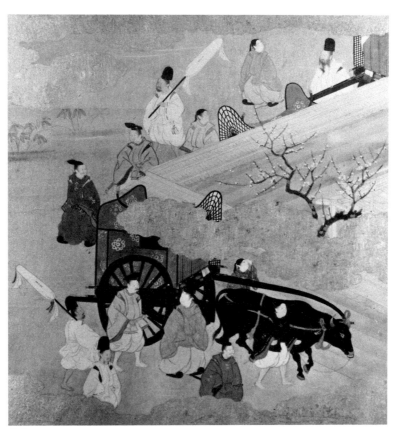

42–1

## SCENE 2

EKOTOBA
Following the above episode, there is a banquet at Yūgiri's Rokujō mansion. There are seats reserved for the guards officers, and other seats for Yūgiri's sons and high courtiers. Yūgiri and others should be included. Kaoru, who was on the losing side, may have danced. There are more details about Kaoru in the book.

GENJI
Cups were filled and the party became noisier, and several guards officers danced "The One I Seek." Their long, flowing sleeves brought the scent of plum blossoms in from the veranda, and as always it took on a kind of mysterious depth as it drifted past Kaoru.

"The darkness may try to keep us from seeing," said one of the women lucky enough to have a good view of the proceedings, "but it can't keep the scent away. And I must say there is nothing quite like it."　　　　　(s 742)

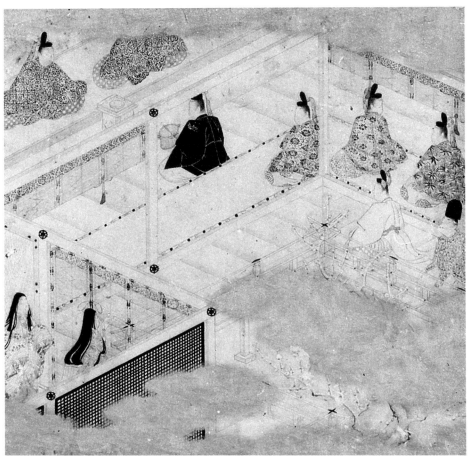

42–2

# 43. The Rose Plum

## SCENE 1

EKOTOBA

Kōbai posts himself before his stepdaughter's curtains. His son, wearing dresses for young boys, is playing the flute. The girl joins him on a koto from behind the curtain. Kōbai whistles an accompaniment. Then, he breaks off a plum branch near the eaves and hands it to the boy.

❖❖❖

GENJI

He managed very commendably.

"Good, very good. I can see that you have profited from our little musicales. And now you must join him," he said to the princess.

She played with obvious reluctance and declined to use a plectrum, but the brief duo was very pleasing indeed. Kōbai whistled an accompaniment, rich and full.

He looked out at a rose plum in full bloom just below this east veranda.

"Magnificent." (s 746)

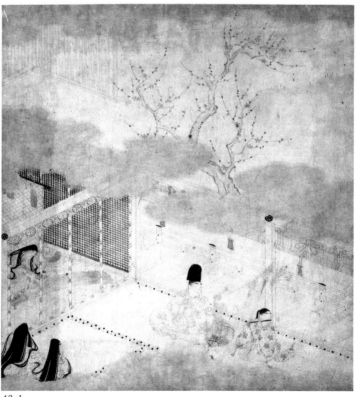

43–1

## Scene 2

EKOTOBA

At the royal palace after the above episode, the same boy waits for Niou to present him with the plum branch. Niou is emerging from the empress's audience chamber. There should be many princes accompanying him.

＞＼＞＼

GENJI

[The boy found Niou] emerging from the empress's audience chamber Niou singled him out among the throngs in her anterooms.

"Why did you have to run off in such a hurry last night? How long have you been here this evening?"

"I was sorry I had to go. I came early this evening because they said you might still be here." He spoke as one man to another.

"You must come and see me at Nijō sometime. It is a more comfortable sort of place, and it seems to attract young people, I don't really know why."

(s 747–48)

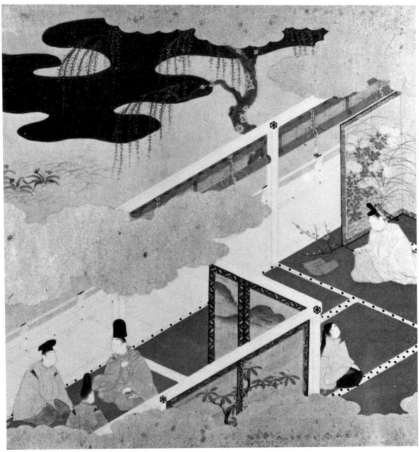

43–2

## 44.  Bamboo River

SCENE 1

**EKOTOBA**

On the New Year's Day, Yūgiri pays a visit to Tamakazura, bringing his six sons. She receives him from behind curtains. Tō no Chūjō's son Kōbai Dainagon, and Tō Chūnagon, Tamakazura's stepson, also come calling.

>.>.>

**GENJI**

They were all of them excellent young gentlemen and their careers were progressing more briskly than those of most of their colleagues. No cause for self-pity here, one would have said—and yet the lieutenant seemed moody and withdrawn. The indications were as always that he was his father's favorite.

(s 753)

SCENE 2

**EKOTOBA**

Kaoru calls on Tamakazura. The young plum tree at the eaves sends forth its first buds and the warbler sings its song. Tamakazura comes forward. There

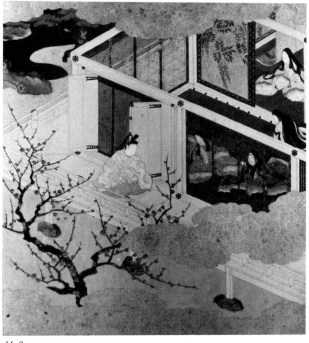

*44–2*

should be many of her women, including one named Saishō. Kaoru is seated at the veranda. He may be seventeen or eighteen years old.

✕✕✕

GENJI
> "Come, young buds—a smile is what we need,
> To tell us that, taken in hand, you would be more fragrant."

Thinking it good for an impromptu poem, he answered:

> "A barren, blossomless tree, I have heard it called.
> At heart it bursts even now into richest bloom.

"Stretch out a hand, if you wish to be sure."
"Lovely the color, lovelier yet the fragrance." And it was indeed as if she meant to find out for herself. (s 754–55)

## SCENE 3

EKOTOBA
Towards the end of the Second Month, Kaoru visits the apartments of the young Tō no Jijū, Tamakazura's son the chamberlain. Coming in through the garden

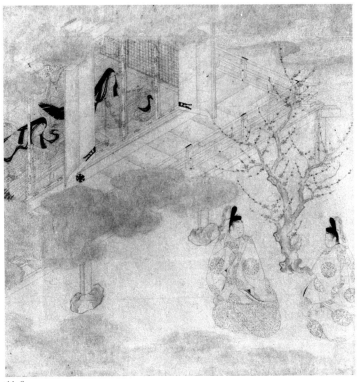

44–3

gate, he sees the lieutenant who has been standing there and who tries to hide from him. Kaoru recognizes and hails him. Tamakazura should be inside the house. The two sisters are playing lutes. In the foregarden should be plum blossoms.

～･～･～

GENJI

Coming in through the garden gate, he saw that another young gentleman had preceded him. Also in casual court dress, the other did not want to be seen, but Kaoru recognized and hailed him. It was Yūgiri's son the lieutenant, very frequently to be found on the premises. Exciting sounds of lute and Chinese koto were coming from the west rooms. Kaoru was feeling somewhat uncomfortable and somewhat guilty as well. The uninvited guest was not his favorite role. (s 756)

SCENE 4

EKOTOBA

In the Third Month, Tamakazura's daughters are seated at a Go board, making the cherry flowers their stakes. Their brother the chamberlain is seated near them. The older sister, who is about eighteen or nineteen, is wearing a white cloak lined with red and a robe of russet with a yellow lining. The younger sister has chosen a light robe of pink, and the soft flow of her hair is like the slender leaves of a willow tree. Some cherry trees are coming into bloom, and some others are shedding their blossoms. The lieutenant peers inside through an open gallery door. There should also be little page girls who gather around the fallen blossoms.

～･～･～

GENJI

The blossoms had been good for an afternoon, and now the stiff winds of evening were tearing at them.

Said the lady who had been the loser:

"They did not choose to come when I summoned them,
And yet I tremble to see them go away."

And her woman Saishō, comfortingly:

"A gust of wind, and promptly they are gone.
My grief is not intense at the loss of such weaklings."

And the victorious lady:

"These flowers must fall. It is the way of the world.
But do not demean the tree that came to me."

And Tayū, one of her women:

> "You have given yourselves to us, and now you fall
> At the water's edge. Come drifting to us as foam."

A little page girl who had been cheering for the victor went down into the garden and gathered an armful of fallen branches.

> "The winds have sent them falling to the ground,
> But I shall pick them up, for they are ours."

And little Nareki, a supporter of the lady who had lost:

> "We have not sleeves that cover all the vast heavens.
> We yet may wish to keep these fragrant petals."          (s 761)

*44–4*

## SCENE 5

EKOTOBA

The time should be about the Fourth Month. The lieutenant* and Tamakazura's son, the chamberlain, sit on the rock to look at a wisteria hanging from a pine tree near the apartments of the lady in the Reizei household.

�широ

GENJI

One still, quiet evening when he was out strolling with her brother the chamberlain, they came to a pine tree before what he judged to be her curtains. Hanging from it was a very fine wisteria. With mossy rocks for their seats, they sat down beside the brook.

There may have been guarded resentment in the poem which Kaoru recited as he looked up at it:

> "These blossoms, were they more within our reach,
> Might seem to be of finer hue than the pine."          (s 765–66)

* This should read Kaoru.

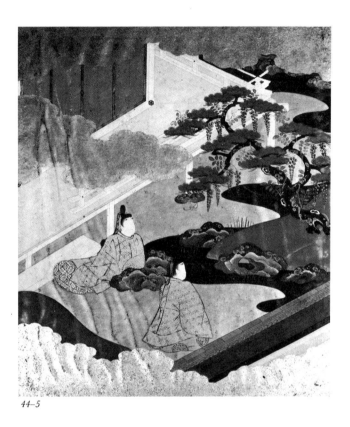

44–5

## Scene 6

EKOTOBA

In the evening of the fourteenth of the First Month, there is a music party at the Reizei Palace. There is a Chinese koto for the emperor's new lady, the older daughter of Tamakazura, a lute for the chamberlain, and a Japanese koto for the emperor.

✕·✕·✕

GENJI

The emperor sent for instruments, a Chinese koto for his new lady, a lute for Kaoru, a Japanese koto for himself. He immediately struck up "This House." The new lady had been an uncertain musician, but he had been diligent with his lessons and she had proved eminently teachable.          (s 769)

# 45.  The Lady at the Bridge

EKOTOBA

Holding his rosary under a sleeve, the Eighth Prince is giving music lessons on
the lute and koto to his daughters. He also holds a holy text in his hand.
Mallards are swimming about on the pond, wing to wing. A daughter takes
out an inkstone and is about to write something on it. He pushes a sheet of
paper towards her.

❥❥❥

GENJI

Oigimi, the older girl, quietly took out an inkstone and seemed about to write
a few lines on it.

"Come now. You know better than to write on an inkstone." He pushed a
sheet of paper towards her.

> "I know now, as I see it leave the nest,
>   How uncertain is the lot of the waterfowl."

It was not a masterpiece, but in the circumstances it was very touching.

(s 777–78)

45–1

THE LADY AT THE BRIDGE  *251*

# SCENE 2

EKOTOBA

While the Eighth Prince is away in a mountain retreat, Kaoru comes to visit the two princesses at Uji. He is dressed in a casual robe, and is accompanied by one guide. The blind has been raised high, and Kaoru peers inside, pushing a gate in the bamboo fence a little. Oigimi is sitting half hidden by a pillar, and has a lute before her. She raises the plectrum as if to bring out the moon, which suddenly bursts forth from behind the clouds. Nakanokimi is leaning against a Chinese koto. There should be a young page girl and an older woman at the veranda.

GENJI

The other, leaning against an armrest, had a koto before her. "I have heard that you summon the sun with one of those objects, but you seem to have ideas of your own on how to use it." She was smiling, a melancholy, contemplative sort of smile. (s 785)

45–2



# SCENE 3

EKOTOBA

It is about the fifth or sixth day of the Tenth Month. Leaves are falling off the branches. Under the lamps, the Eighth Prince is playing a koto. Kaoru, dressed in a cloak and trousers of coarse, unfigured material, is playing a lute. The abbot should be present, and books of holy scriptures should be shown.

GENJI

"You must not make sport of us, sir. Where can music likely to catch your ear have come from? You speak of the impossible."

The prince's koto had a clearness and strength that were almost chilling. Perhaps it borrowed overtones from "the wind in the mountain pines." He pretended to falter and forget, and pushed the instrument away when he had finished the first strain. The brief performance had suggested great subtlety and discernment. (s 794)

# 46. Beneath the Oak

SCENE 1

**EKOTOBA**

On about the twentieth of the Second Month, Niou comes to Uji. His retinue should include many princes and sons of ministers. There should also be six sons of Yūgiri and other princes. There should be gaming boards of Go and backgammon. They naturally bring out wine and musical instruments. It is on the bank of the Uji river. On the mountains should be some cherries coming into bloom, some others already shedding their blossoms. The willows by the river should be dipping the tips of their branches into the water. Wanting to call on the Eighth Prince, Kaoru invites a few princes to join him on a boat. They bring out flutes to play while being rowed across. There should be a messenger from the Eighth Prince. Niou himself writes an answer to the Prince.

*46–1*

Well, thought Niou—from precisely the place that had been on his mind. He himself would send an answering poem:

"On far shore and near, the waves may keep us apart.
Come in all the same, O breeze of the river Uji!"

Kaoru set out to deliver it. In attendance upon him were men known to be particularly fond of music. Summoning up all their artistry, the company played "The River Music" as they were rowed across. The landing that had been put out from the river pavilion of the prince's villa, and indeed the villa itself, seemed in the best of taste, again quite in harmony with the setting.

(s 801–2)

## SCENE 2

EKOTOBA

It is on the same day, and after the above episode. The novel refers to a landing that has been put out from the river pavilion. This must be at the Eighth Prince's villa. Kaoru and his accompanying princes should be talking to the Eighth Prince. There are screens of wattled bamboo. The Eighth Prince plays a Chinese koto. Everyone else plays music and enjoys wine. In the meantime, Niou breaks off a branch of cherry blossoms and has an elegantly attired page boy bring it to the princesses with a message. If a large painting is desired, this scene can be combined with the previous one in one composition, since the two episodes occur on the same day.

GENJI

Matters were even worse for Niou. How constricting it was, to be of a rank that forbade lighthearted adventures! Unable to contain himself, he broke off a fine branch of cherry blossoms and, an elegantly attired page boy for his messenger, sent it across the river with a poem:

"I have come, the mountain cherries at their best,
To break off sprays of blossom for my cap."

And it would seem that he added: "Then stayed the night, enamored of the fields."

(s 802)

## SCENE 3

EKOTOBA

It is winter and there is snow. After the Eighth Prince's death, Kaoru pays a visit to Uji. Oigimi is behind screens, while Kaoru remains on the other side. Ben no Kimi should also be present. Oigimi writes her answer to Kaoru and pushes it from under her curtains. A brazier with fire in it should be set before Kaoru.

46–3

**GENJI**

Presently she pushed a verse from under her curtains:

> "Along the cliffs of these mountains, locked in snow,
>   Are the tracks of only one. That one is you."

"A sort of sophistry that does not greatly improve things.

> "My pony breaks the ice of the mountain river
>   As I lead the way with tidings from him who follows.

'No such shallowness,' is it not apparent?"
More and more uncomfortable, she did not answer.                    (s 816–17)

<p align="center">SCENE 4</p>

**EKOTOBA**

It is the same time as the above episode. Kaoru has the Prince's chapel opened and looks in. As he stands leaning against a pillar, numerous young maidservants peer from behind the corners of screens.

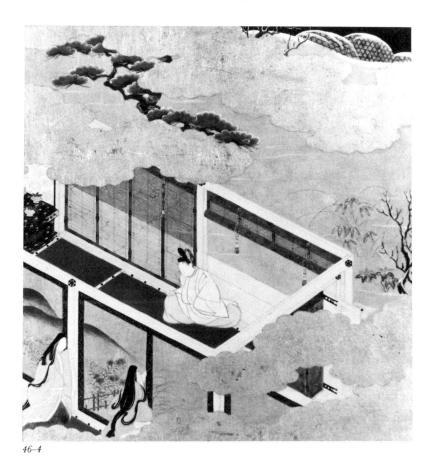

46–4

        "Beneath the oak I meant to search for shade.
        Now it has gone, and all is vanity."

Numerous eyes were upon him as he stood leaning meditatively against a pillar. The young maidservants thought they had never seen anyone so handsome.
                                                 (s 817–18)

## SCENE 5

EKOTOBA

It is summer at Uji. Pulling aside the screen, Kaoru peers through a hole beside the hatch in the partition. The two curtains have been moved to the side, and the wind blows up the blind. The princesses are withdrawing from the chapel to their own rooms. Oigimi wears a dark-gray singlet and orange trousers. The ends of a rosary hang from a sleeve. She looks out at Kaoru's attendants. Nakanokimi wears a singlet and a lined robe of the same dark stuff as her sister's, set off in the same combination. Her hair is less luxuriant, and tapers towards the ends

like a cluster of silken threads. Holding a purple scroll of scripture, she moves toward the curtains, and points out to maidservants that there is a hole in the partition where Kaoru is standing.

<center>〜〜〜</center>

GENJI

Despite their precautions, for but a single thin partition separated the two rooms, he could hear, or rather sense, the withdrawal. In great excitement, he pulled aside the screen before the partition. He had earlier noticed a small hole beside the latch. (s 819)

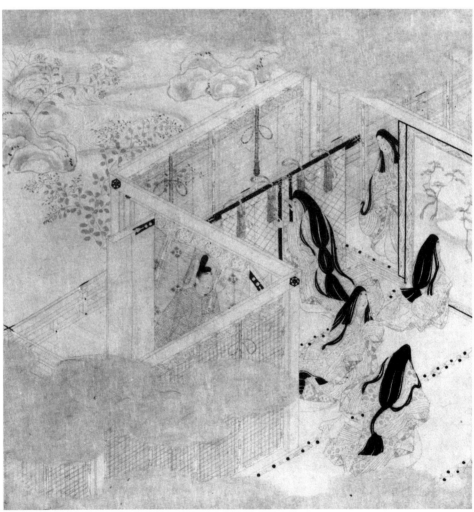

46–5

# 47.   Trefoil Knots

EKOTOBA

It may be in early autumn. At Uji Kaoru sees Oigimi at the chapel. He pushes the screen aside and stops her from fleeing through the door. There is no one nearby. There should be some fruits and lamps.

GENJI

She called to her women to come nearer. No doubt thinking that chaperones would be out of place, they pretended not to hear, and indeed withdrew yet further as they lay down to rest. There was no one to replenish the lamps before the holy images. Again she called out softly, and no one answered.

"I am not feeling at all well," she said finally, starting for an anteroom. "I think a little sleep might do me good. I hope you sleep well." (s 826)

47–1

SCENE 2

EKOTOBA

It is autumn. There is a faint glow from a lamp. Leaving Nakanokimi behind, Oigimi slips out to the side. Kaoru, followed by Ben no Kimi, enters their room, raising a corner of the curtains. Quaking with fear, Oigimi watches from the side.

GENJI

Then, in the dim light, a figure in a singlet pulled the curtains aside and came into the room quite as if he owned it. Whatever would her hapless sister think if she were to awaken? thought Oigimi, huddled in the cramped space between a screen and a shabby wall. (s 834)

47–2

## Scene 3

EKOTOBA

It is probably on the twenty-sixth of the Eighth Month as the book refers to the end of the equinox festival. Kaoru is riding in a carriage and Niou follows him on horseback to Uji. Kaoru clutches at Oigimi's hand through a crack in the blind and is talking to her. Niou signals with his fan to Ben no Kimi from the veranda. They come under cover of darkness. More details are in the book.

◝◝◝

GENJI

He clutched at her sleeve through a crack in the door and began railing at her as he pulled her towards him. She was outraged. What was the man not capable of? But she must humor him and hurry him off to her sister. Her innate gentleness came over to him. Quietly and without seeming to insist, she asked that he be to her sister as he had thought of being to herself.

Niou meanwhile was following instructions. He made his way to the door by which Kaoru had entered that other night. He signaled with his fan and Bennokimi [Ben no Kimi] came to let him in. How amusing, he thought, that his turn should have come to travel this well-traveled route. In complete ignorance of what was happening, Oigimi still sought to hurry Kaoru on his way. (s 839–40)

SCENE 4

EKOTOBA

It is probably early in the Ninth Month. At Uji Niou and Nakanokimi watch the river together as dawn begins to come over the summer sky. There should be Uji Bridge and the faggot boats that are rowing out.

GENJI

As dawn began to come over the sky, he opened a side door and invited her out. The layers of mist delighted him even more than in a familiar setting. As always, the little faggot boats rowed out into the mists, leaving faint white traces behind them. The strangeness of the scene spoke strongly to his refined sensibilities. (s 846)

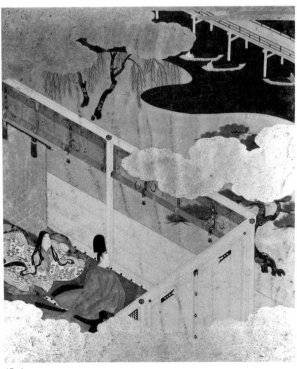

47–4

## SCENE 5

EKOTOBA

It is at Uji around the first of the Tenth Month. The excursion on the boat, which is roofed with scarlet leaves, includes Niou, Yūgiri's son the captain, Kaoru, and other courtiers. The elder brother of the captain, Saemon no Kami, comes with his retinue to meet Niou. There should be music. The young women of the princess's household go out to have a closer look. If a larger composition is desired, it should include some temporary huts along the bank of the river.

GENJI

Music and other exciting sounds came from the boat as it was poled up and down the river. The young women went to the bank for a closer look. They could not make out the figure of the prince himself, but the boat, roofed with scarlet leaves, was like a gorgeous brocade, and the music, as members of the party joined their flutes in this impromptu offering and the next one, came in upon the wind so clearly that it was almost startling. (s 851)

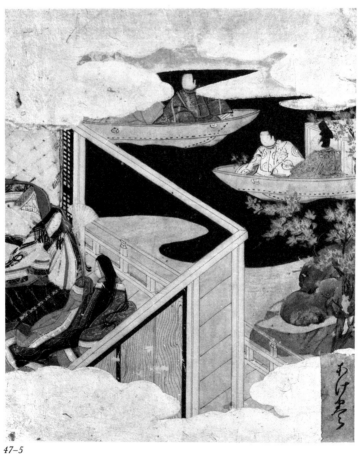

47–5

EKOTOBA

In autumn Kaoru and Niou come to see the First Princess, and they address her through a curtain. There should be many pictures. Niou pushes a scroll under the curtain towards her, and as she bends to look at it her hair is swept aside. There should be many ladies nearby.

GENJI

"'A pity indeed if the grasses so sweet, so inviting,'" he whispered, and one may wonder what he had in mind. "I gather that in those days brother and sister did not have to talk through curtains. You are very remote."

She asked what picture he was referring to. He rolled it up and pushed it under the curtain, and as she bent to look at it her hair was swept aside and he caught a brief and partial glimpse of her profile. It delighted him. He found himself wishing that she were not his sister. A verse came to his lips:

"I do not propose to sleep among the young grasses,
    But ensnared in them I must confess to be."

Her attendants had withdrawn in embarrassment.                    (s 857)

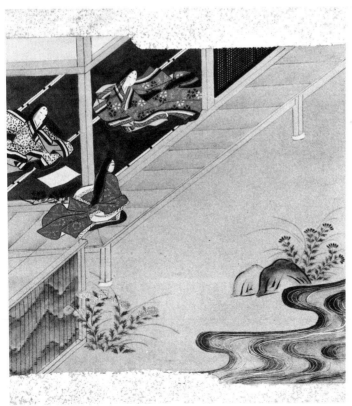

47–6

# 48.   Early Ferns

<br />

<div align="center">SCENE 1</div>

**EKOTOBA**

It is probably towards the end of the First Month. There is a basket of shoots of bracken and fern sent to Nakanokimi from the abbot. The princess should be there.

<div align="center">〜〜〜</div>

**GENJI**

There was a letter from the abbot for one of her women: "And how will matters be with our lady now that the New Year has come? I have allowed no lapse in my prayers for her. She is, in fact, my chief worry. These are the earliest fern shoots, offerings from certain of our acolytes." The note came with shoots of bracken and fern, arranged rather elegantly in a very pretty basket. There was also a poem, in a bad hand, set apart purposely, it seemed, from the text of the letter.

> "Through many a spring we plucked these shoots for him.
>   Today remembrance bids us do as well.

"Please show this to your lady."                                    (s 872–73)

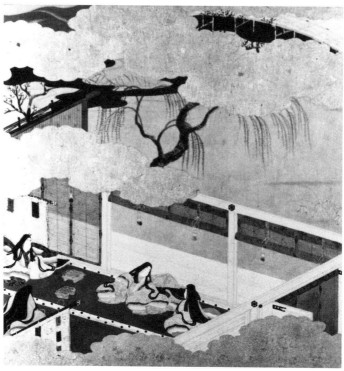

*48–1*

<br />

## SCENE 2

EKOTOBA

The time is spring. Kaoru pays Niou a visit. Niou plays on the Chinese koto. Kaoru breaks off a branch of the rose plum in the foreground and brings it to him.

GENJI

Niou was ... plucking a few notes now and then on the koto beside him. He had always loved the scent of plum blossoms. Kaoru broke off an underbranch still in bud and brought it to him, and he found the fragrance so in harmony with his mood that he was stirred to poetry:

"This branch seems much in accord with him who breaks it.
    I catch a secret scent beneath the surface."

"I should have been more careful with my blossoms.
    I offer fragrance, get imputations back.

"You do not make things easy for me."
    They seemed the most lighthearted of companions as they exchanged sallies.

(s 874)

48–2

EARLY FERNS    265

## SCENE 3

The time is spring and the half-moon is out. Nakanokimi arrives at Niou's mansion late at night. Carriages and other fittings should be beautifully arranged. Niou himself helps her down from the carriage. Many attendants of the Fourth and Fifth ranks are there.

〜〜〜

GENJI

The splendor quite blinded her. The carriage was pulled up at one of the "three-fold, fourfold" halls, and an impatient Niou came out. [He helped her down from the carriage.]*                                                    (s 882)

*This is omitted in Seidensticker's translation.

48–3

# 49.   The Ivy

EKOTOBA

After the emperor and Kaoru have played a game of Go, Kaoru goes down into the garden and breaks off a chrysanthemum branch for the emperor.

゛゛゛

GENJI

Returning, he offered a cautious verse:

>"If I had found it at a common hedge,
>    I might have plucked it quite to suit my fancy."

The emperor replied:

>"A single chrysanthemum, left in a withered garden,
>    Withstands the frost, its color yet unfaded."          (s 888)

49–1

<center>SCENE 2</center>

EKOTOBA

After getting dressed for a visit to Nakanokimi, Kaoru steps down into the garden and breaks off a tendril of morning glories. There should also be maiden flowers in the garden. A carriage and attendants should be included.

<center>～✕～</center>

GENJI

"It lasts, I know, but as long as the dew upon it.
Yet am I drawn to the hue that fades with the morning.

49–2

*Detail of 49–2*

"How very quickly it goes."

He broke it off to take with him, and left without a glance for the saucy maiden flowers.

<div style="text-align: right">(s 893)</div>

## SCENE 3

EKOTOBA

Following the above episode, Kaoru should be seated on a cushion at the threshold to the inner rooms. Nakanokimi is behind the curtain. From under the blind, he thrusts the fan, on which he has laid the withering morning glory.

⌇⌇⌇

GENJI

> "Should I have taken the proffered morning glory
> With the silver dew, the blessing, still upon it?"

He had made no special effort to preserve the dew, but he was pleased that it should still be there—that the flower should fade away fresh with dew.

> "Forlorn the flower that fades with the dew upon it.
> Yet more forlorn the dew that is left behind."

<div style="text-align: right">(s 894)</div>

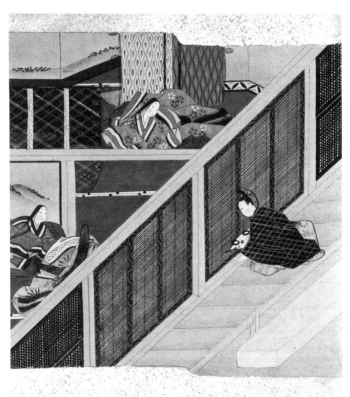

*49–3*

## Scene 4

EKOTOBA
It is in the autumn. As Yūgiri is withdrawing from the royal presence, he invites Kaoru to share a carriage with him.

✕✕✕

GENJI
The empress being indisposed, Niou went to the palace the next day. He found the whole court assembled. She proved to be suffering from no more than a slight cold, however, and Yūgiri, as he left, invited Kaoru to share a carriage with him.                                                                          (s 902)

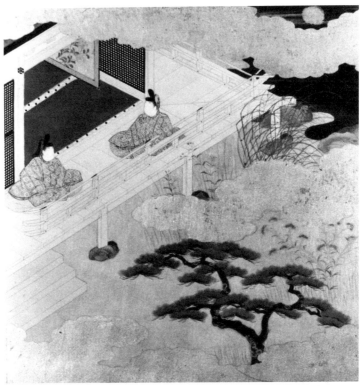

49–4

## Scene 5

EKOTOBA
In the autumn and after the above episode, there is a nuptial ceremony for Niou and Rokunokimi at Yūgiri's palace. Niou comes and meets Rokunokimi's family. There should be eight beautiful stands, dishes, two smaller stands, and trays with festoon-shaped legs and rice cakes. These things may be placed in front of Rokunokimi.

Saemon no Jō and Tō no Saishō should be in attendance. Tō no Chūjō, master of ceremonies, sees to it that the wine cups are refilled. Kaoru should also be present. In the east wing, six men of the Fourth Rank among Niou's retinue receive ladies' robes and cloaks; ten men of the Fifth Rank are given double-lined Chinese robes; and four men of the Sixth Rank receive trousers and brocade cloaks. Handymen and grooms each are given gifts. There should be many, many people and carriages in this scene.

〰〰

GENJI

Arriving at the banquet, Yūgiri pointed out to Niou, who had not yet emerged from the bridal chambers, that it was growing very late and his company was much missed. But Niou still loitered among the ladies, whose company he was enjoying enormously. In attendance upon him were Yūgiri's brothers-in-law, a guards commander and a councillor. Finally the bridegroom emerged, a very spruce figure indeed. Yūgiri's son the captain was acting as master of ceremonies and pressed wine upon Niou. The cups were emptied a second time and a third, and Niou smiled at Kaoru's diligence in seeing that they were refilled. (s 903–4)

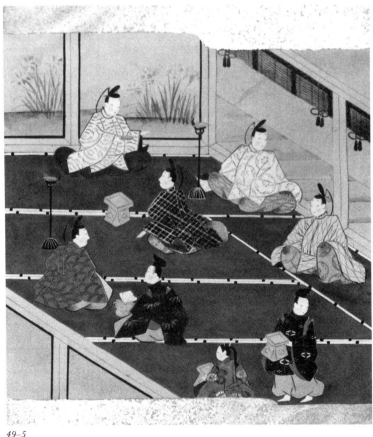

49–5

<div align="center">

SCENE 6

</div>

EKOTOBA

It is at night, and may be towards the end of autumn. At Nakanokimi's apartments Kaoru pushes up the curtain and takes Nakanokimi's sleeve. He then pushes his way after her and sets himself down beside her. There are two women in her attendance, but they withdraw.

<div align="center">⁓⁓⁓</div>

GENJI

Abruptly, he leaned towards the pillar by which he was sitting and reached for her sleeve.

She should have known! She slipped deeper into the room. He pushed his way after her as if he were one of the family and again took her sleeve.     (s 908)

<div align="center">

SCENE 7

</div>

EKOTOBA

It is in the autumn and at Nakanokimi's place. Reaching from under the blind, Kaoru takes her hand. Nakanokimi tries to talk to him as calmly as possible. There should be women in close attendance.

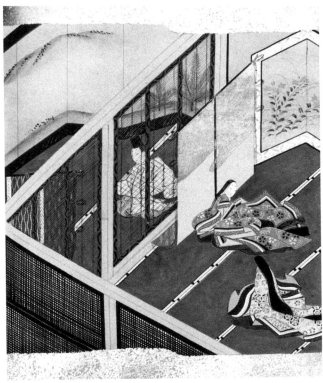

*49–7*

*272*  THE TRANSLATIONS AND PAINTINGS

GENJI

"This image you speak of reminds me of something. Something very strange."

"Yes?" Delighted at this new amiability, he reached under the curtain for her hand.

So here they were again! But her indignation did not keep her from wanting to quiet him somehow and make reasonable discussion possible; and there was the problem of Shōshō, sitting right beside her.                    (s 916)

## SCENE 8

EKOTOBA

Kaoru comes to Uji in late autumn. Ben no Kimi should be before him. The trees have been stripped bare by the winds and there are no tracks through the leaves. The garden is covered with red maple leaves. Kaoru has someone break off a sprig of red ivy that has climbed a mountain tree. There should be Chinese chests, and there may be some cotton, too.

ﾍﾍﾍ

GENJI

The ivy climbing the twisted mountain trees still had traces of autumn color. He broke off a sprig, thinking that even so small a gift would please Nakanokimi.

> "Memories of nights beneath the ivy
> Bring comfort to the traveler's lonely sleep."

This was Bennokimi's answer:

> "Sad must be the memory of lodging
> Beneath this rotting, ivy-covered tree."

Though he would not have called it a modish, up-to-date poem, it was not without charm, and it brought consolation of a sort.                    (s 921–22)

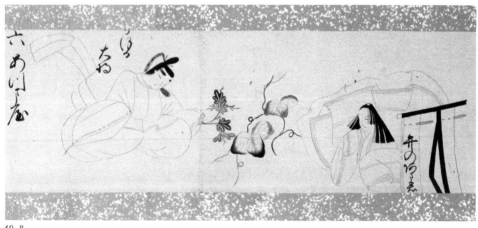

49–8

## SCENE 9

EKOTOBA

Nakanokimi is leaning against an armrest by the edge of a low curtain and is playing with her fan. Niou, dressed in an informal robe, is playing a lute tuned in the *ōjiki* mode. A koto should be before Nakanokimi. In the garden the plumes of autumn grasses are swaying in the breeze; some, which are not yet headed, are flecked with dew. Niou has a chrysanthemum brought to him and looks at it.

〳〵

GENJI

She was a charming figure herself. Leaning against an armrest, she peeped shyly out from behind a low curtain.

> "Weakly, weakly the wind glides over the grasses.
> One knows that the moor is at the end of autumn."

To her poem she added only the words: "Left alone."

Embarrassed at her inability to hold back tears, she hid her face behind a fan. She was a delight, and he pitied her; and at the same time he could see that precisely this appeal would make it difficult for other men to stay away. His doubts came back, and his resentment. (s 923)

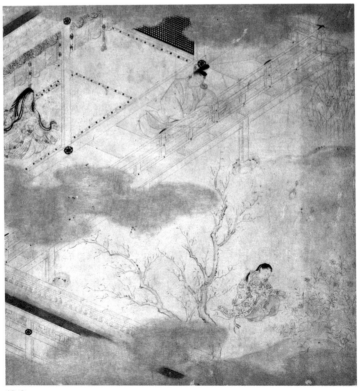

*49–9*

*274* THE TRANSLATIONS AND PAINTINGS

# SCENE 10

EKOTOBA

It is after the above episode and at the beginning of winter. As in the previous scene, a Chinese koto should be placed before Nakanokimi. It is tuned to the *banjiki* mode. Yūgiri stops by Niou's place, and as he leaves he takes Niou with him. Many courtiers and princes follow them. Nakanokimi's women look out.

GENJI

"What fond memories this place does call up. I ought to come more often, I suppose, but, not having much by way of excuse—" Yūgiri talked of the old days for a time, and when he left he took Niou with him.

It was indeed a parade, row upon row of sons and courtiers. (s 924)

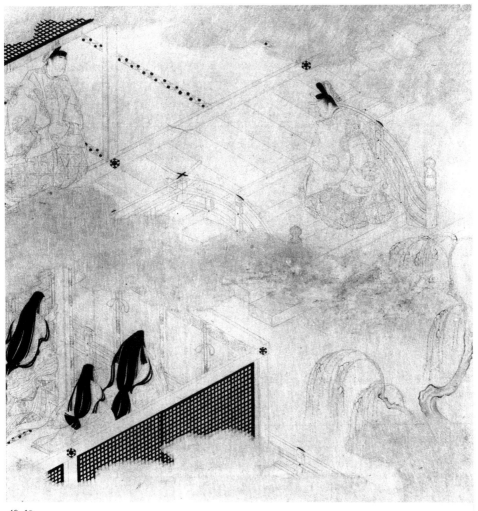

49–10

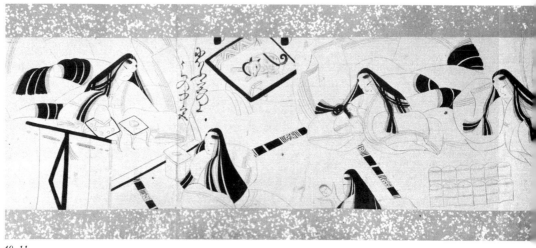

49–11

## SCENE 11

Early in the Second Month, Nakanokimi gives birth to a prince. All the courtiers and princes come to congratulate her. Kaoru sends fifty servings of ceremonial rice, prizes for the Go matches, and other stores of food. The book also refers to thirty trays on stands, five sets of swaddling clothes, and diapers, which are set before Nakanokimi.

GENJI
As is the custom, the celebration on the third night was private. On the fifth night Kaoru sent fifty servings of ceremonial rice, prizes for the Go matches, and other stores of food, as custom demanded. To Nakanokimi he sent thirty trays on stands, five sets of swaddling clothes, and diapers and the like. There was nothing grand or obtrusive about these various gifts, but close inspection revealed uncommonly fine taste. To Niou went twelve trays of aloeswood, and, on stands, steamed cakes of the five-colored cereals. The women in attendance upon Nakanokimi received trays on stands, of course, and thirty cypress boxes. Everything was in the best taste, in nothing was there even a hint of wanton display. (s 926)

## SCENE 12

EKOTOBA
In the Fourth Month the emperor pays a royal visit to the apartments of the Second Princess's mother for a wisteria-viewing party. The blinds are rolled up and the royal seat is put out on the south veranda. Yūgiri and Kōbai are in attendance, as are Kaoru and Sahyōe no Kami; Niou and Prince Hitachi are also present. Courtiers of medium rank are seated beneath the wisteria arbors.

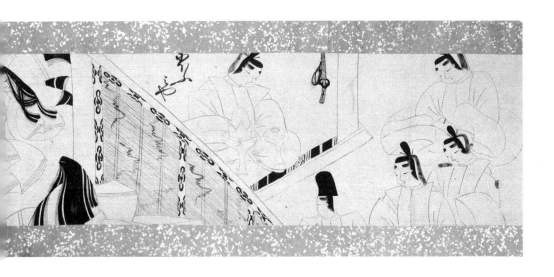

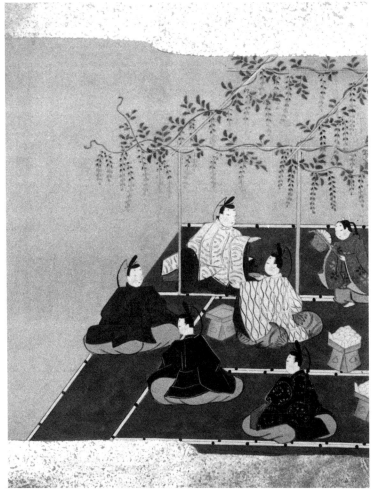

49–12

Court musicians are called in to play wind instruments. Yūgiri presents to the emperor two scrolls of koto scores attached to felicitous pine branches. Lutes, flutes, as well as the Chinese and Japanese koto are brought out from behind the curtain. Behind the blinds should be the Second Princess, Kaoru's wife.*

Kaoru descends to the garden to offer ritual thanks. The Second Princess sends out cakes of five-colored cereals. There are four trays of aloeswood and stands of sandalwood, and cloths of varied lavender embroidered with wisteria branches. There are glass cups and silver saucers and indigo decanters. Hyōe no Kami is responsible for the cups being kept full.

⌣⌣⌣

GENJI

Yūgiri also presented two koto scores in the late Genji's own hand. Genji had given them to Kaoru's mother, and now, for presentation to the emperor, they were attached to felicitous pine branches. Lutes as well as kotos of the several varieties were brought out, all of them once the property of the Suzaku emperor.

(s 929)

* Their wedding ceremony has not taken place yet. See scene 14 of this chapter.

SCENE 13

EKOTOBA

The setting for this scene is the same as above. There should be sheets of poems upon the lectern. Kaoru breaks a sprig of flower for the royal cap and presents it to the emperor. It is probably a wisteria branch.

⌣⌣⌣

GENJI

"Wisteria, thought I, to grace the august bonnet;
And my sleeve has caught upon a high, high branch."

Such are the airs one assumes when one marries a princess. And this His Majesty's reply:

"Its fragrance shall last through all the centuries.
We shall not then be weary of it today."

Someone else presented this:

"The wisteria spray that graces the august bonnet
Competes with the purple clouds of paradise."

And yet another:

"It sends its cascade of flowers to the loftiest heights.
Of a most uncommon hue is this wisteria."

(s 930–31)

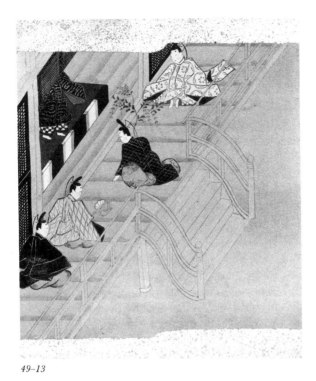

*49–13*

## Scene 14

EKOTOBA

On the same evening, the Second Princess is escorted to Kaoru's mansion for the wedding. The princess rides in a brocaded carriage with a wide, flaring roof. In the procession are three carriages with plain roofs, six carriages whose facings of plaited palmetto are embossed with gold, and twenty similar carriages without the gold, and two more with wickerwork facing. Each carriage is attended by eight little maids of honor and eight serving women. From Kaoru's house come twelve carriages to meet them. A large number of high courtiers and medium-ranking officials of the Sixth Rank come with the princess.

⌁⌁⌁

GENJI

The princess rode in a brocaded carriage with a wide, flaring roof. In the procession were three carriages similarly brocaded but with plain roofs, six carriages whose facings of plaited palmetto were embossed with gold, twenty such carriages without the gold, and two carriages with wickerwork facings. There were thirty ladies-in-waiting, each attended by eight little maids of honor and eight serving women, and they were joined by women who had been sent from Kaoru's house in twelve carriages. The ranks of courtiers down to the Sixth Rank quite exhausted the possibilities of gorgeous display. (s 931)

# SCENE 15

EKOTOBA

Following the above episode, probably in the Fifth Month, Kaoru goes to Uji and chances to see Ukifune as she stops there on her way back from the temple at Hatsuse. A screen about four feet high has been spread against the door. Kaoru looks in through the hole above the screen. Inside, Ukifune is lying down, her head resting upon her arm, and her face turned away from him. She is dressed in a robe of deep red, and over it a cloak that seems to be pink lined in lavender, with another pale-green cloak showing beneath it. There should be two female servants nearby. Ben no Ama is dressed in blue and gray. There should be carriages and rustic-looking men, who unload luggage from their horses. Kaoru peeps in again, and sees Ben no Ama and other women taking their meals.

〜〜〜

GENJI

Their mistress had lain down, in silence. The arm upon which she rested her head was plump and pretty. Such a charming girl, one knew, could not have been sired by a boor like the governor of Hitachi. (s 933)

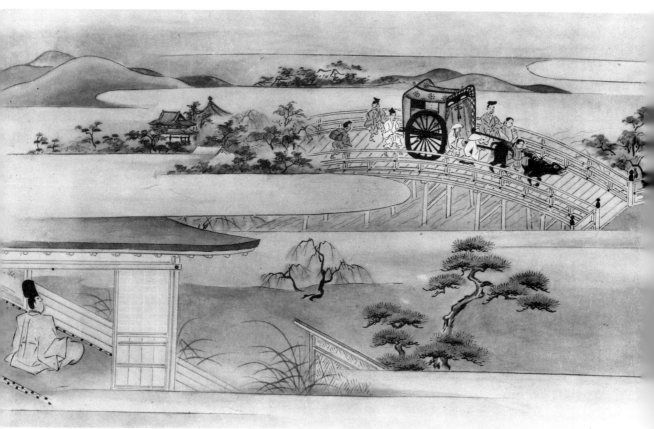

49–15

# 50.　The Eastern Cottage

EKOTOBA

It is autumn. The marriage intermediary comes to see the governor of Hitachi at his house with a hinged door. There should be bows in the room, and the governor should be dressed informally, wearing a sword. The intermediary, a soldier, may wear trousers and an informal cap.

～～～

GENJI

"I have all sorts of children, but she's far and away my favorite. Just let him be good to her, and I'll see him all the way, I'll make a minister of him. He won't have to ask for a thing, even if I have to borrow money while I'm getting things done." (s 942)

SCENE 2

EKOTOBA

The time is autumn. As the governor's wife peers, Niou emerges in court dress. Lieutenant Sakon, dressed in a lined robe and wearing a sword, waits at the

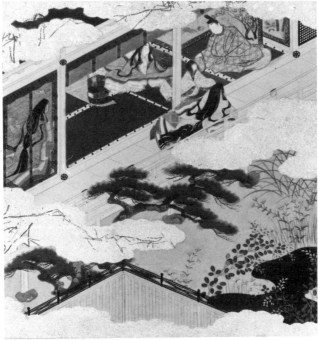

50–2

veranda. There should also be other men in Niou's attendance. Niou's baby crawls from under a blind on hands and knees.

—·—·—

GENJI

On hands and knees, the little prince was peering from under a blind. Niou came back and gave him another bouncing.

"If the empress is feeling better, I'll come straight home. Otherwise I suppose I'll have to stay until morning. I do hate to be away for even a single night."

The governor's wife gazed on and on until finally he made his departure, and when he was gone she was somehow lonely. (s 947)

## SCENE 3

EKOTOBA

It is late in the Eighth Month. Niou sees a screen and beside it a curtain of a light cloth. Wearing a robe of a bright lavender and a cloak of what looks like

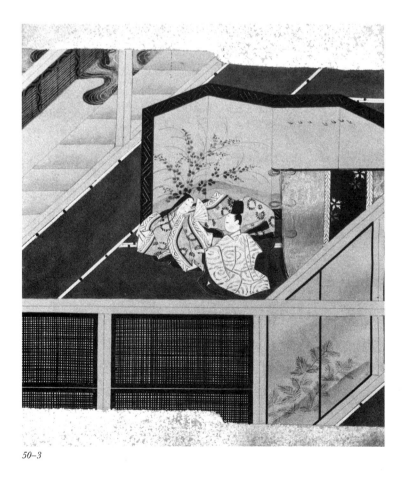

50–3

greenish yellow with woven patterns, Ukifune sits at the edge of the veranda, near the garden in front of the room. The garden is enclosed by a gallery and high rocks are placed along a brook. There is a profusion of autumn flowers.

Niou slides himself through the opening between screens and takes hold of Ukifune's sleeve. She brings a fan to her face. He then pushes the door shut with his other hand. Ukifune's nurse pushes aside the screen, sees the two, and is horrified. This happens while Nakanokimi is taking a bath.

GENJI

She brought a fan to her face, and, very engaging in her shyness, turned to see who he might be. He took the hand that held the fan.

What was she to do? And who might he be? He had caught her quite unawares.                                                                                          (s 954)

SCENE 4

EKOTOBA

At the same time as above, Nakanokimi sends for Ukifune. The princess takes out various pictures, and spreads them over the armrests. The lamp is near. Facing each other, the two women examine the pictures, while Ukon reads the texts.

GENJI

The princess took out illustrations to old romances, which they examined while Ukon read from the texts. Absorbed now in the pictures and facing her sister in the lamplight, Ukifune had a delicate, girlish beauty that was perfection of its kind.                                                                                          (s 958)

SCENE 5

EKOTOBA

It is autumn, and there are autumn leaves on the mountains. Kaoru visits Uji. He sits on a rock in the foregarden and looks into the brook. His retinue may be shown.

GENJI

He went into the garden and sat on a rock by the brook. The scene was not an easy one to pull himself away from.

> "They still flow on, these waters clear and clean.
> Can they not reflect the image of those now gone?"                          (s 963)

50–5

## SCENE 6

EKOTOBA

It is the same time as above. Kaoru comes to a small cottage with a hinged door in Sanjō where Ukifune has been moved. It is in ruinous condition. He is seated at the edge of a veranda. At dawn peddlers are offering their wares, and women among them are striding with their wares balanced on their heads. Ben no Ama should also be there.

GENJI

The women among them, he had heard, could look like veritable demons as they strode about in the dawn with their wares balanced on their heads. It was a new experience, passing the night in a tangle of wormwood, and he was not at all bored.

(s 967)

## SCENE 7

EKOTOBA

It is probably on the next day. Kaoru brings Ukifune to Uji. There is a bright moon. Ukifune and Kaoru should be there. Ukifune holds a white fan. Fruits are brought from the nun's rooms. Sprigs of ivy and maple have been laid out on the lid of the box. There should be a koto too. Jijū is a messenger.

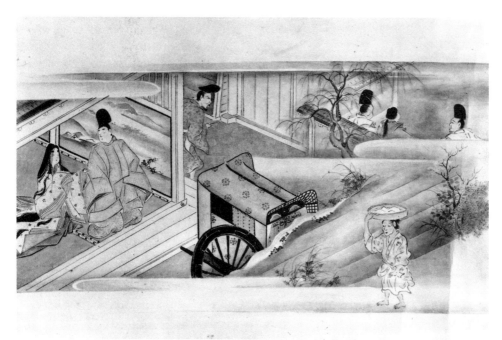

*50–6*

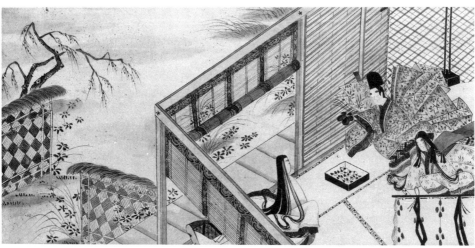

*50–7*

GENJI

Refreshments were brought from the nun's rooms. Sprigs of ivy and maple had been laid out tastefully on the lid of the box, and on the paper beneath (one may imagine that he was hungry) he caught a glimpse, in the bright moonlight, of a poem in a shaky old hand:

> "Autumn has come, the leaves of the ivy change;
> And bright as of old, the moon of memories." (s 971)

# 51.   A Boat upon the Waters

EKOTOBA

Early in the New Year, a little girl brings a greeting from Uji to Nakanokimi. The letter is in a cream-colored envelope. With it is a small whiskered basket attached to an artificial seedling pine. The basket may be gold-colored. A branch at a fork in the pine has been strung with artificial red berries, and a poem is attached to it. Niou sees the letter and Nakanokimi flushes.

ᘑᘑᘑ

GENJI

"Our seedling pine has not known many years.
I see for it, withal, a pine's long life."

It was not a particularly distinguished poem. Yet he continued to read it over, sensing that it would be from a lady who had been much on his mind.

"Send off an answer. You must not be rude, and I see no need for secrecy." He turned to go. "I have no choice but to leave you when you are in one of your moods." (s 975)

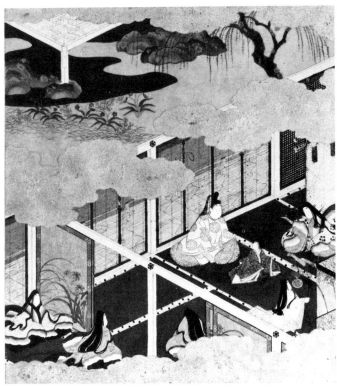

*51–1*

## SCENE 2

EKOTOBA

Towards the end of the First Month Niou comes to Uji in secret. Breaking
through the reed fence, he slips inside and makes his way up to the veranda.
The house is new and roughly finished; there are many cracks. Inside, a lamp
is burning bright, and women are sewing and spinning thread. Ukifune herself
lies gazing into the light, her head pillowed on her arm.

GENJI

Ukifune herself lay gazing into the light, her head pillowed on her arm. Her
eyes, charmingly girlish and not without a certain dignity, and her forehead,
thick hair spilling down over it, reminded him astonishingly of his princess at
Nijō.                                                                    (s 978)

51–2

## Scene 3

EKOTOBA
At the same time as above, Niou draws some pictures and shows them to Ukifune.

~·~·~

GENJI
"You must look at this and think of me when I am not able to visit you." He sketched a most handsome couple leaning towards each other. "If only we could be together always." And he shed a tear.

"The promise is made for all the ages to come,
  But in these our lives we cannot be sure of the morrow."      (s 983)

*51–3*

## Scene 4

EKOTOBA
It is at the same time as above. Niou is preparing for the departure, and Ukifune sees him to the door.

GENJI

She saw him to the door, and still he could not leave her.

> "What shall I do? These tears run on ahead
>   And plunge the road I must go into utter darkness."

She was touched.

> "So narrow my sleeves, they cannot take my tears.
>   How then shall I make bold to keep you with me?"     (s 985)

## SCENE 5

EKOTOBA

On the first day of the Second Month,* Kaoru is at Uji. He and Ukifune together are looking at the river under the new moon of the month. The Uji bridge should

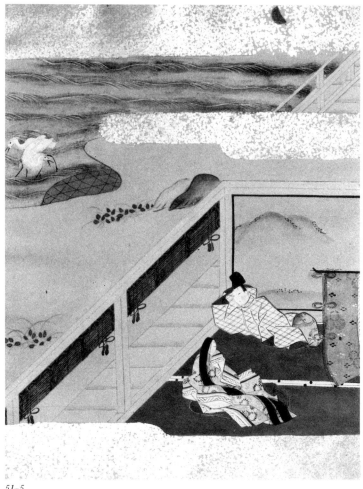

*51–5*

be shown, with faggot-laden boats weaving in and out. The hills are veiled in a mist and crested herons have gathered at a point along the strand.

➳➳➳

GENJI
At a loss to console her, for it seemed that her tears were about to spill over, he offered a poem:

> "No need to grieve. The Uji bridge stands firm.
> They too stand firm, the promises I have made you.

"I am sure that you know what I mean."
She replied:

> "The bridge has gaps, one crosses gingerly.
> Can one be sure it will not rot away?"                    (s 989–90)

*The writing is not clear here.

## SCENE 6

EKOTOBA
It is probably on the fourteenth or fifteenth of the Second Month. There is a heavy snowfall and the moon is out in the early morning sky. Niou takes Ukifune

51–6

*Detail of 51–6*

and Jijū out on a boat to the Islet of Oranges. There should also be a boat-man.

❧❧❧

GENJI

"See," said Niou, "they are fragile pines, no more, but their green is so rich and deep that it lasts a thousand years.

> "A thousand years may pass, it will not waver,
>   This vow I make in the lee of the Islet of Oranges."

What a very strange place to be, thought the girl.

> "The colors remain, here on the Islet of Oranges.
>   But where go I, a boat upon the waters?"

The time was right, and so was the girl, and so was her poem: for him, at least, things could not have been more pleasingly arranged.                    (s 991)

SCENE 7

EKOTOBA

At the same time as the above, Niou takes Ukifune to the house of the governor of Inaba. It is a rustic house and there are plaited screens. There is a heavy snowfall, and patches of snow can be seen at the fence. Ukifune is wearing layers of white singlets, not the formal kind with twelve layers or robes in many different colors.

The mountain above caught the evening glow as in a mirror. He described, with some embroidering, the horror of last night's journey. A crude rustic inkstone having been brought to him, he set down a poem as if in practice:

> "I pushed through snowy peaks, past icy shores,
> Dauntless all the way—O daunting one!

"It is true, of course, that I had a horse at Kohata."
In her answering poem she ventured an objection:

> "The snow that blows to the shore remains there, frozen.
> Yet worse my fate: I am caught, dissolve in midair."

This image of fading in midair rather annoyed him.                (s 993)

## SCENE 8

EKOTOBA

Niou's messenger comes to Jijū, bearing Niou's letter to Ukifune. It is written on purple tissue paper, and is tied to a cherry branch. Kaoru's guardsman also happens to come by and questions him.

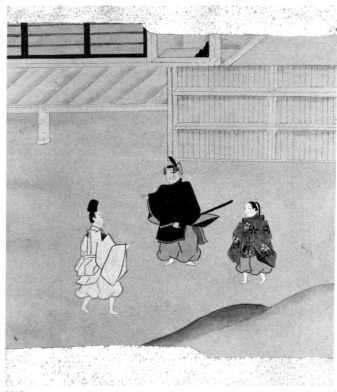

51–8

The two messengers had crossed paths that rainy day and today they met again. Kaoru's messenger, a guardsman, had occasionally seen the other, a groom, in the house of that accommodating secretary.

"And what brings your honorable self out into the country so often?" he asked.

"Well, you see, there's someone here I write little notes to."

"Come, now. You deliver your own notes? I suspect you're not telling me everything."

"Well, as a matter of fact, the governor, you see, is in touch with someone here."

It all seemed very odd, very improbable. This was not, however, the time to press the matter, and they went their separate ways.          (s 1000–1001)

<div align="center">SCENE 9</div>

EKOTOBA

It is at the same time as above. All the courtiers and princes are at the royal palace. The secretary presents Ukifune's letter to Niou at the doorway to one of the withdrawing rooms. Niou takes her note, written on fine red paper, and

51–9

inquires after her closely. On her way from an interview with the empress, Kaoru stops to watch. Yūgiri is also behind a door.

◦◦◦

GENJI

Niou took Ukifune's note, along with several others, at the doorway to one of the withdrawing rooms. On his way from an interview with the empress, Kaoru sensed something furtive in the meeting and stopped to watch.          (s 1001)

SCENE 10

EKOTOBA

The guardsman brings Kaoru's letter to Ukifune. She may be weeping as she reads it.

*51–10*

GENJI

At Uji, the increasing frequency of his messages was a new worry. The latest said only:

"It yet stands firm, the pine-clad mount of Sué,
Thought I. And even then the waves engulfed it!

"Do not, I pray, make us an object of unkind laughter."
An odd thing to say—what could he mean? (s 1003)

## SCENE 11

EKOTOBA

It is probably towards the end of spring. Ukifune takes out Niou's letters and other papers to burn. Ukon's nurse tries to stop her. The rest is described in detail in the book.

GENJI

Unobtrusively, she began tearing up suggestive papers, burning them in her lamp and sending the ashes down the river. Women not in her confidence assumed that she was destroying fugitive notes written to beguile the tedium and not worth taking to the city. (s 1006)

## SCENE 12

EKOTOBA

It is at Uji at night. Dismounting from his horse and seating himself on a saddle blanket in the open field, Niou talks to Ukon. Village dogs are barking suspiciously, and the guards make the bowstrings twang. They try to hide the torches.

GENJI

His men chased the dogs away repeatedly but still they barked. From the villa came the twang of bowstrings and the rough voices of the guard alerting the house to the danger of fire.

We need not seek words to describe Niou's feelings as Jijū hurried him on his way.

"I weep, I go—to lose myself!—where soar
No mountains but know the white of clinging clouds.

"Hurry home yourself."
Jijū wept the whole of the way back. (p. 1009)

# 52.   The Drake Fly

## Scene 1

EKOTOBA

It may be in the Fourth Month. As Ukifune seems to have passed away, Ukon and Jijū load a carriage with her personal belongings, cushions, and quilts [she had actually slipped away from them the night before]. Mother and nurse are both near collapse from grief. In the procession are two or three monks. The funeral carriage is burned at the moor of the mountain on the other side.

～･～･～

GENJI

Mother and nurse were near collapse from grief and (the omens were not good) foreboding.

Udoneri, who had so intimidated them all, stopped by with his son-in-law. "We ought to let the general know of the funeral, and allow time to do it right."

"We want it to be very quiet, before the night is over."

The funeral carriage proceeded to the moor at the foot of the mountain. No one was allowed near save the few monks who knew what had happened.

(s 1016)

## Scene 2

EKOTOBA

It is in the Fifth Month, at Kaoru's mansion. Kaoru breaks off a sprig of orange blossom and sends it to Niou. A cuckoo calls as it flies overhead.

～･～･～

GENJI

The scent of the orange blossoms near the veranda brought memories. A cuckoo called and called a second time as it flew overhead. "Should you stop by her dwelling, O cuckoo." His heart heavy with memory and yearning, he broke off a sprig of orange blossom and sent it with a poem to Nijō, where Niou was spending the night.

> "It sings in the fields its muted song of the dead.
> Your muted sobs may have joined it—to no avail."     (s 1021)

## Scene 3

EKOTOBA

At night Niou sends for Jijū and sees her at a gallery. She has on a mourning

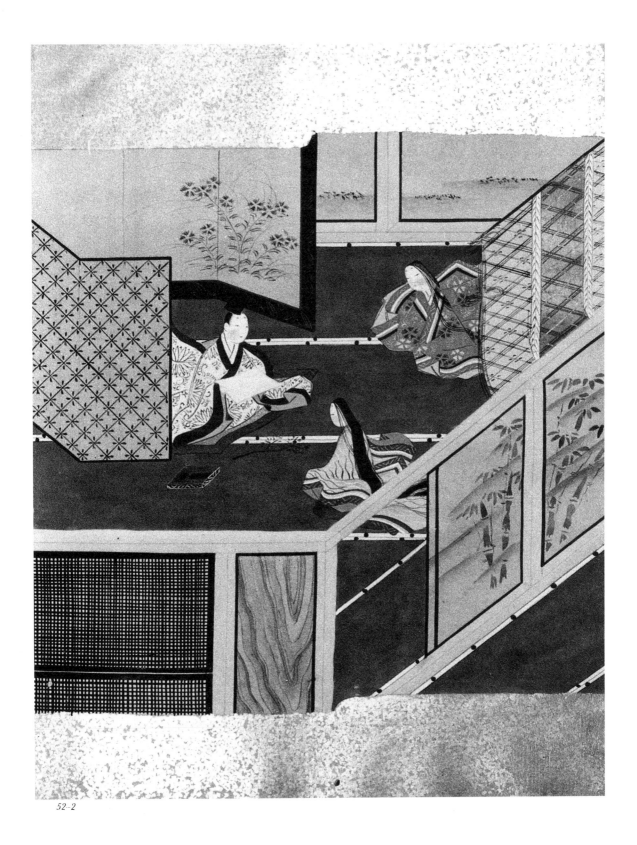

52-2

robe of lighter hues. Niou gives her a comb box and a clothespress he had had made for Ukifune.

>·<·<

GENJI

He gave her a comb box and a clothespress he had had made for Ukifune. Though he had in fact put together a considerable collection of boxes and chests, he gave her only what she could take with her.                    (s 1023)

SCENE 4

EKOTOBA

It is at the same time as above. Kaoru comes to Uji to question Ukon about Ukifune. He sits on the stool which is used for supporting the carriage shafts. Ukon should be shown a few steps away from him.

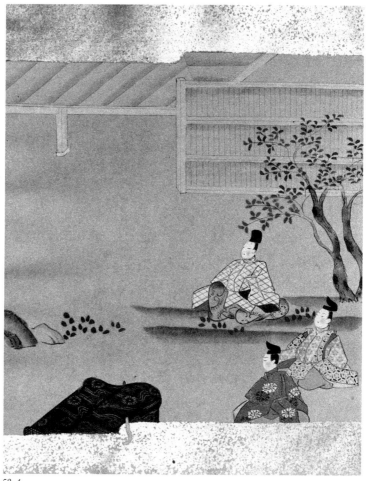

52–4

GENJI

There had been no remains and so there could be no pollution. Wishing to maintain appearances before his men, he stayed on a side veranda all the same, not far from his carriage. After a time it came to seem a not very dignified position, and so he went to sit in the garden, deep-shaded moss for his cushion. He did not think that he would again be visiting this ill-starred house.

> "Should even I, sad house, abandon you,
> Who then will remember the ivy that offered shelter?"     (s 1026)

## SCENE 5

EKOTOBA

It is probably in the first of the Sixth Month and at Rokujō. Kaoru looks in through an opening of a sliding door above a boardwalk. The curtains, behind which are three women and a little girl chipping at a large block of ice on a tray, are somewhat disordered. A lady in a white gossamer robe and red trousers, ice in hand, watches the others bickering and behaving in a rather unladylike fashion. She is probably the First Princess. Her hair is pushed forward.

GENJI

The day being a warm one, her hair, indescribably rich and lustrous, had been pushed to one side, revealing her full profile. By comparison her women seemed rather plain.     (s 1031)

52–5

*Detail of 52 5*

## SCENE 6

EKOTOBA

It is at the same time as the above episode. All the gossamer robes are hanging over a curtain rack. Kaoru takes one and helps the Second Princess slip into a white one. Her trousers are scarlet.

✕✕✕

GENJI

"Do try it on. You will feel half undressed, I know, with all these ladies around, but don't let them worry you."

He held the new robe for her to slip into. Her trousers were scarlet, as her sister's had been. (s 1032)

## SCENE 7

EKOTOBA

It is probably towards the end of the summer, and at the royal palace. Kaoru looks into the east galleries where numbers of women are at practice on their calligraphy. They all have slipped off their outer cloaks. As he approaches, they slip to the side or behind curtains. Several sprays of flowers lie on the lid of a writing box. Pulling the inkstone nearer, he writes a poem and hands it to a lady who has turned her face away from him.

52–6

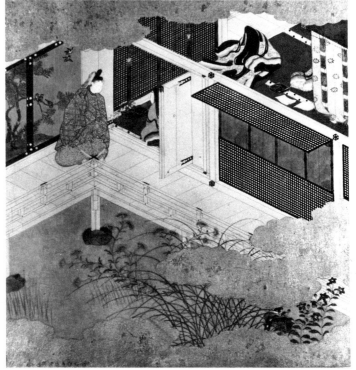

52–7

It seemed too that she had been toying with flowers, for several delicate sprays lay on the lid of her writing box. He was treated to an elegant array of ladies, though some had slipped behind curtains and the others had turned so that their faces could not be seen through the open door.

He pulled the inkstone nearer.

> "Now through a field of riotous maiden flowers
> I go, untouched by any drop of dew.

"Do you still not trust me?"

He handed it to a lady who sat turned away from him, very near the door. Calmly, quickly, with scarcely a motion, she set down an answering poem.

> "A flower whose name may suggest a want of judgment,
> It does not bend for every passing dew."  (s 1037–38)

## SCENE 8

EKOTOBA

At the west gallery of the First Princess's mansion, her ladies leave the blinds raised and watch the full moon of the Eighth Month. They are also playing

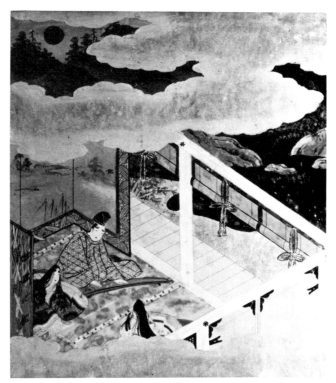

*52–8*

the koto. Kaoru comes in and plays the opening bars of a song on a Japanese koto. It is probably in minor scales. Chūjō should also be present.

~·~·~

GENJI

It was not unsuccessful, since minor scales are thought especially suited to the moods of autumn; but he broke off before he had finished. The women had been listening with great interest and half wished he had not begun at all.

(s 1040)

## 53. At Writing Practice

EKOTOBA

It is in the Fourth Month at the rear of the Uji villa. Ukifune is crouching down and weeping under a large tree in a grove. She is dressed in a white robe over her scarlet trousers. The bishop and two of his disciples bring their torches nearer, and one of them lifts the cover to investigate. Monks make motions with their hands in the gestures of exorcism.

⌣·⌣·⌣

GENJI

"Come on, now. The sensible thing would be to tell us." He tugged more assertively, though he rather hoped he would not be permitted a view of the face. It might prove to be the hideous mask of the eyeless, noseless she-devil he had heard about. But he must give no one reason to doubt his mettle. The figure lay face in arms, sobbing audibly now. (s 1046)

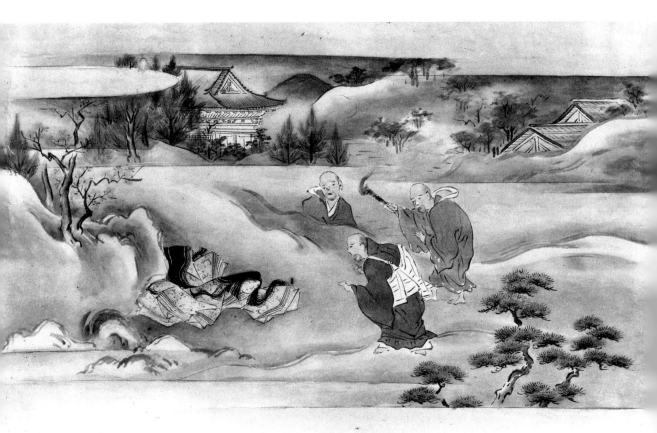

*53–1*

## Scene 2

EKOTOBA

At the same time as above, the sixty-year-old nun holds up Ukifune and forces medicine upon her. Monks look in. The bishop is with the ailing eighty-year-old nun. People in traveling clothes and carriages must be included in this composition.

⊱‧⊱‧⊱

GENJI

She had almost forgotten her mother in the struggle to save the girl. Yes, she was a stranger, nothing to them, if they would have it so; but she was a very pretty stranger. Everyone who saw her joined in prayers that she be spared.

(s 1047)

53–2

## Scene 3

EKOTOBA

It is probably either in the late summer or early autumn and at Ono. Breaking off a maiden flower, Chūjō addresses the sixty-year-old nun through a darkened curtain. Ukifune must be behind the curtain. She is probably wearing a white singlet and lusterless trousers. Other nuns must be around. Chūjō's retinue may be there.

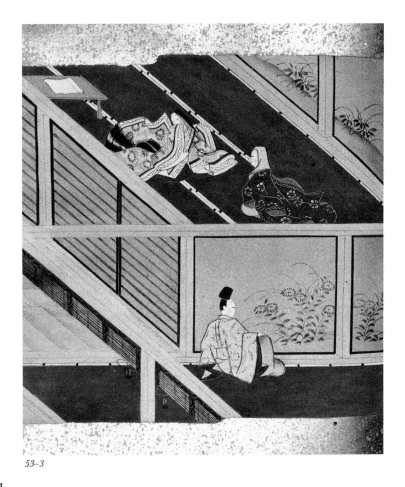

53–3

GENJI

Breaking off a maiden flower below the veranda, he was heard to murmur as
he went out: "Why should our nunnery be bright with maiden flowers?"

    The older women recognized the allusion and thought it gratifying.  (s 1055)

## SCENE 4

EKOTOBA

It may be in the middle of the Eighth Month. There is a late moon in the dawn.
Chūjō comes to Ono and plays on a flute, while the mother of the nun has a
koto brought out. Chūjō's attendant should be there, holding a small falcon.

GENJI

The wind blew a counterpoint through the pines, and the flute seemed to be
urging the moon to new splendors. Delighted, the old nun was prepared to stay
up until dawn.                                         (s 1060)

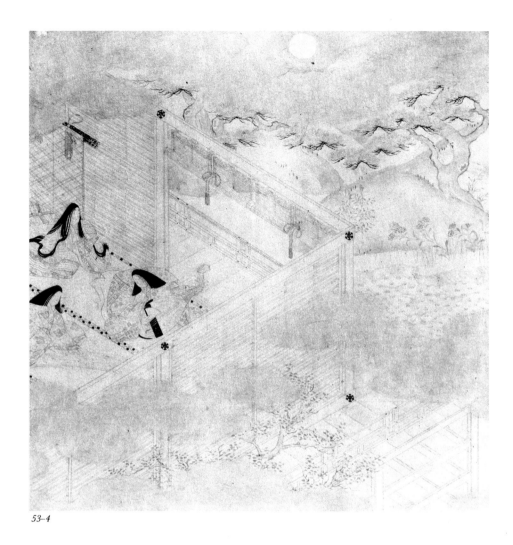

53–4

SCENE 5

EKOTOBA
In the Ninth Month when the nun is away, Ukifune plays a game of Go with
Shōshō the nun. There should be another nun in the composition.

~·~·~

GENJI
"Come, now. This gloom is getting to be contagious. Let's see if I can best you
at Go."

"Of course you can. I always lose." The girl seemed not unhappy at the sug-
gestion, however, and the board was brought out. Expecting an easy victory,
Shōshō let her have the first play. But the girl was no weakling, and in the next
match Shōshō was easily persuaded to play first.                    (s 1062–63)

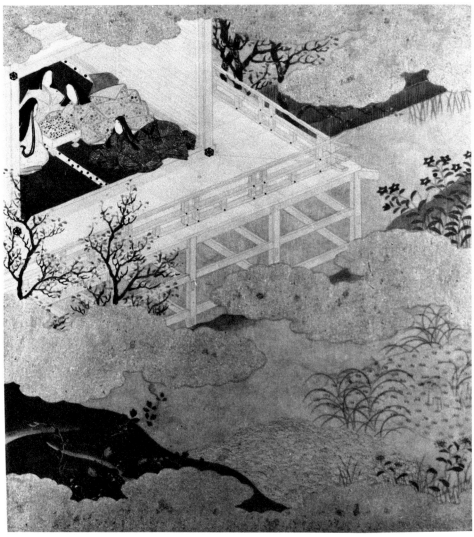

53–5

## Scene 6

EKOTOBA

It is at Ono and at the same time as above. The nun is away. Ukifune pushes her hair, a good six feet long, between the curtains as the bishop and his disciples cut it with scissors. Horrified, Komoki reports to Shōshō what is in progress.

〜〜〜

GENJI

But the bishop's favored disciple hesitated even as he raised the scissors. The hair pushed forward between the curtains was altogether too beautiful.　(s 1068)

308　THE TRANSLATIONS AND PAINTINGS

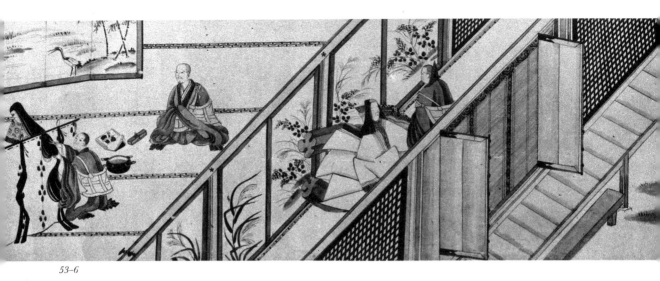

*53–6*

<h2 align="center">Scene 7</h2>

EKOTOBA

On a rainy night, the bishop talks to the empress Akashi through a curtain. Saishō moves up closer to hear the story. The other women are aroused from their sleep.

>·>·>

GENJI

That Kosaishō in whom Kaoru had shown a certain interest had heard the bishop's story. The others had been asleep. The bishop, noting the royal perturbation, saw that his narrative had perhaps been too vivid, and did not go into further details.
(s 1071)

<h2 align="center">Scene 8</h2>

EKOTOBA

The time is probably towards the end of the First Month. The women are at work preparing Ukifune's clothes, and watch her turning a hem. Among the clothes are a red singlet and a damask robe with a cherry-blossom pattern in the weave. She should be dressed in a cloak of light gray and trousers of a quiet burnt yellow. In the previous episode her hair is described as like an open fan.

>·>·>

GENJI

Another nun held up a red singlet and a damask robe with a cherry-blossom pattern in the weave. "If only we could ask you to try this on for us. It seems such a waste that you should always be in grays and blacks."

> "Shall I, having taken the habit of the nun,
>    Now change to robes of remembrance, think of the past?"

The girl sighed as she jotted down her poem. This world kept no secrets, and if she were to die and the bishop's sister to learn the truth, her secretive ways would no doubt seem cold and unfeeling.

"I have forgotten everything," she said, "but when I see you at this sort of work something does seem to come back, and make me very sad." (s 1078)

# 54. The Floating Bridge of Dreams

SCENE 1

EKOTOBA

Kaoru goes to Yokawa to see the bishop and inquires about Ukifune. He should be accompanied by Ukifune's little brother.

GENJI

"I have heard that a person I once knew well is in hiding there. I thought that when I had learned a few of the facts I might ask you exactly what had happened, and now I hear that you have taken her under your protection and made a nun of her. Might I ask whether it is true? She is very young and her parents are living, and I feel somewhat responsible for her disappearance."     (s 1081–82)

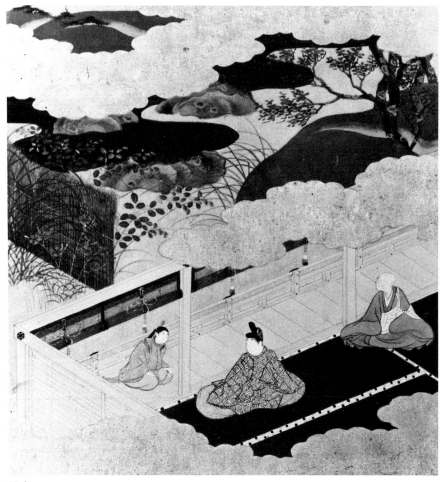

54–1

## SCENE 2

EKOTOBA

Ukifune's little brother comes to Ono. He should be seated on a cushion before the blind. The nun takes Kaoru's letter to Ukifune and shows it to her.

・ヽ・ヽ・ヽ

GENJI

"I lost my way in the hills, having taken a road
    That would lead, I hope, to a teacher of the Law.

"Have you forgotten this boy? I keep him here beside me in memory of one who disappeared."

It was friendly, even ardent. (s 1089)

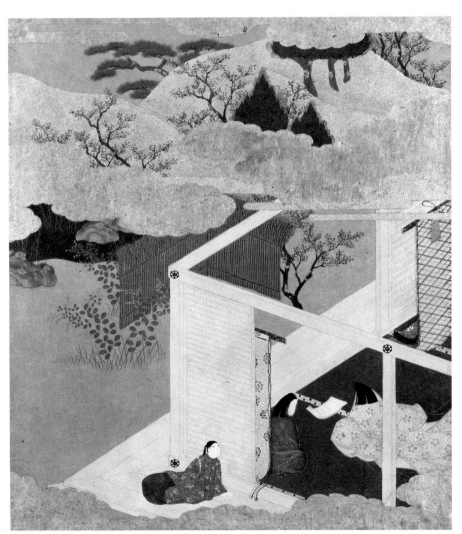

54–2

*312* THE TRANSLATIONS AND PAINTINGS

# Reference Material

# Guide to Chapters in the *Tale of Genji*

# Annotated Catalogue of *Genji* Paintings

## 1. Burke Screen

Pair of sixfold screens, ink, color, and gold on paper
Each screen, 170 × 379 cm
Edo period (early eighteenth century)
Anonymous Kanō artist
Mary Griggs Burke, New York
Published: Miyeko Murase, *Japanese Art: Selections from the Mary and Jackson Burke Collection*, Metropolitan Museum of Art exhibition catalogue (New York, 1975), no. 58

This pair of screens includes 54 scenes: one scene per chapter, 27 to each screen. The first one, depicting a scene in chapter 1, is shown at the top righthand corner of the right screen. The story continues downward to the bottom of this panel, then moves back to the top of the second panel (counting from right to left), and moves downward again. The background for all 54 episodes was conceived as a continuous panorama, with mountains and hills serving as natural dividers between episodes. Many scenes take place indoors, visible because the roofs of houses have been eliminated in the traditional *fukinuki-yatai* technique. Stylistically, the compositions of the 54 scenes scattered among the hills and along the shores of lakes and the sea are typical of *Genji* paintings executed by Kanō artists and of those works illustrating only one scene per chapter. The miniature screens shown in room interiors, almost all of them landscape paintings in monochrome ink, reflect the unmistakable academic training of a Kanō artist. The dry, mannered style of these ink paintings is contrasted against the cursory depictions in colors of natural elements for outdoor settings, such as rocks and hills, which are depicted with little delineation of surface textures in ink. The style of these landscape elements suggests that the pair was painted during the late seventeenth or the early eighteenth century. A second artist painted five scenes on the upper parts of the left screen, which illustrate chapters 26, 28, 29, 32, and 41.

## 2. Heian Scroll

Twenty-eight sections of text and 20 sections of painting; ink, color, gold, and silver on paper
Size of individual sections vary slightly (see below)
Heian period (early twelfth century)
Anonymous artists
Various collections, primarily in the Tokugawa Reimeikai and Gotō Art Museum in Tokyo (see below)
Published: Akiyama Terukazu, et al., *Nihon Emakimono Zenshū*, vol. II (rev. ed., Tokyo, 1975), and many others

The set to which these fragments originally belonged consisted of many handscrolls. All the sections of text and painting have been separated into individual sections for better preservation. A detailed discussion of these oldest and most beautiful *Genji* paintings in existence is in the introduction to this book (chapter 2). The extant scenes are listed below.

| CHAPTER NUMBER AND NAME | | SCENE NUMBER IN THE MANUAL | COLLECTION |
|---|---|---|---|
| 1. 5 *Waka Murasaki* (Lavender) | Text (3 lines) | Not in the Manual (nm) | Private |
| | Painting (21.1 × 21.2 cm) | 3 | Tokyo National Museum |
| 2. 6 *Suetsumuhana* (The Safflower) | Text (3 lines) | nm | Shogei Bunka-in |
| 3. 15 *Yomogiu* (The Wormwood Patch) | Text (48 lines) | nm | Tokugawa Reimeikai (TR) |
| | Painting (21.5 × 48.2) | 2 | TR |
| 4. 16 *Sekiya* (The Gatehouse) | Text (24 lines) | 1 | TR |
| | Painting (21.5 × 47.2) | 1 | TR |
| 5. 17 *E-awase* (A Picture Contest) | Text (22 lines) | 2 | TR |
| 6. 18 *Matsukaze* (The Wind in the Pines) | Text (7 lines) | nm | Shogei Bunka-in |
| 7. 19 *Usugumo* (A Rack of Cloud) | Text (13 lines) | 4 | Private |
| 8. 21 *Otome* (The Maiden) | Text (2 lines) | nm | Private |
| 9. 25 *Hotaru* (Fireflies) | Text (9 lines) | 1 | Private |
| 10. 26 *Tokonatsu* (Wild Carnations) | Text (2 lines) | 2 | Shogei Bunka-in |
| 11. 36 *Kashiwagi* (The Oak Tree) | | | |
| a. | Text (4 lines) | nm | Shogei Bunka-in |
| | Text (50 lines) | nm | TR |
| | Painting (21.8 × 48.3) | nm | TR |
| b. | Text (109 lines) | nm | TR |
| | Painting (21.9 × 48.4) | nm | TR |
| c. | Text (23 lines) | 4 | TR |
| | Painting (21.9 × 48.1) | 4 | TR |
| 12. 37 *Yokobue* (The Flute) | Text (26 lines) | nm | TR |
| | Painting (21.9 × 38.7) | nm | TR |

| | | | | |
|---|---|---|---|---|
| 13. 38 *Suzumushi* (The Bell Cricket) | | | | |
| a. | Text (34 lines) | nm | The Gotoh Museum (GM) | |
| | Painting (21.8 × 47.4) | nm | GM | |
| b. | Text (50 lines) | 3 | GM | |
| | Painting (21.8 × 48.2) | 3 | GM | |
| 14. 39 *Yūgiri* (Evening Mist) | Text (24 lines) | 2 | GM | |
| | Painting (21.8 × 39.5) | 2 | GM | |
| 15. 40 *Minori* (The Rites) | Text (69 lines) | 2 | GM | |
| | Painting (21.8 × 48.3) | 2 | GM | |
| 16. 44 *Takekawa* (Bamboo River) | | | | |
| a. | Text (31 lines) | 2 | TR | |
| | Painting (22.0 × 46.9) | 2 | TR | |
| b. | Text (109 lines) | 4 | TR | |
| | Painting (22.0 × 48.1) | 4 | TR | |
| 17. 45 *Ujibashihime* (The Lady at the Bridge) | Text (22 lines) | 2 | TR | |
| | Painting (22.0 × 48.9) | 2 | TR | |
| 18. 48 *Sawarabi* (Early Ferns) | Text (13 lines) | nm | TR | |
| | Painting (21.4 × 39.2) | nm | TR | |
| 19. 49 *Yadorigi* (The Ivy) | | | | |
| a. | Text (20 lines) | 1 | TR | |
| | Painting (21.5 × 38.2) | 1 | TR | |
| b. | Text (21 lines) | nm | TR | |
| | Painting (21.4 × 37.8) | nm | TR | |
| c. | Text (13 lines) | 9 | TR | |
| | Painting (21.5 × 48.9) | 9 | TR | |
| 20. *Azumaya* (The Eastern Cottage) | | | | |
| a. | Text (44 lines) | 4 | TR | |
| | Painting (21.5 × 39.2) | 4 | TR | |
| b. | Text (42 lines) | nm | TR | |
| | Painting (21.4 × 47.9) | nm | TR | |

## 3. HOSOMI SCROLL

Two handscrolls with text and ink drawings; ink on paper
h. 14.2 cm
Late Muromachi period (late sixteenth century)
Anonymous artist
Hosomi Minoru, Osaka
Published: Akiyama Terukazu, *Genji-e*, in the Staffs of the National Museums of
Tokyo, Kyoto, and Nara (eds.), *Nihon no Bijutsu*, no. 119 (Tokyo, 1976), figs.
75–79

The first scroll includes chapters 23 through 27, the second scroll, chapters 28 through
31. In many ways, these scrolls are typical of the *hakubyō* scrolls that were produced
in the late Muromachi period and later but they differ from them in that they have
much longer textual excerpts. Most chapters have only one illustration, but occasion-
ally some chapters are illustrated with two or three scenes. The first text in the first
scroll begins almost at the start of chapter 23, but the last painting in this scroll,
illustrating chapter 27, was crudely cut, suggesting that there was little more to this
scroll after this scene. The second scroll begins equally abruptly in the middle of a
scene illustrating chapter 28, which suggests that these two scrolls originally might
have formed one continuous scroll. The third scene for chapter 31 completes the
second scroll.

Delicate ink drawings show distinct traces of mannerism, especially in such details
as the strongly stylized stratification of ink shading along the contours of hills and
rocks. These scrolls should be dated slightly later than the Spencer Scroll 37, which is
dated to 1554 (Cat. No. 15).

## 4. IKEDA SCROLL

Three handscrolls with text and ink drawings; ink, red ink, and gold on paper
Painting: h. 18.8 cm
Text: h. 20.3 cm
Momoyama and Edo periods
Text attributed to various calligraphers
Painting attributed to Tosa Mitsunobu's daughter
Ikeda Fumio, Kyoto
Former Collections: the Ozu family, Ise; Hongan-ji, Kyoto

Each of the three scrolls contains text and paintings representing eighteen chapters;
together they represent all fifty-four chapters. At the end of each scroll is a colophon
written by Tosa Mitsuoki (1617–91) that is dated to the middle of the Sixth Month,
fifth year of the Kambun era (1665). In it, Mitsuoki attributes the painting to a young
daughter of Tosa Mitsunobu (fl. 1469–1521), the archpatriarch of the Tosa family
who served the court as its official painter while working for the shoguns as well.
Unfortunately, there is no documentary basis for this attribution; neither has the
identity of this woman been ascertained.

On the frontispiece of each scroll, which is decorated with wave patterns painted in
gold, is a list of chapter names included in the respective scroll, and Ōgimachi Kin-
michi (1653–1733), a noted courtier, is identified as its scribe on a narrow strip of

paper pasted on the back of the first scroll. Also pasted on the back of each text is a narrow piece of paper giving the name of the calligrapher. These names include those of some famous courtier-calligraphers who often wrote texts for *Genji* books and scrolls. For example, chapter 3 is attributed to Yottsuji Suetaka (1630–68), who wrote the text for one of the three scrolls of chapter 6 in the collection of Ishiyama-dera; chapter 19, to Ōimikado Tsunetaka (1613–82), to whom chapter 24 of the Mitsunori album in the Tokugawa Reimeikai is attributed (Cat. No. 7); and chapter 38, to Yabu Tsugitaka, to whom chapter 50 of the same Mitsunori album is attributed. Convincing stylistic affinities may be found among these specimens. Furthermore, Ōimikado Tsunetaka is identified as a former *Udaijin* (Minister of the Right), a position that he held for a year, from 1663 to 1664. In 1670, he was appointed to the higher position of *Sadaijin* (Minister of the Left). Were this attribution to be taken seriously, the text of these scrolls must be dated sometime between 1664 and 1668, the year Yottsuji Suetaka died. There are, however, problems in accepting this attribution. For example, two of the scribes whose dates are known, Higashizono Motokazu (1653–1710) and Ōgimachi Kinmichi (b. 1653), were merely fifteen years of age in 1668, too young for the mature calligraphic styles that characterize these works.

Moreover, while the paper for the text is 20.3 centimeters in height, that for the paintings is only 18.8 centimeters high, which suggests the distinct possibility that the text was added in a later period, most probably either in 1665 when Mitsuoki made the attribution to Mitsunobu's daughter or later. It seems that the painting for chapter 42 was missing at that time, and that a replacement was made. This painting shows a marked stylistic change from the rest of the scroll, with features strongly resembling Mitsuoki's known works, and it is possible that Mitsuoki supplied the lost painting for this chapter when he wrote the colophon in 1665. There are seals at the seam of the last painting in the third scroll, placed where the sheet used for the last painting is joined to a blank sheet of paper. The narrow rectangular seal near the bottom of the scroll reads "Tosa Mitsuoki," and near the top is an unclear impression made from what seem to be two small square seals; the one at the left reads "Mitsuoki," the one at the right, "Mitsu," both known to have been used by Mitsuoki.

Some text excerpts begin with chapter names, and many of the excerpts include passages quoted in the Osaka manuscript. Each chapter is illustrated by one scene, whose composition follows a fairly standard type. While the paintings reflect some features of Tosa Mitsunobu's style, such as the small egg-shaped faces of attendant figures, the highly decorative compositions on the miniature screens within paintings show unmistakable traces of Momoyama screen style. The sharp contrast between lines and ink-filled areas that characterizes the traditional *hakubyō* technique is modified and softened in this work by the use of washes in both dark ink and softer-grey ink in large areas. The painting should be dated to the late sixteenth or the early seventeenth century.

## 5. KANGA SCREENS

Sixty fans pasted on a pair of sixfold screens, five on each panel; ink, color, and gold
   on paper
Screens: 163.5 × 366 cm each; fans: 61 cm at the widest × 18.5 cm
Edo period.
Each fan has a cauldron-shaped seal reading "Kanga"
Eisei Bunko, Tokyo

Published: Staffs of the Eisei Bunko (eds.), *Tokubetsu Tenrankai: Hosokawa-ke Collection Tōyō Bijutsu* (Tokyo, 1981), no. 7.

A pair of screens on which *Genji* fans bearing Kanga's seal(s?) were pasted, is listed in the late nineteenth-century catalogue of old paintings, the *Koga Bikō*, edited by Asaoka Okisada (vol. 19, 644). This book identifies the owner of the screen as Lord Hosokawa.

The pair of screens had long been stored at the Kumamoto Castle in Kyushu, the seat of the Lord Hosokawa's fief before the Meiji restoration, and has only recently been moved to the Eisei Bunko, the newly established foundation that occupies the former Tokyo residence of the Hosokawa family.

The cauldron-shaped seal with pointed bottom and two handles was popular among Kanō artists. However, nothing specific is known about Kanga's life or training. The naive painting style, with little individuality, reflects none of the standard Kanō vocabulary.

Each fan includes, in addition to the artist's seal, either a chapter heading or other legend that helps clarify the setting or the protagonist represented therein. Fans are arranged starting from top right of the right screen and ending at the lower left of the left screen. Some chapters are not illustrated, while others are represented by more than one scene. Most fans show standard scenes, but there are some unusual ones, such as the one reproduced here (chapter 41, scene 4). Also unusual is the painting which is identified as the scene of Genji's death, an event that is merely hinted at but not discussed in the novel.

## 6. MITSUMOTO ALBUM

One album, 54 paintings; ink, color, and gold on paper
20.9 cm × 17.6 cm
Muromachi period (sixteenth century)
Painting attributed to Tosa Mitsumoto (1530–69)
Published: Funabashi Seiichi and Hisamatsu Senichi (eds.), *Genji Monogatari, Bessatsu Taiyō*, 3 (Tokyo, 1973); Shirahata Yoshi, "Den Tosa Mitsumoto hitsu Genji Monogatari Gajō," *Kokka*, 965 (1974), 15–25.

This album, according to a note that accompanies it, originally had a text that was lost during the Edo period. The paintings are pasted on both sides of the book, and each chapter is represented by one painting, except for chapter 35 which has no painting and chapter 51 for which there are two scenes. Small strips of paper with the names of chapters written on them are pasted at the lower corner of the pages. These seem to be later in date than the paintings; some are lost, and others are erroneous. For example, the painting for chapter 34 is identified as New Herbs II when it should read New Herbs I; chapter 42 is erroneously labeled New Herbs I, and the label for chapter 42 is mistakenly pasted on the second painting for chapter 51.

Another document that accompanies the book, written by Tosa Mitsunari (1646–1710), attributes the painting to Tosa Mitsumoto. Mitsumoto, grandson of Mitsunobu, seems to have held the position of official painter at the Imperial Court. But since he is listed among the dead in the Ashikaga shogun's army, he might also have served a shogun. Not much else is known about his life nor is his work known today, making it difficult to determine the validity of this attribution. Stylistically, however, this album can be dated to Mitsumoto's lifetime in the sixteenth century. Monumentality

and simplicity characterize the composition of these small album pieces. Devoid of minute decorative details, they reflect a style that predates the delicate miniature works of Mitsuyoshi and suggest that the artist was familiar with large screen compositions.

## 7. TOKUGAWA MITSUNORI ALBUM

Album with sixty leaves each of painting and of text; color, gold, and ink on paper
Painting: 15.3 × 14.1 cm
Text: 15.3 × 14.0 cm
Edo period
Painting by Tosa Mitsunori (1583–1638)
Text attributed to sixty calligraphers
Tokugawa Reimeikai Foundation Tokyo
Published: Akiyama Terukazu, *Genji-e,* in the Staffs of the National Museums of Tokyo, Kyoto, and Nara (eds.), *Nihon no Bijutsu,* no. 119 (Tokyo, 1976); and Akiyama Ken, et al., *Genji Monogatari, Zusetsu Nihon no Koten,* vol. 7 (Tokyo, 1978)

The book contains sixty sheets each of text and of paintings. The text is written on paper richly decorated with abstract designs in gold and silver; there are also sheets with marbled patterns like flowing water created in the *sumi-nagashi* (ink flowing) technique. In this technique, delicate patterns are produced by spreading a thin film of India ink on water, which is then carefully transferred onto paper. The rather lengthy text excerpts, often excluding poems, have little relationship to the text quotations found in the Osaka manuscript. A small piece of paper is attached to each text, identifying the chapter title and the name of its scribe; included are such well-known courtier-calligraphers as Asukai Masaaki (1611–79) and Nakanoin Michimura (1588–1653). Michimura, to whom chapter 17 is attributed, Shirakawa Masataka, whose name is mentioned for chapter 47, and Takakura Nagayoshi, chapter 20, are also credited with some texts for the album leaves pasted on the screens in the Tokyo National Museum (Cat. No. 11). The names of Ōimikado Tsunetaka, who is identified as the scribe for chapter 24, and Yabu Tsugitaka, chapter 46, also appear on the Ikeda scrolls (Cat. No. 4). In addition, Saionji Saneharu (1600–73), whose name appears in the Mitsuyoshi album (Cat. No. 12), is listed as the scribe for chapter 19. There are sufficient stylistic affinities in these examples of calligraphy to allow one to take these attributions seriously, but the final judgment must be left to calligraphy experts.

An attribution of the painting to Tosa Mitsunori and a red square seal reading *Shōgen* are found on a small piece of paper attached at the end of the album. *Shōgen* is an honorary title that Mitsunori's son Mitsuoki (1617–91) held. A seal in black ink, reading "Tosa Mitsunori," is found on the back of the painting for chapter 41. The same seal may have been impressed on the back of each painting.

Tosa Mitsunori is believed to be either a pupil or son of Mitsuyoshi (see Cat. No. 12), who had moved to Sakai, a port city southwest of Kyoto. Mitsunori worked with the older master in this bustling port, but the dwindling fortunes of the Tosa school could not support him. The government's ban on foreign trade, issued in 1633, dealt a severe blow to Sakai, and may have prompted Mitsunori to move back to Kyoto the following year. His decision was a wise one, since his son, Mitsuoki, eventually regained the family's traditional position as the official artist of the Imperial Court.

Mitsunori was clearly influenced by Mitsuyoshi in many ways, including the latter's

habit of impressing seals in black ink on the back of album leaves. Mitsunori's compositions are even smaller and more delicate than Mitsuyoshi's, however. Executed in brilliant colors, these paintings in the Tokugawa album represent the best of Mitsunori's work as a miniaturist. Human figures as well as landscape backgrounds have softer, more rounded silhouettes and tend to be more decorative than the paintings by Mitsuyoshi. In this sense, these paintings evoke the works by a certain Chōjirō in the Mitsuyoshi album in the Kyoto National Museum (Cat. No. 12), prompting a speculation that Chōjirō, a youthful sounding name, might have indeed been young Mitsunori's name. (*See* Takeda Tsuneo, "Tosa Mitsuyoshi to Saiga: Kyōto Kokuritsu Hakubutsukan *Genji Monogatari* Zujō o megutte," *Kokka*, 996 [December, 1976], 24.)

Mitsunori's work consists mainly of miniatures such as the small album leaves reproduced here. Altogether, five groups of album leaves, totaling 216 sheets, which are either by Mitsunori or attributed to him, are assembled in this book. Unfortunately, not one of them includes even a clue as to its date of production. Stylistically they are so similar that they virtually defy any effort to establish a chronological development of his art based upon them.

8. BURKE MITSUNORI ALBUM

Two albums, thirty leaves of paintings each; ink, red ink, and gold on paper
Each leaf: 13.4 × 12.9 cm
Edo period
Tosa Mitsunori (1583–1638)
Mary Griggs Burke, New York
Published: Miyeko Murase, *Japanese Art: Selections from the Mary and Jackson Burke Collection*, Metropolitan Museum of Art exhibition catalogue (New York, 1975), no. 59; Akiyama Terukazu (ed.), *Emakimono*, in Shimada Shūjirō, et al. (eds.), *Zaigai Nihon no Shihō* 2 (Tokyo, 1980), no. 27

The exact meaning of some of the scenes in these small album leaves is unclear, partly because they lack text and partly because there are sixty paintings instead of the usual fifty-four. Also the sequence of these leaves was disturbed, most likely in a recent remounting, contributing to the difficulty in identifying some scenes. To compound the problem, many compositions deviate from the standard iconographic formula, which however, makes these books valuable material for our study.

A large seal of Tosa Mitsunori (2.3 × 2.4 cm) was exposed by cutting a flap in the backing paper of the last leaf. Most likely the same seal was impressed on each leaf, a practice that was customary with Tosa Mitsuyoshi (1539–1613), thought to have been his father or teacher.

Mitsunori excelled in this type of delicate *hakubyō* drawings. Red ink is occasionally applied on the lips of figures and on some decorative details. Gold is used extensively for the cloud patterns and decorative designs on furnishings. Mitsunori filled the costumes of men and women with delicate designs in ink, thereby softening the effect of stark black areas against spidery ink lines. As if he were nearsighted, he has drawn even the small details that are barely visible to the naked eye, it has even been suggested that Mitsunori used a magnifying lens to execute his work. (*See* Tadashi Kobayashi, *Tosa Mitsunori E Tekagami* [Kyoto, 1972], p. 21.) Magnifying glasses were quite popular after 1551, when they were introduced to Japan from the West. The city of Sakai was an active port and often set the latest fashion during the time Mitsunori lived and worked there.

One album with thirty leaves each of text and of paintings; ink, red ink, and gold
   on paper
Each leaf: 14.9 × 13.7 cm
Edo period
Painting by Tosa Mitsunori (1583–1638)
Calligraphy by an anonymous calligrapher
Freer Gallery of Art, Smithsonian Institution, Washington, D.C.
Published: Akiyama Terukazu (ed.), *Emakimono,* in Shimada Shūjirō, et al. (eds.)
   *Zaigai Nihon no Shihō* 2, (Tokyo, 1980), no. 26

Originally pasted on folding screens, these leaves of paintings and of text must have
been divided into two albums at the time of remounting. Since the Freer album has
thirty leaves each of text and paintings, originally (if we assume that the set was
divided evenly) there must have been sixty leaves each of paintings and of text. The
whereabouts of the other book is unknown. Of the thirty sheets of text, two are for
chapter 1, and the remainder correspond to twenty-eight chapters but do not always
coincide with paintings remaining in the book. The text for each chapter includes
only its title and one poem. The paper used for the text is delicately decorated in the
*sumi-nagashi* (flowing ink) technique (see Cat. No. 7).

   This album is similar to, though slightly larger than, the albums in the Burke col-
lection (Cat. No. 8). Each leaf of painting has the same seal of Tosa Mitsunori on
its back, and, as in the Burke albums, red ink is used on the lips of the figures and
decorative details, and gold is brushed on cloud patterns and decorative designs of
furnishings. However, the compositions in this album are not as dense as those in
the Burke albums, and the line drawings are gentler and less vigorous.

   Chapters of the novel represented by text and/or painting are listed below, but it
must be noted that the paintings are not always in the correct sequence; they are as
follows:

| | | | | | | | | | | | | | |
|---|---|---|---|---|---|---|---|---|---|---|---|---|---|
| Text | 1, | 1, | 2, | 3, | 4, | 5, | 6, | | 7, | | | | 14, |
| Painting | 1, | | | | | 5, | 6, | 6, | | 9, | 11, | 12, | |

| | | | | | | | | | | | | |
|---|---|---|---|---|---|---|---|---|---|---|---|---|
| Text | 15, | 16, | 17, | | 19, | | 20, | 21, | | | 22, | 24, |
| Painting | 15, | 16, | | 18, | 19, | 19, | | 21, | 21, | 24, | | |

| | | | | | | | | | | | | |
|---|---|---|---|---|---|---|---|---|---|---|---|---|
| Text | 25, | 26, | 29, | | | 34, | | 36, | | 40, | 41, | 43, |
| Painting | | 26, | 29, | 31, | 32, | 34, | 35, | 36, | 37, | | 41, | 43, |

| | | | | | | | | |
|---|---|---|---|---|---|---|---|---|
| Text | 44, | 46, | | | 50, | | 52, | 54 |
| Painting | 44, | | 48, | 49, | | 51, | 52, | |

## 10. Stockholm Mitsunori Album

One album with twelve leaves each of text and of paintings; ink, color, and gold
   on paper
Each leaf: 23.4 × 20.2 cm
Edo period
Text by one calligrapher

Painting attributed to Tosa Mitsunori (1583–1638)
Östasiatiska Museet, Stockholm
Published: Bo Gyllensward, "Tolv scener ur Genji Monogatari," *Östasiatiska Museet och Foreningen Östasiatiska Museets Vanner, 1976–80* (Stockholm, 1981), 68–82

This book, which was only recently discovered in Japan and was acquired by the Stockholm museum soon thereafter, was found to be in an incomplete state as early as 1670. In the winter of that year, Tosa Mitsuoki (1617–91) wrote a colophon at the end of the book, attributing twelve paintings to his father, Mitsunori.

The short text sections, each accompanied by a chapter name, were written by one scribe. The twelve paintings, all brilliantly colored and sumptuously decorated with cut gold designs, bear a strong similarity to Mitsunori's paintings in the Tokugawa album in the palette, the painstaking depiction of details, and the full, plump-faced figures. The following chapters are represented in the book: 14, 15, 17, 19, 20, 21, 23, 24, 29, 36, 37, and 54.

## 11. TOKYO NATIONAL MUSEUM SCREEN

Pair of sixfold screens, with fifty-four leaves each of text and paintings pasted on them; ink, gold, and red ink on paper
Painting: 13.4 × 14.1 cm
Text.: 16.7 × 14.1 cm
Edo period
Text attributed to twelve calligraphers
National Museum, Tokyo

The pair of screens in the Tokyo National Museum has fifty-four leaves of text and of paintings that are evenly divided between the two screens. These album leaves were originally mounted in book(s) and were later remounted onto screens. Many leaves are badly damaged, making it difficult to examine them thoroughly and determine their authorship. The drawings are, in general, mannered, but they are similar in style to Mitsunori's *hakubyō* works in the Freer and Burke albums. The selection of scenes is rather uninspired, however.

The text excerpts are very short, as in the Freer book, and consist mainly of poems. Attached to each text sheet is a narrow strip of paper with the calligrapher's name. There are altogether twelve calligraphers, including some famous courtiers such as Karasumaru Mitsuhiro (1579–1638) and Nakanoin Michimura (1588–1653). But these labels are most likely of later dates and are not wholly reliable.

## 12. MITSUYOSHI ALBUM

Four albums with 54 sheets each of paintings and of text; ink, color, and gold on paper
Painting: 25.7 × 22.6 cm
Text.: 25.7 × 22.3 cm
Momoyama period
Paintings by Tosa Mitsuyoshi (1539–1613), and Chōjirō
Text by 23 calligraphers
National Museum, Kyoto

Published: Tsuneo Takeda, "Tosa Mitsuyoshi to Saiga: Kyōto Kokuritsu Hakubutsu-kan *Genji Monogatari* Zujō o megutte," *Kokka* 996 (December, 1976), 11–40

This set of four books originally comprised of two codices until recent repair. These books, which include fifty-four leaves each of text and of paintings, seem to have been made under some unusual circumstances. First of all, the last six chapters, from 49 to 54, were never illustrated. As a supplement for these missing leaves, a group of six paintings was substituted, duplicating already existing chapters 4, 5, 6, 10, 11, and 15.

During the latest repair, sheets of painting and text were separated from the books, revealing the signature "Chōjirō," written in black ink, on the back of the duplicate chapters. Furthermore, a seal reading "Kyūyoku" was found on the backs of the leaves of chapters 1 through 36. Neither seal nor signature was found on the paintings for the twelve chapters from 37 to 48; and the painting style of these leaves differs noticeably from that of the first group bearing the Kyūyoku seal, while revealing a close similarity to Chōjirō's works.

The paper on which the text is written is decorated with elaborate designs of flowers, landscapes, and abstract patterns, executed in gold and silver pigments and thin metal foil cut in various sizes and shapes. In fact, these designs are so elaborate that they often obscure the writing. The text tends to consist of rather long quotations from the novel and has little relationship to excerpts found in the Osaka manuscript.

At the time of the repair, the names of calligraphers and their official ranks and positions were also discovered on the backs of the sheets; these include Emperor Go-Yōzei (1571–1617) and twenty-two other noted noblemen and courtiers. Among them are several men who are also associated with other *Genji* books and scrolls reproduced here, including the monks Zuian of Daikaku-ji (1573–1650) and Sonjun of Shōren-in (1591–1653), who are credited with some texts for the album leaves in the Tokyo National Museum (Cat. No. 11), and Saionji Saneharu (1600–1673), who is identified as the calligrapher of chapter 19 in the Mitsunori album of the Tokugawa Reimeikai (Cat No. 7). Judging from the dates of appointments to ranks and positions listed with the names of the courtiers (*See* Takeda Tsuneo, "Tosa Mitsuyoshi to Saiga: Kyōto Kokuritsu Hakubutsukan *Genji Monogatari* Zujō o megutte," *Kokka*, 996 [December, 1976], 169–70.) the project must have taken a long time, continuing even after the death of some of the scribes.

It has been suggested that Mitsuyoshi was commissioned to produce these books toward the end of his life. He was able to complete paintings only through chapter 36 and then turned the project over to an assistant who continued it under his guidance up to chapter 48. Mitsuyoshi probably passed away at this point, and the same assistant took over the project; instead of completing it, he repeated six earlier compositions by Mitsuyoshi and signed them "Chōjirō." (*See* Akiyama Terukazu, *Genji-e*, in the Staffs of the National Museums of Tokyo, Kyoto, and Nara (eds.) *Nihon no Bijutsu*, 119, [Tokyo, 1976], pp. 65–66.) Another, and more likely scenario proposes that the paintings by Chōjirō were incorporated into this group at some later date, so that the book has the outward appearance of a completed work, with fifty-four leaves.

It has been speculated that the name "Chōjirō" may be a youthful acronym of Mitsunori. (*See* Takeda, *op. cit.* p. 24, also see Cat. No. 7.) There are strong stylistic similarities between the works by Chōjirō and those by Mitsunori, except that figures in Chōjirō's paintings have rather awkward, stiff postures; this may well be explained by the fact that they are Mitsunori's youthful works.

Tosa Mitsuyoshi, the artist who painted the first thirty-six leaves, lived through the turbulent years of the Momoyama period. (*See* Yamane Yūzō, "Tosa Mitsuyoshi

to sono Sekiya, Miyuki, Ukifune Zu Byōbu," *Kokka*, 749 [August, 1954], 242–249.) A grandson of Mitsunobu and younger brother of Mitsumoto (see Cat. No. 6), Mitsuyoshi left the war-torn old capital of Kyoto and moved to the port city of Sakai where he tried to continue the Tosa-school tradition. Kyūyoku is his priestly name, which he assumed upon taking the tonsure, and it is found on a number of small album leaves of *Genji* scenes like these. Mitsuyoshi generally used standard compositional types in a cycle of fifty-four paintings. Astonishingly minute details fill these small paintings. Tall, slender figures have tiny heads, and the attendants have facial features distinctly reminiscent of those in the works by his grandfather, Mitsunobu. Colors are applied rather thickly, and gold dust and flakes in varying hues are used for backgrounds and cloud patterns, creating a grand effect commensurate with monumental painting.

Chōjirō, about whom nothing certain is known, was obviously Mitsuyoshi's follower, continuing his master's colorful miniature style. Yet stylistic differences distinguish his work from the master's: for example, his palette is brighter, and he gives much less attention to small details. His landscapes are flatter and more decorative, and his figures have fuller, rounded silhouettes, with noticeably larger heads.

### 13. OSANA GENJI

Ten books with printed text and illustrations; ink on paper
Each book: 27.2 × 18.8 cm
Edo period, 1672 printing
Preface by Hinaya Rippo (d. 1669)
C.V. Starr Library, Columbia University, New York City

Rippo (d. 1669), the author of the preface, is known by his family name of Nonoguchi or by Hinaya, the name of his doll shop. A versatile man, Rippo is believed to have studied *waka* with Karasumaru Mitsuhiro (1579–1638) and painting under Kanō Tan'yū (1602–74). He is also known to have illustrated many books, both classical and contemporary. He seems to have been responsible for both the illustrations and the text for these volumes. In his preface, Rippo states that he intended these volumes for young people and that in this version he "mixed in a number of lies and fantasies." Yet the text is faithful to the novel, with only occasional, slight abbreviations.

The iconographic program of the illustrations is based on a standard formula of one picture to a chapter, although occasionally two or three scenes are depicted in a chapter. Altogether there are sixty-five compositions interspersed throughout the text; they are usually simple, but they directly and succinctly express the essential elements of the iconography.

### 14. SEATTLE SCREEN

Pair of sixfold screens, color on gilded paper
152.1 × 355.6 cm
Edo period (late seventeenth century)
Anonymous artist of the Kanō School
Seattle Art Museum

Published: Henry Trubner, et al., *Asiatic Art in the Seattle Art Museum* (Seattle, 1973), no. 231

Typical of *Genji* screens that illustrate one scene per screen, they represent chapter 33 (on the right screen), and chapter 35 (on the left), in large compositions that extend over the entire surface.

Figures of both men and women have small, but full faces, and their squat bodies move rather stiffly. A strong emphasis on the angularity of brush-lines on courtiers' clothing and the obvious ink lines applied on tree trunks and rocks, suggest that the artist of these screens had a solid training in the Kanō style of painting.

## 15. SPENCER 37

Six handscrolls, with text and painting; ink on paper
9.8 cm
Muromachi period (1554)
Text and painting by Keifuku-in Gyokuei
Spencer Collection, New York Public Library, New York
Published: Sorimachi Shigeo, *Supensā Korekushon Zō Nihon Eirbon oyobi Ehon Mokuroku*," rev. ed. (Tokyo, 1978), no. 37

In these small scrolls, figures of men, women, plants, and flowers are depicted in almost equal size. Somewhat amateurish yet full of charm and often pathos, this painting is typical, though one of the most delightful examples, of the ink drawings known as *hakubyō* (white drawing), a technique that was often practiced by amateur artists during the late Muromachi and the Momoyama periods.

There is a note on the frontispiece of Scroll I stating that both text and painting were executed by Keifuku-in Gyokuei, a daughter of Konoe Taneie (1502–66). Unfortunately, nothing is known about this woman, but her father Taneie was a distinguished courtier who held the position of Kampaku (Regent) twice, once from 1521 to 1533 and again in 1536.

The six scrolls represent fifty-four chapters: Scroll I, chapters 1 to 13; II, 14 to 21; III, 22 to 31; IV, 32 to 35; V, 36 to 44; and VI, 45 to 54. On the average, there is one scene per chapter, and the text includes an average of two to five poems and introductory prose for each chapter. Most of the figures in the painting are identified by their names, written in the same calligraphic hand as that of the text and of the inscription at the end of Scroll VI. However, this calligrapher was not the same person who inscribed the frontispiece. The inscription in the last scroll states that in making these scrolls, an old model was copied as carefully as possible so that the traces of the brush (style of painting) are indistinguishable from the earlier work. It also gives the date as an auspicious day in the Fourth Month, twenty-third year of the Tenmon era (1554).

## 16. SPENCER 67

Three handscrolls with text and painting; color and gold on paper
35.4cm
Edo period (mid-seventeenth century)

Painting by anonymous artists
Text by several calligraphers
Spencer Collection, New York Public Library, and others
Published: Kyoto National Museum exhibition catalogue, *Genji Monogatari no Bijutsu* (Kyoto, 1975), nos. 19, 20; Akiyama Terukazu, *Genji-e*, in the Staffs of the National Museums of Tokyo, Kyoto, and Nara (eds.), *Nihon no Bijutsu* 119 (Tokyo, 1976), pl. 18; Galerie Janette Ostier, *Les jardins d'or du Prince Genji: Peintures japonaises du XVIIᵉ siècle* (Paris, 1980)

This set of sumptuous scrolls, their text reproducing the entire novel and the pictures forming the densest cycle of *Genji* illustrations known today, once comprised perhaps more than one hundred handscrolls. Unfortunately, this set was broken up, and so far only a fraction of it has been brought to our attention.

The Spencer Collection contains three of the scrolls, one of which represents chapter 2 (The Broom Tree). A small piece of paper pasted on its cover identifies it as the autumn scroll, indicating that this was the third scroll in a four-scroll set for chapter 2. The two other scrolls in this collection represent chapter 6 (Safflower). Ishiyama-dera, a Buddhist temple near Kyoto, owns another scroll, which is the first of the three-scroll set that completes this chapter. A set of six scrolls representing chapter 9 (Heart-vine) has been reported in a Japanese collection, and six scrolls of chapter 10 (The Sacred Tree) were recently cut into small pieces in Europe and dispersed.

Illustrations in these scrolls reflect very little relationship to standard compositions and iconography. Rather than depending on an accepted formula, the artists of these scrolls seem to have closely followed the novel itself and created a dense picture cycle, seldom attempted before. The colophon at the end of the Safflower scrolls in the Spencer Collection states that the text was written by Nishinoike Suemichi. The companion scroll in the Ishiyama-dera collection has a colophon by Yottsuji Suetaka, who wrote a small portion of the text for that scroll. He signed his name as one holding the rank of Chūjō (lieutenant general), a rank which he was awarded in 1647. The inscription written in the Broom Tree scroll in the Spencer Collection states that its text was written by a certain Minamoto no Toshinaga, who also wrote most of the text for the mutilated Sacred Tree scrolls. The other scribe for this chapter was a monk named Zuishin-in Eigen. Nothing is known about these scribes, however.

The paintings of these scrolls have traditionally been attributed to Tosa Mitsuoki (1617–91), but their style widely differs from the known works of this master. More than one artist seems to have been involved in this enormous undertaking. A large round seal (2.6 cm in diameter) reading "Moriyasu," is found at the end of the Safflower and Sacred Tree scrolls. It may belong to a painter or a mounter, but his identity remains unclear. These scrolls are among the most sumptuous works from the Edo period: gold is used abundantly on the ground, on the cloud patterns that fill the top and bottom of the paper, and on all sorts of small decorative designs. Furthermore, the scrolls are in extremely good condition, except for those that were recently cut up. All the pictorial forms are delineated with the utmost care, but they lack liveliness and spontaneity and are rather cold and academic. Landscape backgrounds and miniature screen paintings within the paintings reflect Kanō, rather than Tosa influences.

## 17. SPENCER 129

Fifty-four volumes, each with text and illustrations; ink, color, and gold on paper
Each book: 24.0 × 17.7 cm

Edo period (early eighteenth century)
Anonymous artist
Spencer Collection, New York Public Library, New York

This is a typical example of an Edo-period *Genji* book with a complete text and an extensive picture cycle executed in a delicate style in brilliant colors. A set of fifty-four volumes such as this one often comes in a beautifully decorated lacquer box; these sets seem to have been made as dowries for young women.

The cycle of illustrations, with 230 pictures, the choice of scenes, and the composition of individual illustrations are typical of many so-called dowry sets. These large sets of hand-painted books also seem to be closely related to printed books like the one made by Yamamoto Harumasa, which is reproduced in Seidensticker's translation. Although the pictorial cycle is extensive, the painted scenes in this recension of *Genji* books deviate from the types favored by the Tosa artists and tend to lack clarity of meaning. A more detailed investigation of the ultimate source for this recension of *Genji* pictures is necessary in order to understand them better.

The paintings in the Spencer book typify a miniature style commonly designated as *nara-e*, which generally refers to the colorful and delicate, if somewhat stereotyped, painting style that dominated the narrative paintings on scrolls and codices from the sixteenth century through much of the Edo period.

## 18. TENRI BOOK

One book with two paintings on the front and back covers; ink, color, and gold on
   paper
25.4 × 17.2 cm
Muromachi period (early sixteenth century)
Text by Priest Senzō
Paintings by an anonymous artist
Tenri Library, Nara
Published: Akiyama Terukazu, *Genji-e*, in the Staffs of the National Museums of
   Tokyo, Kyoto, and Nara (eds.), *Nihon no Bijutsu*, 119 (Tokyo, 1976), pl. 7

Similar to the book of *Ukifune* from the Kamakura period (Cat. No. 21) and many dowry sets dating much later (for example, Spencer 129, Cat. No. 17), this book reproduces the entire text of the novel. However, the Tenri book, which reproduces chapter 17 (A Picture Contest), differs from the others in that it has no illustrations other than those decorating the front and back covers of the volume. A cartouche on the front cover identifies the chapter, and, at the end of the book, the name of the calligrapher of the text is given as Iwakura Shinshō-in Senzō, a son of Nakamikado Ippon (otherwise known as Nobutane, 1442–1525). (See Akiyama, *Genji-e*.)

The paintings on the covers are among the earliest examples of the brilliantly colored miniature style of *Genji* pictures that began to appear in a greater number in the Momoyama period. The warm colors, the full, rounded figures, the uncomplicated contours of gold cloud patterns, and the smooth, flowing ink outlines all suggest a date slightly earlier than the album attributed to Tosa Mitsumoto of the mid-sixteenth century (Cat. No. 6). The front cover shows the scene in which Genji and Murasaki prepare for a picture contest; the contest itself is illustrated on the back cover.

## 19. Tenri Scroll

Two handscrolls, with text and ink drawings, ink on paper
16.0 cm
Muromachi period (sixteenth century)
Anonymous artist
Tenri Library, Nara
Published: Akiyama Terukazu, *Genji-e,* in the Staffs of the National Museums of
Tokyo, Kyoto, and Nara (eds.) *Nihon no Bijutsu* 119 (Tokyo, 1976), figs. 72–74

Once part of a large set, only two scrolls are known today. They are encased in an
unusual container made of bamboo. Scroll I covers the last part of chapters 7 through
9, and Scroll II represents chapters 35 through 39.

The text consists mainly of poems from the novel, and more are quoted than are
usually found in other *Genji* editions. Its dense pictorial cycle is also unusual; for
example, twelve scenes were illustrated in chapter 9 in contrast to the seven suggested
in the Osaka manual. Most of the figures in the illustrations are identifiable because
their names are written alongside them.

As in Spencer 37 (Cat. No. 15), the *hakubyō* drawings are sometimes crude in execu-
tion, but they have the appealing qualities of directness and freshness peculiar to the
works of amateur artists. Less sophisticated than the scrolls in the New York collection,
which bear the date of 1554, these scrolls should nevertheless be dated to about the
same time.

## 20. Tokugawa Album

An album with fifty-four sheets each of text and of paintings; ink, color, and gold on
paper
Text: 24.0 × 20.2 cm
Painting: 24.4 × 23.3 cm
Edo period (seventeenth century)
Text by several calligraphers
Paintings by an anonymous artist
Tokugawa Reimeikai Foundation, Tokyo
Published: Funabashi Seiichi and Hisamatsu Senichi (eds.), *Genji Monogatari, Bessatsu
Taiyō* 3 (Tokyo, 1973), 76–77

All fifty-four paintings are pasted on one side of the book, with the text on the other
side, but their sequence is reversed—that is, the text for the first chapter is pasted on the
back of the painting that represents the last chapter.

The text is written on paper decorated with designs in colors and gold; its content
has little relationship to the excerpts quoted in the Osaka manual. The strong personal
style of the painter, whose training was outside of the Tosa or Kanō traditions, is
apparent in such details as the strong, exaggerated, and coarse play of ink lines on
landscape elements, a noticeable fondness for large mountains as background settings,
and the narrow, slender faces of the men and women.

## 21. BOOK OF UKIFUNE

One handscroll and one codex, with text and ink drawings; ink on paper
About 24.0 × 19.0 cm
Kamakura period (mid-thirteenth century)
Anonymous artist
Handscroll in the Tokugawa Reimeikai Foundation, Tokyo; codex in the Yamato Bunkakan Museum, Nara
Published: Akiyama Terukazu, "Hakubyō Eiri *Ukifune* Sasshi: Kamakura Jidai *Genji Monogatari-e* no Ichi Irei," *Heian Jidai Sezoku-ga no Kenkyū* (Tokyo, 1964), 279–300

Of the original book that once contained the entire text and its illustrations only chapter 51 remains, and this was divided between the Tokugawa Reimeikai and Yamato Bunkakan Museum. The section in the Tokugawa collection, the beginning of the chapter, is thought to have been pasted on a pair of sixfold screens in the late eighteenth century, but it was recently remounted in a handscroll. (See Akiyama, op. cit., p. 284.) This handscroll includes the first half of chapter 51 with three illustrations, and a few pages of the text from chapter 52. The latter section of chapter 51 in the Yamato Bunkakan, which has been preserved in the original book form, includes two illustrations.

The text is written in a flowing *kana* script, on paper that is occasionally decorated with the elegant marblelike patterns in ink created in the *sumi-nagashi* technique (see Cat. No. 7).

The illustrations in ink are the earliest extant examples of *hakubyō* drawing, and they represent the best of this genre known today. In places, the exquisite ink outlines have become almost invisible with age. A thin, delicate grey tone makes an even starker contrast against the large pitch-black areas in the flowing hair of the women color, and the tall hats worn by the men.

## 22. YŪSETSU SCROLL

Two handscrolls, twenty-seven sections of text and of paintings in each scroll; ink, color, gold, and silver on paper
23.7 cm
Edo period
Painting attributed to Kaihō Yūsetsu (1598–1677)
Text attributed to twenty-seven noblemen
Mary Griggs Burke, New York
Published: Miyeko Murase, *Japanese Art: Selections from the Mary and Jackson Burke Collection*, Metropolitan Museum of Art exhibition catalogue (New York, 1975), no. 57

Accompanying the two scrolls is an anonymous document attributing the text to twenty-seven courtier-calligraphers. The names of the calligraphers are listed with the chapter headings, one calligrapher for each of the first twenty-seven chapters, and their names are repeated in the same sequence, in most instances, for the second group of twenty-seven chapters. For example, the first chapter and the twenty-eighth chapter

are attributed to the former *kampaku* (Regent) Takasu. It is not known when or by whom these attributions were made. The calligraphers are identified by their family names and ranks, without their personal names. Since such ranks were hereditary, it is difficult to identify the individuals, but most of the names are familiar and are associated with many calligraphic specimens of the Edo period. Some texts show close stylistic affinities with those in other *Genji* scrolls and albums included here, suggesting that the attributions may not be totally groundless.

The text excerpts, though brief, and more condensed than those given in the Osaka manual, are intelligent descriptions of the situations illustrated in the accompanying paintings. Each chapter is represented by one painted scene, which in general follows the standard iconographic type. With the exception of chapter 45, the two scrolls were painted by one master. The artist who painted chapter 45 was probably a young assistant, since his handling of the brush is much less convincing than that of the master. In the remaining fifty-three scenes, colors are applied lightly; occasional touches of gold and silver are added in a restrained manner. Light, fluid ink lines define the forms, but a darker ink is often applied in a free, painterly manner on the rocks and pebbles that dot the streams and undulating shorelines. Elegant autumn grasses often grace the garden scenes; hedges are painted in light brown washes over the ink lines. These features mark the paintings of Kaihō Yūsetsu (1598–1677), son of the great Momoyama-period master, Kaihō Yūshō (1533–1615). Yūsetsu's paintings, which only faintly echo his father's powerful works of ink-play, present a pleasant mixture of Kanō and Tosa features. Through Lady Kasuga (1579–1643), who had been reared by Yūshō and his wife and who later became the wet-nurse of the third Tokugawa shogun, Iemitsu (1605–51), Yūsetsu obtained some commissions from the shoguns, the Imperial family, and courtiers. This set of *Genji* scrolls might have been one of such works commissioned by a courtier.

# Notes to the Introduction

## 1

1. Edward G. Seidensticker, trans., *The Tale of Genji* (New York: Knopf, 1976). In my translation of the Osaka manual, names of people and chapters in the novel, as well as certain phrasings, follow those adopted by him.
2. Ibid., xi.
3. Edward G. Seidensticker, trans., *The Gossamer Years* (Rutland, Vt.: Tuttle, 1964).
4. Annie Shepley Omori and Kochi Doi, trans., *Diaries of Court Ladies of Old Japan* (Tokyo: Kenkyūsha, 1963), 3–70; and a more recent translation in Ivan Morris, *As I Crossed a Bridge of Dreams: Recollections of a Woman in Eleventh-Century Japan* (London: Oxford University Press, 1971).
5. Richard Bowring, *Murasaki Shikibu: Her Diary and Poetic Memoirs* (Princeton, N.J.: Princeton University Press, 1982), 139.
6. Ibid., 135.
7. Ibid.
8. Ibid., 91.
9. Ibid., 137.
10. Ibid., 143.
11. Ivan Morris, trans., *The Pillow Book of Sei Shōnagon*, two vols. (Harmondsworth: Penguin, 1971).
12. Edwin A. Cranston, trans., *The Izumi Shikibu Diary: A Romance of the Heian Court* (Cambridge, Mass.: Harvard University Press, 1969).
13. Suzuki Hiromochi, ed., *Kōchū Mumyō Zōshi* (Tokyo: Kasama Shoin, 1970), 15
14. Morris, *A Bridge of Dreams*, 55.

## 2

1. Ienaga Saburō, *Jōdai Yamato-e Nempyō*, rev. ed. (Tokyo: Bokusui Shobō, 1966), 19–20.
2. Osvald Sirén, *Chinese Painting: Leading Masters and Principles* (London: Lund Humphries, 1956), 3: pls. 120–23.
3. Akiyama Terukazu, "Pelliot-bon Gōmahen Rōdosha Tōseihen Gakan to Tonkō Hekiga (Tun-huang paintings illustrating a magic competition between Śāriputra and Radurākṣa—a scroll brought back by Pelliot and the murals of cave temples)," *Heian Jidai Sezokuga no Kenkyū* (Tokyo: Yoshikawa Kōbunkan, 1964), 389–426; for *etoki* see also Barbara Ruch, "Medieval Jongleurs and the Making of a National Literature: Toward the Reconstruction of a Theoretical Framework," in John W. Hall and Takeshi Toyoda, eds., *Japan in the Muromachi Age* (Berkeley, Calif.: University of California Press, 1977), 288–90.
4. Kikutake Jun'ichi "Shōtoku Taishi E-den," *Nihon no Bijutsu* 91 (1973): 30–35.
5. Seidensticker, *Genji*, 958.
6. Ienaga, *Jōdai Yamato-e*, 40; Katagiri Yōichi, ed., *Ki no Tsurayuki Zen Kashū Sōsakuin* (Kyoto: Daigakudō Shoten, 1968); for the English translation of some of these poems and prefaces, see Kenji Toda, "Japanese Screen Paintings of the Ninth and Tenth Centuries," *Ars Orientalis* 3 (1959): 152–63.
7. Akiyama Terukazu, "Fujiwara Bunka," in Kitayama Shigeo, et al., "Iwanami Kōza Nihon Rekishi," *Kodai* 4 (1962): 226.

**335**

8. Tamagami Takuya, "Byōbu-e to Uta to Monogatari to," *Kokugo Kokubun* 22, no. 1 (1953): 1–20.

9. For the English translation of this tale, see Harold Parlett, trans., "The Sumiyoshi Monogatari," *Transactions of the Asiatic Society of Japan* 29 (1901): 35–123.

10. Hashimoto Fumio, ed., *Gosho-bon Sanjūrokunin Shū* (Tokyo: Shintensha, 1970), 105–6, 110–12. The poems were first discussed in Horibe Seiji, *Chūko Nihon Bungaku no Kenkyū* (Kyoto, 1943); see also Ishikawa Tōru, "Kohon Sumiyoshi Monogatari no Naiyō ni kansuru Okusoku," *Chūko Bungaku* 3 (1967): 3.

11. In Yoshinobu's poems and their prefaces, Chūjō is called Jijū.

12. Tamagami, "Byōbu-e," 20.

13. Akiyama, "Fujiwara Bunka"; Tamagami, "Byōbu-e," 125–28.

14. Zōho Shiryō Taisei Kankō-kai, ed., *Zōho Shiryō Taisei*, vol. 16, *Chōshū Ki I* (Kyoto: Rinsen Shoten, 1965), 183–84; see also Komatsu Shigemi, "*Genji Monogatari* no aida Kami Choshin subeshi: *Chōshū Ki* no dokkai o megutte," *Museum* 105 (1959): 21–23; and Julia Meech-Pekarik, "The Artist's View of Ukifune," in Andrew Pekarik, ed., *Ukifune: Love in the Tale of Genji* (New York: Columbia University Press, 1982), 173.

15. Akiyama Terukazu, *Genji Monogatari Emaki*, vol. 2 of *Shinshū Nihon Emakimono Zenshū*, new ed., (Tokyo: Kadokawa Shoten, 1975).

16. Akiyama, "*Genji Monogatari Emaki* Wakamurasaki Zu Dankan no Genkei Kakunin," *Kokka* 1011 (1978): 9–26.

17. Akiyama, *Genji Monogatari Emaki*.

18. Ibid.

19. Mildred M. Tahara, trans., *Tales of Yamato: A Tenth-Century Poem-Tale* (Honolulu: University Press of Hawaii, 1980), 95.

20. Teramoto Naohiko, "Genji-e Chinjō Kō," *Kokugo to Kokubungaku* 41 (September, 1964): 26–43; (November, 1964): 24–39; and Inaga Keiji, "Genji Higishō fusai no Kana Chinjō," *Kokugo to Kokubungaku*, 41 (June, 1964): 22–31; see also Julia Meech-Pekarik, "The Artist's View," 174–75, 180–82.

21. Inaga, "Genji Higishō," 23. He also suggests that these twelfth-century scrolls may be the same as those mentioned in the *Chōshū Ki*.

22. A ten-scroll set was made as a prize to be given out in a shell contest in the spring of 1233. This is mentioned in the *Meigetsu Ki*, a diary of Fujiwara Teika (1162–1241). See Kokusho Kankō-kai, ed., *Meigetsu Ki*, 3 vols., entry for the second year of the Jōei era (1233), 20th day of the third month; see also chapter 11 of the *Kokon Chomonjū*, a collection of tales, edited by Tachibana Narisue in 1254, in Nagazumi Yasuaki and Shimada Isao, eds., *Kokon Chomonjū*, vol. 84 of *Nihon Koten Bungaku Taikei* (Tokyo: Iwanami Shoten, 1968). Many *Genji* paintings are also mentioned in the Muromachi-period court diaries such as the *Kammon Gyoki* and the *Oyudono no Ue no Nikki*, some of which possibly date back to the thirteenth century. See Ienaga, *Jōdai Yamato-e*, 239.

23. Akiyama Terukazu, "Hakubyō Eiri *Genji Monogatari*, Ukifune, Kagerō no Maki ni tsuite," *Bijutsu Kenkyū* 227 (1964): 207–24; and "Hakubyō Eiri-bon *Genji Monogatari* (Sawarabi) no Kotobagaki Dankan," *Bijutsu Kenkyū* 305 (1977): 32–38

24. Umezu Jirō, "*Genji Monogatari Emaki*: Tenri Bon," *Emakimono Zanketsu no Fu* (Tokyo: Kadokawa Shoten, 1970), 67–85.

25. Edward Putzar, trans., "*Chikusai Monogatari*," *Monumenta Nipponica*, 16, nos. 1, 2 (Tokyo, 1960–61): 176. For an example of such fans, attributed to Sōtatsu's studio, see

Yamane Yūzō, ed., "Sōtatsu-ha I," *Rimpa Kaiga Zenshū,* no. 16 (Tokyo, 1977).

26. For the examples of the crafts, see Kyoto National Museum, *Genji Monogatari no Bijutsu* (Kyoto: Kyoto National Museum, 1975) [exhibition catalogue].

### 3

1. Tamagami, "*Genji Monogatari Ekotoba ni tsuite,*" *Joshidai Bungaku (Kokubunhen)* 19 (1967). A reprint of this manual arrived after this translation went into press. See also Katagiri Yōichi, ed., *Genji Monogatari Ekotoba: Honkoku to Kaisetsu* (Kyoto: Daigakudō Shoten, 1983).

2. Katagiri, *Genji Monogatari Ekotoba,* 131.

3. Tamagami, *Joshidai Bungaku,* 1.

4. Katagiri dates this version to the Genroku era (1688–1704), see reprint, 120: see also Shimizu Yoshiko, "*Genji Monogatari* Kaiga no Ichi Hōhō: Shin Shiryō *Genji Monogatari Ekotoba* no Shōkai," *Kokugo Kokubun* 29 (1960): 1–14.

5. These lost pages represented scene 7 of chapter 9 (*Aoi*) and scene 1 of chapter 10 (*Sakaki*).

6. Seidensticker, *Genji,* 663.

7. Akiyama, *Genji Monogatari Emaki; Genji-e,* in Staffs of the National Museums of Tokyo, Kyoto, and Nara, eds., *Nihon no Bijutsu,* no. 119 (Tokyo: Shibundō, 1976); "Genji-e no Keifu," in Akiyama Ken, et al., *Genji Monogatari,* vol. 7 of *Zusetsu Nihon no Koten* (Tokyo: Shūeisha, 1978); and Shirahata Yoshi, "*Genji Monogatari-e* ni tsuite," *Genji Monogatari Emaki Gojūyonjō,* in *Bessatsu Taiyō* (Summer, 1973).

# Selected Bibliography

### WESTERN-LANGUAGE SOURCES

Akiyama, Terukazu. *Heian Jidai Sezoku-ga no Kenkyū* (in Japanese; French summary). Tokyo: Yoshikawa Kōbunkan, 1964.

Bowring, Richard. *Murasaki Shikubu: Her Diary and Poetic Memoirs.* Princeton: Princeton University Press, 1982.

Cranston, Edwin A., trans. *The Izumi Shikibu Diary: A Romance of the Heian Court.* Cambridge: Harvard University Press, 1969.

Galerie Janette Ostier. *Les jardin d'or du Prince Genji: Peintures japonaises du XVII^e siècle.* Paris, 1980.

Ienaga, Saburō. *Painting in the Yamato Style.* Translated by John M. Shields. New York: John Weatherhill, 1973.

Mason, Penelope E. "The House-bound Heart: The Prose-poetry Genre of Japanese Narrative Illustration." *Monumenta Nipponica* 35, nos. 1–4 (1980): 21–43.

Meech-Pekarik, Julia. "The Artist's View of Ukifune." In *Ukifune: Love in the Tale of Genji,* edited by Andrew Pekarik. New York: Columbia University Press, 1982.

Murase, Miyeko. *Japanese Art: Selections from the Mary and Jackson Burke Collection.* New York: Metropolitan Museum of Art, 1975.

Morris, Ivan, trans. *As I Crossed a Bridge of Dreams: Recollections of a Woman in Eleventh-Century Japan.* London: Oxford University Press, 1971.

————. *The Pillow Book of Sei Shōnagon.* 2 vols. Harmondsworth: Penguin, 1971.

Okudaira, Hideo. *Emaki: Japanese Picture Scrolls.* Rutland, Vt: C. E. Tuttle, 1962.

————. *Narrative Picture Scrolls.* Trans. by Elizabeth ten Grotenhuis. New York: John Weatherhill, 1973.

Omori, Annie Shepley and Kochi Doi, trans. *Diaries of Court Ladies of Old Japan.* Tokyo: Kenkyūsha, 1963.

Parlett, Harold, trans. "The Sumiyoshi Monogatari." *Transactions of the Asiatic Society of Japan* 29 (1901): 35–123.

Rosenfield, John M., et al. *The Courtly Tradition in Japanese Art and Literature: Selections from the Hofer and Hyde Collections.* Cambridge: Harvard University, Fogg Art Museum, 1973.

Seckel, Dietrich. *Emakimono: The Art of the Japanese Painted Handscroll.* Trans. from the German by J. Maxwell Brownjohn. New York: Pantheon Books, 1959.

Shimizu, Yoshiaki. "Some Elementary Problems of the Japanese Narrative, *Hiko-hoho-demi no Mikoto,*" *Studia Artium Orientalis et Occidentalis* 1 (1982): 29–41.

Seidensticker, Edward G., trans. *The Gossamer Years.* C. E. Tuttle: Rutland and Tokyo, 1964.

Shikibu, Murasaki. *The Tale of Genji.* Trans. by Edward G. Seidensticker. New York: Alfred A. Knopf, 1976.

Soper, Alexander C. "Rise of Yamato-e." *Art Bulletin* 24 (December 1942): 351–79.

Sorimachi, Shigeo. *Catalogue of Japanese Illustrated Books and Manuscripts in the Spencer Collection of the New York Public Library.* Tokyo: Kōbunsō, 1978.

Tahara, Mildred M., trans. *Tales of Yamato: A Tenth-Century Poem-Tale.* Honolulu: University Press of Hawaii, 1980.

Toda, Kenji. "Japanese Screen Paintings of the Ninth and Tenth Centuries," *Arts Orientalis* 3 (1959): 153–66.

———. *Japanese Scroll Painting*. Chicago: The University of Chicago Press, 1935.

## JAPANESE-LANGUAGE SOURCES

Akiyama Terukazu. *Emaki*. In *Zaigai Nihon no Shihō*, vol. 2, edited by Shimada Shūjirō et al. Tokyo: Mainichi Shimbunsha, 1980.

———. *Emakimono*. In *Genshoku Nihon no Bijutsu*, vol. 8, edited by Akiyama Terukazu et al. Tokyo: Shōgakukan, 1968.

———. "Fujiwara Bunka," In *Iwanami Kōza Nihon Rekishi, Kodai*, vol. 4, edited by Kitayama Shigeo et al. (1962), 212–54.

———. *Genji-e*. In *Nihon no Bijutsu*, no. 119, edited by the Staffs of the National Museums of Tokyo, Kyoto, and Nara. Tokyo: Shibundō, 1976.

———. "Genji-e no Keifu." In Akiyama Ken et al., *Genji Monogatari, Zusetsu Nihon ·no Koten* 7 (1978), 113–35.

———. *Genji Monogatari Emaki*. In *Shinshū Nihon Emakimono Zenshū*, vol. 2, edited by Tanaka Ichimatsu. Tokyo: Kadokawa Shoten, 1975.

———. "*Genji Monogatari Emaki* Wakamurasaki Zu Dankan no Genkei Kakunin," *Kokka* 1011 (1978), 9–26.

———. "Hakubyō Eiri *Genji Monogatari*, Ukifune, Kagerō no Maki ni tsuite," *Bijutsu Kenkyū* 227 (1964), 207–24.

———. "Hakubyō Eiri-bon *Genji Monogatari* (Sawarabi) no Kotobagaki Dankan," *Bijutsu Kenkyū* 305 (1977), pp. 32–38.

Doi Tsugiyoshi. *Kanō Eitoku and Mistunobu*. In *Nihon Bijutsu Kaiga Zenshū*, vol. 9, edited by Tanaka Ichimatsu et al. Tokyo: Shūeisha, 1978.

———. *Kanō Sanraku and Sansetsu*. In *Nihon Bijutsu Kaiga Zenshū*, vol. 12, edited by Tanaka Ichimatsu et al. Tokyo: Shūeisha, 1976.

Ienaga Saburō. *Jōdai Yamato-e Zenshi; Jōdai Yamato-e Nempyō*. Rev. ed. Tokyo: Bokusui Shobō, 1966.

Inaga Keiji. "*Genji* Higishō fusai no Kana Chinjo." *Kokugo to Kokubungaku* 41 (June 1964), 22–31.

Katagiri Yōichi, ed. *Genji Monogatari Ekotoba: Honkoku to Kaisetsu*. Kyoto: Daigakudō Shoten, 1983.

Komatsu Shigemi, "*Genji Monogatari* no aida Kami Chōshin subeshi: *Chōshū Ki* no dokkai o megutte," *Museum* 105 (1959), 21–23.

Komatsu Shigemi, ed. *Genji Monogatari Emaki*. In *Nihon Emaki Taisei*, vols. 1 and 23. Tokyo: Chūō Kōronsha, 1977 and 1979.

Kyoto National Museum. *Genji Monogatari no Bijutsu*. Exhibition catalogue. Kyoto, 1975.

Shimizu Yoshiko. "*Genji Monogatari* Kaiga no Ichi Hōhō: Shin Shiryō *Genji Monogatari Ekotoba* no Shokai," *Kokugo Kokubun*, vol. 29 (1960), 1–14.

Shirahata Yoshi, "*Genji Monogatari-e* ni tsuite." In *Bessatsu Taiyō: Genji Monogatari*, edited by Funabashi Seiichi and Hisamatsu Sen'ichi. Tokyo: Heibonsha, 1973.

———. "Den Tosa Mitsumoto hitsu Genji Monogatari Gajō," *Kokka* 965 (January, 1974), 15–25.

Takeda Tsuneo, "Tosa Mitsuyoshi to Saiga: Kyoto Kokuritsu Hakubutsukan *Genji Monogatari* Zujō o megutte," *Kokka* 996 (December, 1976), 11–40.

Tamagami Takuya. "Byōbu-e to Uta to Monogatari to." *Kokugo Kokubun* 22, no.1 (1953), 1–20.

———. "*Genji Monogatari Ekotoba* ni tsuite," *Joshidai Bungaku, Kokubun-hen* 19 (1967).

Teramoto Naohiko, "*Genji*-e Chinjō Kō," *Kokugo to Kokubungaku* 41 (1964), 9: 26–43; 11: 24–39.

Yamane Yūzō, "Tosa Mitsuyoshi to sono Sekiya, Miyuki, Ukifune Zu Byobu," *Kokka* 749 (August, 1954), 242–49.

Yamane Yūzō, ed. *Rimpa Kaiga Zenshū, Sotatsu-ha I*. Tokyo: Nihon Keizai Shimbunsha, 1977.

Yoshida Yūji. *Tosa Mitsunobu*. In *Nihon Bijutsu Kaiga Zenshū*, vol. 5, edited by Tanaka Ichimatsu et al. Tokyo: Shūeisha, 1979.

# Subject Index to the Osaka Manual

snow, 5–4 (frost), 5–7 (frost), 6–5, 10–3, 16–1 (frost), 19–1, 20–2, 20–4, 21–3 (frost), 31–1, 34–3, 35–11, 42–1, 46–3, 51–6, 51–7

storm, 10–8, 13–1, 28–1

Person:

baby (or child), 5–1, 5–2, 19–1, 23–2, 50–2

boy, 2–4, 2–6, 3–1, 3–2, 4–2, 14–2, 24–1, 31–2, 31–3, 33–3, 34–4, 35–5, 35–11, 36–4, 37–2, 37–5, 38–1, 39–3, 40–1, 41–4, 43–1, 43–2, 44–1, 46–2, 54–1, 54–2

dancer, 6–4, 7–1, 14–2, 21–4, 21–5, 33–3, 34–11, 35–4, 35–11, 40–1

fisherman, 12–5, 18–3

girl, 5–1, 18–2, 19–1, 19–2, 19–3, 20–4, 23–1, 25–2, 31–2, 35–5, 44–4, 51–1, 52–5

monk (or ascetic), 5–2, 5–3, 10–1, 10–6, 13–2, 13–6, 18–1, 19–5, 34–2, 34–10, 35–7, 36–1, 36–2, 36–3, 38–1, 45–3, 52–1, 53–1, 53–2, 53–6, 53–7, 54–1

musician, 21–5 (on the boats), 23–2 (singers), 24–1 (on the boats), 24–2, 33–3, 34–11, 35–2, 35–4, 35–11, 38–2, 40–1

nun, 1–1, 5–1, 5–2, 19–1, 20–3, 34–13, 35–10, 36–3, 53–2, 53–3, 53–5, 53–8, 54–2

peddler, 50–6

villager (or old person), 10–6, 13–1, 20–2, 49–15

weaver (or seamstress or spinner), 28–5, 51–2, 53–8

Vehicles:

Boat, 7–1, 14–2, 14–3, 22–2, 22–3, 24–1, 24–3, 33–3, 46–1, 46–2, 47–4, 47–5, 51–5, 51–6

Carriage, 1–1, 2–3, 4–1, 4–4, 5–3, 5–4, 5–6, 6–5, 7–3, 9–1, 10–1, 10–2, 10–3, 10–6, 11–1, 12–1, 14–2, 14–3, 15–1, 16–1, 19–1, 20–2, 29–1, 31–1, 31–2, 32–4, 34–9, 34–10, 34–12, 35–2, 38–3, 42–1, 47–3, 48–3, 49–2, 49–4, 49–5, 49–14, 49–15, 52–1, 52–4, 53–2

# Seasonal Index to the Osaka Manual

Spring (2nd, 3rd, and 4th months), 5–1, 5–3, 6–1, 6–2, 8–1, 9–1, 9–2, 10–7, 12–1, 12–2, 12–3, 12–5, 13–1, 13–2, 13–3, 13–4, 13–5, 15–2, 17–2, 17–3, 17–4, 21–5, 24–1, 24–2, 24–3, 29–3, 29–4, 29–5, 31–4, 32–2, 32–3, 32–4, 32–5, 33–1, 34–6, 34–7, 34–8, 34–9, 34–14, 35–1, 35–6, 35–7, 36–4, 36–5, 36–6, 37–5, 40–1, 41–1, 41–2, 43–1, 43–2, 44–2, 44–3, 44–4, 44–5, 46–1, 46–2, 48–2, 48–3, 49–11, 49–12, 49–13, 49–14, 51–5, 51–6, 51–7, 51–8, 51–9, 51–10, 51–11, 52–1, 53–1, 53–2

Summer (5th, 6th, and 7th months), 1–1 (and autumn), 2–1, 2–2, 2–4, 2–5, 2–6(?), 3–1, 3–2, 4–2, 4–3, 4–4, 4–5, 6–3, 6–4, 7–5, 7–6, 7–7, 8–3, 10–4, 10–8, 14–1, 21–1, 22–1, 22–2, 24–2, 24–4, 24–5, 25–1, 25–3, 26–1, 27–1, 27–2, 33–2, 35–8, 37–1, 37–2, 38–1, 41–3, 46–5, 49–2, 49–3, 49–15, 52–2, 52–5, 52–6, 52–7, 53–3 (late summer or early autumn)

Autumn (8th, 9th, and 10th months), 1–1, 1–2, 2–3, 7–1, 9–3, 9–4, 9–5, 9–6, 10–1, 10–5, 10–6, 12–4, 13–6, 14–2, 14–3, 14–4, 16–1, 18–1, 18–2, 18–3, 18–4, 19–6, 19–7, 20–1, 21–2, 21–6, 22–3, 22–4, 22–5, 26–2, 28–1, 28–2, 28–3, 28–4, 28–5, 30–1, 33–3, 34–10, 34–11, 34–12, 35–2, 35–3, 35–4, 37–3, 37–4, 38–2, 38–3, 39–1, 39–2, 40–2, 40–3, 45–3, 47–1, 47–2, 47–3, 47–4, 47–5, 47–6, 49–1, 49–4, 49–5, 49–6, 49–7, 49–8, 49–9, 50–1, 50–2, 50–3, 50–4, 50–5, 50–6, 50–7, 52–8, 53–4, 53–5, 53–6

Winter (11th, 12th, and 1st months), 5–4, 5–5, 5–6, 5–7, 5–8, 6–5, 6–6, 6–7, 7–2, 9–7, 10–3, 15–1, 19–1, 19–2, 19–3, 19–4, 20–2, 20–3, 20–4, 21–3, 21–4, 22–6, 23–1, 23–2, 29–1, 29–2, 31–1, 31–2, 31–3, 32–1, 34–1, 34–2, 34–3, 34–4, 34–5, 35–5, 35–11, 39–6, 41–4, 42–1, 42–2, 44–1, 44–6, 46–3, 46–4, 49–10, 51–1, 51–2, 51–3, 51–4, 53–8

# General Index

Akashi empress (also the Akashi princess, crown princess): 120, 122, 123, 145, 146, 199, 202, 204, 204–5, 235–36, 245, 309

Akashi lady: 25, 109, 110, 119, 122, 124, 138, 145, 146, 197, 199, 202, 204–5, 234

Akikonomu: 25, 116–17, 126–27, 137–39, 148, 150, 164, 170, 188

Aoi: 3, 62, 67, 80; and birth of son, 84; death of, 85

Asagao: 25–26, 128, 180

Ben no Kimi (also Ben no Ama): 255, 259, 260–61, 273, 280

*Chōshū Ki*: 10–11, 13

dowry sets (of Genji pictures): 16, 22, 331

Eighth Prince: 251, 252, 253, 254, 255; death of, 255

emperor: see Kiritsubo emperor, Reizei emperor, Suzaku emperor

*etoki*: 8

Fifth Princess: 128, 129, 130

First Princess: 80, 263, 299, 302

Fujitsubo: 73, 90, 91

Fujiwara Michinaga: 5, 6

*fukinuki-yatai*: 12, 317

Genji: 3–4, 13–14, 18, 21–22, 25–26, 30–32; as an infant, 35; as a young child, 38, 39; 40, 42, 45–46, 47–48, 48, 49–50, 50–51, 52–53, 53–54, 54–55, 55, 56, 58, 59, 60, 61, 62, 63, 64, 66–67, 67, 68, 69, 69–70, 70; at age of 17 or 18, 72, 73, 74; 75, 75–76, 77, 78; at age of 19, 79; 80; at age of 21 or 22, 82; 83; and birth of Yūgiri, 84; and death of Aoi, 85; 86, 87, 88, 89, 90–91, 91–92, 92, 94, 96, 97; exiled, 98, 99; 100, 101, 101–2, 103–4, 104, 105, 106, 107, 108, 109, 110, 111, 113, 114, 115, 116, 116–17, 118, 119–20, 121, 122, 123, 124, 126, 127, 128, 129, 130, 131, 132, 136–37, 137–38, 143, 144, 145, 146, 147, 150, 152, 154, 155, 156, 157, 158, 160, 161, 163–64, 164, 164–65, 165, 168, 170, 172, 173, 177, 179, 180, 181, 183, 186–87, 190; 40th birthday of, 191; 192, 193, 194, 195, 196, 197, 199, 200, 202, 203, 205, 207, 208, 209, 212, 213, 217, 218, 223, 224, 225; and death of Murasaki, 235–36, 237, 238; 239, 240, 241, 278; death of, 322

*Genji-e Chinjō*: 13, 19

*Genji Higishō*: 13

*Genji Monogatari*: plot of, 3–4; date of, 5; literary context of, 6–7, 8, 9; painting, 10–19; *Osaka Manuscript*, 19–28; Seidensticker translation of, 3, 28, 31

*Genji Monogatari Ekotoba*: see Osaka Manuscript

*hakubyō*: 14–15, 24, 320, 321, 324, 326, 329, 332, 333

*Hamamatsu Monogatari*: 6

Higekuro: 23, 167, 175, 176, 177, 205, 210

*hikime-kagihana*: 12

Hinaya Rippo: 328

Hitachi: 242, 276

Hotaru: 99, 116–17, 118, 136–37, 154, 179, 180, 192, 197–98, 199, 200, 210, 224, 238

Hyōbu: 73, 90, 91–92

*Ikuta Otome Zuka*: 10

*Ise Monogatari*: 6

Jijū (Ukifune's attendant): 284, 291, 292, 295, 296

*Kagerō Nikki*: 4

Kaihō school: 15, 27, 334

The "weathermark" identifies this book as a production of John Weather-hill, Inc., publishers of fine books on Asia and the Pacific. Supervising editor: Stephen B. Comee. Book design and typography: Miriam F. Yamaguchi. Layout of illustrations: Shinji Moriyama. Production supervisor: Mitsuo Okado. Composition: Korea Textbook Company, Seoul. Plate-making and printing, in offset: Kyodo Printing Company, Tokyo. Binding: Makoto Binderies, Tokyo. The typeface used is Monotype Baskerville.